Great Houses of **HAVANA**

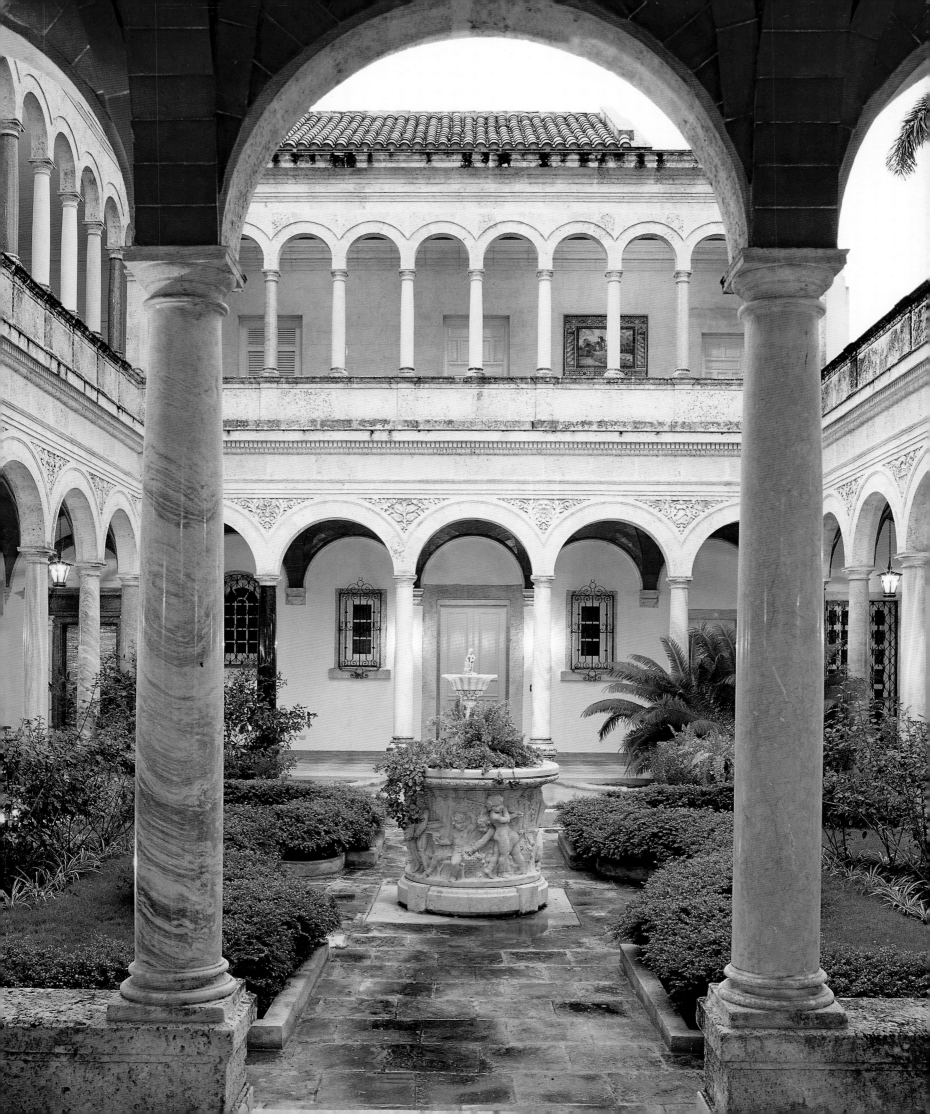

Great Houses of *HAVANA*

A CENTURY OF CUBAN STYLE

Hermes Mallea

THE MONACELLI PRESS

Library of Congress Cataloguing-in-Publication Data

Mallea, Hermes.
 Great houses of Havana : a century of architecture and design / Hermes Mallea.
 p. cm
 Includes bibliographical references.
 ISBN 978-1-58093-288-2
 1. Architecture, Domestic--Cuba--Havana--History--19th century. 2. Architecture, Domestic--
 Cuba-- Havana--History--20th century. 3. Havana (Cuba)--Buildings, structures, etc. I. Title.
 NA7276.H38M35 2011
 747--dc23
 2011023189

Printed in China

10 9 8 7 6 5 4

Designed by Susan Evans, Design per se, Inc.

www.monacellipress.com

Contents

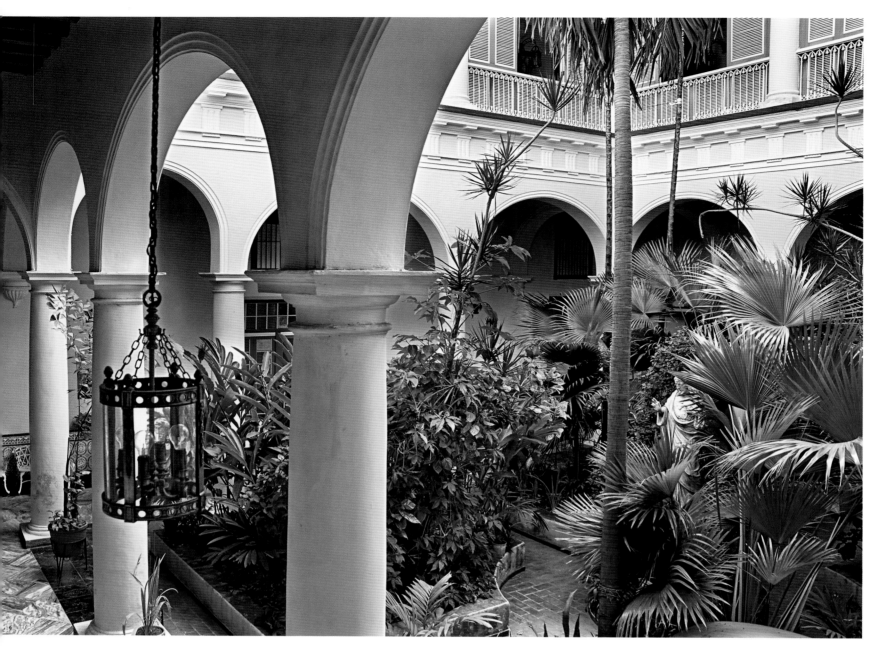

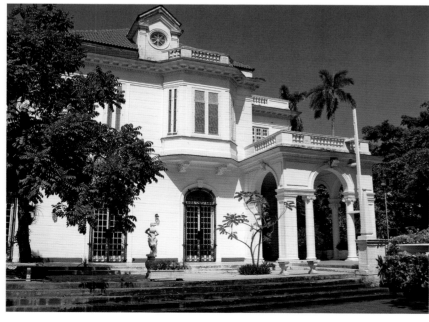

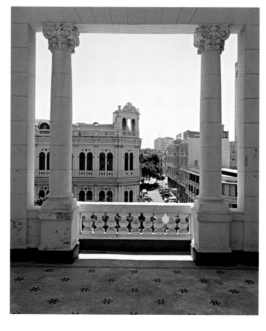

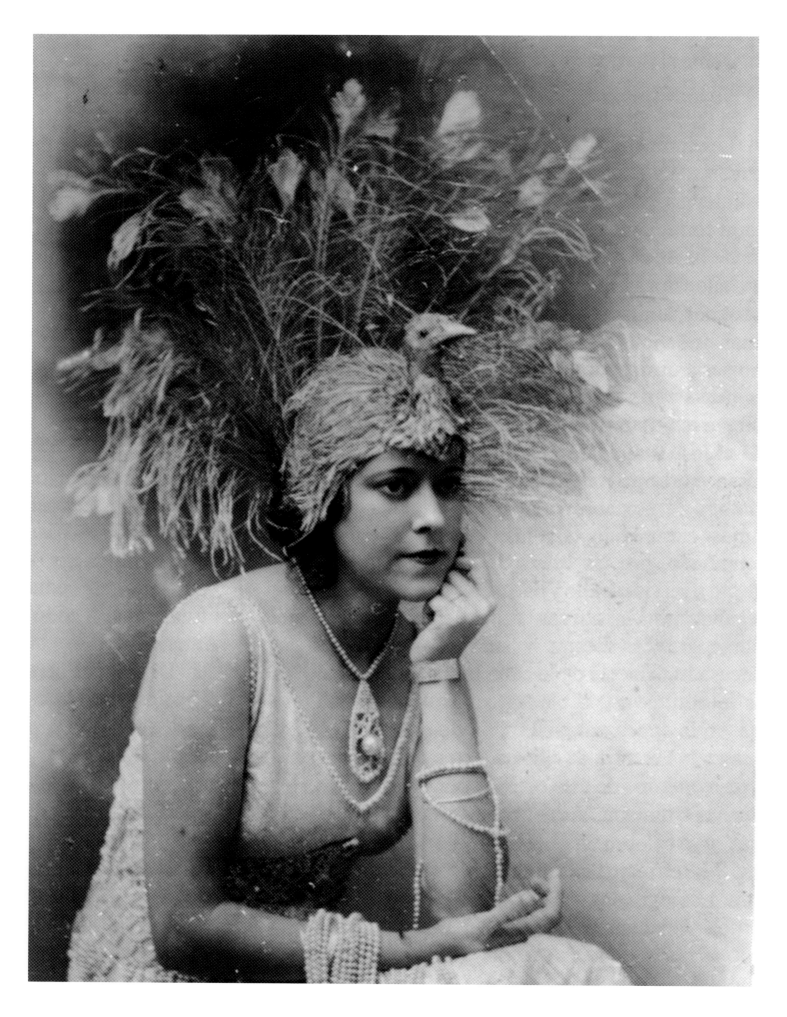

Preface

The making of *Great Houses of Havana* was a hugely rewarding enterprise that allowed me to draw on my professional experience and my Cuban roots to connect to the island, generating great pride in these houses and the sophisticated culture that gave birth to them. In this book I am presenting the human stories behind a century of exceptional Havana houses, and I hope the reader is able to sense the excitement I felt on entering a house I had "coveted" for months and to feel my delight in serving as guide to life inside. It was particularly rewarding to introduce this architecture to the young Havana photographers who worked on the project. And nothing surpassed the emotional experience of interviewing the residents of a great house while sitting in the home their family built generations ago.

During two years of research, I realized that the architects, historians, and present and former homeowners I was meeting had been waiting for five decades to share their reminiscences of the city's famous houses. Their recollections and anecdotes always evoked the vibrant Havana lifestyle they had experienced and still longed for.

My great aunt "Chea," Mercedes López de Quintana Sartorio, photographed by her father in the early 1920s. She was a respected provincial photographer who won prizes in Cuban and international competitions in the 1940s and 1950s.

Throughout these interviews, I was reminded of the stories I had been told by my own Cuban exile family in Miami as they recalled their life in Gibara, a small town on the island's northeast coast. My personal concept of "home" was shaped by my maternal great aunts, who played an important part in my upbringing after the death of my mother. In their daily conversations, *las tías* referred to earlier generations of our family as if they had just left the room. In the photograph albums they had brought from the island, the family house and its waves of occupants came alive for me. In these pages, I admired images taken by my great-grandfather Joaquín López de Quintana Gurri, a late-nineteenth-century photographer and photojournalist, as well as pictures by two of his daughters, my great aunts. Joaquín's photographs captured the life of his community and the intimacy of the family home at a time when Cuba still felt very Spanish. One generation later, his daughters documented an increasingly Americanized Cuba, the result of decades of U.S. commercial and cultural influence. These albums accompanied by family reminiscences instilled in me a love of vintage Cuban photographs and an appreciation for the wealth of information they contained regarding family life. The island's homes, from urbane Havana to rural Gibara, shared unmistakably Cuban characteristics that were captured in these images.

That formative exploration of family history together with my profession as an architect specializing in residential design have shaped *Great Houses of Havana*. Here, I am presenting portraits of houses and their builders in order to tell the story of Havana's architectural patrimony. Each portrait is an appreciation of a unique way of living in the Cuban home, focusing on the family life of earlier generations in order to illustrate the island's architecture at different moments between 1860 and 1960. Each house has something compelling to say about Cuban home life at a moment in time. It was important to present these houses in their neighborhood context, to describe the social life of clubs, churches and schools these homeowners enjoyed and to focus my tour on the important connection between the architecture and the interior decoration.

In addition to social history, this group of houses reveals the development of Cuban architectural style from the traditional Spanish Colonial courtyard house to the assimilation of fashionable European and North American design trends from the tenets of Beaux-Arts classicism to local manifestations of art deco and eclectic revivals.

Havana followed step-by-step what was occurring in the international design scene, since connection to the contemporary world has always been important for Cubans. This progression culminated in the mid-1950s with the uniquely Cuban tropical modernist houses that adeptly reconciled the latest international design trends with construction elements from the island's colonial traditions, thus balancing foreign design influences with the quest for national identity. Following the revolution, priorities shifted in Cuba and the building of private homes decreased.

Havana saw herself as an international city, with sugar prosperity financing impressive public works projects as well as many of the houses presented here. It is my hope that this book will generate curiosity about Cuba and encourage further conversation about the city of Havana, whose unique sense of place results from its myriad neighborhoods, beautiful sea views and tropical vistas, and world-class houses that constitute an archive of every significant architectural style of the twentieth century.

Havana in the Nineteenth Century

By the 1860s Havana had arrived at a golden moment in its history. Cuba was enjoying a period of great wealth as a result of the industrialization of the sugar mills, the influx of thousands of slaves, and the relaxation of trade restrictions by the Spanish government that allowed Cuban sugar to be sold in Europe and the United States. Havana was the third largest city in the New World and the most important in Spanish America, boasting a fine university, imposing churches, convents, and academies, as well as theaters, casinos, restaurants and cafés, bull rings, and cultural societies. The streets were crowded with private carriages, horses and pack animals, slaves and free people of color. Farmers passed through the city gates daily to sell crops, competing with street vendors. The docks were hives of activity with the loading of tobacco, coffee, and sugar on ships that had brought cargoes of European and American luxury goods, South American cacao and indigo, and Chinese silks and porcelains.

Havana had been the terminus for Spain's legendary treasure fleet during the sixteenth and seventeenth centuries. The fortified harbor was a safe haven for galleons to gather before returning as a fleet to Spain laden with gold and exotic goods from across the empire—from the Philippines to Peru. In Havana, these vessels were stocked with water and provisions for

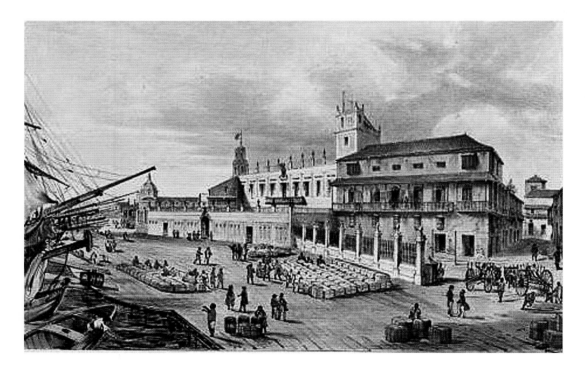

Left: Barrels in the Plaza de San Francisco, one of Havana's most important squares, are ready to be loaded onto nearby ships.

Opposite: *The Harbor with the Iron Warehouse in the Distance*, 1860, a stereoscopic view published in E. Anthony's *Scenes in Cuba*.

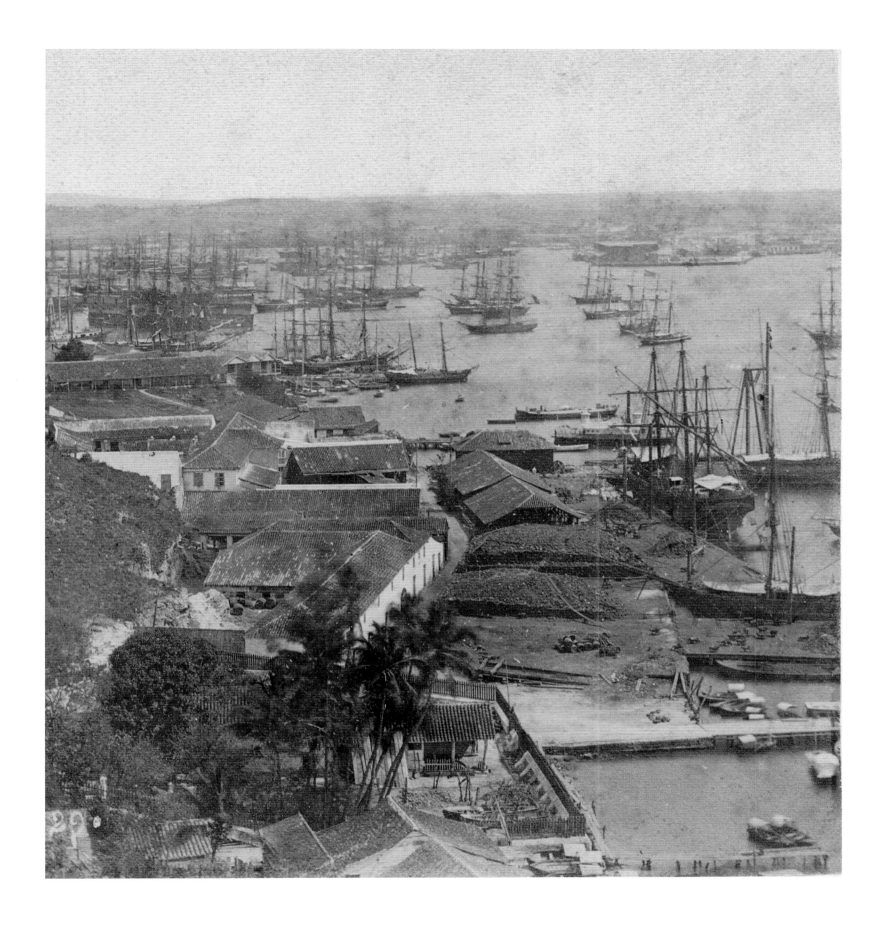

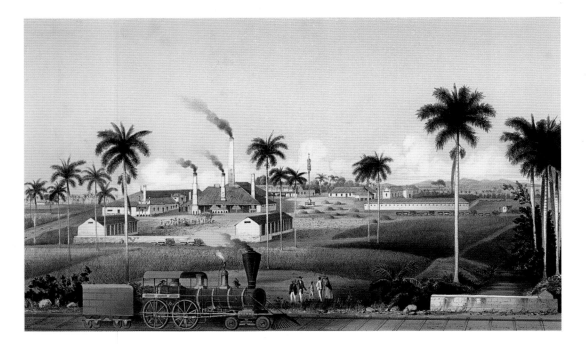

Eduardo Laplante's 1855 publication *Los Ingenios* (The Sugar Mills) artistically documented Cuba's most advanced sugar-processing plants, such as the Ingenio Acana, which was linked to the port of Havana via the new railroad.

the return trip and repaired at the city's famous shipyards. Thick walls had surrounded Havana since 1660, protecting the city from pirate raids and from invasion by European powers competing for dominance in the New World. Massive fortifications on both sides of the harbor remain the city's signature to this day.

The island of Cuba has more than 2,300 miles of coastline—almost twice that of Florida. Havana sits on the northwest coast, only ninety miles from the Florida Keys. The earliest Spanish colonists founded seven towns in Cuba beginning in 1515, with Santiago de Cuba, at the eastern end, as the capital. By the 1550s Havana was functioning as the de facto capital and was so designated in 1607.

Until the mid-eighteenth century, restrictive trade policies prohibited foreign ships from landing in Cuba, in order to enforce the Spanish monopoly on the sale of goods to the colonists. The British occupation of Havana in 1762 opened Cuba to free trade with Europe and the American colonies. Between 1791 and 1804, the Haitian slave uprising forced hundreds of French sugar growers to flee to Cuba, bringing their planting techniques and their slaves with them. With the introduction of the railroad and steam-powered machinery in the 1830s, production expanded dramatically. Plantations far to the west were linked with the port, expanding the area where sugar could be grown, and processing took place in large-scale mills called *ingenios*. Although sugar production was more and more mechanized, vast numbers of slaves were also needed. Cuba emerged as the world's leading producer of sugar, heavily involved in international trade after centuries of relative isolation.

The evolution of residential architecture in Havana followed a parallel course, initially related to Spanish tradition but opening to American and European influences as trade broadened. Havana's development was somewhat guided by the requirements of the Laws of the Indies promulgated by Philip II in 1573, as well as a series of later building codes or *Ordenanzas*. The compact layout of narrow streets and abutting houses was intended to ensure safety from attack, to segregate noxious activities, and above all to deal with the harsh climate of blistering sun and torrential rains. Cuba's colonial houses had an

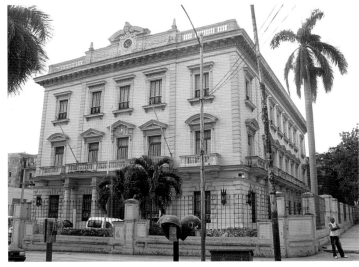
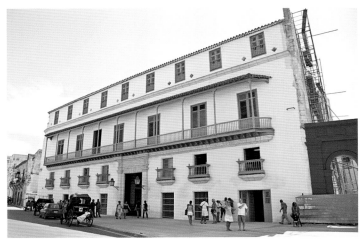
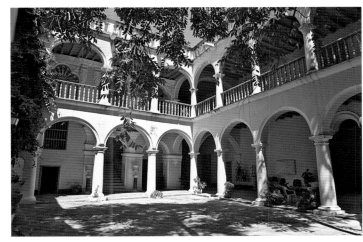

Clockwise from upper left: A seventeenth-century Old Havana house; the Madrid-style house of the Marques de Balboa in Las Murallas; courtyard of the Casa de la Obrapia, derived from the patio houses of Seville; the grand baroque mansion of Mateo Pedroso.

introverted layout, with an interior organized around a courtyard. This building type descended from the patio houses of Seville, which had both Moorish and ancient Roman antecedents. The solid exteriors of those early houses can be seen as a metaphor for a city that was itself surrounded by solid walls.

Havana's mercantile identity meant that colonial houses often combined a commercial use at the street level with a family home above. Dozens of slaves and servants lived in a mezzanine level between the family and the merchandise. There was an inevitable interaction between the ground-floor spaces open to business and the private area occupied by the family. With the accumulation of wealth, the simple, solid colonial house grew into the baroque mansion. The scale became monumental, the street entry was richly ornamented to proclaim status, vast ceiling heights encouraged ventilation, and projecting balconies became windows onto the life of the street. La Casa de Mateo Pedroso (1780) is representative of the baroque house, with its functional stone exterior pierced by windows of different scales, pitched clay tile roofs, turned wood railings and balcony columns, and an ornamented front door leading to a vast courtyard within. Havana's houses were plastered and painted in different pastel colors—never white—to prevent glare from the sun.

The neoclassical-style architecture that succeeded the baroque was primarily adapted from French sources. It was the style of the Enlightenment, representing the rational, orderly, and

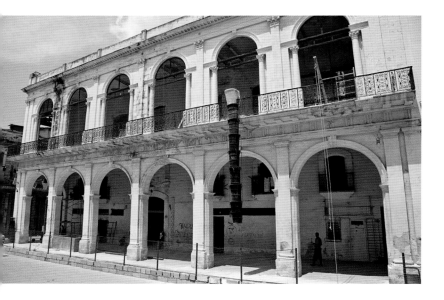

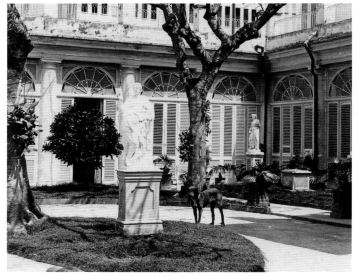

modern. El Templete, built in 1828, was Cuba's first neoclassical-style building, a perfect Greek temple on the Plaza de Armas where the Spanish governor lived opposite the Count of Santovenia. Colonnades were a signature of the neoclassical, gracing city squares, important streets, and the summer villas of El Cerro. Around this time, facades were fitted with large openings to allow air to circulate between the exterior and the courtyard, which then acted as a chimney, exhausting hot air out of the interior. These large openings were infilled with iron grilles and illustrate the often-referred-to extroversion of the Cuban house whose interior was now opened to the life of the city street. To Fanny Elssler, visiting Havana in the 1840s, the houses "seemed designed to stimulate the curiosity of the passer-by—requiring a great effort in order not to stare at what was going on within." However, Cubans were untroubled by being observed from the street, as they sat in the evening hours, close to these tall windows, which supplied light for reading and sewing in addition to the breezes. These windows also provided entertainment, allowing families to chat through the grilles with neighbors, connecting them to the life of their community.

The link between inside and outside was mirrored in the adjacency of bedrooms to public spaces. Even in the fanciest houses, these spaces were often separated by nothing more than lace portiere curtains or partial-height doors, known as *mamparas*. The Havana home of 1860 was eclectically furnished. Rocking chairs were the islander's preferred seating—their caned backs and seats kept sitters cool as they moved back and forth in the heat. Just as Cuban builders appropriated European architectural styles, the island's craftsmen adapted European and American furniture designs using the island's hard woods, which were resistant to termites. These local pieces were mixed in with the imported furniture in the latest Empire or rococo revival styles.

Captain General Miguel Tacón, governor of Cuba in the 1830s, did much to improve the quality of life in Havana by paving streets, installing public lighting, building markets, and employing firefighters and street cleaners. His scorn for the Cuba-born population—the *criollos*—made him hugely unpopular, increasing the animosity that had always existed between the *criollos* and the Spanish-born *peninsulares* who ruled the colony. An American visitor likened the tensions felt throughout the island to "dogs and cats locked up in the same cage." Tacón's beautification of the city was made possible by the island's sugar profits. The governor

Left: The beautifully detailed neoclassical-style palace of the Marqués de Almendares illustrates the public arcades required on private residences that overlooked the city's squares.

Right: Shaded galleries surround the courtyard at the heart of this nineteenth-century villa. Operable louvers framed views of the private landscape decorated with sculpture.

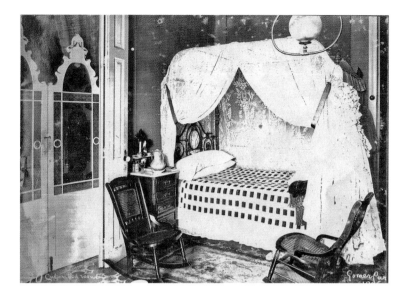

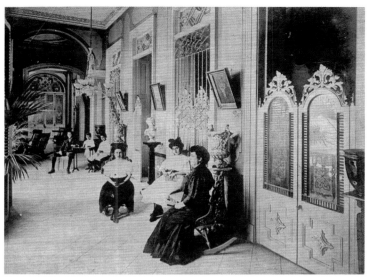

Left: This typical Cuban bedroom is separated from the adjacent spaces by low doors, or *mamparas*; the iron bedstead is fitted with a lacy mosquito net, protection from Havana's notorious insects.

Right: The Countess of Buenavista and her daughters occupy rocking chairs in the gallery of their Old Havana house, where Gothic-style *mamparas* are combined with iron grilles and glass transoms at the openings to adjacent rooms.

improved the Paseo Extramural (future Paseo del Prado), Paseo Militar, and Campo de Marte, three pleasure grounds located outside the city walls. Tacón's improvements were needed because the city within the walls was dirty, congested with carriages and animals, and lacking most infrastructure. For some time, Havana had been growing so that by the mid-nineteenth century a sizable commercial district existed outside the walls offering furniture, hardware, haberdashers and ready-made clothing stores, cafés, pharmacies, and restaurants. These walls were torn down in 1863, and the fashionable new Murallas neighborhood was further developed.

Life in the city's mansions was described in detail by the Countess of Merlin, who in 1842 returned to her native Havana from Paris. Merlin was a member of Havana's closed circle of intermarried families by birth and an insider at European royal courts by marriage. Her letters to Parisian friends depict the intimate life of the Cuban planter class without the prejudice of a foreign reporter and yet with a certain objectivity on uncomfortable subjects like African slavery. Merlin takes the reader inside her uncle's mansion, the Casa de Mateo Pedroso, where her clan assembled nightly. Today, a visit to Havana house museums, like the Museo de Arte Colonial or the Casa de la Obrapía, allows us to imagine the music of their nightly gathering being interrupted by the Angelus bells that initiated the family's prayers.

Merlin visited Havana at a time when Cuba still felt very Spanish—before the influx of North American capital that would take over the economy and permeate the culture of the island. By the mid-nineteenth century, the United States had become Cuba's main trade partner. There was intense traffic between Havana and the ports of New Orleans, Baltimore, Savannah, and Mobile. Cuba was dependent on American foodstuffs as well as manufactured goods, and the States consumed vast amounts of the island's exports. Hundreds of Americans had moved to the island to oversee this commerce. From the 1850s on, several U.S. presidents considered buying Cuba from Spain. Many Cuban planters, dissatisfied with Spain's colonial rule, had seriously considered annexation to the United States, feeling this option would allow the slavery on which their fortunes depended to continue. However, Spain had lost her vast Latin American colonies only a decade earlier, and she was determined to hold onto "the ever faithful isle" of Cuba and her vast sugar wealth.

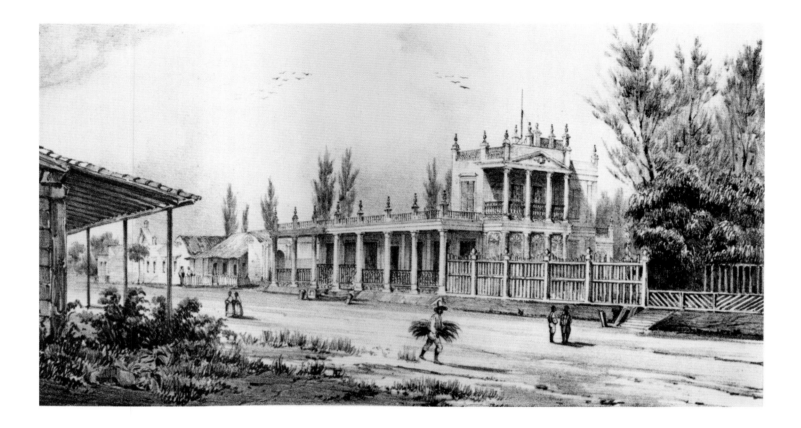

Cuba was one of the last countries in the world to outlaw slavery—as late as 1886—although the trade had officially ended in 1865. The *criollo* resentment of the *peninsular* was complicated by the Cuban-born elite's fear of the impact on sugar production if slavery were abolished as the Europeans and Americans demanded. The bloodshed of the Haitian slave uprising confirmed the *criollo's* worst fears: white families murdered by the enslaved Africans and the island's economy ruined.

In 1868 Carlos Manuel de Céspedes, a planter in Oriente province, declared open rebellion against Spain and freed his slaves so they could join his freedom fight. This action launched the conflict known as the Ten Years War. Soon the eastern province was in chaos and Spanish troops had built a fortified moat across the island in an attempt to contain the rebels. Over 250,000 Spanish troops were deployed to the island. Sugar mills were burned, families were torn apart, patriots were executed or deported, and many Cubans abandoned their estates and left the island in exile.

Havana was fairly insulated from the fighting in the eastern part of Cuba. The city was able to maintain the good life fueled by sugar prosperity while war raged throughout the island. Havana's harbor was a forest of ship masts with vessels from the four corners of the world loading sugar and unloading imported luxuries: foodstuffs, wines, fabrics, books, paintings and sculpture, Oriental porcelains and lacquers, and the latest European furniture. Cuba's eclectic taste in interiors is said to be a direct result of the abundance of these extravagant, worldly goods. Every evening carriage rides on the landscaped Paseo were followed by *plein air* concerts by the governor's band, an international opera singer performing at the Teatro Tacón, a masked ball or indulging in the Cuban passion for sweets at La Dominca. For the gentlemen there was gambling at a casino after the obligatory nightly gathering of the family under the patriarch's roof. Havana was the place to show off and indulge in expensive whims allowed by the sugar wealth. Tales of extravagance during this golden age include a

A street-level portico and a two-story templelike porch connected the summer villa of the counts of Fernandina to the expansive garden setting in this view from Frederic Mialhe's *Paseo Pintoresco por la Isla de Cuba*.

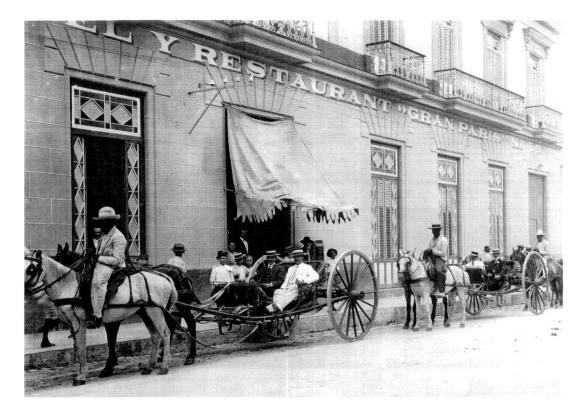

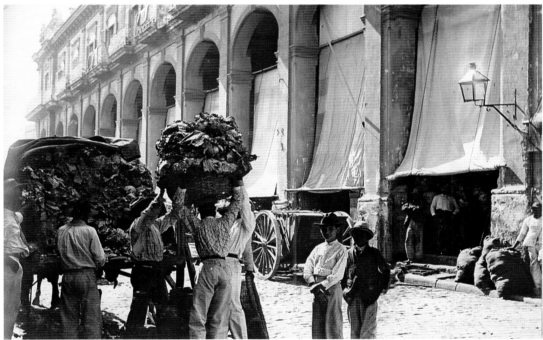

planter who shod his horses in solid silver horseshoes and a gentleman whose fountains ran with eau de cologne for the ladies and gin for the men.

The *Ordenanzas* of 1861 attempted to guide new development and to give the city a more coherent appearance. The goal was to make Havana beautiful and to emulate the great European capitals. The mezzanine level was banned and limits were set on street-level heights. Ground-floor arcades were required on all major streets, providing pedestrians with protection from sun and rain. The new buildings with their continuous balconies and consistent decoration suggest a small-scale version of Baron Haussmann's achievements

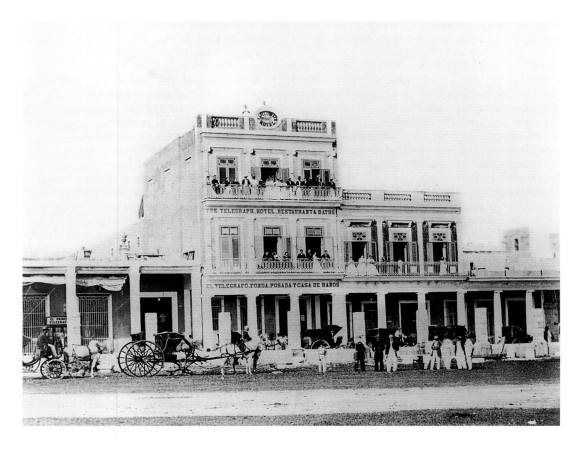

in Paris. Charles DeForest Fredricks's photograph of the Hotel Telegrafo shows the fanciful neoclassical rooftop meeting the sky and how the new continuous balconies became extensions of the public rooms within.

The late nineteenth century in Cuba was marked by loss: the Ten Years War left the sugar industry in crisis, with many mills destroyed by the conflict and production at others greatly decreased. The traditional system, where sugar planters borrowed from merchants against the proceeds of their next crop, was thrown out of balance. Planters were now indebted and many of the merchants were wiped out. These depressed conditions set the stage for United States investors to step in and take over the mills. American capital built rail lines and mechanized mills in order to increase production. This kept the sugar industry going but led to the demise of the old land-based upper class. Hugh Thomas wrote that the result was the loss of an "unmistakable national social tone, the Cuban *criollo* as opposed to North American." This fun-loving, extravagant, slave-owning, snobbish, and patriotic group would lose its control on the island. Spain would be defeated and Cuba would thus become independent and "open to United States cultural, political, and economic penetration." Throughout the twentieth century, an important cultural theme in Cuba would be the progressive strengthening of American influence over every aspect of the island's life and the resistance from intellectuals—including artists and architects— asserting their national identity by creating works that are unmistakably Cuban.

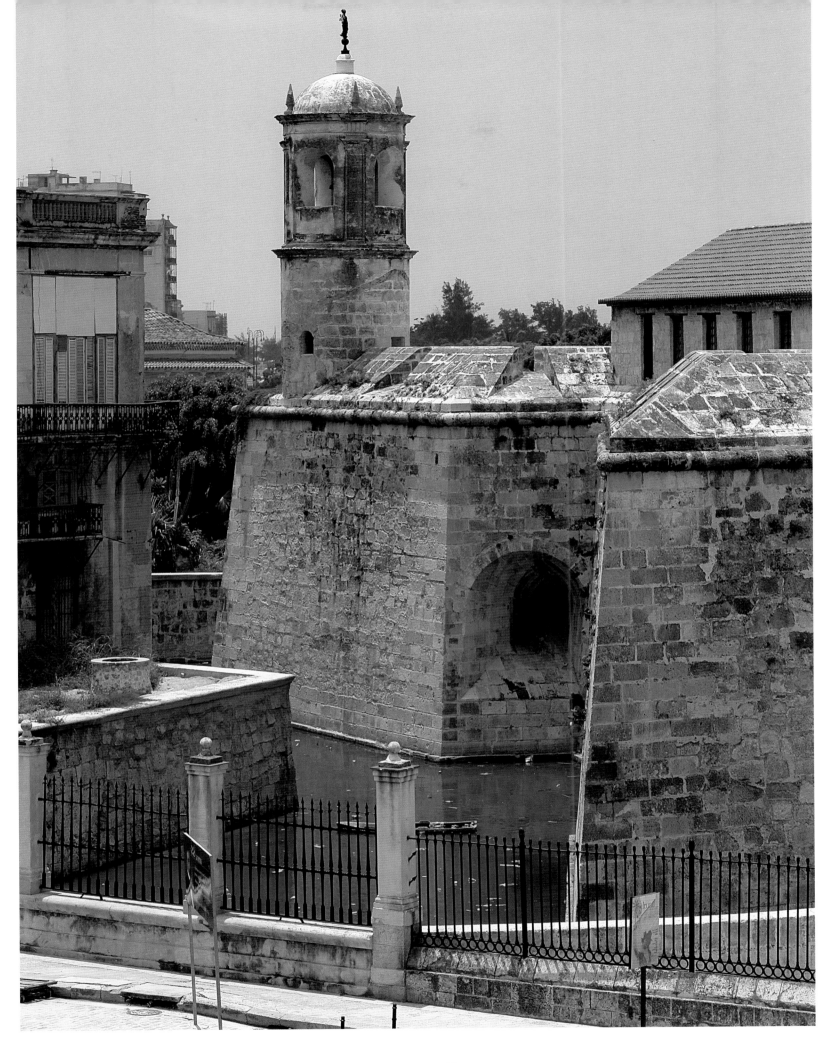

El Palacio y La Quinta de los Condes de Santovenia

In 1860 American photographer George Barnard was permitted to take his camera inside one of Havana's greatest houses, the *palacio* of the counts of Santovenia. He documented room after room of paintings and sculpture, crystal chandeliers, Chinese porcelains, and ornate European furniture, and his images formed part of New York publisher E. Anthony's *Scenes in Cuba–Vistas Cubanas*, 191 views of life on the island—from urban landmarks to slaves working on sugar plantations. Soon after the American Civil War, Charles DeForest Fredricks photographed the exterior of the neoclassical mansion. By then a sign proclaiming it the Hotel Santa Isabel had been affixed to the facade, identifying the premier lodgings for Americans visiting Havana. Barnard and Fredricks were among the reporters, artists, and travel writers whose work helped to satisfy American curiosity about Cuba—a fascination that continues to this day.

In addition to giving Havana the perfect neoclassical town palace, the counts of Santovenia built one of the city's most luxurious summer residences, the Quinta de los Condes de Santovenia, in suburban El Cerro, outside the city walls. The villa, surrounded by vast gardens, was as grand and sophisticated as the town palace and acted as a social center during Havana's summer season. Taken together, the town palace and the summer getaway allow us to form an image of the opulent lifestyle of Havana's mid-nineteenth-century sugar aristocracy before the devastation of the Ten Years War for Cuban independence from Spain.

As was the case with many Spanish colonial cities, Havana was laid out to some extent in accordance with the Laws of the Indies, which required a grid of narrow streets and contiguous buildings sharing common walls. The tight urban building sites and Havana's role as a terminus for the vast amount of goods being shipped between Spain and her New World colonies had created a distinctive building type: a combination of the family home above a ground-floor commercial space or warehouse. These diverse uses happily coexisted in commercially driven Havana, though visitors such as Samuel Hazard were shocked that the Santovenia house combined "elegant private mansion with filthy store-house." One contemporary engraving brings that reality alive, showing barrels stacked in the palace's street-level arcade while a stevedore toils nearby.

Havana's building codes required the construction of arcades on public squares and streets of primary importance. The first count of Santovenia, Nicolas Martinez de Campos y Gonzalez del Alamo, purchased his townhouse early in the nineteenth century, sometime after the ground arcade had been added to an earlier building. Martinez de Campos was

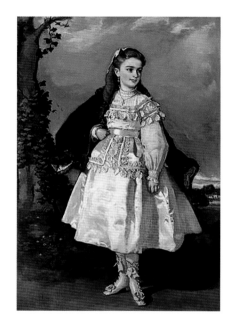

Above: Eduardo Rosales, *Portrait of Conchita Serrano Dominguez*, 1871. She married the third count of Santovenia in Paris in 1880.

Opposite: The courtyard of the Santovenia townhouse is defined by three stories of stone arcades supported on Doric columns. Neoclassical iron railings and beamed wood ceilings painted Havana blue characterize the galleries.

Overleaf: The ground-floor arcade and continuous second-floor balcony of the front facade of the Santovenia townhouse face the Spanish Governor's palace.

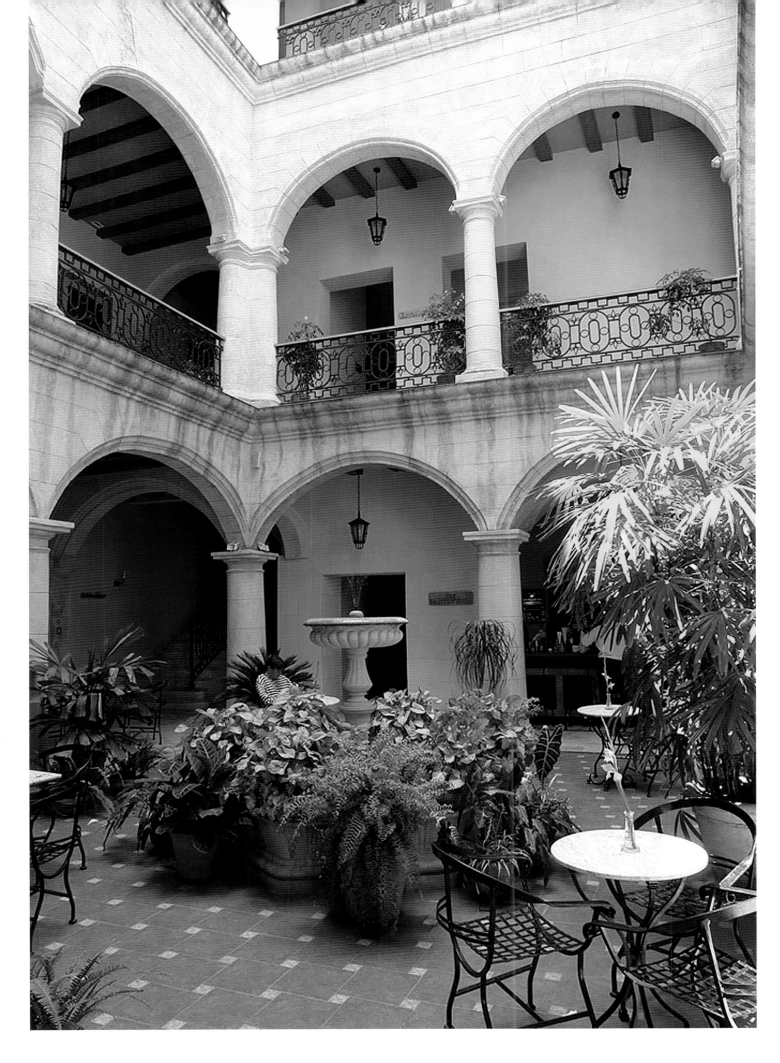

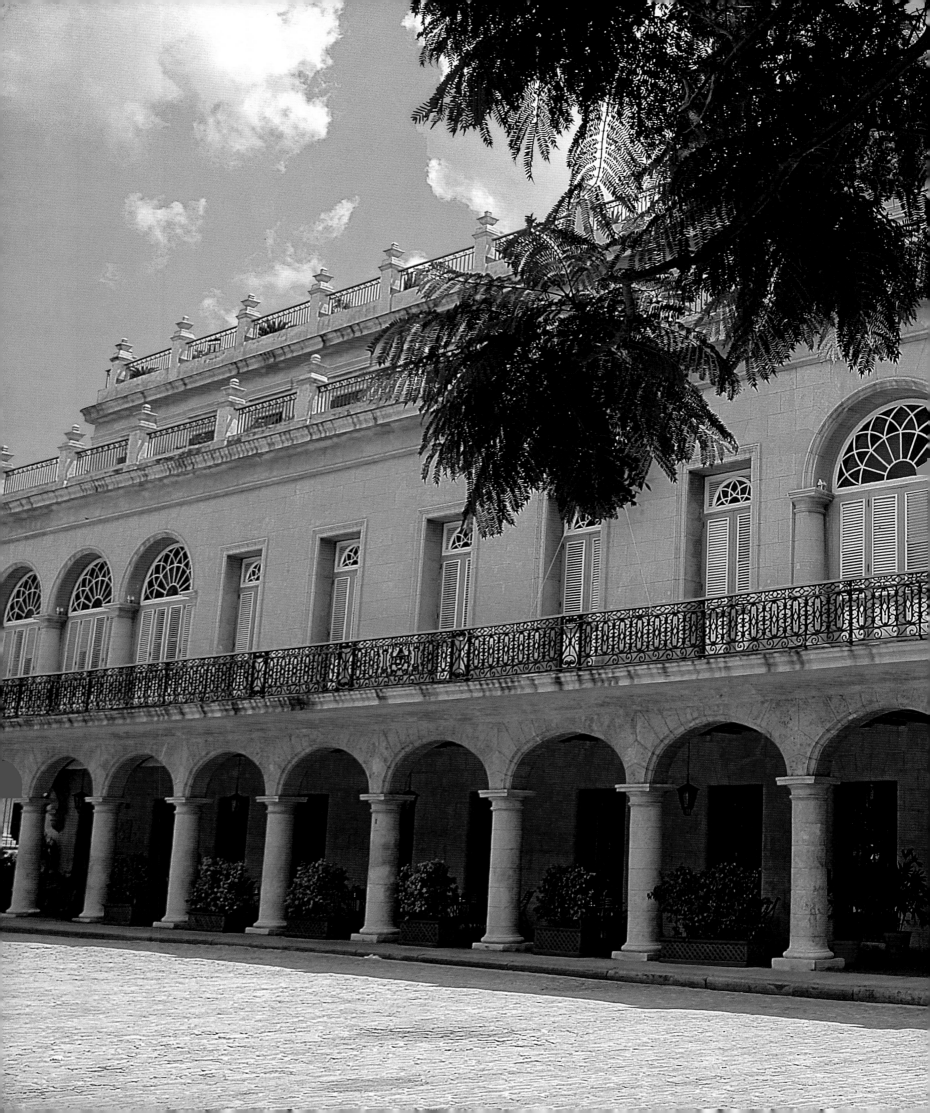

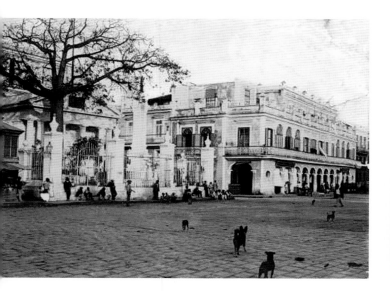
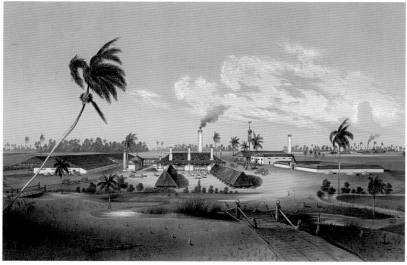

responsible, however, for extensive interior renovations, including the addition of graceful ironwork railings that featured the initials "CSV" in celebration of the title he received in 1824. He also installed the louvered wood shutters and the distinctive colored glass fanlights on the front facade. The ironwork, louvers, and colored glass are signature design elements also found at the summer villa. Eventually they came to signify traditional Cuban architecture, and their use in the twentieth century—whether in art or architecture—was a form of shorthand for references to national identity. Standing in admiration at the mansion's graceful balcony and rooftop terraces, one can almost picture the count's guests observing the nightly ritual of Havana's elite: a carriage ride around the Plaza de Armas followed by an open-air performance of the captain general's orchestra. In 1832 Count Nicolas was succeeded by his nephew and heir, José María Martínez de Campos y de la Vega, second count of Santovenia. The second count was a prominent citizen, active in politics—serving as *regidor, alcalde ordinario*, militia colonel, and senator of the realm. His sugar plantation, the Ingenio Monserrate, was one of the island's most important and is included in the book of engravings by Eduardo Laplante.

It was the second count's luxurious home that Barnard photographed. In his view of the count's gallery, two young women sit quietly in the foreground, and the photographer has captured himself in the mirror at the rear. To the side are the arched openings seen at either end of the second-floor facade. The image is a masterpiece, capturing a wealth of detail regarding Cuban adaptations of European design trends and the tastes, comforts, and lifestyle of the residents of one of Havana's most well-appointed houses. Surprisingly, the photographer was also allowed inside the countess's boudoir and so was able to record the feminine intimacy of comfortable upholstery, floral wallpaper, and lace curtains endlessly reflected in mirrors. Havana homes had always incorporated the luxury elements that arrived at the port in the course of trade: European furniture and sculpture, Chinese porcelains, manufactured goods from the United States all contributed to the citizens' famously eclectic tastes.

The high quality of Santovenia's interior architecture and decoration was unusual in colonial interiors, which were typically vast but rather unornamented spaces. The count's interiors illustrate a moment in the development of the Cuban colonial house when the critical issues of ventilation and protection from the sun had been resolved, allowing wealthy homeowners to focus on using the home to affirm their social status and increase personal comfort.

Left: To the left of the Santovenia townhouse is the Templete, a Greco-Roman style commemorative pavilion built in 1828 and considered the first neoclassical building in Havana.

Right: Smoke issues from the chimneys of the Ingenio Monserrate, the count of Santovenia's sugar processing plant, which was fitted with the latest steam-powered machinery, in a view from Laplante's *Los Ingenios*.

Below: In Barnard's photograph of the countess's boudoir, European luxury items include the marble sculpture, crystal chandelier, rococo revival furniture, and lace portiere curtains.

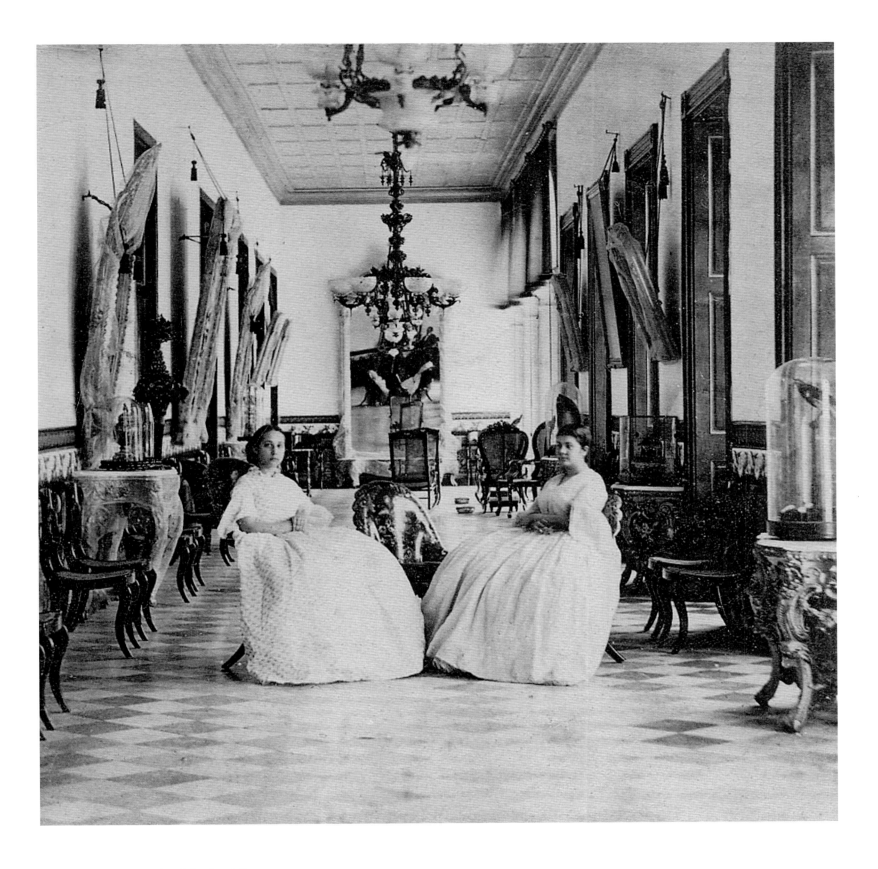

A series of gaslight chandeliers
and the ornate giltwood consoles
and mirrors gave the gallery of
the Santovenia townhouse a
formal scale. Lightweight chairs
were ranged against the walls
until needed in the center of
the room.

Although life within Havana's walls was pleasant for the city's aristocratic families, the Cuban climate made summer in the old city an ordeal. In the early nineteenth century there was a fashion among the elite for country houses constructed in the healthier atmosphere of the hills of El Cerro. The earliest of these mansions were characterized by openness to their garden surroundings, with porches and terraces and floor-to-ceiling windows providing ample light and air.

The Quinta Santovenia is striking in its horizontality: a long colonnade defines a deep porch that brings shade to the front facade and supports a continuous terrace accessible from the second floor. Contemporary writers noted the fashion for sitting on these terraces to enjoy the evening breezes while someone strummed a guitar. The Quinta Santovenia forsakes the round arch found in the Santovenia townhouse for the flat lintel of a purer neoclassical style, recalling what Americans refer to as the Greek revival style. In its day, the style conveyed modernity and orderliness in contrast to the exaggerations of the baroque style that had preceded it. As El Cerro developed, block after block of rational colonnades lined the main street, defining the neighborhood. The villa's summer lifestyle—set inside a private park— must have contrasted sharply with the lack of privacy inherent in living on one of the city's most popular squares. The Quinta Santovenia, now a nursing home, maintains its sense of apartness to this day, buffered from the urban chaos of its surroundings. The traditional repertoire of iron grilles, wood louvers, paneled shutters, and colored glass fanlights provide privacy and shade and facilitate airflow. Cool marble floors—even on the massive front porch—convey a feeling of freshness. A pair of stone spaniels guards the front door, in lieu of the lions favored by the city's nobility.

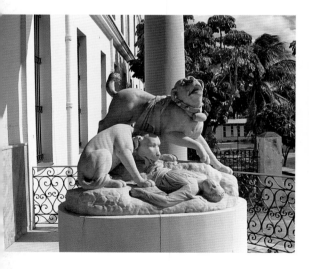

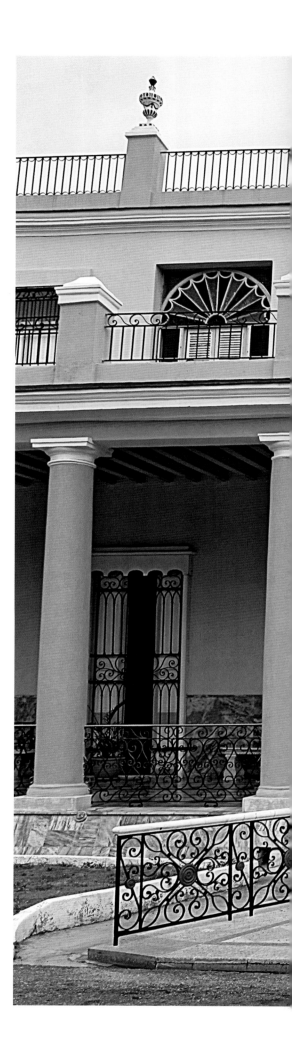

Left: An unusual marble sculpture, possibly representing two dogs rescuing a buried body, is the focal point of one end of the monumental front porch of the Santovenia *quinta*, or summer villa.

Right: In keeping with the neoclassical preference for a flat lintel above classical columns, the arched fanlights of colored glass are inserted into the rectangular openings at bedrooms and the ground-floor courtyard.

Opposite: Stylish marble spaniels, broad steps, and ornate iron railings mark the entry to the villa; shaded porches and breezy terraces connect the interior to the landscape in a way previously unknown in Havana.

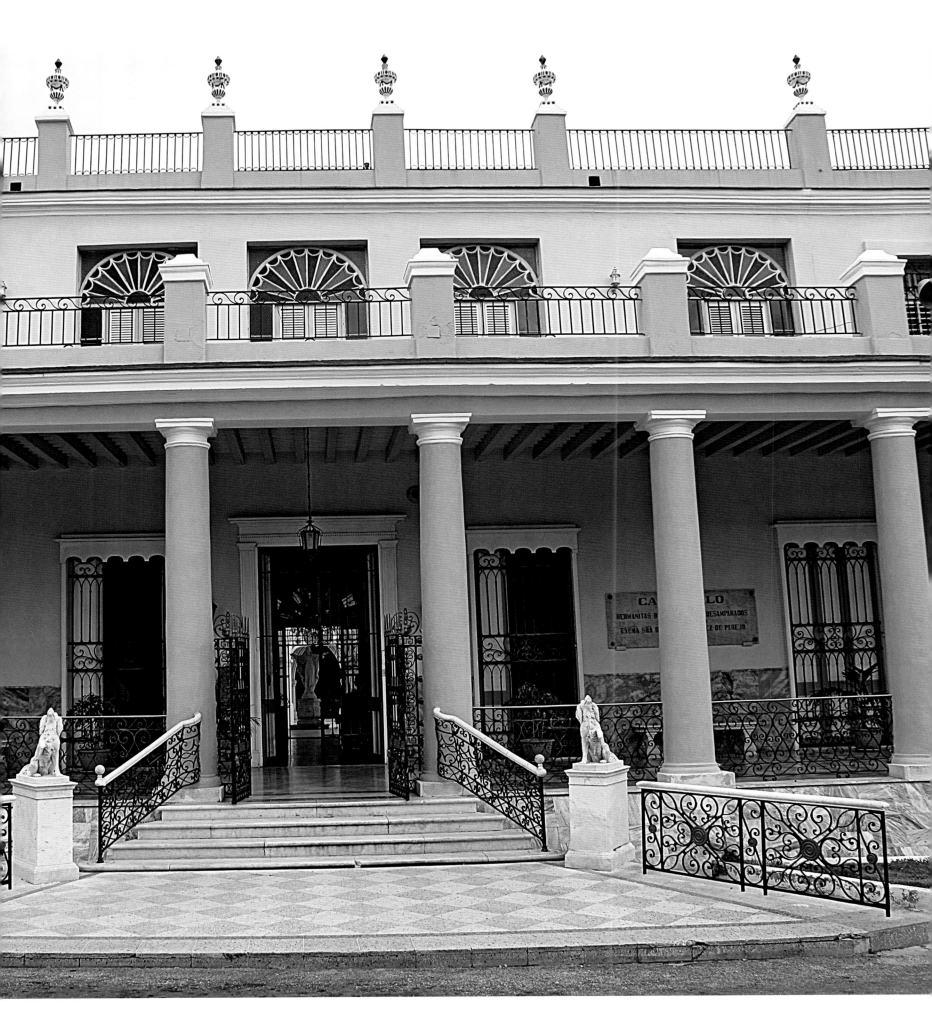

Cuban-made rococo revival furniture has caned seats and backs to keep the sitter cool. An eighteenth-century sacristy chest, a portrait of donor Susana Bénitez de Parejo, and a suite of European crystal sconces and chandelier complete the décor of the salon.

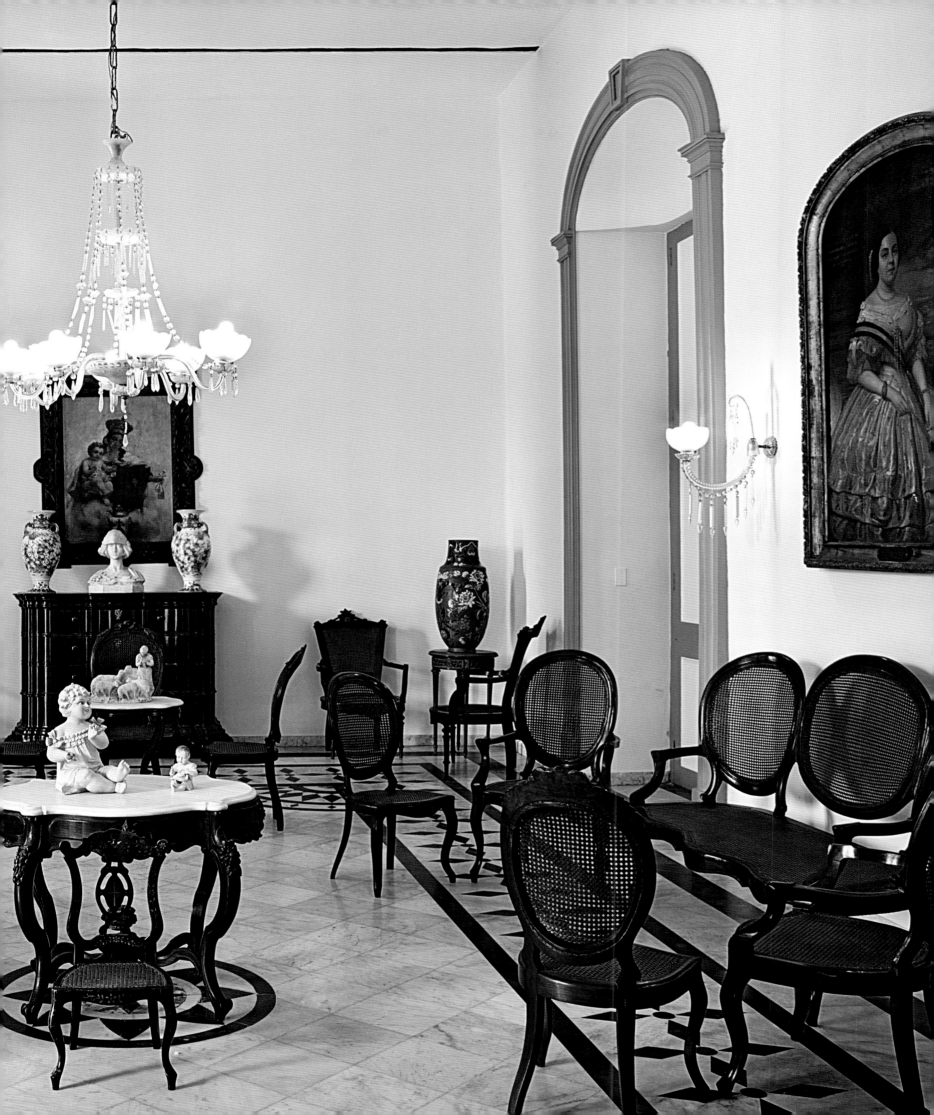

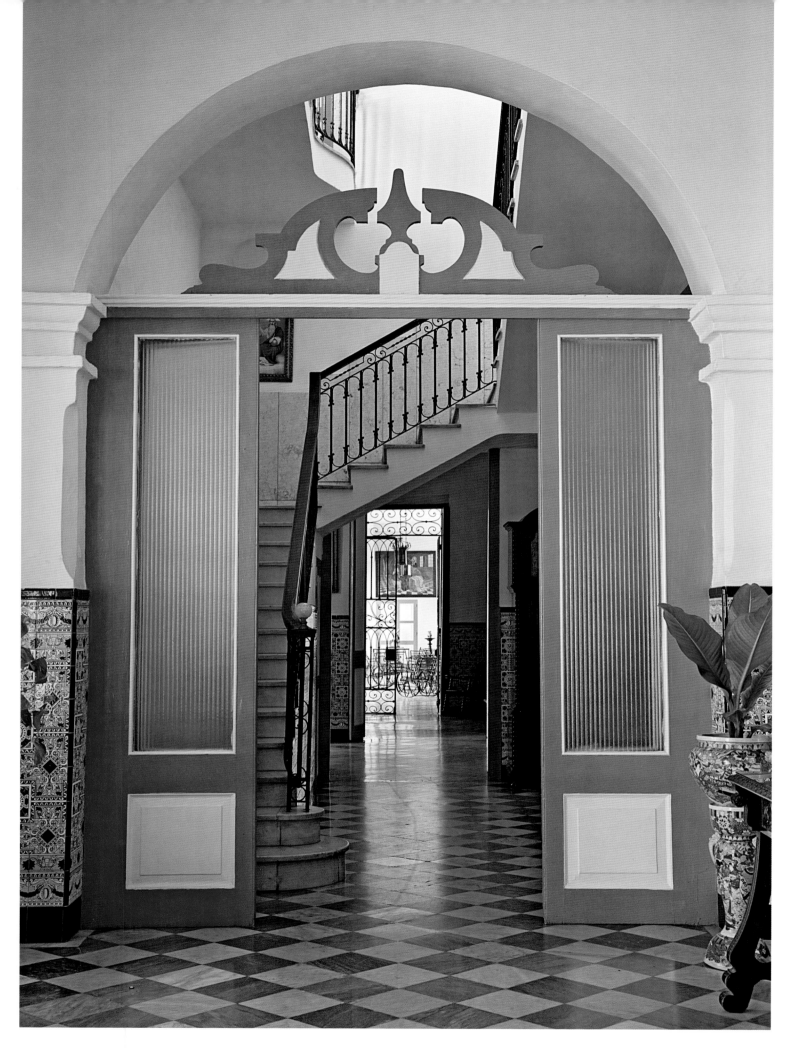

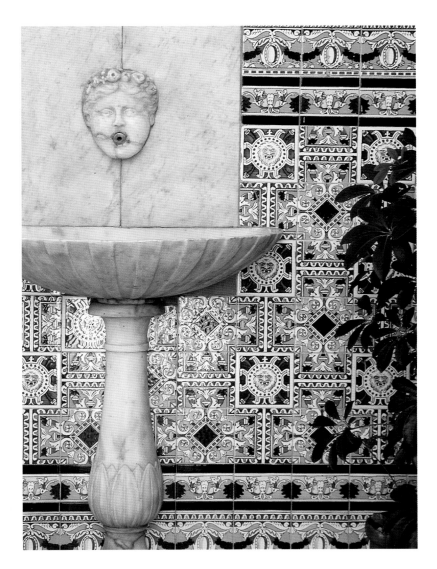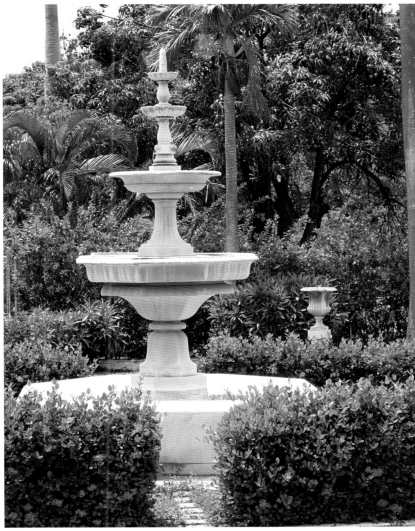

Opposite: A fanciful wood-and glass-partition partially screens the staircase leading to the second-floor bedrooms.

Above left: A neoclassical-style marble wall fountain is installed on a wall of *azulejos*, or glazed Andalusian tiles, in one of the courtyard galleries.

Above right: A marble fountain is a focal point of the Santovenia gardens, which originally included an English-style romantic landscape featuring an ornamental lake.

The Santovenia townhouse has been functioning as the Hotel Santa Isabel on and off since 1867. That year, the second count's widow married Cuba's governor, Captain General Domingo Dulce y Garay, in a lavish ceremony in Havana's cathedral. Soon after, the couple returned to Spain with the Santovenia children, and the mansion was rented to an American colonel, who converted the house into the city's foremost hotel. Its excellent location on the Plaza de Armas included proximity to the American consulate. Late-nineteenth-century visitors commented on the establishment's large, airy rooms and English-speaking chambermaids ready to attend the ladies. Up till then, travel writers had focused on the horrors of Havana's hotels: the insects, the shared quarters, the absence of plumbing. After 1897 the building served a number of functions, including warehouse, tavern, offices, and multiple dwelling. The 1996 restoration by Eldris Miranda prepared it to receive international travelers once again. The hotel is now operated by Habaguanex, the hospitality wing of the Office of the Historian of the City of Havana, which is responsible for the preservation of Havana's historic core.

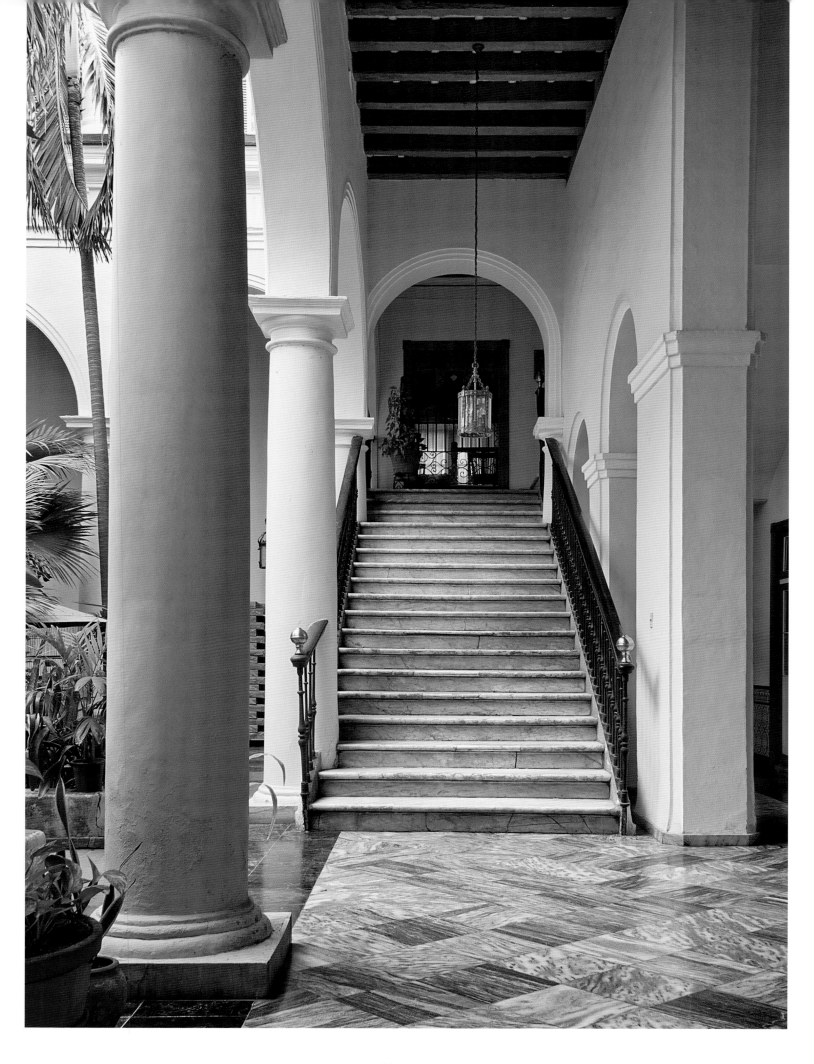

Palacio Episcopal of Havana

Above: The solid exterior of the palaces of Old Havana permitted an introverted family home life organized around the central courtyard.

Opposite: Marble steps and wrought-iron railings were signs of wealth in the stairs of neoclassical-style houses of the early nineteenth century. The placement of the stair off the courtyard was a colonial holdover.

The Catholic prelate of Cuba, Cardinal Archbishop Jaime Ortega, lives today in the splendid colonial house where Havana's bishops have resided for the past 150 years. Nearby, the flamboyant baroque of Havana Cathedral embodies the importance of the church in the administration of Spain's New World colonies. During Cuba's fight for independence from Spain, the Catholic Church was often accused of supporting the Spanish colonial government and of suppressing liberal-minded Cuban-born clergymen. Not surprisingly, it was not until after Cuba achieved independence from Spain that the island had its first Cuban-born bishops. Well into the twentieth century a high percentage of the island's clergy were Spanish born—a continuation of the rivalry between Cuban-born *Criollos* versus Spanish-born *peninsulares*.

The house was built around 1818 by one of Havana's wealthiest citizens, José Ricardo O'Farrill y Herrera, who was among the most influential Cubans of the early nineteenth century, active in island politics both in Cuba and at the Spanish court. In contrast to many planters of his day, José Ricardo was active in the management of his sugar plantations and mills. In 1773 he married a cousin and had twelve children, establishing the O'Farrill y Arredondo line of the family.

In 1862 the house was renovated for use as the Catholic archbishop's residence. The neoclassical style of the renovated building—in contrast to the previously fashionable baroque—is evident in the classical orders on the exterior. A strong horizontal emphasis is provided by the continuous balcony separating the upper and lower portions of the facade and by the roof cornice carrying a series of pedestals and classical urns. Verticality is suggested by thin pilasters decorating the second floor. The *entresuelo*, or mezzanine level—traditionally inhabited by servants and slaves—features unadorned windows with small balconies. The exquisite neoclassical details framing the entry door relate to the moldings applied to the courtyard within. Many of these facade elements are found in the neoclassical architecture of the summer villas in El Cerro and their urban counterparts within Havana's walls.

While the stylistic details of the house reflected the latest fashion, the layout relied on the tried-and-true solution of a central courtyard providing light and air in the urban setting. The house was entered via the *zaguán*, a combination vestibule and porte cochère connecting the interior of the building with the city outside. Everything that was needed in the house—water, firewood, supplies—was delivered through the elegant front door. And everything that was taken out of the house—including all garbage and waste—went the same route. Every night the *volanta*, or family carriage, would be brought inside the house and

either rolled to the stables or kept in this hall, where it would remain during the family's nightly gathering.

Directly beyond the *zaguán* is the lushly planted courtyard, framed by circulation galleries on all four sides, an indication of the large-scale house required by an important family and their servants and slaves. Hefty Doric columns form arcades around the patio, supporting an elegant cornice of triglyphs, which in turn carries an arcade of Ionic columns—all according to the classical canon. The second-floor arcades surrounding the patio have been filled in with the combination of wood louvers and stained-glass transoms that came into fashion at the time the house was built. These elements became "traditional" immediately, recognizable as part of the Cuban national style. The colored glass and wood slats in the second-floor gallery give the impression of a luminous box having been dropped into the heart of the house.

The nineteenth-century family house was the center of the social activities for Havana's wealthy families, and homes like this accommodated them with a variety of spacious public rooms on the second floor. The expansive courtyard galleries served as multipurpose spaces that took on different roles as furniture was moved in and out. When servants brought chairs and a draped table, this circulation space was transformed into a dining room where the family could have their meals while enjoying the breezes of the patio. The countess of Merlin wrote that even in her uncle's luxurious palace, it was customary to dine in one of these galleries, since in Havana, "Due to the heat, there were very few dining rooms enclosed within four walls." Coincidentally, Merlin had been brought up by her aunt, José Ricardo O'Farrill's mother, whom she called *"mamita"* in her memoirs and who would become known as the grandmother of *La Habana Elegante*, because her children became the scions of Havana's most important families.

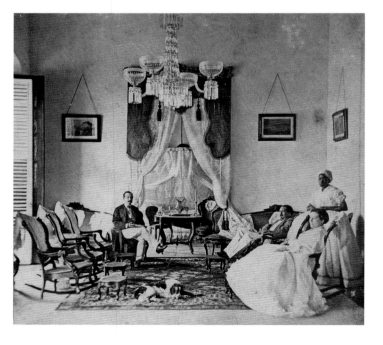

Left: In this mid-nineteenth century parlor, Cuban-made rococo revival rocking chairs and footstools are arranged on an oriental carpet to benefit from the gaslight cast by the imported crystal chandelier.

Right: Doric columns support open arcades surrounding the ground floor of the courtyard, while the second-floor arcades are infilled with neoclassical iron railings and wood louvered walls.

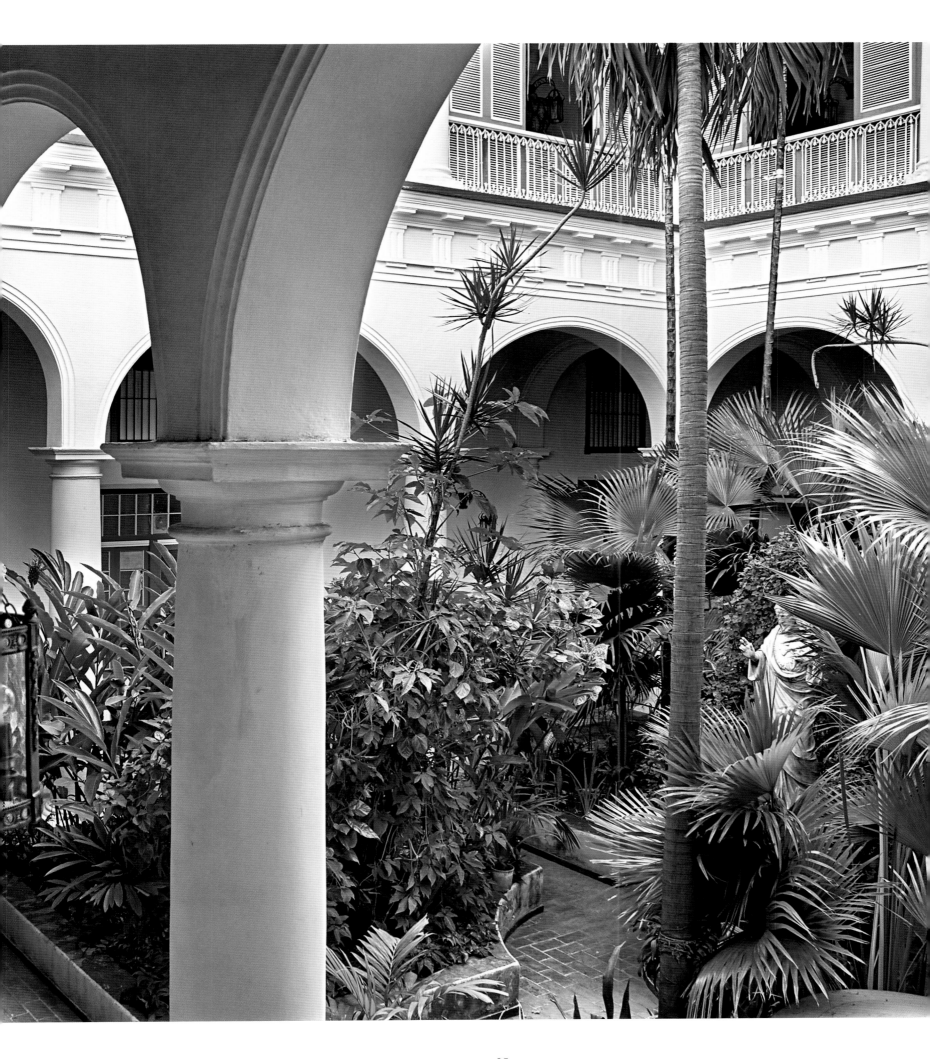

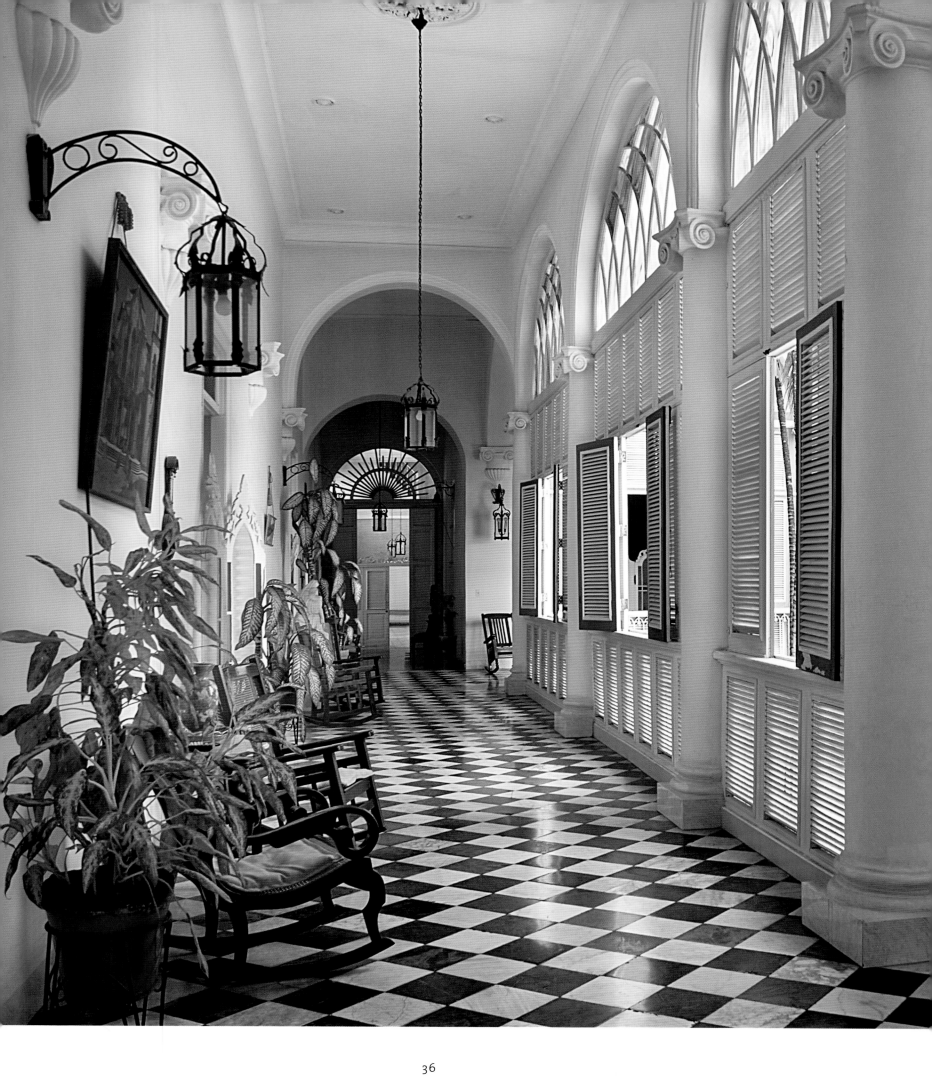

Left: Arches are fitted with colored-glass fanlights that temper the harsh sun, while adjustable louvers and checkered marble floors keep the second-floor gallery feeling cool.

Above: The lacy, serpentine frame on the low doors, or *mamparas*, at the entry to the archbishop's salon is in keeping with the popular rococo revival style.

The rooms of Cuba's colonial houses had very tall ceilings to encourage air circulation. The full-height openings between rooms were often fitted with *mamparas*, or pairs of low doors, which allowed the air to flow above while providing a degree of privacy between adjacent spaces. The archbishop's house preserves a variety of these quintessentially Cuban design elements. The parlor is separated from the courtyard gallery by a rococo revival–style *mampara* whose scrolling ornament relates to the design of the 1860s furniture in the room. It was customary for the *mamparas* to feature colored-glass designs surrounded by areas of patterned glass. In the openings between the parlor and adjacent rooms are *mamparas* in the popular Gothic revival style with beautiful decals of Mary and Jesus surrounded by geometric borders.

The archbishop's parlor is a typically Cuban colonial space: lacy iron grilles allow a visual connection and ventilation at the openings to the gallery, and black-and-white marble floors help both spaces feel cool. Among the furnishings are two suites of Cuban-made, rococo revival seating—pieces that talented Cuban woodworkers adapted from imported American furniture using local hardwoods. The caned seats and backs were a Cuban adaptation intended to keep the sitter cool. Furniture is placed on an oriental rug, clustered around a marble-topped center table that sits below a cut-glass chandelier—just as it would have been in the 1860s.

The dining room is an airy space connected to the gallery via tall arched openings fitted with Gothic-style *mamparas*. In addition to these low doors, full-height, paneled wood shutters allow the room to be closed off completely. A simple suite of Renaissance revival furniture, including some display pieces, sits below a crystal chandelier.

Historian Luis Bay Sevilla writes that on February 10, 1862, this house was the setting for a great dance in honor of the island's new Spanish governor, Captain General Francisco Serrano, and his Cuban-born wife, Antonia Borrell y Dominguez. José Ricardo O'Farrill and his wife were old friends of the couple they introduced to Havana society that night. *El Diario de La Marina* called this one of the most brilliant events of its day. One can imagine the salons, courtyard, and galleries of the house as the setting for quadrilles and *contradanzas*. Captain General Serrano reciprocated by hosting a costume ball in his own palace, which was considered the social event of that generation. Sevilla refers to this house and the nearby Hotel Palacio O'Farrill as the sole examples of twin buildings in Old Havana. One of José Ricardo's daughters, Maria Luisa O'Farrill y Arredondo, married her uncle, Rafael, and built the twin mansion, which today is the hotel. Rafael was also active in politics, addressing the abolition of slavery, an issue that so concerned the planter class, which depended on African labor.

The bobbin-turned furniture in the Elizabethan cottage style includes rocking chairs. Their design relates to the design of the ogee arches of the Gothic revival–style *mamparas* of nearby rooms.

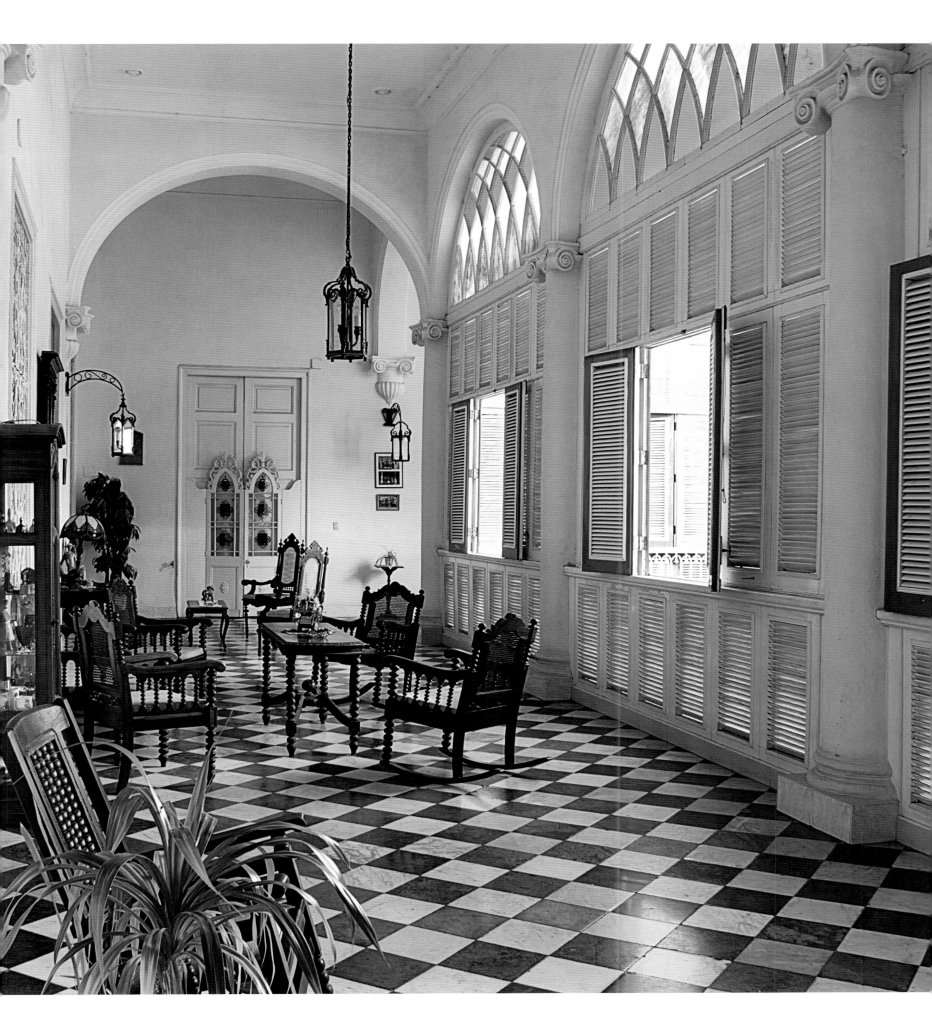

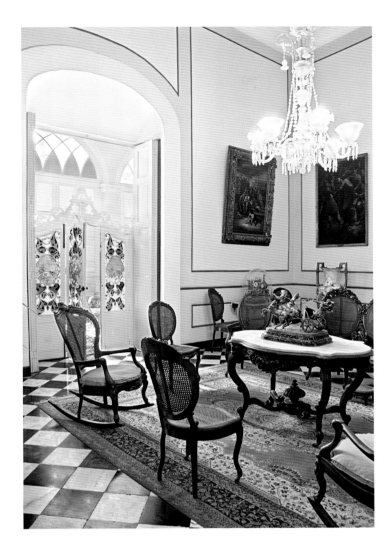

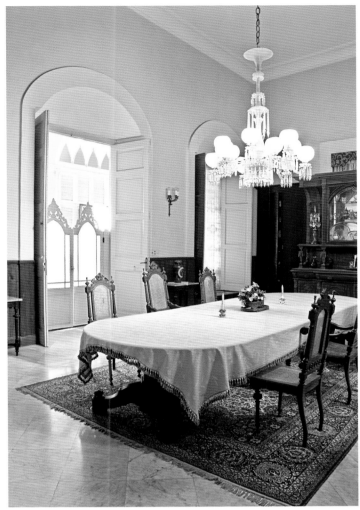

Left: Painted wall panels create architectural scale in the salon, which was typically tall to encourage ventilation.

Right: Elizabethan and Renaissance revival elements characterize the dining room furniture, including sideboards and a glass-fronted buffet.

Opposite: Eighteenth-century devotional paintings and sculpture and a twentieth-century baroque-style altar are found in the archbishop's private chapel.

One of the house's most famous residents was Manuel Arteaga y Betancourt, who was appointed Cuba's first cardinal, in 1946. Arteaga was beloved by Havana's haute bourgeoisie—having had him officiate one's marriage or baptize one's child constitutes bragging rights to this day. In 1958 Arteaga was one of the cardinals who elected the new pope, John XXIII. Stories of the cardinal being roughed up by Batista thugs were followed by tales of his disagreements with the revolution, leading to his asylum at the Argentine embassy and, later, with the Vatican nunciature. The archbishop's tiny private chapel was reinstalled by Cardinal Arteaga and serves as a reminder of his time in the house.

Until the revolution, the Catholic Church enjoyed privileged status in Cuba, despite the twentieth-century laws separating church and state. The church had provided the nation with important social services at the hundreds of religious houses, boys' and girls' schools, children's homes, hospitals, and nursing homes it operated.

To the surprise of outsiders, the Catholic Church's relevance to Cuban life is returning, thanks in part to the social services again made available by orders of nuns and priests throughout the island's eleven dioceses. As in the past, the Archbishop's Palace is bustling as a result of its increasingly active role in the life of Cuba's Catholics.

Palacio de los Capitanes Generales

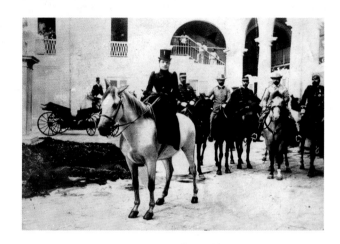

In a well-known photograph, taken in 1893, HRH the Infanta Eulalia of Spain poses in a side-saddle habit on a white horse, surrounded by the gentlemen of her escort on dark horses. The setting is the courtyard of the Palacio de los Capitanes Generales. The horses do not seem out of place in what today is a lushly planted garden at the center of the Museum of the City of Havana. The morning's ride, along with many other activities, was carefully documented during the official visit to Havana of the royal princess, an aunt of Spain's King Alfonso XIII, whose family's yoke the Cubans had been trying to throw off for the preceding thirty years. Eulalia was a symbol of the centuries of the Spanish colonial stranglehold on the island, and yet the city went wild in receiving her visit, renovating the palace for her use and organizing entertainments.

The baroque Palacio de los Capitanes Generales has lived through the political evolution of the island. The building was home to sixty-five Spanish colonial governors from 1791 until 1898, when U.S.-backed troops wrested control from Spain. The Spanish governors turned control over to the U.S. military forces—and the Plaza de Armas, which the palace dominates, exchanged its festive bandstand for the regulation tents of the American soldiers. Thus, the Stars and Stripes flew over the palace from 1898 to 1902, while it housed the American military governors. On May 20, 1902, the palace salons were the setting for the official birth of the Cuban republic as the Americans turned control over to Cuba's first elected president, Tomás Estrada Palma. Vintage photographs capture the excitement of the moment. Representatives from both sides are reflected in the mirrors of the *Salón de Espejos*, whose frames still bore the Spanish royal coat of arms. The American governor-general Leonard Wood dominates the scene in epaulets and shining brass buttons—a personification of the ornate, official setting. It is almost difficult to pick out Estrada Palma, the unassuming, white-whiskered man on whom the hopes of the crowd rested—a Quaker who had just spent ten years as a teacher in upstate New York. This contrast between the modest president and the gilded décor was highlighted by a series of photographs of the palace interiors taken during the early years of his presidency. There is an endearing quality to the eclectic mix of

Above: Infanta Eulalia de Borbon and her entourage in the courtyard.

Opposite: J. Cuchiari's statue of Christopher Columbus, 1862, in the courtyard.

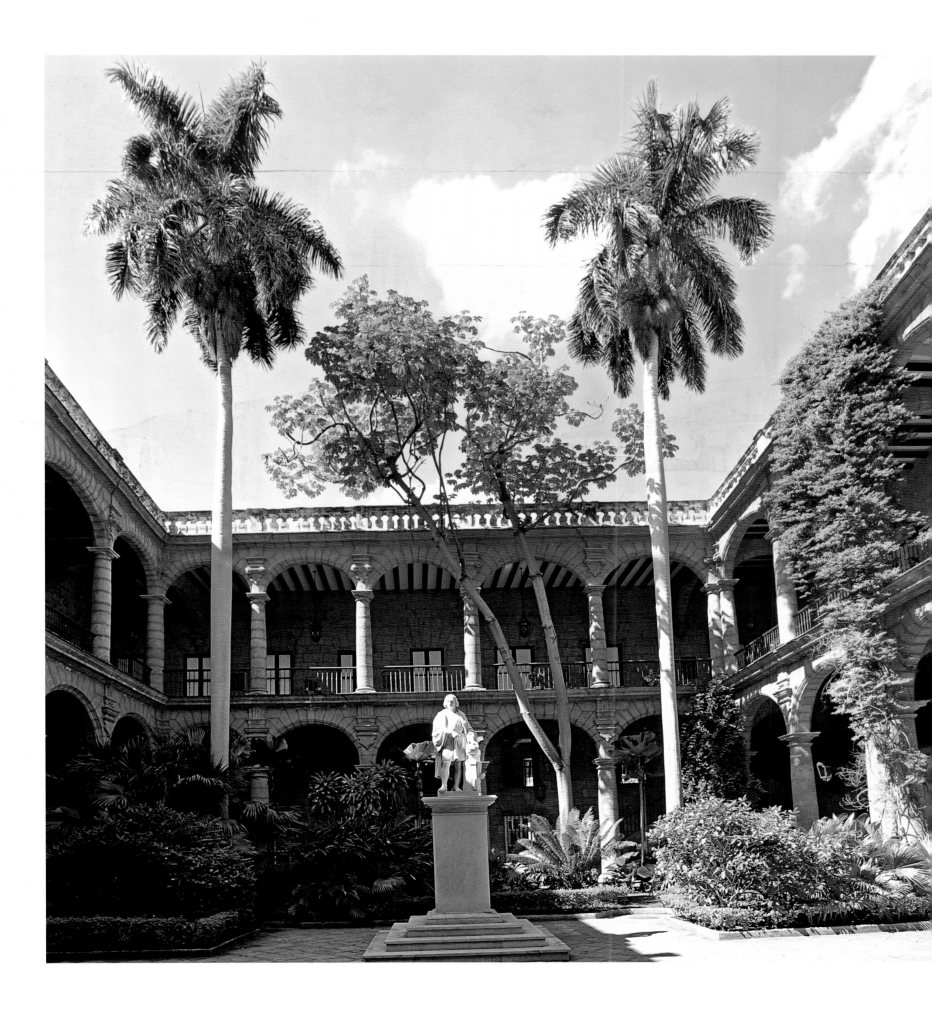

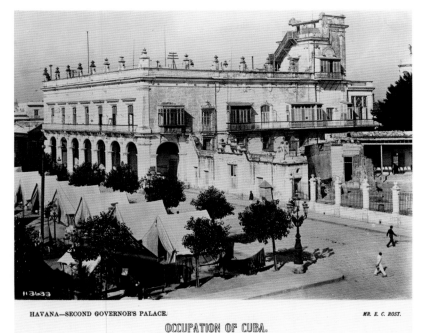

HAVANA—SECOND GOVERNOR'S PALACE. MR. E. C. ROST.

OCCUPATION OF CUBA.

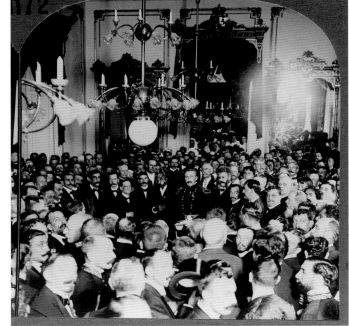

furniture revealed in these photos—staples of the middle-class home, such as wicker rockers, an upright piano, and caned seating—juxtaposed with the grand décor of these symbolic spaces, such as the ornate pelmets over swagged curtains, suites of gilded mirrors and consoles, and enormous chandeliers that had been installed for Infanta Eulalia's visit. Subsequent presidential families would make their home at the Palacio de los Capitanes Generales, until the 1920 construction of a monumental new presidential palace ornately decorated by Tiffany Studios.

Those familiar with Spanish colonial cities might be surprised that in Havana the colonial governor's seat of power presides over a different square from that of the cathedral. Spanish colonial town planning typically mandated one main square where the religious, political, and civil authorities were housed. At one end of the Plaza de Armas—the military parade ground that the palace dominates—is the ancient moated castle, the Castillo de la Real Fuerza, where the early governors lived. The construction of the baroque palace between 1776 and 1791 required the demolition of an earlier church, town administration building, jail, and governor's house. Over the centuries the square was repeatedly beautified with plantings, sculpture, benches, and fountains, creating a popular spot for Havana society's twilight *paseo*. Today, as in earlier times, an orchestra often plays music for the crowds at the end of the day.

Even though the scale of the palace is enormous, the building is a traditional Cuban colonial courtyard house as perfected in the eighteenth century. Two levels of soaring arcades are supported by massive Doric columns that define the courtyard, which is decorated today with royal palms and a statue of Christopher Columbus. Sheltered within the ground-floor arcade is the mezzanine service level found in colonial houses; the openings of these service spaces are linked by wrought-iron balconies tucked under the arcade. In the 1890s, low louvered walls—a version of the Cuban *mampara*—were inserted between the ground-floor columns to shield the service activities from public view. The upper galleries were infilled with traditional *persianeria*, or wood louvers, creating pleasant galleries around the courtyard.

Left: During the American occupation, army tents were pitched in the gardens of the Plaza de Armas.

Right: Tomás Estrada Palma, first president of the Cuban Republic, and American General Leonard Wood in the *Salón de Espejos*, May 20, 1902.

Opposite: The palatial scale of the *Salón Azul* with dramatic curtains and painted wall decorations is juxtaposed with the comfortable, climate-appropriate wicker rockers favored by all Cuban families. Similarly, in the sitting room, the official decoration of gilded consoles and oversized mirrors contrasts with more intimate and practical family pieces.

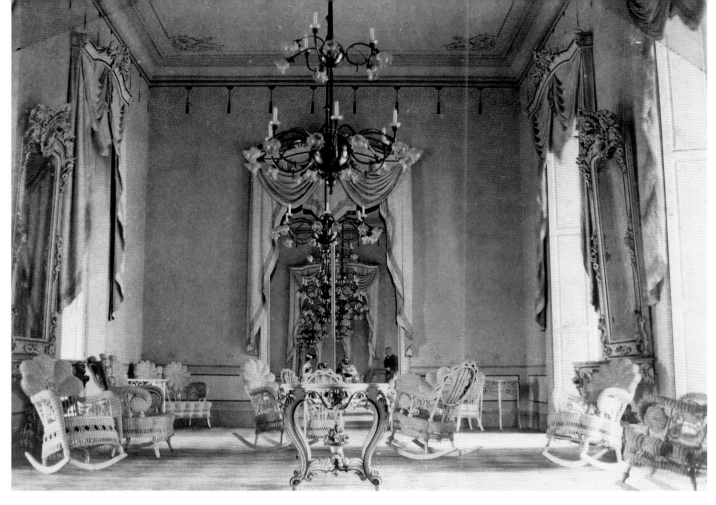

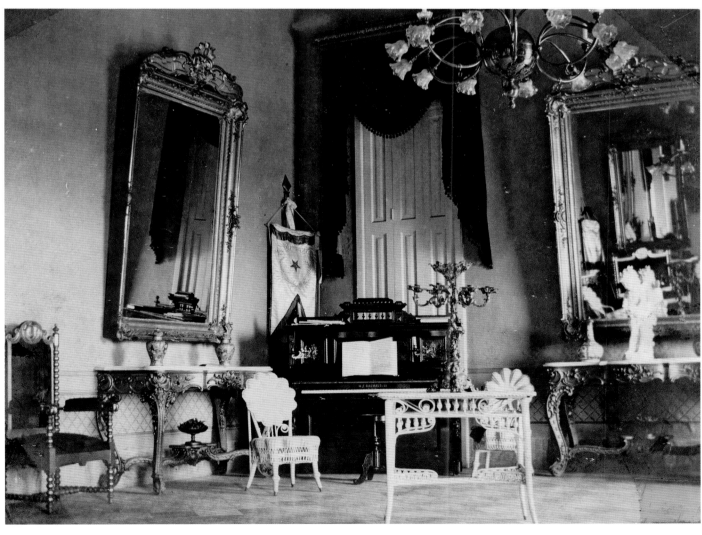

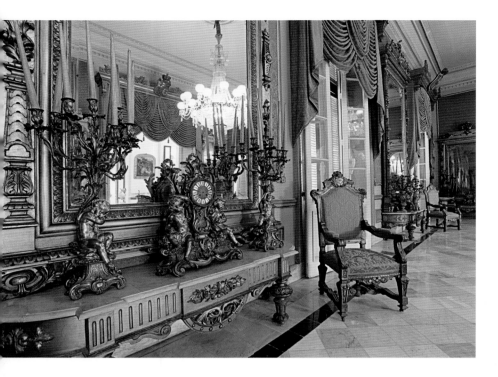

Left: The Mirror Salon was also the setting for Spain turning Cuba's sovereignty over to the U.S. on January 1, 1899.

Right: Two Carrara marble bathtubs, carved in the form of shells, recall the Infanta's bathroom located in this area.

Much of the interior dates from the 1893 visit of Infanta Eulalia and her husband, who stopped in Cuba en route to the World's Columbian Exposition in Chicago. Contemporary reports affirm that the palace was redecorated from scratch—all the spaces to be used by the couple were refurnished, reupholstered, and in certain cases built anew. The *New York Times* wrote of the "extensive repairs . . . being made to the palace of the Captain General . . . in anticipation of the arrival of a live Spanish Princess." The governor-general moved out to his summer house, and an army of carpenters, masons, painters, and upholsterers invaded the house. Forty-five thousand pesos were spent to prepare for the royal visitors, who stayed only a week.

Of special interest are the personal spaces—in particular, two new bathrooms, which each featured frosted-glass walls concealing a WC and a bidet, marble bathtubs, and a shower contraption with piped hot and cold water, an innovation in late-nineteenth-century Havana. Two stunning marble tubs carved to resemble enormous seashells are now installed in the gallery off the bedroom, recalling its former use. The infanta's bedroom furniture survives in a room that also features seating furniture by John Henry Belter. Reporters approvingly commented that her bed was grander than her husband's, as royal protocol would require. The infanta's intimate sitting room, or *Salón de Confianza*, was purposely overfurnished, following the late Victorian fashion, with bibelots and upholstered furniture.

Faux finishes are used to create wainscots, elaborate door surrounds, and ornate cornices that give the spaces an architectural scale. In the transition to museum use, these were re-created throughout to harmonize with the carved wood doors, the variety of wood louvers, and the stained-glass transoms. Marble floors and cut-glass chandeliers complete the typically Cuban decoration.

It seems likely that the 1902 pictures of Leonard Wood and Tomás Estrada Palma in the Salon de Espejos show the ambitious decoration carried out for the infanta's visit. The ornate curtain pelmets with their Spanish coats of arms remain today, as do the mirrors in fanciful

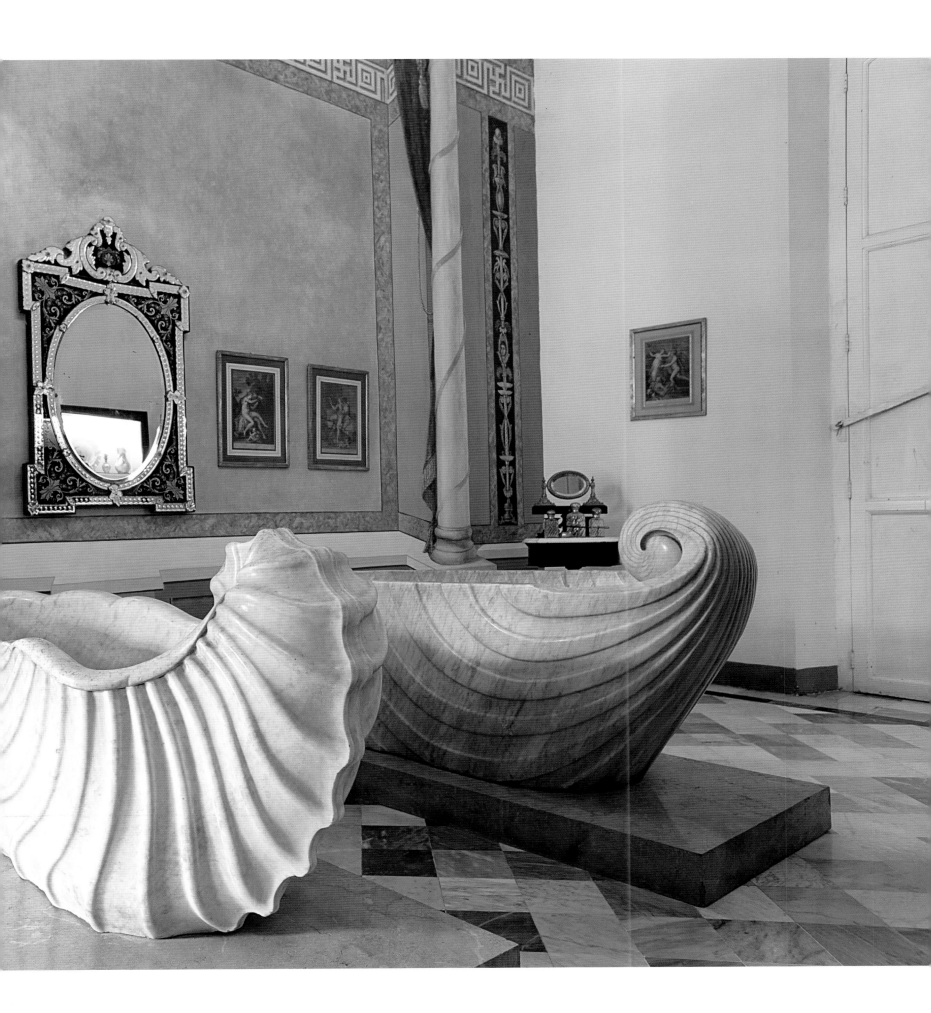

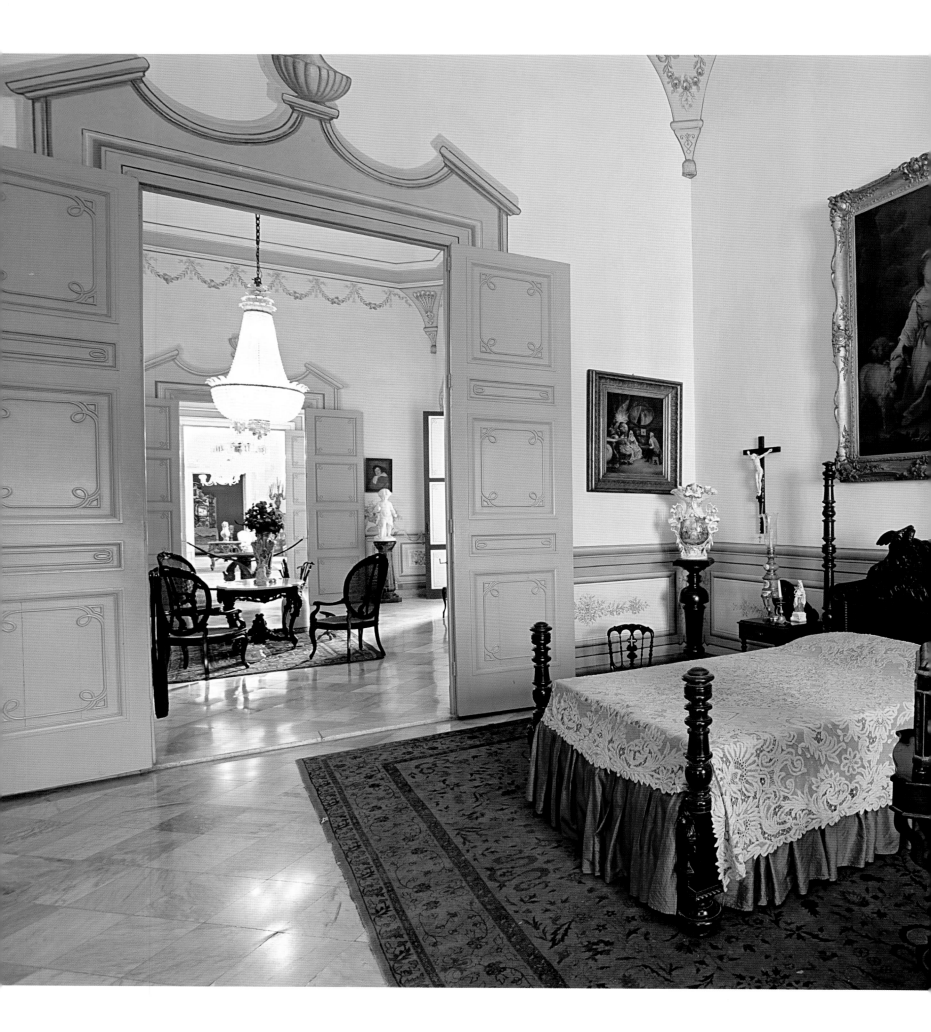

Left: The painted trompe l'oeil decoration includes a paneled wainscot and fanciful door casing that give architectural scale to the infanta's bedroom, which was connected to a private sitting room.

Above: A porcelain bust of Marie Antoinette is among the blue glass scent bottles and toilette items on the infanta's dressing table.

49

A portrait of the child king Alfonso XIII and the Queen Regent presides over the salon where the Havana Town Council met during Spanish colonial times.

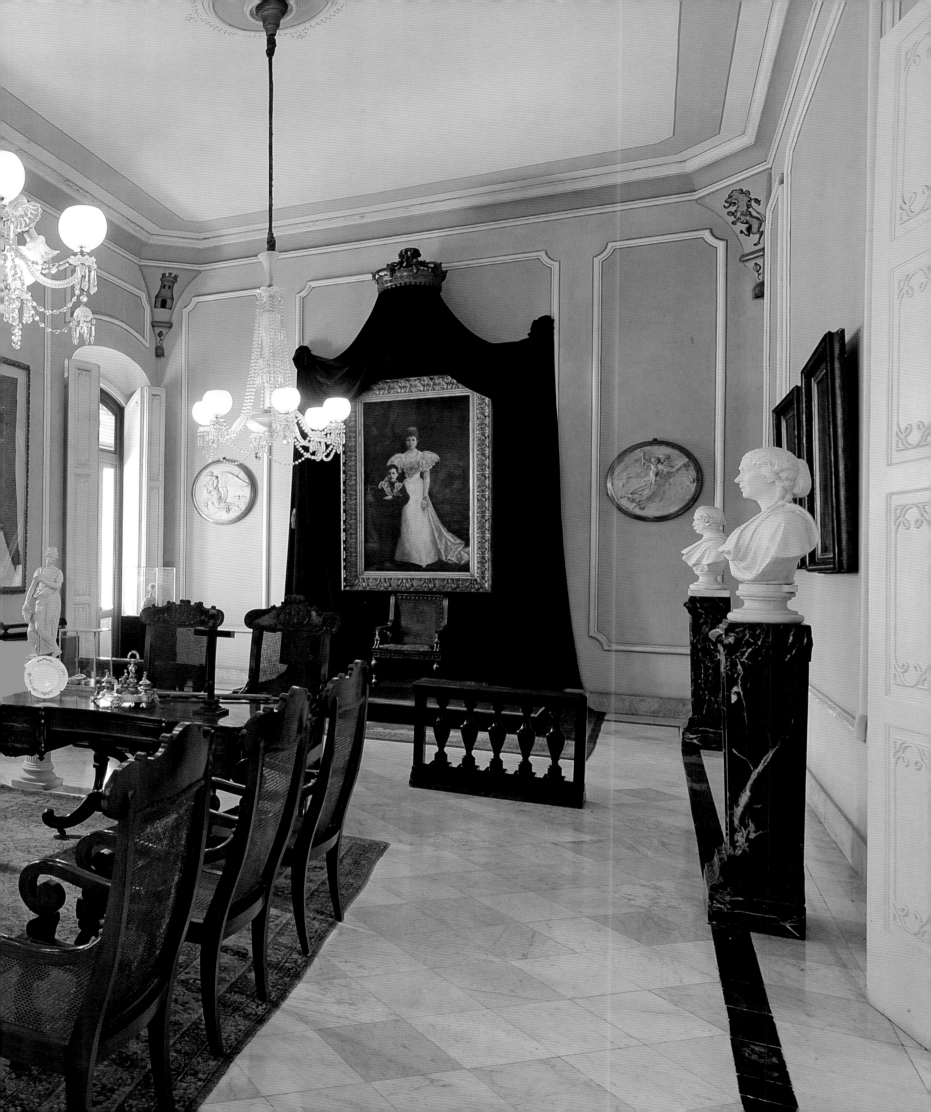

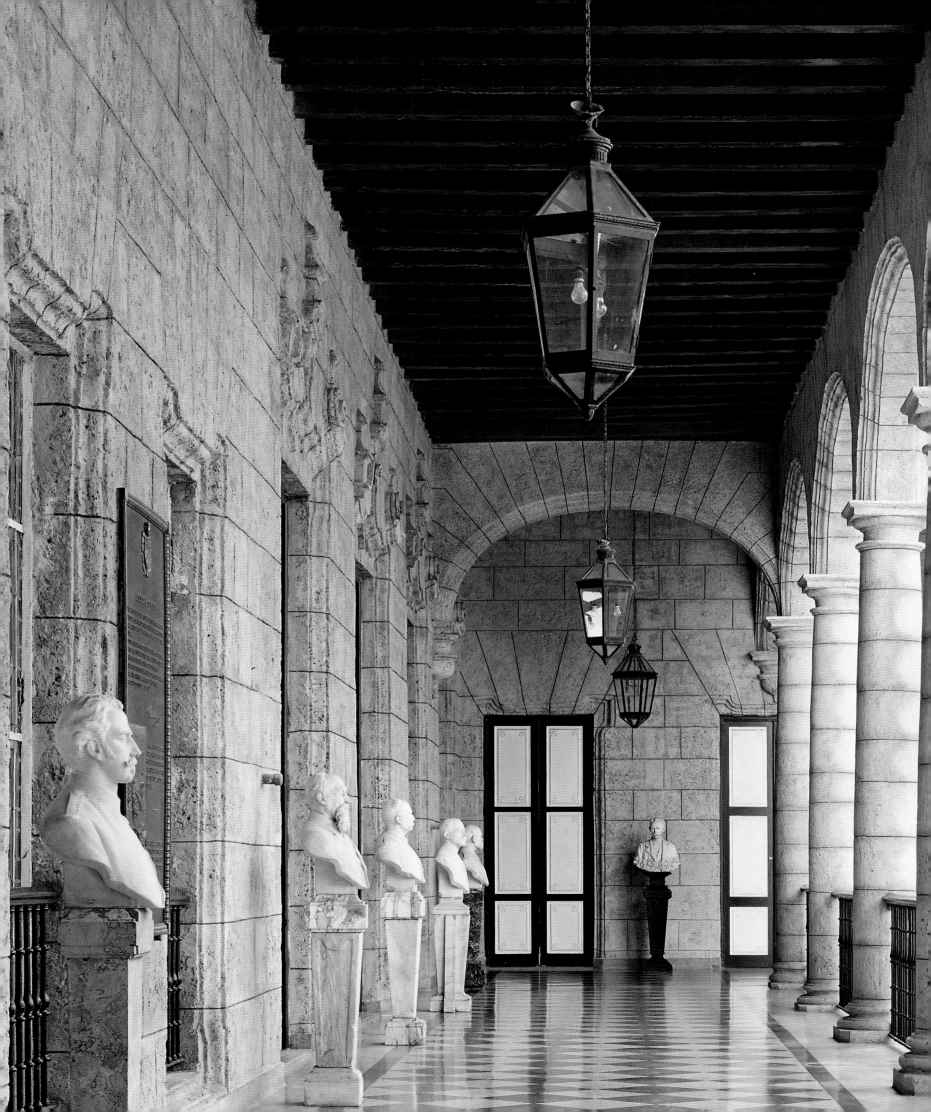

Left: The monumental scale of the courtyard columns can be appreciated after a restoration that removed the louvered walls and the plaster that was often applied to Havana's stone buildings.

Right: Walls of wood louvers set between stone columns transformed the circulation space of the second-floor gallery into a comfortable open-air sitting area.

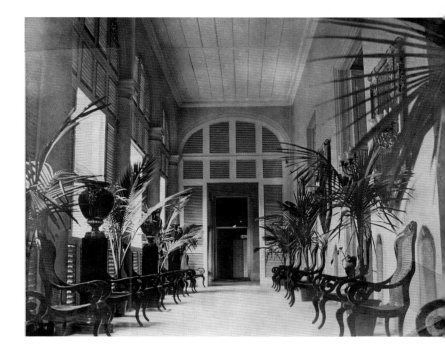

gilt frames. The electric chandeliers seen in the photographs would have been viewed as modern improvements to the old house. In Estrada Palma's day, the vast scale of the *Salón Azul* was balanced by curving pelmets and draperies installed at windows and openings between rooms. The chandeliers, mirrors, and console tables brought in at the time of the infanta's visit remained in place during his occupancy, although willow-ware rocking chairs were added, demonstrating the triumph of comfort over official style. The walls were blank—perhaps the portraits of oppressive royals and their governors were unacceptable. In a corner of another room, more willow-ware pieces and an upright piano intermingled with the official carved and gilded décor.

Images of the second-floor gallery—enclosed with wood louvered panels as seen at the Archbishop's Palace—show armies of armchairs formally pushed up against the walls, while potted palms on both sides give the space a tropical feeling. The mix of wicker and willow furniture arranged on an oriental carpet, the personal touch of the vase of roses on a side table create an intimate space for the first family to sit to enjoy the evening breeze. Estrada Palma's official life in the house is captured in a photograph of a cabinet meeting in his very simple office. Traditional Cuban combinations of louvered panels, glass doors, and stained-glass transoms now include an American import: metal screens to keep the tropical insects out.

The Palacio de los Capitanes Generales underwent a thorough renovation in 1930 that restored the courtyard and included removal of the stucco from the original stone. In 1967 the building opened as the Museum of the City of Havana, and a renovation by Daniel Taboada followed. Admirers of Cuban decorative arts find here an important collection of island-made pieces—Cuban adaptations of the furniture styles popular in Europe—beginning with ornate eighteenth-century sacristy chests, sober neoclassical pieces, delicate nineteenth-century suites of balloon-back rococo revival seating, and Renaissance revival display pieces grouped below the light of an ornate glass chandelier. Cuban paintings—historical and genre scenes as well as portraits—are found throughout. European porcelains, bronzes, and marble sculptures represent hundreds of years of acquisition by the island's colonial masters.

Fashionable Neighborhoods: El Paseo del Prado and El Vedado

Cuba entered a new era in 1898, when the Treaty of Paris ending the Spanish American War recognized Cuban independence. Spain relinquished all claims to sovereignty, leaving the United States to institute a new political system. The United States governed Cuba until its first elected president, Tomás Estrada Palma, took office in 1902. A second U.S. occupation followed his term in office. During this period, the mechanisms that make an independent nation viable were put into place: new banking, constitutional, and judicial systems were established. The years of American occupation were characterized by public works projects across the island: the building of roads, bridges, ports and docks, and schools; the laying of electrical, telegraph, water, sewer, and gas lines. This period also saw a major influx of American speculators who considered Cuba a frontier where fortunes could be quickly made.

Between 1907 and 1914, new banks, a stock exchange, and new docks were constructed in Old Havana. Many of these buildings were designed by American architects, and most were constructed by the American builders who had taken over the construction industry with their technical and organizational skills, as well as their adherence to U.S. building standards. Designs relied on the classical language of architecture as taught at the Ecole des Beaux-Arts, often enhanced with allusions to the Spanish Renaissance. The Lonja del Comercio, or Stock Exchange, designed by Tomás Mur, is a particularly beautiful example; its location on the Plaza San Francisco allowed it to be admired from a distance, something unusual in this crowded quarter. Across the street, the new Customs House of 1914 by Barclay Parsons Klapp was thoroughly up-to-date, containing customs and immigration offices and connecting the docks with the railroad lines that permitted arriving goods to be distributed throughout the island.

A variety of office buildings and banks were also constructed, including the Royal Bank of Canada (1903, José Toraya), the Banco de Narciso Gelats (1910, Luis Dediot), and the National Bank of Cuba (1907, José Toraya) with a neoclassical temple framing the ground-floor entrance. Many of these buildings were organized around a skylit central atrium—a variation on the colonial patio that provided light and ventilation. Interior finishes included marble paving, bronze and wrought-iron doors and railings, and hardwood paneling.

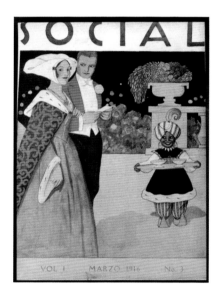

Above: *Social* magazine's March 1916 cover features the *Baile Rojo*, or Red Ball, given by Lili Hidalgo de Conill, one of the events that defined the social life during Havana's sugar boom.

Opposite: Lonja del Comercio on Plaza San Francisco in the heart of Old Havana.

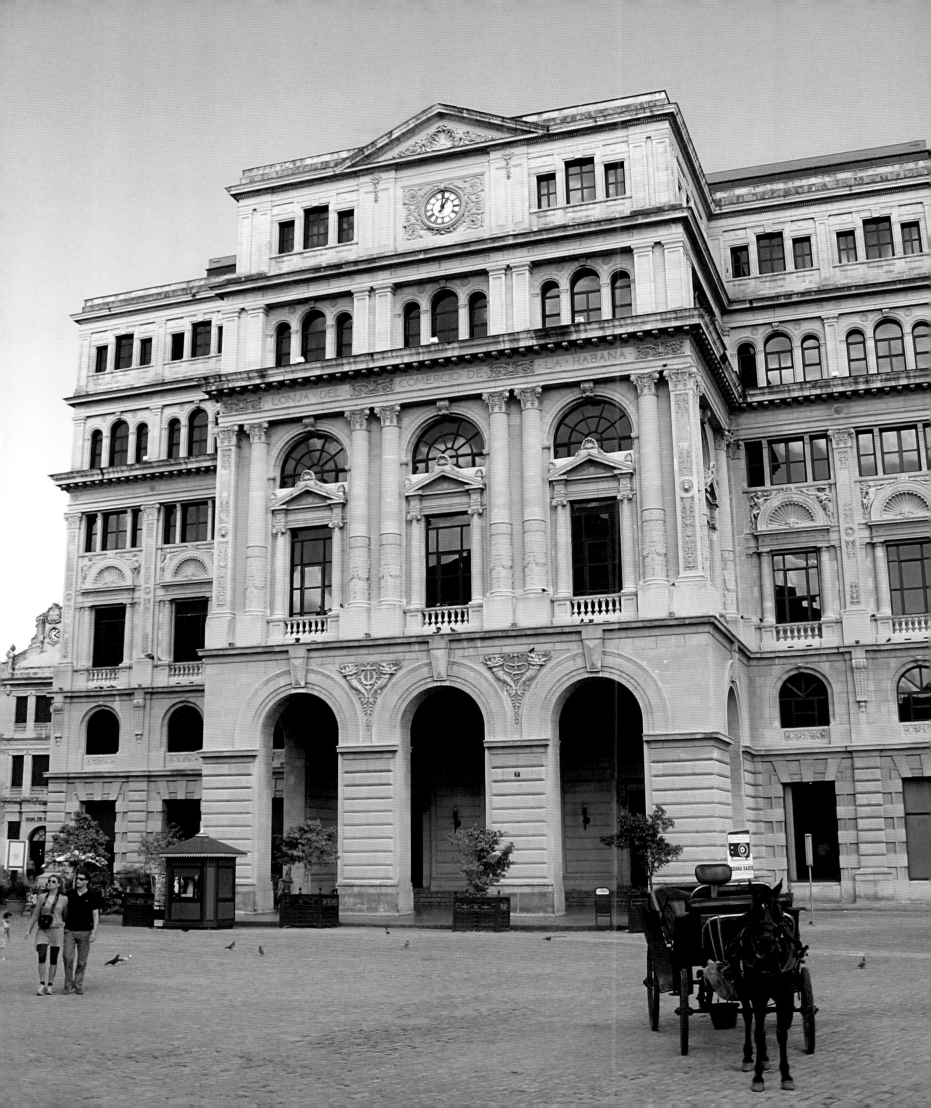

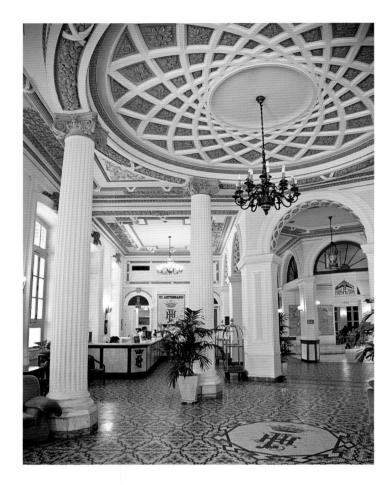

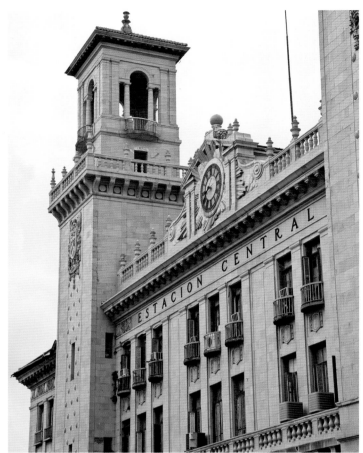

With any major political upheaval comes a shift in economic leadership and the emergence of new neighborhoods where those leaders choose to live—often leading to a new type of house. Cuba's sugar aristocracy was financially destroyed by the wars; its successors were victorious generals of the War of Independence turned politicians or businessmen. These new "men of action" built Havana's last urban mansions on the landscaped Paseo del Prado.

The Prado house of the early twentieth century descended from the colonial model but with the traditional commercial use of the warehouse and mezzanine removed. Family offices were the sole business component of these houses, which had a new emphasis on privacy and comfort. Many Prado houses were renovations of earlier structures, with their updated exteriors still recalling traditional colonial houses. The most interesting designs, however, followed the Beaux-Arts style on the exterior as well as in the interior layout. These new mansions are known for their arcades—required by building codes—and the second-floor balconies and loggias that allowed the salons to enjoy the views of the Prado gardens.

During the teens, the Prado became Havana's most fashionable avenue with the construction of new theaters, cafés, and hotels, in addition to the mansions discussed. The lobby of the luxurious Plaza Hotel is a delight of ornate columns and arches, geometric ceilings and mosaic tile floors. When a ballroom and a roof garden restaurant were added, locals claimed that a corner of Paris had been transported to central Havana. Across the Prado was the sidewalk café of the Hotel Inglaterra, another society meeting place near the Tacón and Payret Theaters and the Parque Central's bandstand concerts.

Left: The ornate lobby of the Plaza Hótel, one of the Prado's most fashionable establishments.

Right: Kenneth H. Murchison designed the Central Railroad Station in the Italian Renaissance style with appropriate Spanish touches.

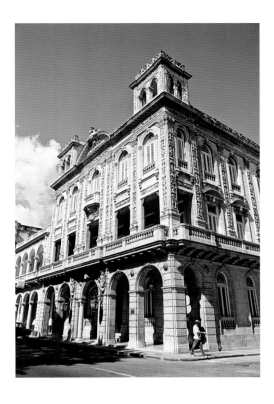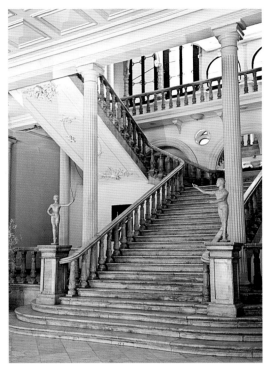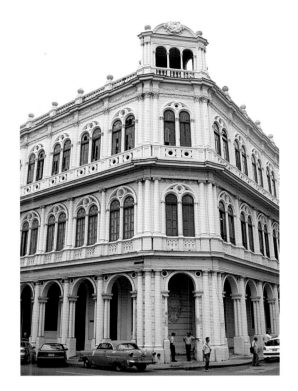

Left: The ornately carved exterior of the Casino Español features a ground-floor public portico and second-floor loggia coherent with the design of adjacent mansions on the Paseo del Prado.

Center and right: Designed in the Venetian Renaissance style, the Asociación de Dependientes del Comerico was the first of the Spanish social clubs to bring a monumental scale to the Prado.

Below: Within the Paseo del Prado arcades were the new republic's most fashionable sidewalk cafés, shops, and hotels.

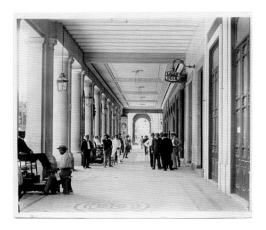

The Paseo del Prado was given a monumental scale by the lavish clubhouses built for the social organizations that Spanish immigrants had formed to help their communities achieve success on the island. These clubs are a testimony to the large Spanish migration to Cuba, one that rivaled the North American one. The Centro Gallego's membership hailed from the Galician region of Spain. Members of the Casino Español were Spaniards of a wealthier class, while membership in the Centro de Dependientes was open to anyone employed in the service trades regardless of their province of origin. Club members had access to cultural and educational programs, libraries, health clinics, gymnasiums, and meeting rooms. Elegant ballrooms, bars, lounges, and cafeterias were accessed via grand staircases crowned by skylights, decorated with murals and heavy ornament.

The Prado neighborhood became the preferred location for Havana's finest retailers, many offering a modern (American-style) shopping experience. The U.S.–based Harris Brothers Co. constructed a modern four-story building off the Prado for its stationery and office goods store. Nearby Frank Robbins Co. claimed to sell anything from a piano to a truck. And the Cuban-owned La Manzana de Gómez occupied an entire city block with two interior streets in the manner of the covered shopping arcades of London, Paris, and Milan. Americans had introduced Cuba to all sorts of modern conveniences—from electric trains, comfortable hotels, and modern plumbing fixtures to dry cleaning and refrigeration. Louis Perez Jr. has documented how the use of American consumer goods made the Cuban family feel modern and up-to-date. Contemporary publications advertised the many U.S. products and services available on the island, a condition that would only increase with time as Cuba became a commercial colony of her northern neighbor.

Although the installation of American-style infrastructure improved life in the old city, those measures could not stave off the exodus of the upper middle class to the western suburb of El Vedado. By 1918—the year Cuba became the world's leading sugar producer—few fashionable families continued to live in central Havana.

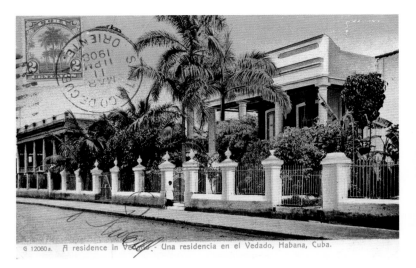

G 12060a. A residence in Vedado. Una residencia en el Vedado, Habana, Cuba.

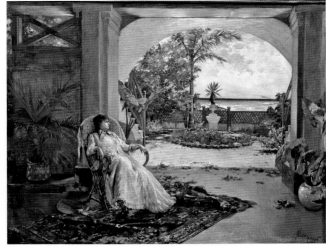

El Vedado was a coastal community that had provided escape from the summer heat to the affluent families living in Old Havana. Here the wealthy spent the summer season in simple houses, attending dances at the Hotel Trotcha, playing baseball or swimming at one of the many bathing establishments. Guillermo Collazo's 1886 painting *La Siesta* sums up the summer lifestyle: a fashionable woman dozes in a wicker chair on the plant-filled porch of her Vedado garden, just a block away from the sea.

The streets of El Vedado were laid out to maximize breezes coming from the nearby coast. Side gardens between houses and setbacks separating buildings from the street ensured further ventilation around and through the houses. The continuity of front gardens set behind iron railings and shaded by a canopy of trees created an extremely pleasant transition between the public and private zones. Although El Vedado was envisioned as a primarily residential neighborhood—in contrast to the mixture of uses in Old Havana—sites were programmed for the construction of markets, churches, and parks. The Malecón, Havana's waterfront boulevard, continued in some form through Vedado all the way to the Alemandares River.

The earliest Vedado houses were simple colonial villas, similar to the neoclassical-style *casa quinta* built in El Cerro, freestanding summer houses surrounded by gardens. Early pictures show this type side by side with sprawling, North American–style wood-framed bungalows with wraparound porches. Many examples of those late-nineteenth-century houses remain: one- or two-story masonry buildings, organized around a central patio, provided with the traditional details of the colonial house: a shaded front porch, tall wood-beamed ceilings encouraging airflow, marble floors, and Spanish tile wainscots that made the interior feel cool. As always, stained-glass fanlights and wood louver shutters tempered the sun, while allowing the air to flow.

Vedado's popularity relied on improvements in transportation that made commuting easy: the private automobile as well as the new electric rail line connecting the development to the city center. Between 1918 and 1921 planters and millowners, politicians, and businessmen used their sugar boom wealth to build impressive houses in El Vedado, where they could enjoy a lavish lifestyle.

Left: The typical elements of the Vedado residential streetscape— iron railings at the property line, a front garden, and a raised front porch—provided privacy to residents while allowing a visual connection to the street.

Right: Guillermo Collazo, *La Siesta*, 1886.

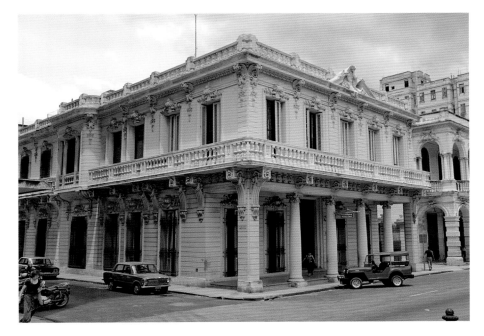
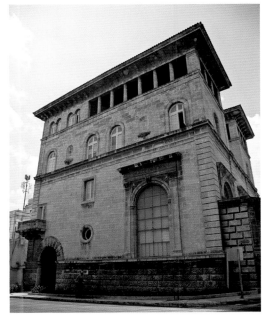
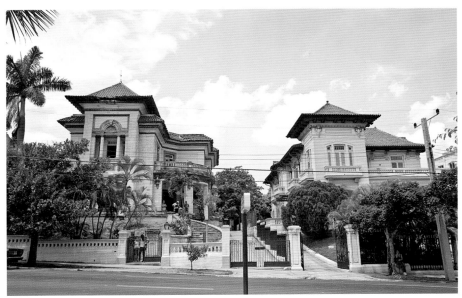
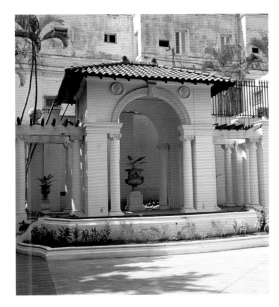

Clockwise from upper left: The Estevez Abreu house on the Prado in the opulent Beaux-Arts style; the fortresslike mansion of politician Orestes Ferrara; garden pavilion typical of the spacious gardens of Vedado mansions; two houses with distinctive towers and green tile roofs constructed for Carlos Nadal and his sister Alicia in Vedado.

Many of Vedado's early mansions followed a straightforward Beaux-Arts design in which a two-story mass, crowned by balustrades where the house meets the sky, is enlivened by projecting balconies and porches that extend the house into the landscape. These masonry houses recall French pavilions of the eighteenth century and are decorated with a repertoire of classical columns, moldings, and garlands.

Gardens became an important element of the Havana mansion design: not just terraces and flowered borders, but fountains and shaded pavilions, extending family life outdoors. The most interesting works of the 1920s are houses expressing the individuality of the builder. Examples include the side-by-side tower houses, with green tile roofs on Avenida

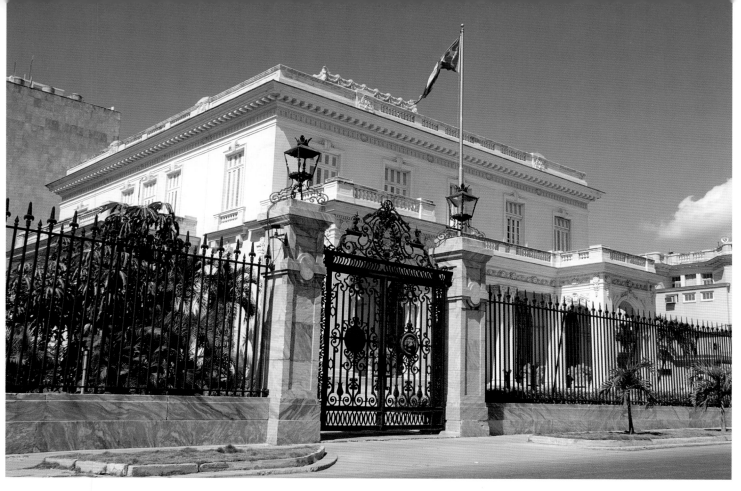

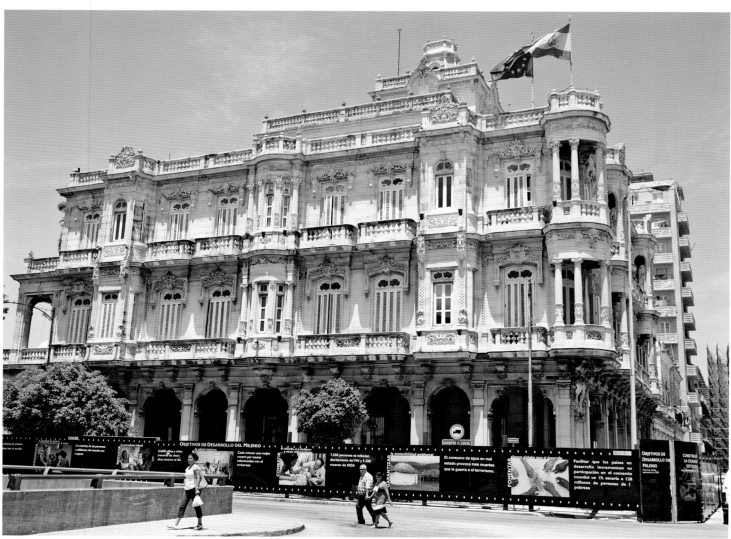

Opposite above: The Vedado house of Alfonso Gomez Mena, 1923, was a Cuban adaptation of the luxurious Second Empire taste of mid-nineteenth-century Paris.

Opposite below: The Dionisio Velasco house, 1912, at the intersection of the Paseo del Prado and the oceanfront Malecón. The undulating facade reflects the Art Nouveau style then popular in Spain.

Right: The Vedado house of architect Enrique Raynieri Piedra exemplifies the eclectic expressions that coincided with the popularity of the Beaux-Arts classicism.

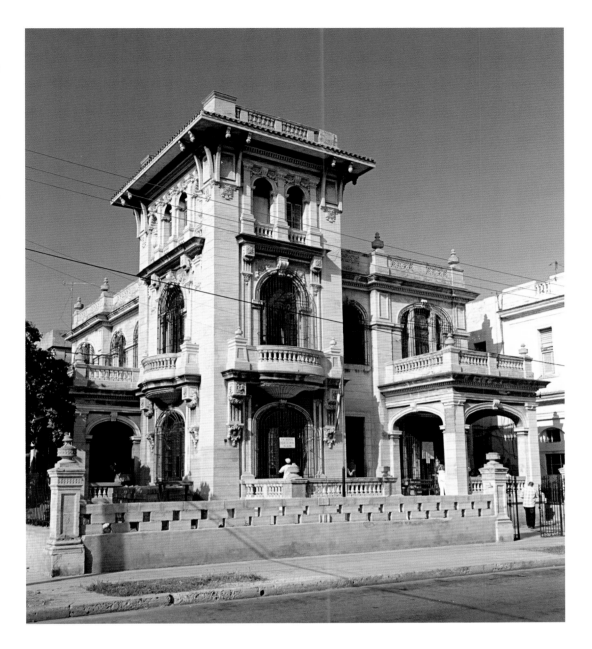

de los Presidentes for Carlos Nadal and his sister Alicia and her husband, Luis Menocal. The Italian Renaissance fortified tower house for politician Orestes Ferrara resembles nothing else: its loggias, balconies, and walled gardens define a world of their own.

During the sugar boom, the magazine *Social*, which chronicled the lifestyle of this new elite, published a new mansion each month in an effort to guide the new homebuilder toward the editors' standards of good taste. Old families did not need this advice, but they often allowed their homes to be featured. Havana's eclectic taste was a constant: as always, the wealthy incorporated objects purchased or design ideas encountered in their international travel.

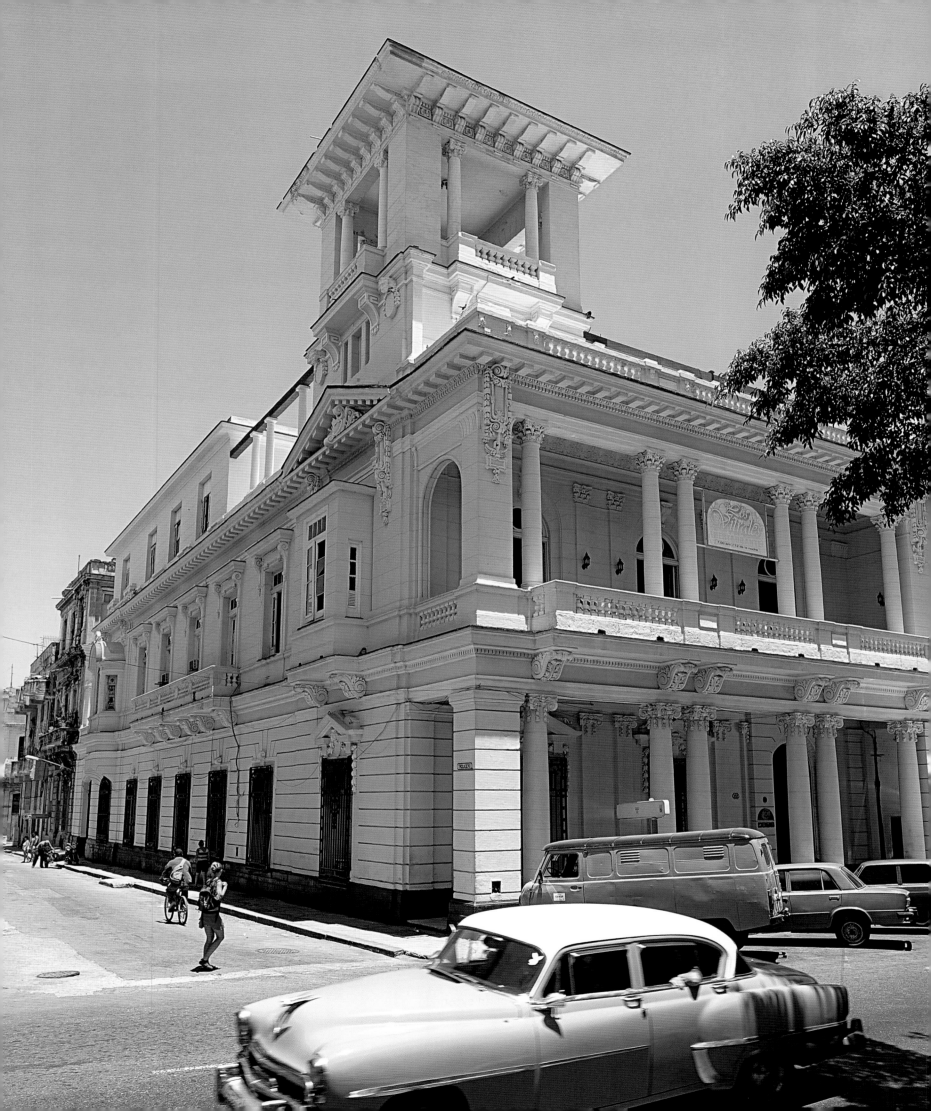

Casa de José Miguel Gómez

Above: Monument to Gómez, with sculptures by Giovanni Niccolini.

Opposite: Like its Paseo del Prado neighbors, the Gómez house featured a second-floor loggia used for al fresco entertaining.

The built legacy of José Miguel Gómez, second president of Cuba, includes one of the Paseo del Prado's most interesting houses, a surprisingly rustic tomb in Colón Cemetery, a presidential train car, and a monument on the Avenida de los Presidentes. Gómez represents the generation of army generals who parlayed their victories in the War of Independence into a place governing Cuba after the Spanish had been ejected from the island. He was pragmatic about working with the unavoidable American presence, holding posts during the first U.S. intervention and becoming president in 1908 after the second occupation. His term in office is known for corruption: he was nicknamed the shark—the one who splashes those around him while he bathes—reassuring cronies that they, too, would benefit during his tenure. He entered office as a ruined planter and left as a wealthy man. Yet during his presidency the construction of much-needed infrastructure that the Americans had begun continued—hundreds of new classrooms, miles of new roads—and new national academies and museums were funded. Two popular Cuban pastimes were reinstated: cockfights and the national lottery. Hugh Thomas called Gómez "the most sympathetic of all the presidents of Cuba . . . Easygoing, tolerant, loving the good life, he was to the Cubans the archetype of their own ideal personalities." Despite the financial scandals that marked his years in office, in the 1930s all classes of the Cuban population joined the public subscription that funded construction of a monument in his honor—a Caribbean-scale version of the Victor Emanuel II monument in Rome.

At the end of his term in 1913—he had asserted he was not running, while hoping for reelection—Gómez acquired two houses on the corner of Prado and Trocadero, with the intention of remodeling them as his private residence. He wound up building a completely new house that broadcast an appropriate public image on the street he imagined as a future ceremonial avenue. Gómez remained active in Liberal Party politics, for years keeping an eye on the possibility of his reelection. While his house epitomized the Prado residence—with the piano nobile over public ground-floor arcades—it took this type to a new level. The spatial sequences and ornamented surfaces were clearly designed to demonstrate power to a constant flow of courtiers and politicians. Yet the rooftop pergolas conveyed the delight of living in Havana, overlooking the landscaped avenue, just blocks from the sea.

Gómez's house displays an attention to the decoration of individual interior spaces that feels unique for its day. Havana's colonial houses had been grand in scale but rather plainly finished inside, relying for interest on painted decorations, patio columns, marble floors, tile wainscots, woodwork, and colored-glass windows. Even the Palacio de los Capitanes Generales relies on this limited set of design elements for its decoration. But in Gómez's house there is a sense of sequencing of decorative treatments and the idea that the rooms are connected to each other

63

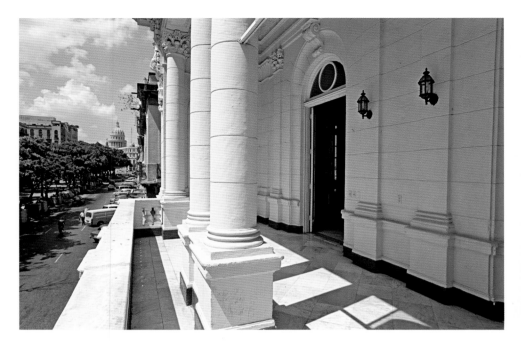

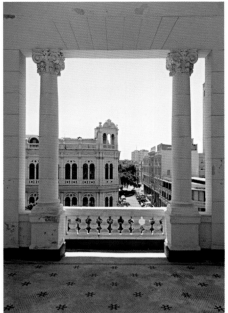

by decorative zones—not simply entered via traditional doorways. This idea of overlapping adjacent spaces is first encountered in the exterior of the house, where the ground-floor portico and the upstairs loggia are extensions of the private realm into the public areas. One could add that the life of this house included a similar overlap of the public life of a politically ambitious ex-president with the home life of a traditional Cuban family.

Many of today's Prado houses are twentieth-century renovations of colonial houses, their exteriors often recalling the traditional Cuban house they descend from. Others have monumental Beaux-Arts facades added onto a colonial layout of small rooms within. Gómez and his architect, Hilario del Castillo, attempted to do something different. The corner site allowed for a dynamic composition anchored by the thrust of a tower linking facades that are appropriate for each front. The Prado elevation is both transparent and suitably grand: pairs of columns float in front of shaded porticos on both floors. The second-floor loggia is a theater box overlooking the performance of urban life on the Paseo. On Trocadero Street the house feels more sober: in the classical tradition the ground floor of the house is rusticated to appear as a solid base, as though defending the home from outside intrusion. The upper floor is smoother and animated by scrolling brackets that frame windows and support balconies and bay windows, and by garlands decorating the pediments above.

The Beaux-Arts-inspired sequence of arrival experiences begins at the ground-floor portico, which leads to a vestibule, where the marble staircase with its inviting steps is framed by marbleized columns and capped by a coffered ceiling. The prominent location of the stair is a departure from the colonial house layout, where it would have been placed off to a side of the patio. Throughout the house, there is a sense of framed views, of invitations to spaces beyond, of all surfaces being given decorative attention.

Daylight spills into the side of the front hall through two successive rows of columns supporting a central arch. It is possible that this motif was intended to suggest a Roman triumphal arch, a masculine power theme that is expressed in other bellicose symbols in the decoration. Beyond is an open-air courtyard, around which the rooms on both floors have been organized.

Left: View from the loggia toward the National Capitol.

Right: A picturesque tower serves as a mirador above the rooftop gardens, affording views of the Centro de Dependientes across the Paseo.

Below: Commemorative photograph of José Miguel Gómez.

Opposite: The sweeping marble stair occupies a prominent place in the richly ornamented front hall.

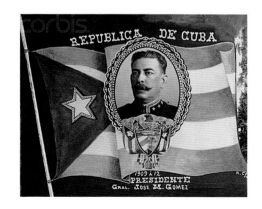

64

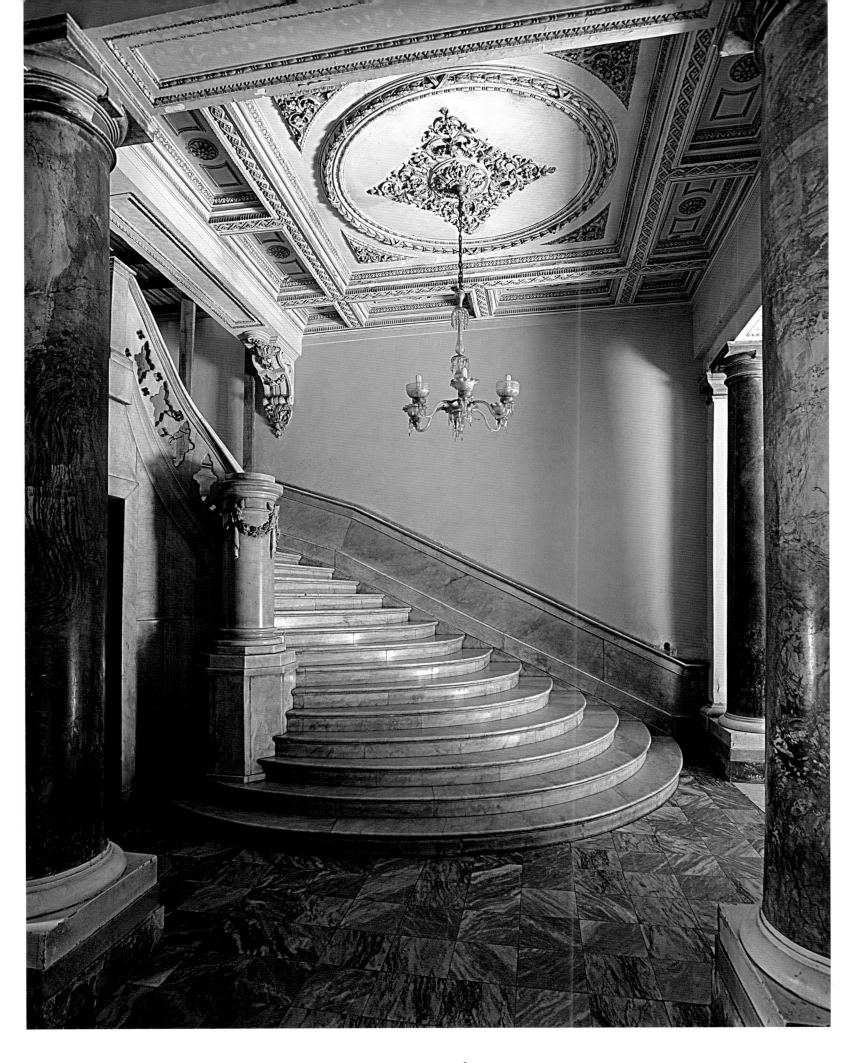

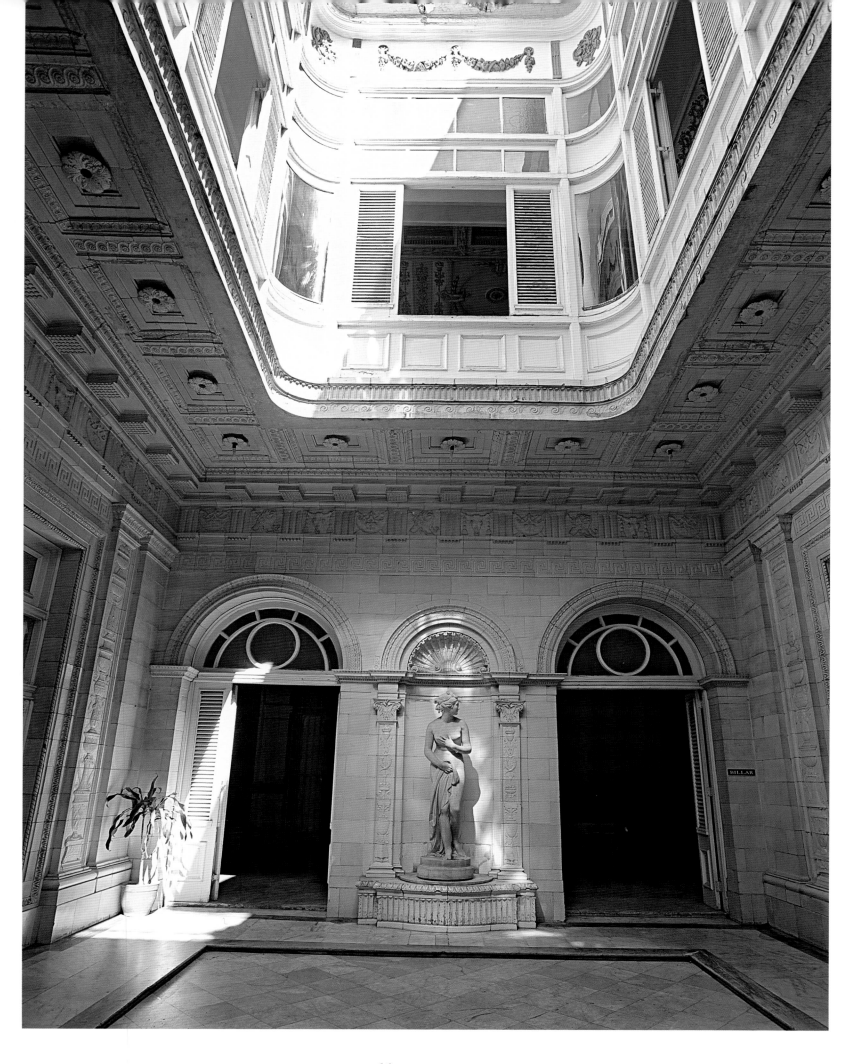

The lozenge-shaped courtyard recalls those of Spanish colonial houses, reconciling traditional construction elements and Beaux-Arts classical detailing. The ground floor is sheathed in ornate terra-cotta panels, while walls of wood louvers and glass panels define the bedroom area above.

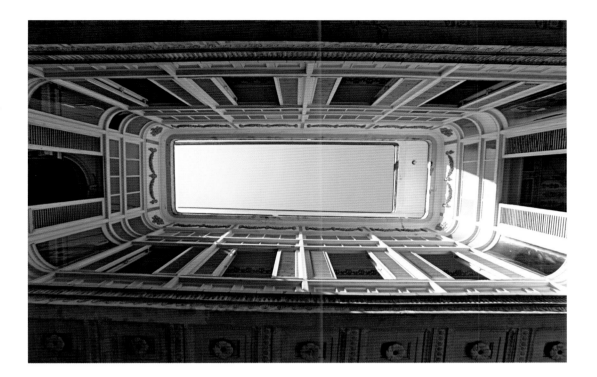

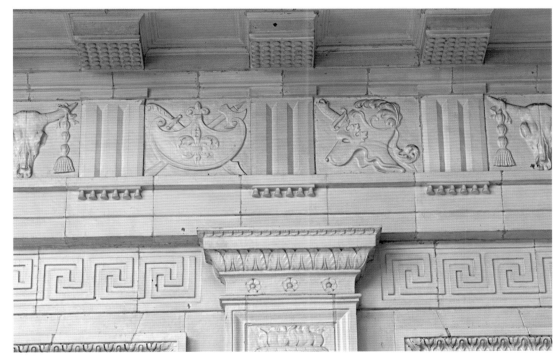

The courtyard is unusual in that it is completely sheathed in glazed white terra-cotta; its pilasters, decorated with classical ornament, support a frieze of ox heads, helmets, and shields. Sculptural coffers support the upstairs wall, which is cantilevered over the patio, providing shelter from sun and rain. The view culminates in an arched niche in which a sculpture stands. This central patio is related to the colonial patio, yet with its white marble floor and shiny walls, it feels cold and closed off. The ground floor accommodates service areas, extra bedrooms, and stables, as well as spaces reserved for the males of the family—law offices of Gómez and his son, as well as a billiard room, smoking room, and fencing studio—settings for plotting a return to presidential power.

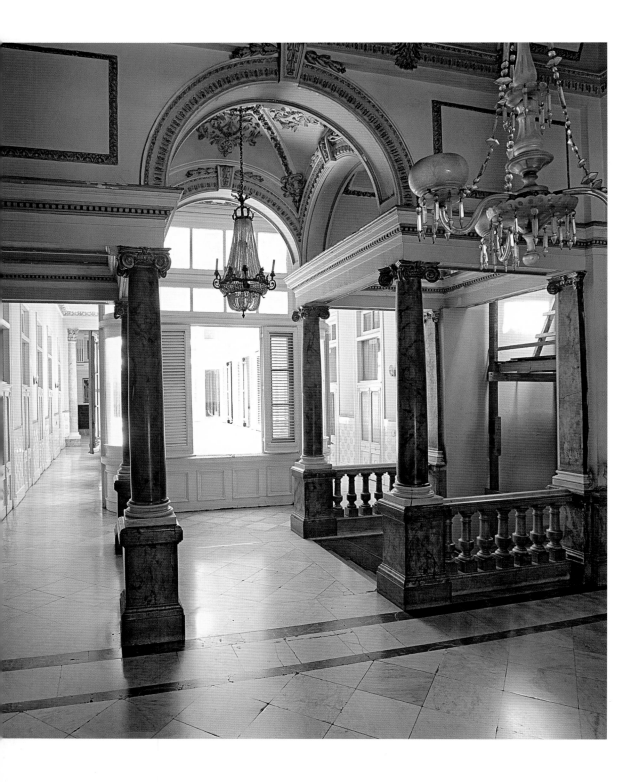

The staircase rises to another pair of columned screen walls supporting a groin vault and acting as a buffer between the front and the rear of the house. To one side is the louvered and glazed wall surrounding the courtyard; toward the front, another decorated space leads to the dramatic salon that occupies the full width of the Prado side of the house. This is a spectacular space with marbleized pilasters, garlanded wall panels, and an ornate cornice of frolicking putti, all supporting a coffered ceiling and lit by the requisite crystal chandeliers. Arched French doors lead to the shaded privacy of the loggia overlooking the activity on Paseo del Prado—just as in Gómez's day, a perfect place to while away the hours. To the south is a view of the dome of the National Capitol that must have tantalized Gómez.

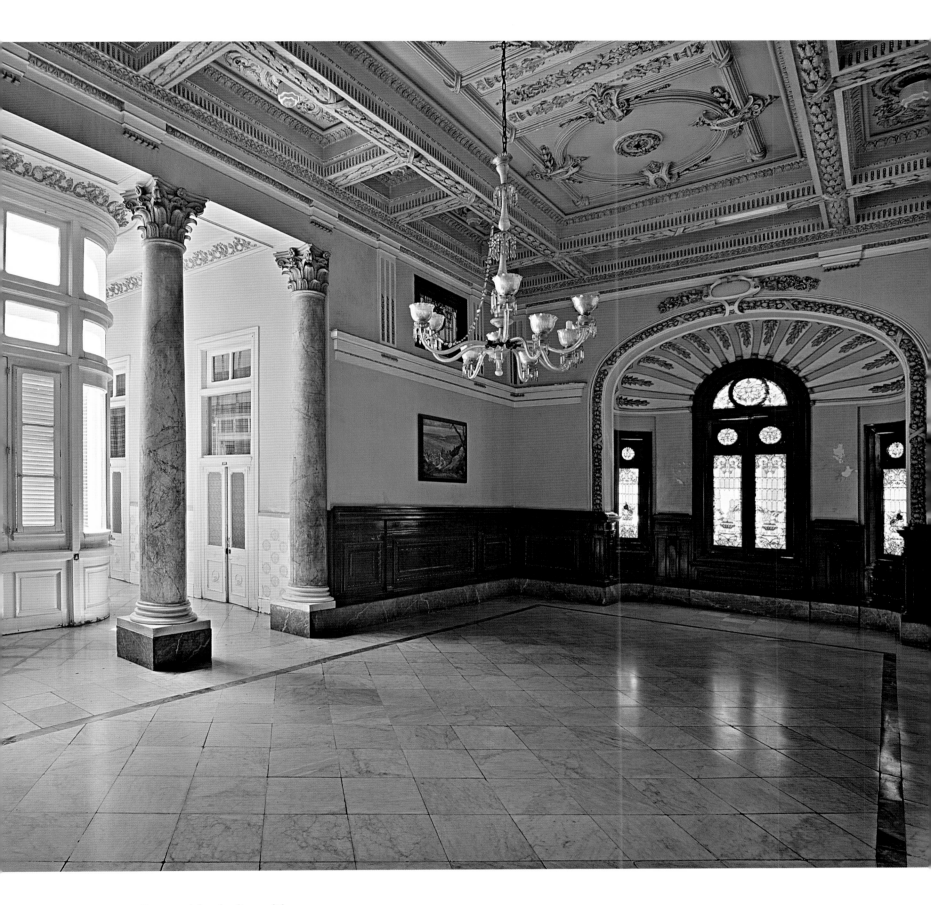

The second-floor landing and the dining room, with a central bay window lit by colorful stained glass.

At the rear of the house is the equally dramatic dining room, entered through a column screen that creates a boundary with the courtyard corridor while allowing that daylight to flood the room. Deep coffers decorate the dining room ceiling, which is supported by an exaggerated frieze circling the upper walls, while a stained wood wainscot decorates the lower area. The room culminates in another focal point: a projecting bay window set with stained-glass panels depicting urns filled with flowers and tropical fruit. These were appropriate symbols of the abundance that characterized Republican banquets with larger-than-life cronies like Orestes Ferrara and future president Gerardo Machado. Although Gómez lost his bid for reelection in 1920, he did manage to lay the groundwork for the election of his son, Miguel Mariano Gómez, as Cuba's twelfth president in 1936.

One of the house's most dramatic spaces was not created for a show of power so much as to satisfy the function of circulation space connecting the front and rear of the house. At the second floor, the courtyard is enclosed by walls of wood panels, glass panes, and adjustable louvers—an update of the colonial tradition seen at the Archbishop's Palace. The walls protect the gallery from the sun and rain and provide privacy from the more public areas of the courtyard below. A series of tall openings, fitted with combinations of fixed transoms and hinged lower doors, allowed for both privacy and air circulation in the bedrooms beyond.

The spatial sequences of the house culminate on the rooftop terrace, with a two-story observatory tower anchored by rows of columns that once supported the wood beams of pergolas defining a generous outdoor space. Although this level has been much changed, one can still imagine a roof garden similar to ones found in the best Beaux-Arts hotels of the period—flowering vines growing on beams, illumination by lanterns and fairy lights, a beautiful meeting of the house and the tropical sky. The view today is much the same as that enjoyed by Gómez's guests: the grand social clubs and hotels, as well as the National Capitol and the Presidential Palace.

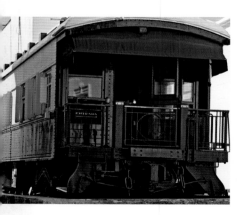

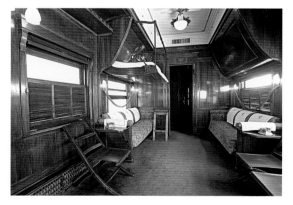

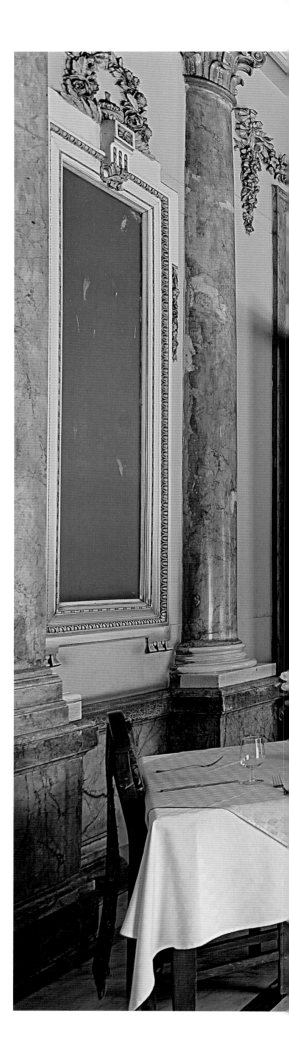

Above: The American-made presidential railroad car, or *Tren Mambi*, used by Gómez included hideaway beds.

Opposite: Ornate plaster moldings and marbleized pilasters bring grandeur to the salon, whose French doors lead to the loggia overlooking the activity of the Prado.

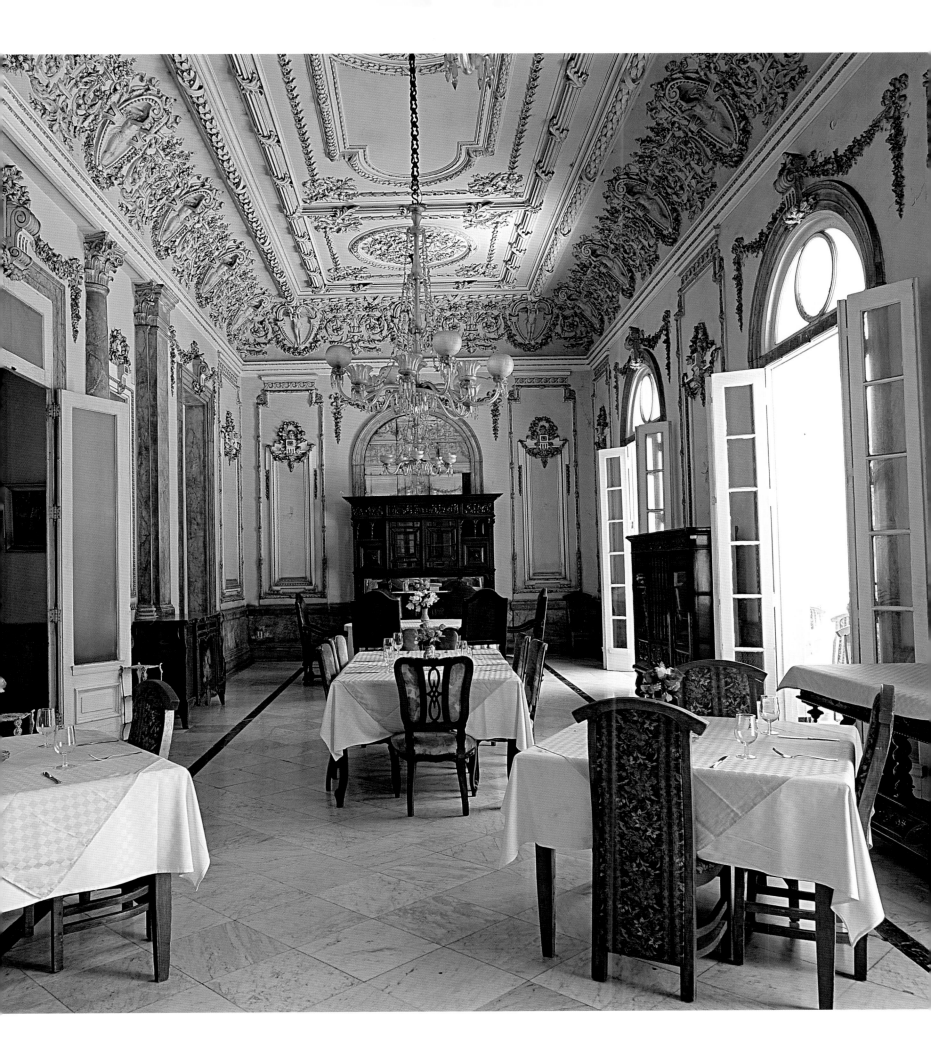

Casa de los Marqueses de Avilés

In an 1886 portrait, the artist José Arburu Morell captured three generations of the González de Mendoza family in the elegant parlor of the Old Havana compound where they lived under the patriarch's stern rule. The painting gives visual form to the transition from the insular Spanish colonial world to the showy style of the Cuban sugar boom. Antonio and his wife, Marìa de las Mercedes Pedroso y Montalvoî, preside over their family from the comfort of a tufted sofa. The painting documents the luxurious, late-nineteenth-century setting: a Savonnerie carpet on the marble floor, a gilded Louis XVI–style mirror and console table, portraits and tapestries hung on paneled walls. The painting also records the alliances made by the couple's children with some of Havana's most powerful families: Arellano, Freyre de Andrade, Batista, Arostegui. Their descendants would continue to marry into the island's most important families and occupy positions of power in many sectors of Cuba's economy.

Antonio Mendoza's Havana law practice, started in 1854, became one of Cuba's most prestigious. He was a professor of mercantile law at Havana University and a founder of the Circulo de Abogados de la Habana. He was mayor of Havana from 1879 to 1881. Although he was the son of a Spaniard, Antonio was passionate about Cuba's independence from Spain, favoring annexation to the United States. His support of the abolition of slavery extended to him freeing his own slaves in 1879.

Antonio and Marìa de las Mercedes raised twelve children in their Old Havana home. In the portrait we see thirteen adults, two adolescents, and six young children. As the children married, they received a suite of rooms for their own new families in one of the three interconnected houses. But mostly they shared the maze of sitting rooms, galleries, dining rooms, billiard room, courtyards, and service spaces. At its busiest, almost a hundred people, including servants and business staff, occupied the houses. Within one generation, due to the growing American influence, the Cuban tradition of multiple generations of an extended family living together under the father's authority would begin to disappear. Fashionable

Left: A vintage view of Seventeenth Street in Vedado, a street renowned for its series of sumptuous residences.

Right: Urn at the Avilés entrance gate.

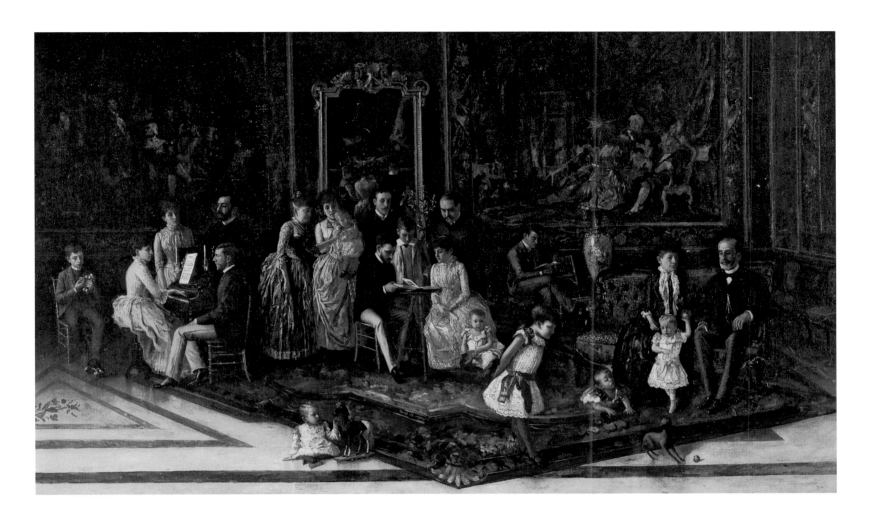

José Arburu Morell, *Portrait of the Family of Antonio González de Mendoza*, 1886. In the foreground is granddaughter Margarita, who married the wealthy Marques de Avilés in 1906.

families would no longer live in Old Havana. Among those destined to leave this family home were a little girl in the foreground of the portrait and a young man in the back, both of whom would build their own homes in the newly fashionable neighborhood of El Vedado. The girl, Antonio's granddaughter, Margarita G. Mendoza, would marry the son of fabulously rich Leopoldo Carvajal, a Spaniard who made a fortune in Cuban tobacco. In all likelihood Margarita, who was the "catch" of her generation, was courted in the very same parlor where she is depicted.

 Margarita married in 1906, one month after the death of her grandfather had initiated the dispersal of the Mendoza clan from their Old Havana compound. The house that she and her husband, Manuel Carvajal, Marques de Avilés, built in 1914 is in a class of its own in the city. Designed by New York architect Thomas Hastings, it presents an elegantly reserved but opulent exterior that communicated the couple's status and taste. Although the house of the Marqueses de Avilés must be described as grand, it is stylistically discreet compared with neighboring sugar boom mansions. The Beaux-Arts-style mansion is set back from the street and raised above the sidewalk, from which it is separated by a masonry balustrade. The architecture suggests the perfectly scaled Louis XVI–style pavilions—based on the Château de Bagatelle or the Petit Trianon—that Hastings had successfully created in the past. A double-height central block is flanked by a service wing on the right and a columned porch on the left. The entrance is placed in a central recess framed by fluted pilasters and a pair of smooth freestanding columns—a typical neoclassical device, yet here the attic

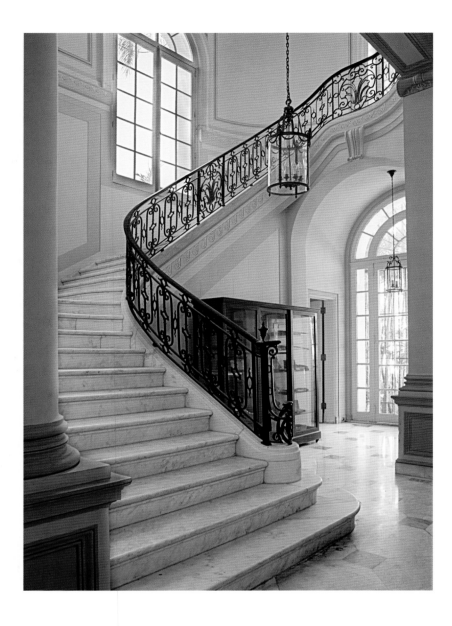

Left: The marble stair is lit by three tall windows, giving the impression of floating in space.

Opposite: A pair of monumental Corinthian columns frames the entrance, which is protected by a pair of reclining bronze mastiffs modeled on those in the Château of Chantilly.

balustrade and the window surrounds are in the Spanish Renaissance style, as is the ironwork used throughout. The design successfully marries the then-fashionable sober French neo-classicism with Spanish Renaissance references, which were probably requested by the client, although the Carrère & Hastings designs for the Pan-American Exposition in Buffalo displayed a similar combination of classicism and Iberian inspirations.

A sequence of exterior design elements leads the visitor inside, extending the house into the streetscape and setting the tone for the interior in the manner of the Beaux-Arts style. When *Social* magazine visited the house in 1930, two royal palms "lent a tropical note to the entry." Today, one of these trees remains, along with a series of smaller palms that reinforce the Caribbean classicism. The cool, refined, and elegant front hall must be one of the most beautiful spaces in Havana. Projects in St. Augustine, Florida, as well as Henry Flagler's Palm Beach mansion, Whitehall, had equipped Carrère & Hastings for adapting European style to the tropical climate. The hall feels like an open-air space from which to access the formal rooms. Originally, the hall was furnished with an oriental rug, a comfortable sofa, and upholstered armchairs from Maison Jansen of Paris. Console tables with stone sculptures, bronze candelabra, Wedgwood vases, the ubiquitous framed family photographs, and potted palms in Chinese porcelain jardinières decorated and personalized the room.

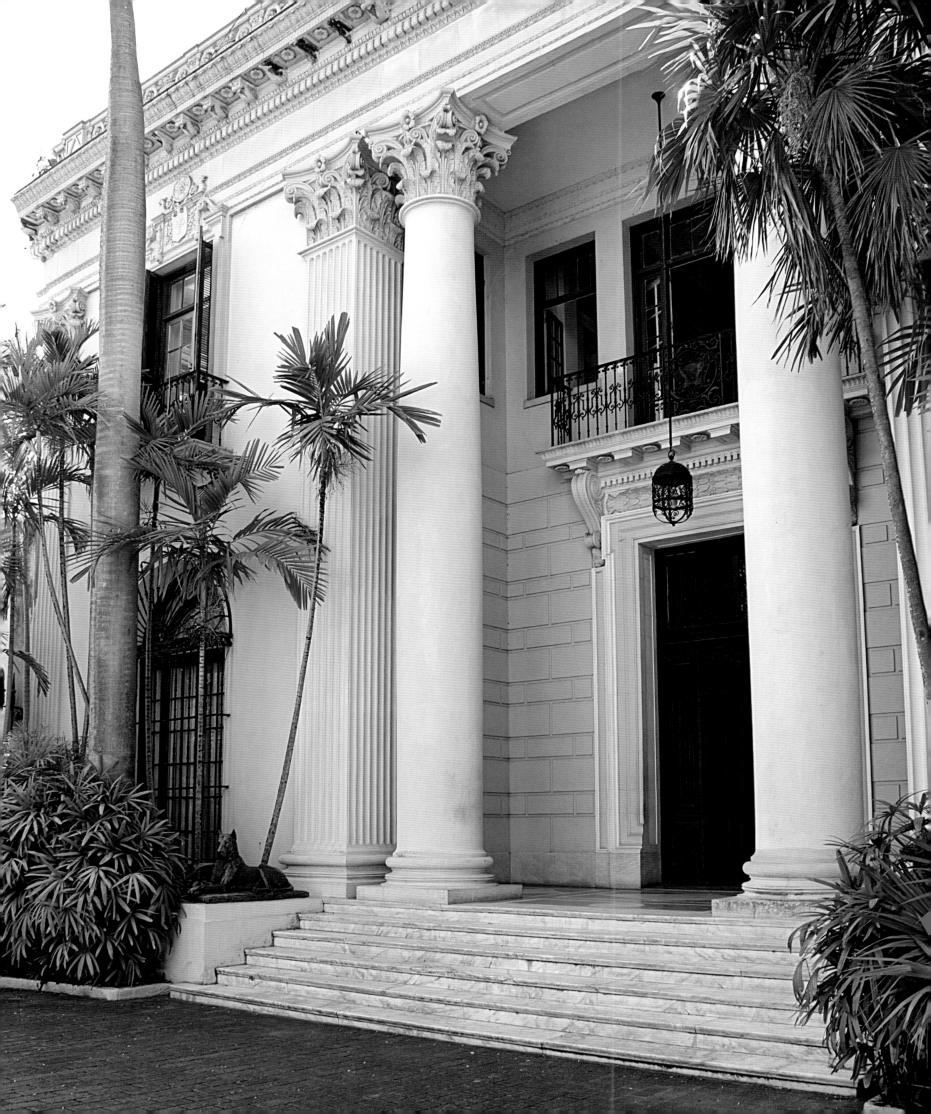

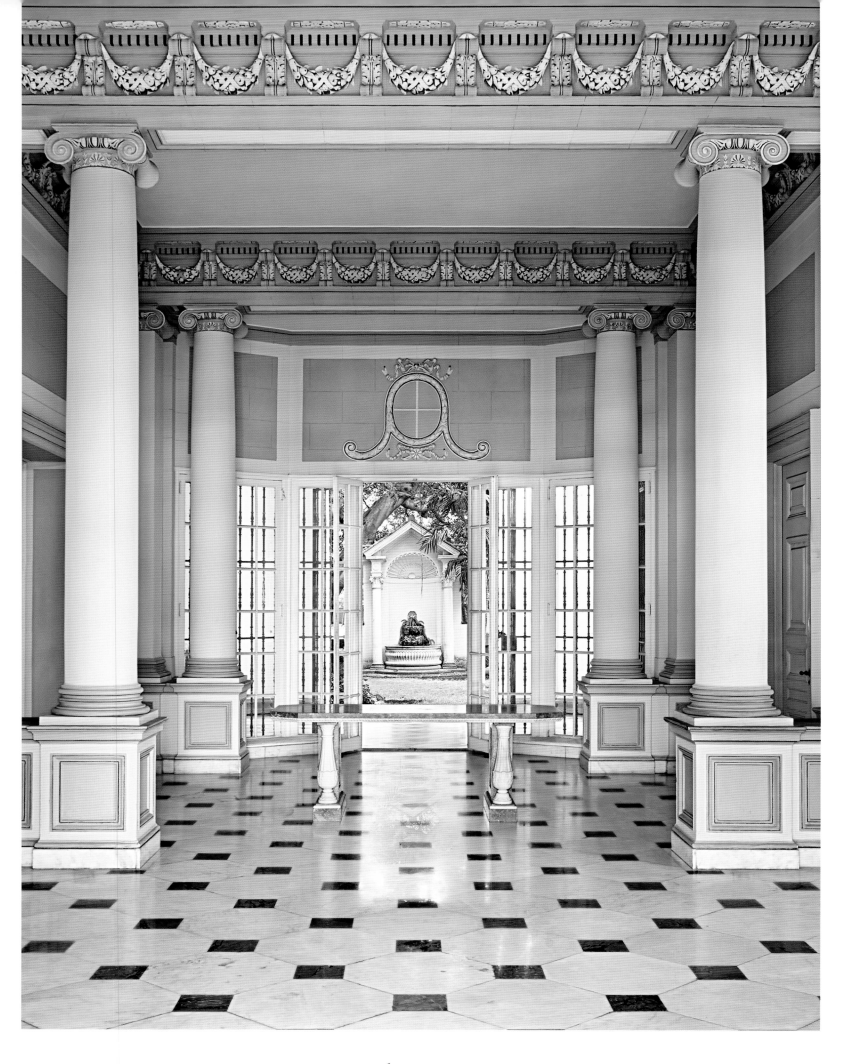

In the front hall, Carrère & Hastings employed a classical Beaux-Arts vocabulary in a Caribbean palette. Pairs of Ionic columns define spaces between the entrance and the garden at the rear.

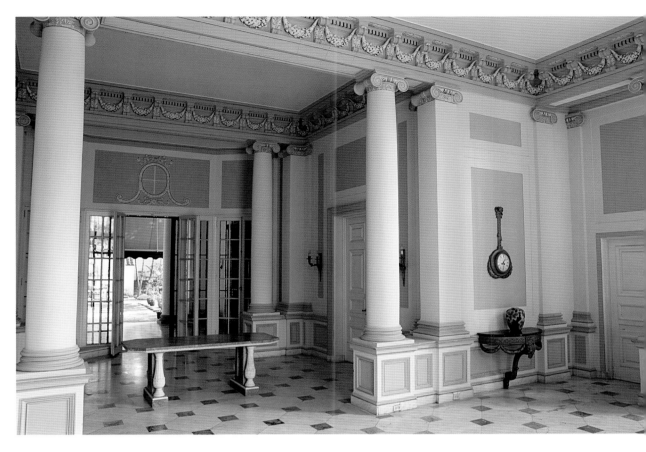

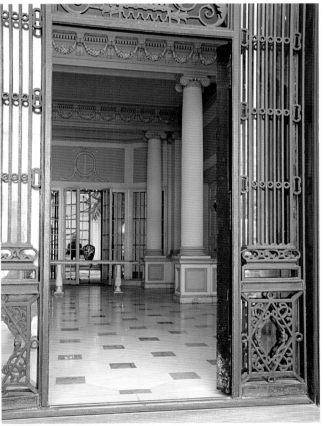

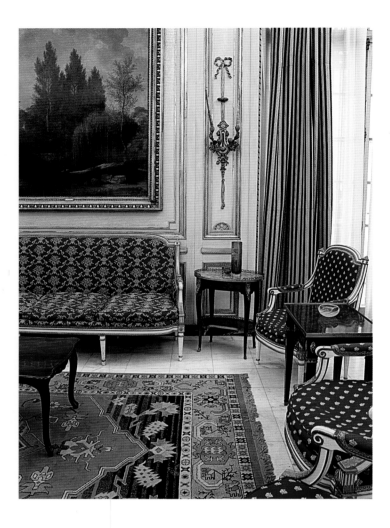

Gilt-bronze wall sconces and a Romantic-style landscape painting are in keeping with the paneling and the gilded details of the salon and its suite of Louis XVI–style furniture.

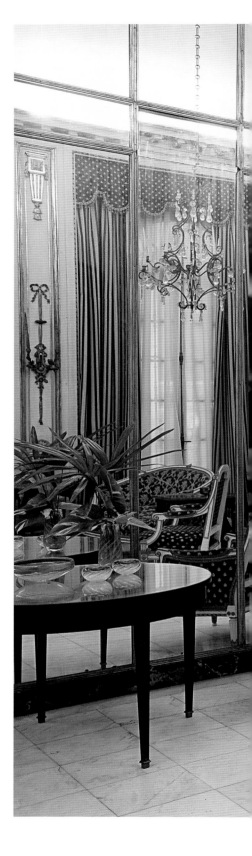

In its day the dining room was recognized as the house's most successful space. The gray-painted wood paneling is one of the most finely executed in Havana. The carvings feature bouquets of lilies, a motif copied from Marie Antoinette's music room at the Petit Trianon. Trompe l'oeil arches frame mirrored niches, creating symmetry with the arched windows. Whereas today a large extension table and a dozen Louis XVI–style chairs fill the room, vintage views show a simple square table and just four chairs made by the English firm of Lenygon & Co., decorator to the British royal family. Margarita decorated the room with a silver centerpiece and candlesticks that had belonged to the count of Fernandina, as well as German porcelain pieces from the Pedroso and Montalvo families. The yellow marble console tables and the airy crystal chandelier found in the room today are not original, yet they work beautifully.

What *Social*'s reporter calls the Georgian-style living room is today the main salon, which has been transformed by the later addition of a chic wall of mirror. This was probably part of a redecoration of the house attributed to Jansen undertaken by a subsequent owner. The space was originally fitted with painted paneled walls above built-in bookcases. Upholstered seating, green damask curtains, antique tapestries, and a thick oriental carpet softened the comfortable room. The English theme was continued with an Adam-style settee between the terrace doors and one opposite that was flanked by English side tables, on top of which were shaded porcelain lamps. A large table held local and foreign magazines as well as framed family photos—an English touch much admired by *Social*.

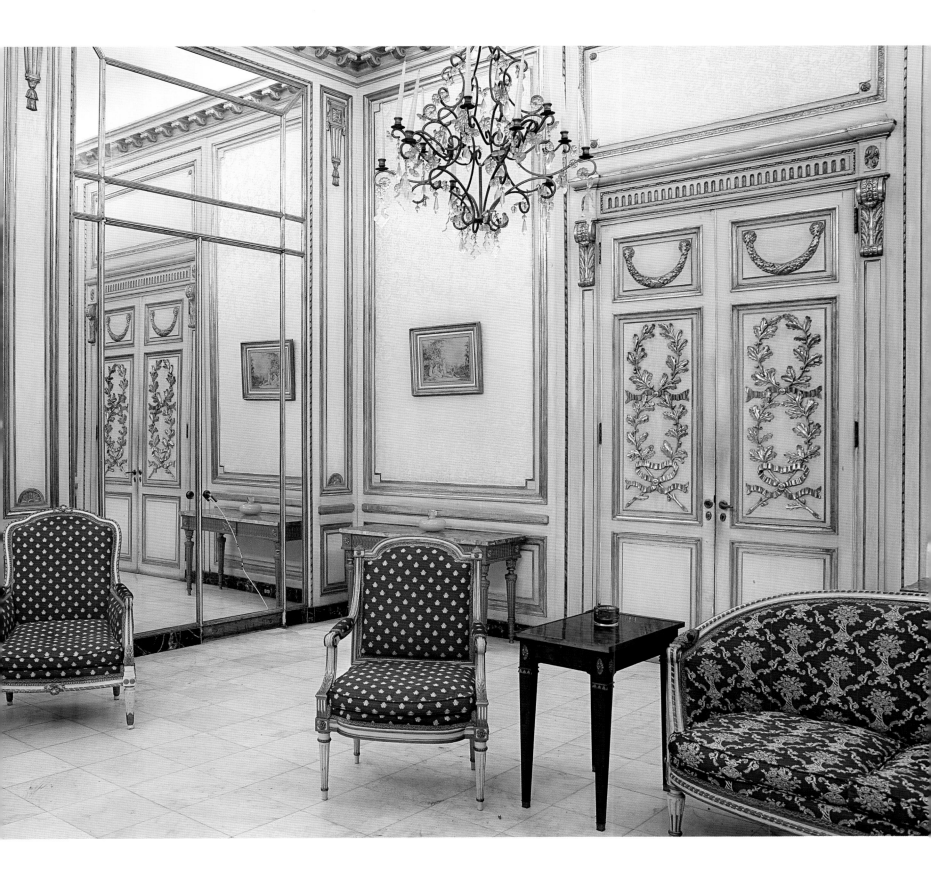

79

In the dining room, cream-painted wall paneling and an airy rock crystal and iron chandelier complement a marble console and the neoclassical-style table and chairs.

Left: The neoclassical garden folly and fountain is on axis with the front door.

Right: Ionic capitals on the porch columns echo those used in the front hall and define a breezy social space that was favored by the family.

As with other houses of the period, the outdoor spaces of the Avilés house are of special interest: the Ionic order of the porch columns is elegant and important, the balustrade below conveys a sense of intimacy and enclosure, and the terraces are as *Social* refers to them, "delicious." Today's subtle cream and gray paint colors are probably inspired by the marble floor, but *Social* describes walls and ceilings decorated with Pompeian frescoes of garlands and grotesques in deep red. The porch was furnished with iron lanterns, beautiful birdcages, marble consoles and benches, and planters filled with orchids. The comfortable wicker furniture arranged in seating groups was lacquered in a striking blue. It is easy to envision the owners enjoying this typical Cuban space in complete privacy, set back from the busy street and surrounded by an extensive garden. The focal point of the rear garden is an elegant classical fountain that leans against the convoluted trunk of an ancient banyan tree. A simple pediment supported by a pair of columns frames an arched niche that shelters a marble basin. Behind it is a vast lawn where a neighboring house once stood, property purchased after the marqueses were unpleasantly surprised by the construction of a new house on another neighboring lot.

Margarita and her husband both died young, in the 1920s, at which point Margarita's father, Miguel Mendoza, moved into the house with his daughter Micaela and her husband, Andres Carrillo de Albornoz. Micaela had appeared as a baby in her mother's arms in the Mendoza family portrait, so this seems a fitting return to the multigenerational family situation they had once shared in Old Havana.

The house is appreciated today by the many visitors to the Instituto Cubano de Amistad con los Pueblos, whose public spaces welcome people from all over the world.

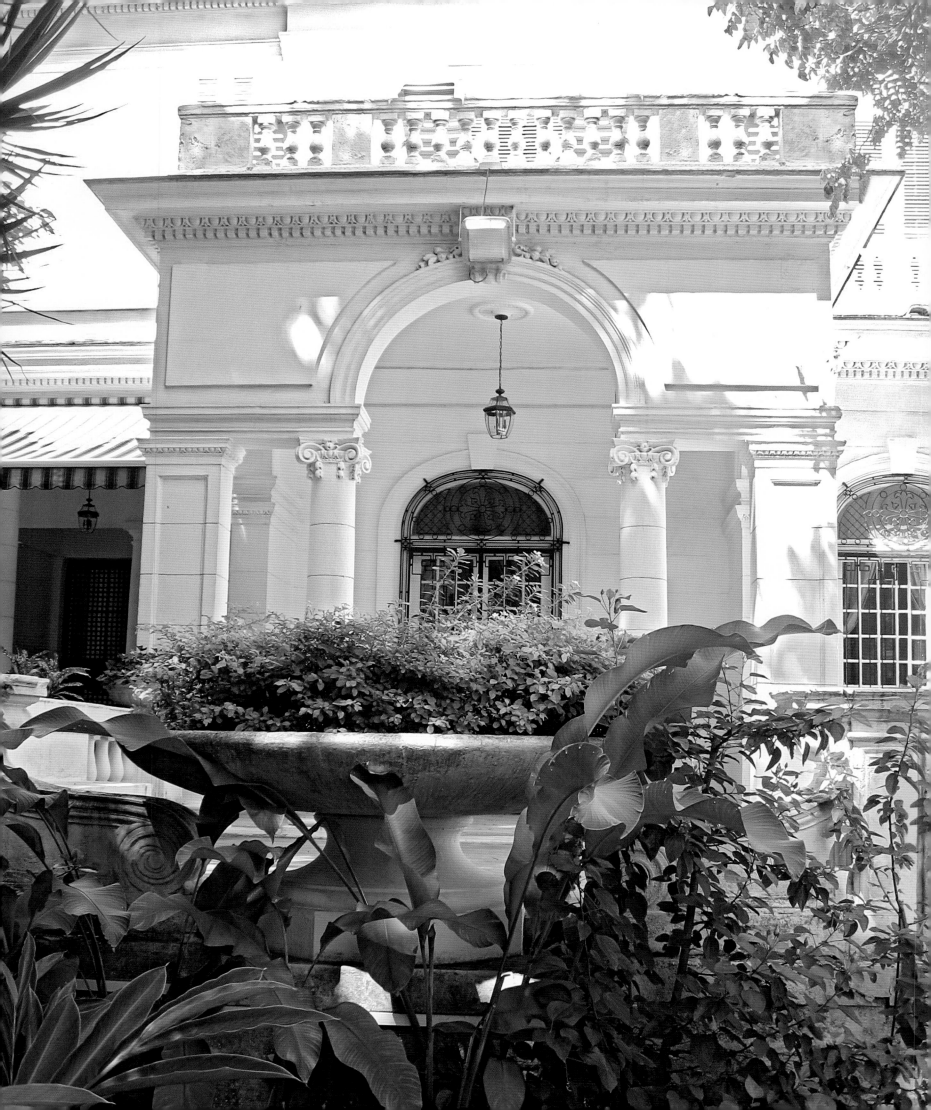

Casa de Pablo González de Mendoza

Above: The radiating spokes of the distinctive glass-and-iron canopy hang within the masonry arch leading to the front door.

Opposite: The Palladian motif of the rear garden porch overlooks a classical tazza overflowing with ferns.

One of the most photographed spaces of twentieth-century Havana architecture is the dramatic indoor swimming pool in the Vedado mansion of banker Pablo González de Mendoza y Pedroso. But the pool house is just one of many interesting features in a house representing the evolution of the Cuban dwelling from the urban Spanish colonial prototype to the free-standing suburban home seamlessly connected to its garden setting by outdoor terraces and porches serving different purposes and creating different moods. This house—like that of Pablo's niece, Margarita Mendoza, Marquesa de Avilés, slightly preceded the sugar boom mansions that were built throughout El Vedado. The Mendoza fortune also predated the boom prosperity of the Dance of the Millions, as did the family's connections to some of Cuba's most important families. Pablo's own holdings included the Banco Mendoza, which he founded before the boom, and later the Banco Hipotecario Mendoza. Pablo had been pictured as a studious young man in the same Mendoza family portrait as the marquesa while both lived under the patriarchal roof in Old Havana. The house that Pablo built on Paseo has served as the British Ambassador's Residence since the mid-1950s. The architect was Leonardo Morales y Pedroso, Columbia University trained and the leading island-born practitioner of the Beaux-Arts style.

Mendoza's house is situated at the side of a generous corner lot—creating a large front garden with driveways on both frontages. Although the front entry faces the side street, there is also a major facade on Paseo. The composition of the house is best understood here, since it remains as originally designed, whereas the entry facade has been altered by the addition of the swimming pool wing. The rear elevation is just as elegantly composed, with a series of projecting volumes and classical balustrades pushing into the garden to connect the house to the landscape. The core of the two-story house is covered by the four broad planes of a sloping clay tile roof. Four pedimented attic dormers, an unusual detail in Cuba, add a picturesque note to the roofline. The entrance is through an arch set at the base of a projecting tower. A distinctive round glass-and-iron canopy with radiating spokes hangs from a crown within this arch—halfway in, halfway out of the opening—providing protection from the rain. It is not clear whether this unusual element is original.

The interior layout is compact, simple, and effective—with dramatic flourishes where visually required. Visitors step up into a double-height entry hall where a marble staircase hugs a curved wall detailed to resemble stone blocks. Lighting the stair is a stained-glass armorial window—a Havana staple for generations. To the left is the simply framed opening to the original salon (the dining room today); straight ahead, fluted columns frame the monumental entry to the living room, which leads to the original dining room beyond. The simplicity of

The sloping clay-tile roof is punctuated by a dormer window, an unusual feature in Cuba. The second-floor bay window and the projecting porch extend the house into the garden.

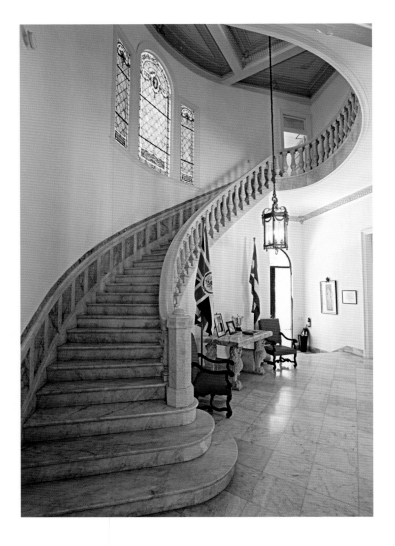

Left: The curved marble stair is lit by a stained-glass window featuring the coat of arms of the builder, Pablo González de Mendoza.

Right: As befits the British Ambassador's Residence, the dining room is furnished with English pieces, including a mahogany table, sideboard, and chairs, as well as a giltwood mirror and ensuite console.

the interior details is satisfying: a plaster cove is the front hall's sole ornament; wall panels and a more ornate cornice add detail and scale to the salon, which in period photographs appears elegantly underfurnished.

The interior conveys a sense of grandeur coupled with a Beaux-Arts sequencing of spaces, and it is not ostentatious as are many later Vedado houses. The design goal seems to have been to create light and airy spaces. This is reinforced by the tall French doors between rooms—mirrored for privacy in the case of the salon—and similar doors giving access to the terraces and porches all around.

The original house is most interesting in its outdoor spaces, where a thoughtful integration of the architecture and landscape is apparent. A pair of porches projects from the house into the rear garden, defining a terrace between them. Balustrades, obelisks, and low, classical tazzas create interest and relate to the wall, a beautiful separation between the rear garden and the neighboring house. Ivy climbs over molded panels, arched niches, pilasters, and pediments, which serve as background for garden sculptures. A lawn, bordered by luxuriant trees and shrubs, leads away from the street, culminating in the curve of a marble bench. Throughout the garden, sculptural details catch the eye, extending views out from the core of the house in many directions.

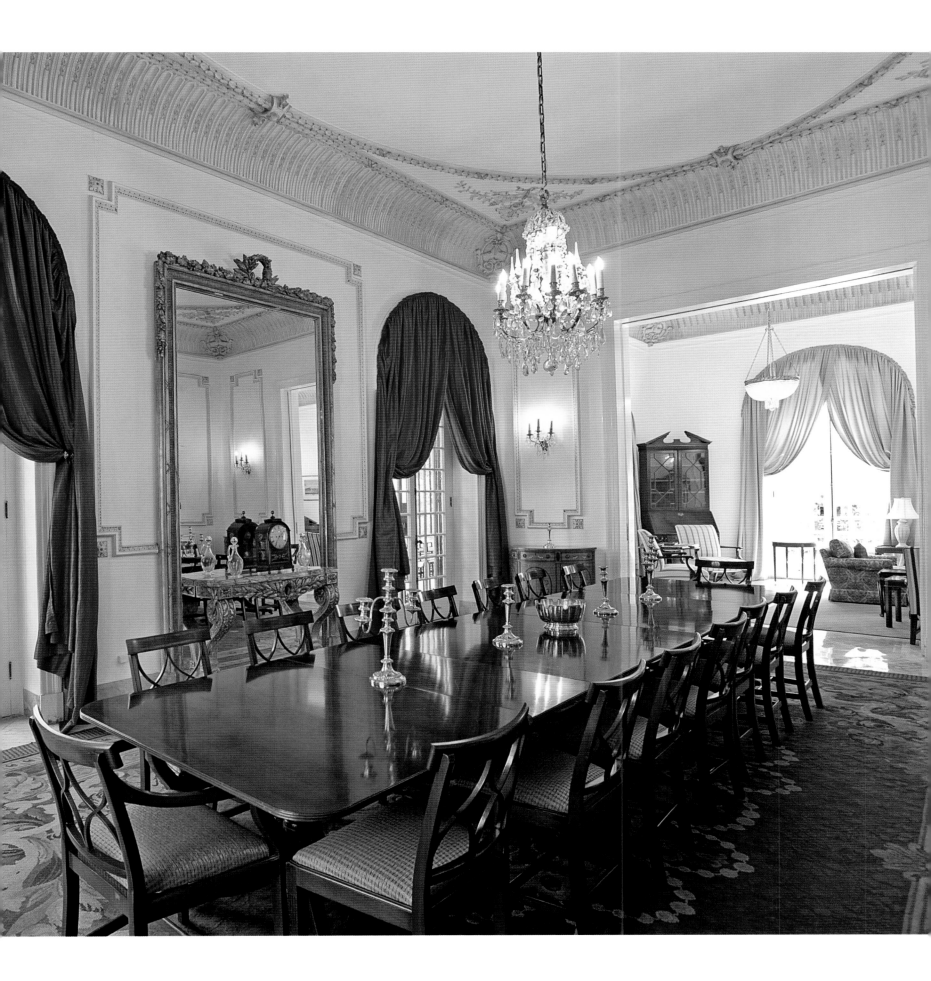

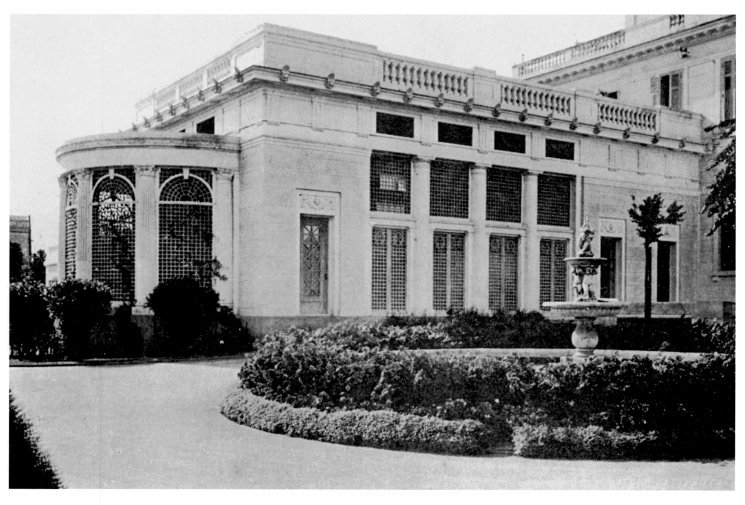

Overlooking the garden is one of the house's most successful—and clearly most popular—spaces: a colonnaded porch that is as large as the adjacent salon. Striped canvas awnings provide additional protection from the sun, just as they would have originally. They can be raised to allow views of the riot of tropical shrubs. Mosaic tile floors feel cool and appropriate for this indoor-outdoor space, as do a pair of trompe l'oeil lattice panels framing mirrors that have been hung above Louis XVI–style console tables.

Latticed glass walls between columns form the sides of the pool house, stained wood beams frame the glass ceiling, polychrome tiles define the floors—in each case there is a burst of natural or reflected light on these surfaces. Light streams in from all sides and reflects off the surface of the pool. The room is open to the elements while providing a complete sense of privacy. It is said that the space was added so the daughters of the family—five of whom went on to marry heirs to some of Cuba's most significant fortunes—could enjoy swimming with modesty. All the details of this space have been carefully considered, consistently reinforcing the overall design vision of the "Roman bath of the Mendozas," as it was known in its day. Following the theme of ancient Greece and Rome are the winged Nikes on stone shelves serving as wall sconces, the series of bronze chandeliers with mythological figures hanging from chains, and the carved wood ceiling beams, metal-strapped and subtly polychromed to suggest the construction of an ancient space.

The focal point of the room is a sculpture of Aphrodite crowned with bronze laurel leaves, at whose feet a dolphin gurgles water into the pool. Behind her an exedra with arched lattice panels set between columns is slightly reduced in scale in order to achieve the perfect theatrical perspective.

The pool house was added in 1918 by the American architect John H. Duncan, known as the designer of Grant's Tomb in New York City. Duncan also designed the clock tower on Fifth Avenue in Miramar, a new neighborhood being developed by Ramon G. Mendoza, among others.

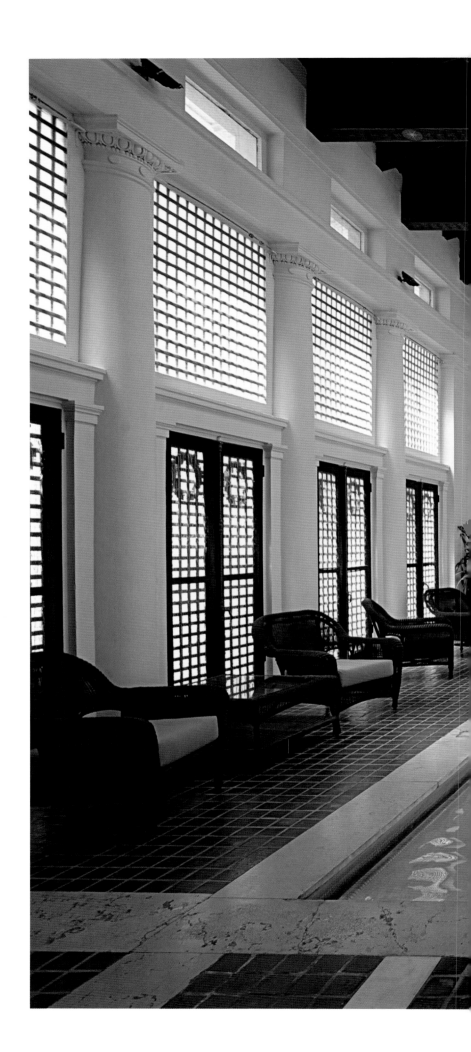

The pool house combines classical elements for a Caribbean setting with a statue of Aphrodite framed by a lattice niche. Hanging bronze lanterns and ornate iron strap-work and stenciled decoration evoke antiquity and the Renaissance.

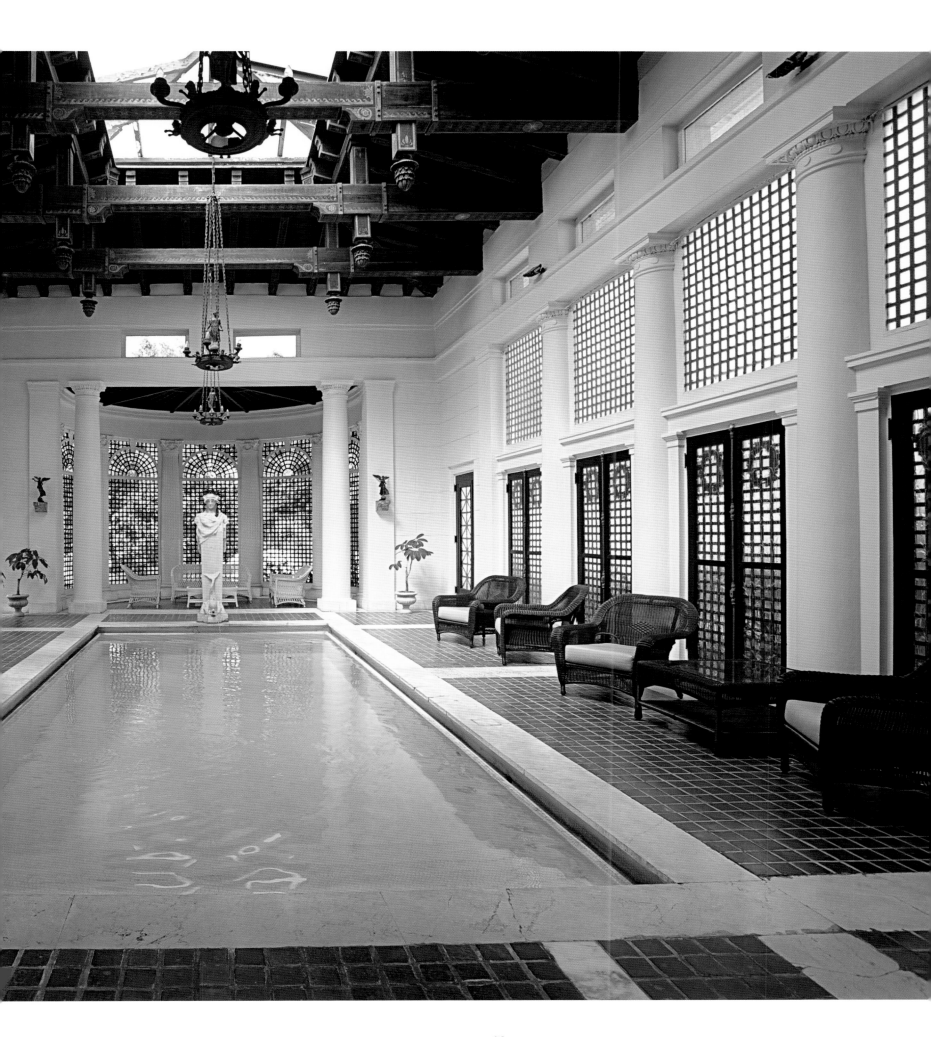

La Casa del Vedado

The Casa del Vedado on Twenty-third Street was built in 1921 by the merchant Manuel Campa Alvarez as a gift for his daughter Ángela on her marriage to José Rivón Alonso, a partner in the jewelry store Cuervo y Sobrinos. Today the Casa del Vedado is a house museum run by the Office of the Historian of the City of Havana. The building represents the smaller, simpler houses that went up in this subdivision at the same time that the mansions of sugar boom millionaires were constructed blocks away—demonstrating the way bursts of economic prosperity benefited many sectors of Cuban society. The Office of the Historian completely renovated the building, preserving as well as re-creating parts of the original structure. The furnishing of the interior was inspired by a storyboard of sorts, with the different spaces being reimagined based on what was known about the lives of the original occupants.

Period furniture and decorative arts have been gathered from a variety of sources and installed to tell the story of a middle-class professional family in El Vedado, the preferred neighborhood of Republican Havana in the 1920s. Architecturally, the Casa del Vedado demonstrates the transition from the traditional urban courtyard housing of the Spanish colonial period to the freestanding single-family house set within a garden.

As mandated by Vedado building codes, the house is separated from the sidewalk by a front garden just large enough for some shrubs and a bit of lawn, with the typical iron fence marking the property line. A few steps up from the garden, a front porch defined by a series of columns spans the full width of the house, separated from the street yet in complete visual contact with it. The wicker rocking chairs are reminders that family members all had their own seat here and that each evening they would read the paper, gossip, and monitor neighborhood activities. Twenty-third Street was one of Vedado's principal thoroughfares, home to shops, restaurants, cafés, and movie theaters, as well as residences.

Above: From the beginning El Vedado featured a mix of grand mansions next to more modest middle-class houses.

Opposite: The small front lawn in front of the house satisfied the setback required by the El Vedado building codes. At the right is the driveway leading to the carport.

The roof of the porch extends past the side of the house, forming a carport over the driveway, which leads back to the garage. Private car ownership brought new mobility that helped make suburban neighborhoods like Vedado and Miramar popular.

Architect José Rosello's design is representative of the exuberant eclecticism of the Republican era. The facade is a riot of cast-concrete ornamentation: fluted Corinthian columns support a frieze of seashells and ribbons, and a balustrade of geometric panels conceals the flat roof. The doors and windows, too, are framed in cast decoration, protected by ironwork and fitted with typical Cuban combinations of glass panels and wood louvers that temper the heat and sunlight.

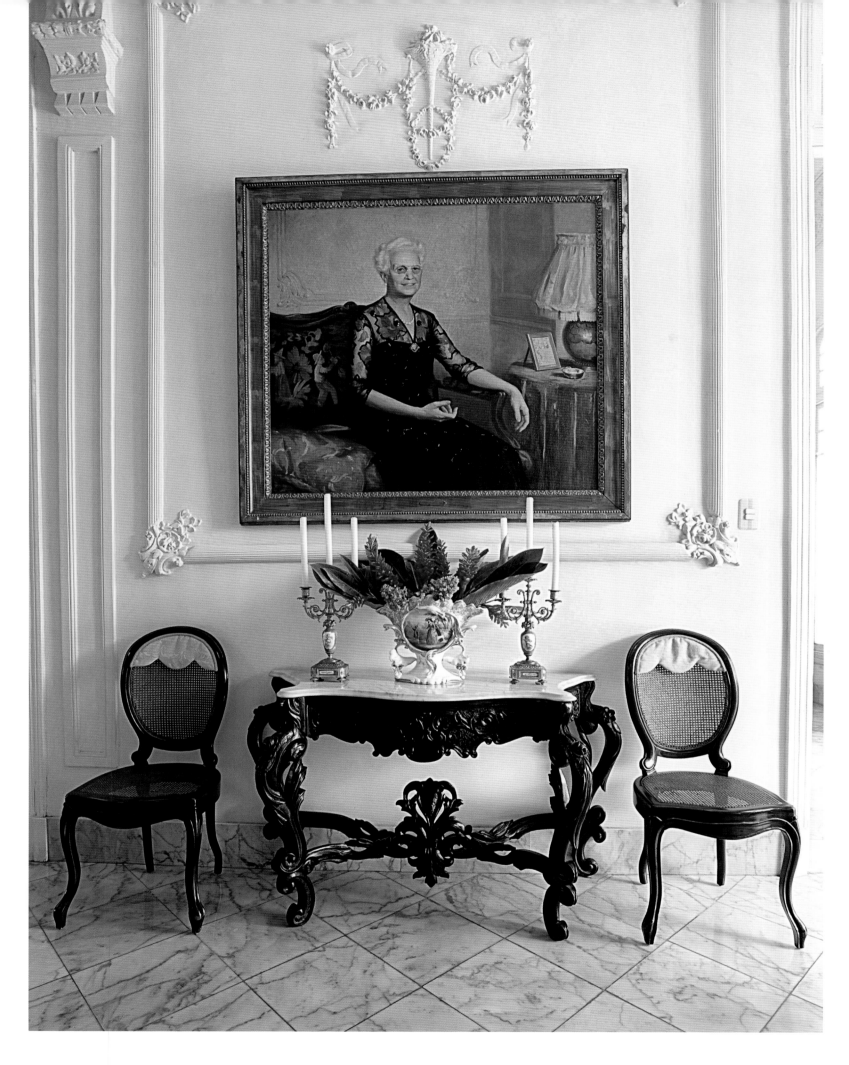

Opposite: In the front hall, a pair of side chairs flanks a console table—Cuban-made pieces from the 1860s.

Above: The public rooms are ornamented with plasterwork in an airy, rococo style, seen in the dining room ceiling and the panels in the front hall.

The varied ornamentation of the exterior continues inside. Applied plaster moldings create wall panels with floral accents, forming a coved ceiling cornice and supporting beams on fluted wall brackets. Scagliola columns, imitating marble, define the formal spaces, breaking them up without walls, which would impede airflow. This approach represents a continuation of traditional Cuban colonial building, as do the high ceilings, another feature that encourages air circulation.

The vestibule area is furnished with a nineteenth-century Cuban-made console table and side chairs in the rococo revival style, intended to suggest ancestral family pieces that were part of middle-class homes. A 1940s portrait of a beloved matriarch hangs above them, and nearby is a photograph of the prosperous family. Details such as these were included in the restoration to emphasize the connection between the house and its original owner-occupants.

As was characteristic of the era's middle-class and elite houses, a distinction was made in the Casa del Vedado between family living spaces and rooms for public display. Immediately adjacent to the vestibule is the *sala*, or parlor, where formal visits would take place. This official role is indicated by the Louis XVI–style gilded furniture. Just beyond is the *saleta*, the family sitting area, where intimate guests would be received. Four typically Cuban rocking chairs have been arranged in a circle here, as Cubans had been doing since the 1860s. The patriarch's office was installed at the front of the house, accessible from the vestibule, so business visitors could be directed there without having to linger in the family areas.

La Casa del Vedado also reveals changes in the development of the Cuban house—influenced, for example, by American houses, though adapted to Cuba's tropical climate. The center hall of Vedado houses is an American-inspired layout that replaced the traditional courtyard plan. Since Vedado's buildings were freestanding, their side walls could accommodate windows, so the central court was no longer required for ventilation. La Casa del Vedado's center hall is defined at either end by a dramatic pair of green columns, its walls are decorated with plaster panels, and the top is fitted with clerestory windows, bringing light into the core of the house. These windows can be opened to draw hot air out of the interior as the patio once did.

Bedrooms are placed on either side of the center hall, their doors opposite both each other and the windows in order to allow for cross ventilation. In addition, all bedrooms are interconnected by a second series of doors running from the front of the house to back, which also encourages airflow if all these doors are left open. The lack of privacy required in order to provide ventilation is something the Cuban family was used to. At the end of the series of bedrooms is the bathroom—a symbol of the new comforts to be found in Vedado's houses, thanks to imported American plumbing fixtures and to the new infrastructure (gas, electric, water, and sewer systems) that was provided in this new development.

The dining room is at the back of the building, as it often was in the colonial courtyard house. Its comparatively large size underscores the room's important role in the social life of the Republican family. The ornate wall decoration sets the scene for dinners celebrating birthdays,

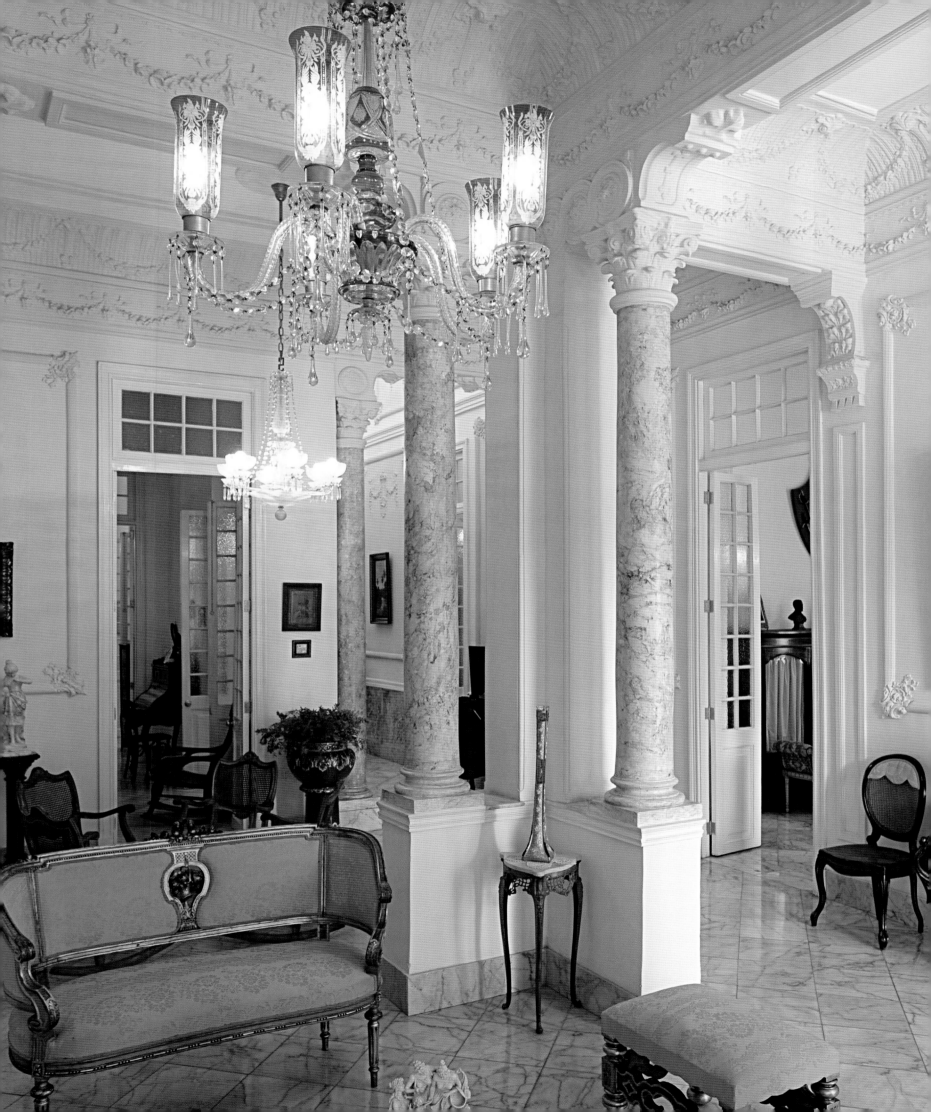

Opposite: Marbleized columns on plinths define formal and informal seating areas at the front of the house.

Right: A grouping of typical Cuban rocking chairs indicates the more informal seating favored by the family.

Below: Bedrooms were located on both sides of the center hall; these were interconnected to ensure additional ventilation.

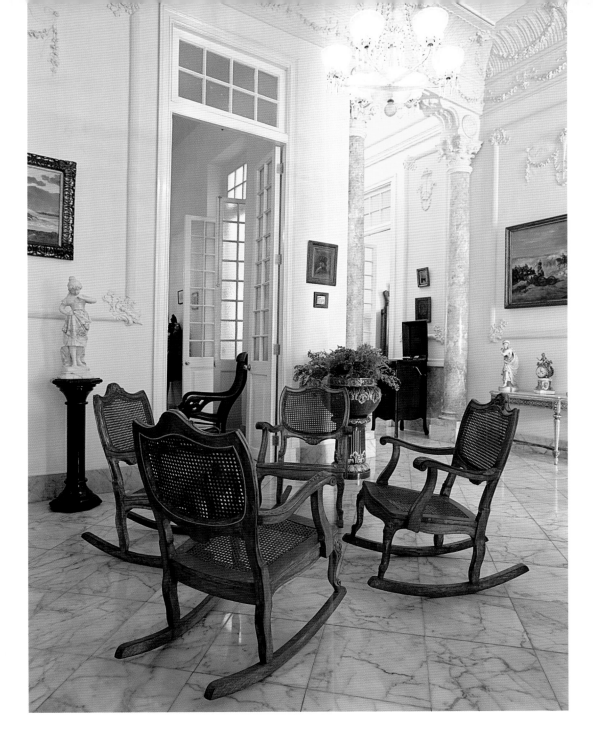

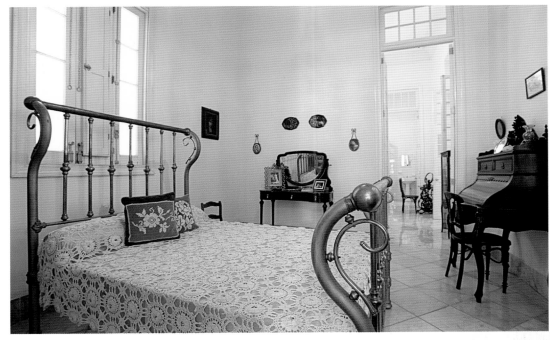

A collection of porcelain dinner plates bearing the monograms of socially significant Cuban families are displayed in the dining room as a sign of the owners' connections.

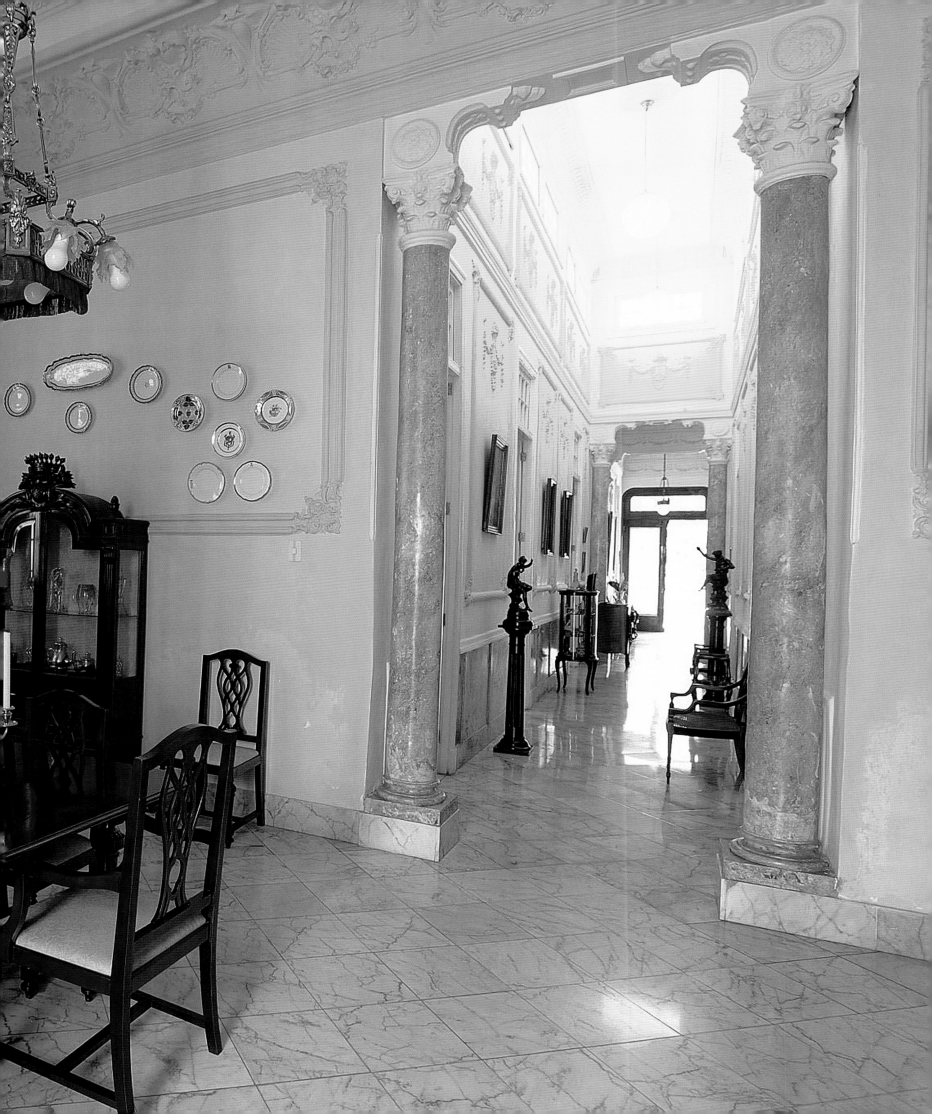

The garden with its beds of tropical flowers shaded by fruit trees and a charming gazebo was a center of family activity.

baptisms, and family weddings. Display cases are filled with glass and silver serving pieces central to these ceremonial family events. Cuban tradition has been observed in the installation of monogrammed porcelain dinner plates decorating the walls—pieces that were exchanged between families and displayed as a sign of social connection. The still life painting of avocados and citrus fruit had a symbolic meaning in the early twentieth century, its depiction of obviously Cuban fruit a representation of national identity. The simple kitchen features an American refrigerator, an amenity that would have asserted the up-to-dateness of this Cuban family at a time when U.S.-made consumer goods flooded the market and advertisements extolled the benefits of modern hygiene and American appliances.

The lush rear garden is a world of its own, shaded by mango and avocado trees, filled with beds of leafy ferns, bananas, and ginger, and enlivened by bougainvilleas climbing the neighboring walls. In the middle, a simple octagonal gazebo with a clay tile roof and plaster walls creates a cool place in which to enjoy the quiet.

The museum very successfully illustrates a transitional moment in Cuban home life when business concerns still overlapped with family life, home life was still connected to street life, and family members' privacy was still somewhat compromised by the need for ventilation.

Casa de Bernardo Solís

El Encanto, one of the most prestigious department stores in Latin America, began as a small fabric store in suburban Guanabacoa, across the Havana Bay. Started in 1888 by Spanish-born brothers Bernardo and Jose Solís Garcia, the elegant premises introduced Cubans to modern business practices like nonnegotiable prices and special promotions. By the late 1950s, El Encanto employed one thousand people, with three hundred of them working at the flagship store in Old Havana. A handful of provincial branches included one at the beach resort of Varadero. Full-time buyers in Paris, New York, and London connected the Cuban clientele to the latest worldwide trends. Christian Dior was among the designers who created special lines for El Encanto's customers, and he traveled to Havana for showings of his couture collection to an exclusive society audience. El Encanto also adapted European and American fashion to Cuban tastes at a more affordable price point. The company's approach to employee relations was revolutionary—publishing an employees' magazine, creating a social club for their use—fostering a loyalty that is evident to this day. El Encanto also showed a commitment to public service that made the company an integral part of the community; their efforts included hosting cultural conferences and sponsoring children's movie matinees, photography exhibits, and even a national literary prize. At a time when North American control of Cuba's top business was taken for granted, El Encanto's success was a national source of pride because the company was Cuban owned and operated.

Just as the newly rich sugar planters celebrated the boom times by building showy Vedado mansions, the capital's successful businessmen also built big houses to display their good fortune. The home that Bernardo Solís built in 1922 overlooks Vedado's Parque Villalón, with the Amadeo Roldán Theater across the way. Here, he lived with his wife, Maria Rita Alió, and their six children.

Typical of the Vedado neighborhood, the Solís house is set back from the sidewalk, behind an iron grille and landscaped front lawn. But the horizontality of this house, which occupies almost the entire length of the building site, has an American feeling to it. The house cascades down to the sidewalk—from the central tower down to the second-floor cornice, and from there to the balustrade of the ground-floor porch and then the iron grille. A repertoire of Beaux-Arts-style elements— classical columns, brackets, balusters, geometric friezes, and keystones—play against the smoothness of the facade.

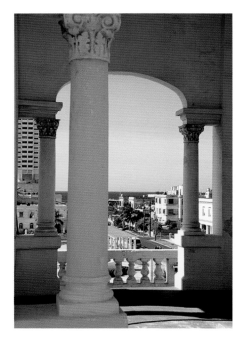

Above: The columns of a rooftop tower frame the view over the Parque Villalón to the sea beyond.

Opposite: As in many Vedado houses, iron gates defined the property line, providing a sense of privacy to the raised front porch while permitting a visual connection to the life of the community.

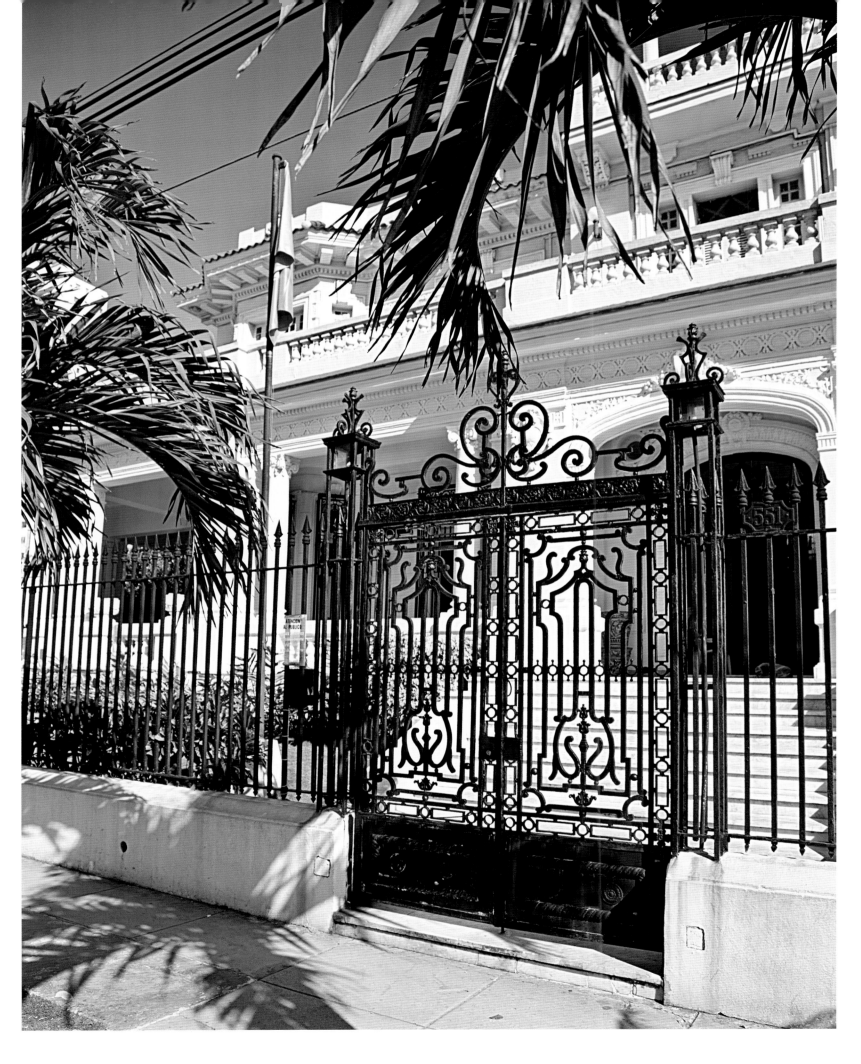

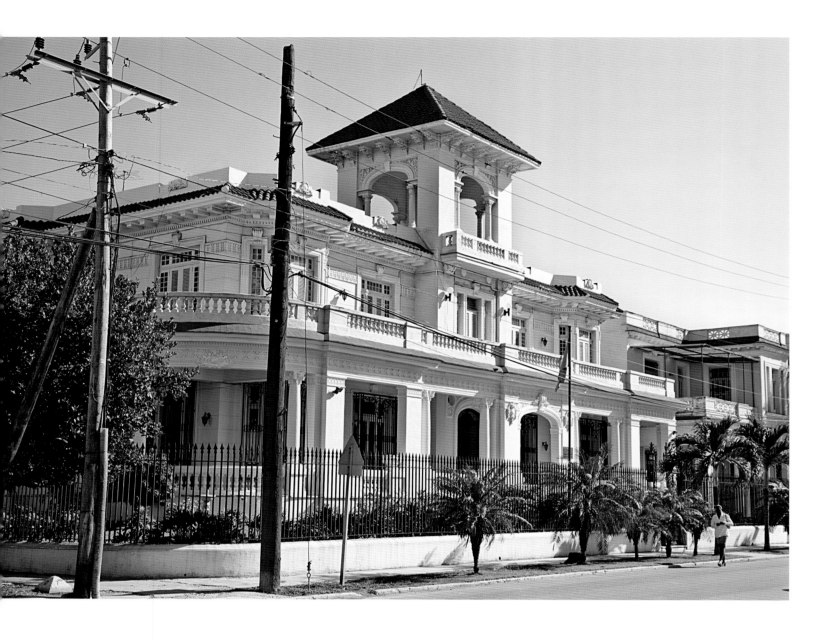

The deep porch serves as an outdoor room and wraps around the side of the house, acknowledging the corner lot—so desirable in Vedado. The porch also helps to keep the house cool and provides further privacy, as does the elevation of the building half a level above the street.

The interiors of the house reflect a Spanish influence in decoration—the result of Bernardo Solís's Asturian roots, of the fashionable Spanish style in architecture and decoration, and perhaps of the owner's access to El Encanto's international resources. The most dramatic space in the house is the stairwell with pale bronze railings, marble steps, and a colorful tile wainscot. Centered on the landing, as a focal point visible from the front door, is the traditional double-height stained-glass window, which features the coat of arms of Spain rather than those of the Solís family. A cartouche at the top proclaims 1922 as the construction date, and the signature at the bottom is that of J. H. Mauméjean, a prestigious glassmaker based in Madrid who supplied Havana churches and homes. Stained-glass skylights set in the delicate coffered ceiling complete the decoration of the space. With daylight entering the stairwell from so many sources and the play of light reflected by the materials, the effect is memorable.

Above: La Casa de Bernardo Solís occupies a coveted corner lot, which accommodates a side garden and provides two exposures to the sea breezes.

Opposite: The walls of the stairwell are painted to resemble stone blocks, while stained-glass windows and skylights illuminate the pale bronze railings and the wainscot of glazed *azulejo* tiles.

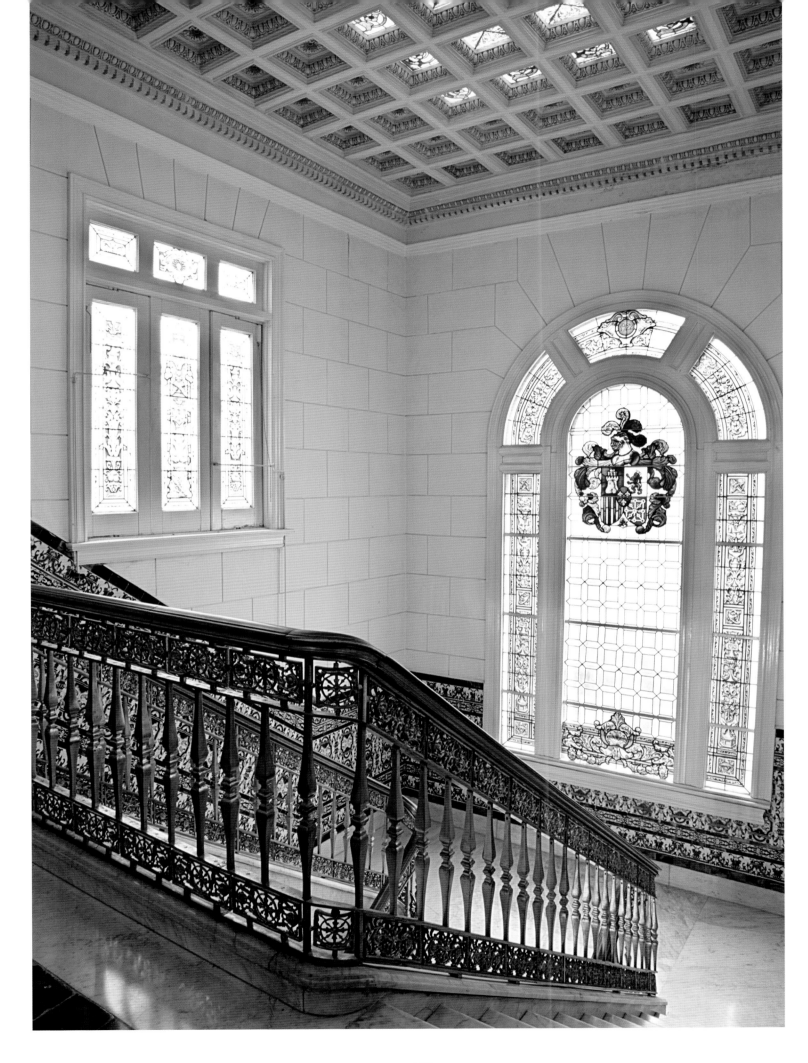

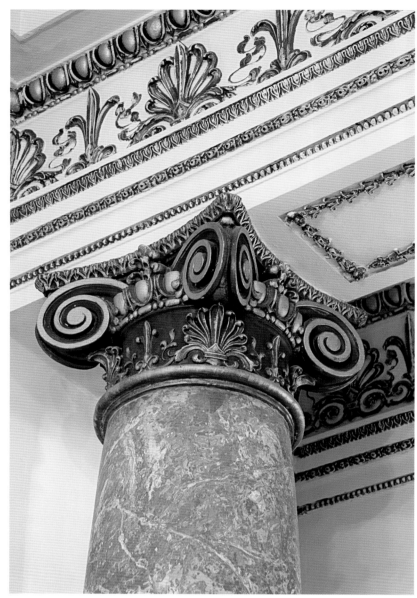

The Empire-style dining room is distinguished by the stained wood doors and wainscot panel-ing. A pair of marbleized columns impart a grandeur to the room and delineate a separate zone within it that perhaps was originally used for informal family dining. The column capitals sport anthemia, stylized ancient Greek honeysuckle flowers, which is a signature of the French Empire style. Beautiful stained-glass windows display motifs of abundance—fruits and flower garlands—as well as classical palmettes and more anthemia. The stained wood dining chairs as well as the paneling are decorated with delicate gilt-bronze details, including the head of a mythological sun god.

The formal dining room has its equivalent in the French rococo–style salon, which is decorated with plaster moldings defining a series of wall panels. Above the doors, painted panels depict scenes of flirtation and romance in the manner of eighteenth-century French painters François Boucher or Jean-Honoré Fragonard. The feminine feeling of the room is reinforced by the glit-tering crystal chandelier, the mirror panels of the sliding doors, the gilded vitrine, and the side chairs in an adaptation of the Louis XV style.

The Empire-style dining room is decorated with rich wood panel-ing, gilded cornice moldings, and marbleized columns with ornate Ionic capitals. Stained-glass windows provide both visual interest and privacy.

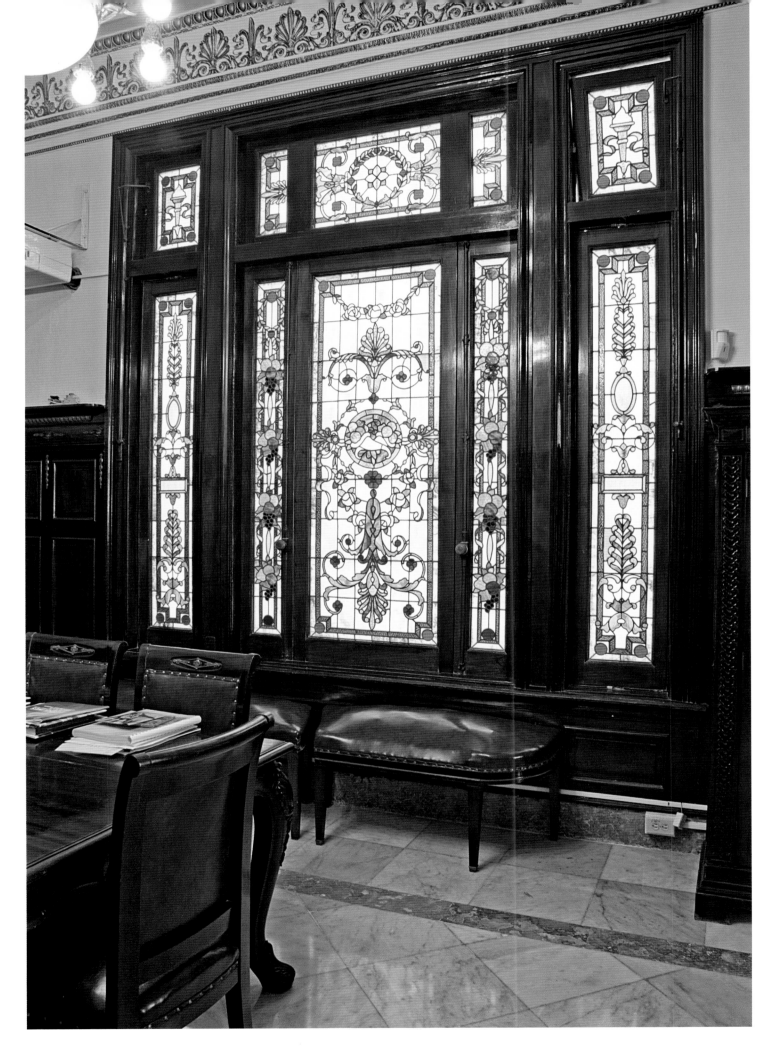

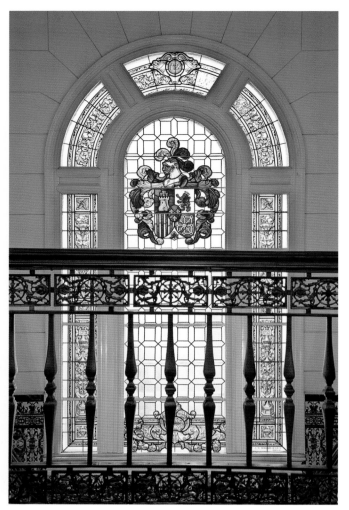

The front hall celebrates the Spanish origins of the Solís family with its wainscot of glazed Andalusian tiles anchoring walls that imitate blocks of stone. The doorways are cased in unusual, rough-textured, terra-cotta moldings in a Spanish Plateresque style. The same material is used for the brackets and beams of the ceiling, which are painted to resemble wood grain. The *pièce de résistance* of the hall is the Spanish tiled floor, designed to suggest a carpet that has been laid in the space, an illusion reinforced by the fringe design that borders the room. Spanish-style carved wood chairs, dark and heavy, line the walls, their leather seats and backs decorated with heraldic paintings and bronze nails. Throughout the house, elements of the Spanish-style decoration have survived: large ceramic jars, decorated plates, ironwork lighting, and a tiled panel depicting a famous Velázquez painting. One imagines other pieces that might have been part of the original decoration: "ancient" Spanish furniture, an old copper brazier, armor recalling the conquistadors' exploits, paintings of Spanish dancers, a carpet from the Real Fábrica de Madrid, or a collection of painted fans in the salon's vitrine.

The winter garden is a rare survivor of a room type that was once very popular in Havana's great houses. The walls of this indoor-outdoor space are decorated with lattice arches, panels, and pilasters framing mirrors that reflect the decoration and landscape beyond. A geometric design embellishes the cool marble floor, an ornate iron-and-glass door connects to the garden, and an iron chandelier of art deco inspiration lights the room. It is

Above left: Mirrored door panels, a crystal chandelier, and a gilded vitrine convey a French lightness and femininity in the formal salon.

Above right: The stained-glass window in the stairwell features the coat of arms of Spain.

Opposite: The Spanish style of the front hall is evoked by the tiled floor and wainscot, the terra-cotta door casings and ceiling beams, the wrought-iron chandelier and the carved suite of Spanish Renaissance–style hall chairs.

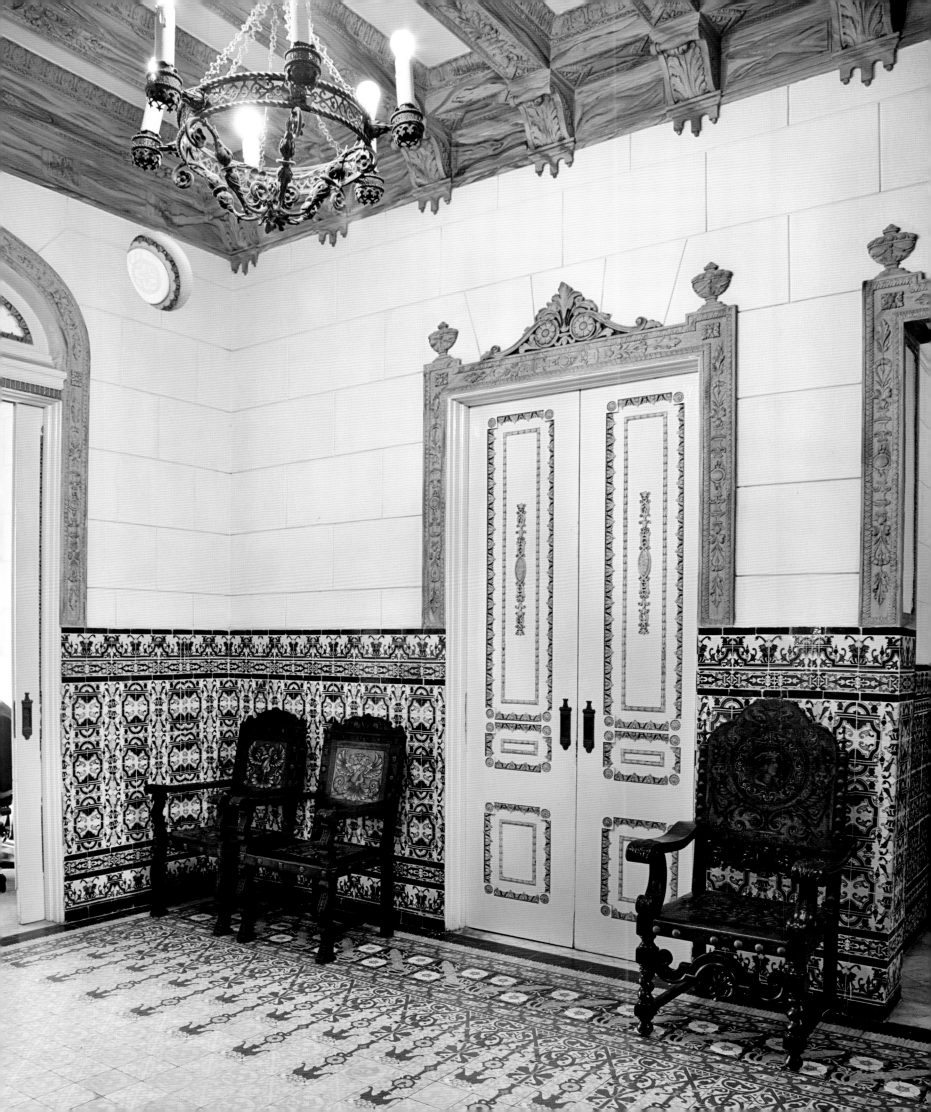

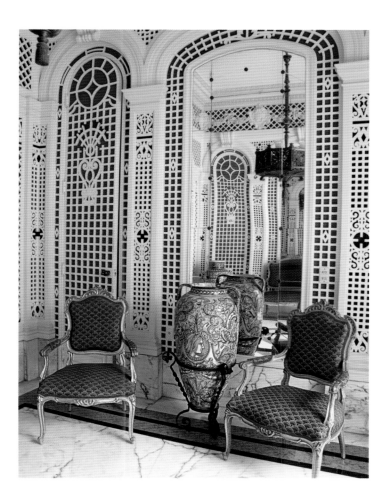

In the winter garden, intricate lattice frames mirror panels while ornate iron-and-glass doors connect the space to the outdoors. A Spanish ceramic jar is centered between a pair of Louis XV–style giltwood chairs.

easy to imagine this intimately scaled space in its day, filled with potted palms and wicker rocking chairs—clearly a room where the family enjoyed garden breezes in privacy. It has been said that the lattice features a stylized radiating sun motif (*sol*) as well as fleur-de-lis (*lis*) decoration, a play on the family name of Solís (*sol* + *lis*). Perhaps this also relates to the dining room's sun god and the Greek honeysuckle flower.

Solís's architects, Facundo Guanche and Enrique Gil, paid careful attention to the garden, designing it to be viewed from various vantage points. At the base of the steps and centered on the lattice room is the geometric basin of a fountain supporting a marble nymph. To one side is the curve of a stone colonnade supporting carved wood beams and a clay tile roof—a theatrical background for the nymph. The colonnade draws attention away from the service wing it conceals. In a similar spirit, the adjacent neighbor's house has been obscured by a low garden wall with a tile roof on wood brackets, pilasters, and carved balusters. Within the limited space of a Vedado building lot the designers accomplished a series of theatrical effects. These might be due to the influence of Gil, a specialist in theater construction, who had built the El Encanto movie theater for Mrs. Solís. Guanche was known as the architect for El Encanto's owners, designing shops, warehouses, and houses for them.

The house has been carefully restored and today is the headquarters for UNESCO in the Caribbean.

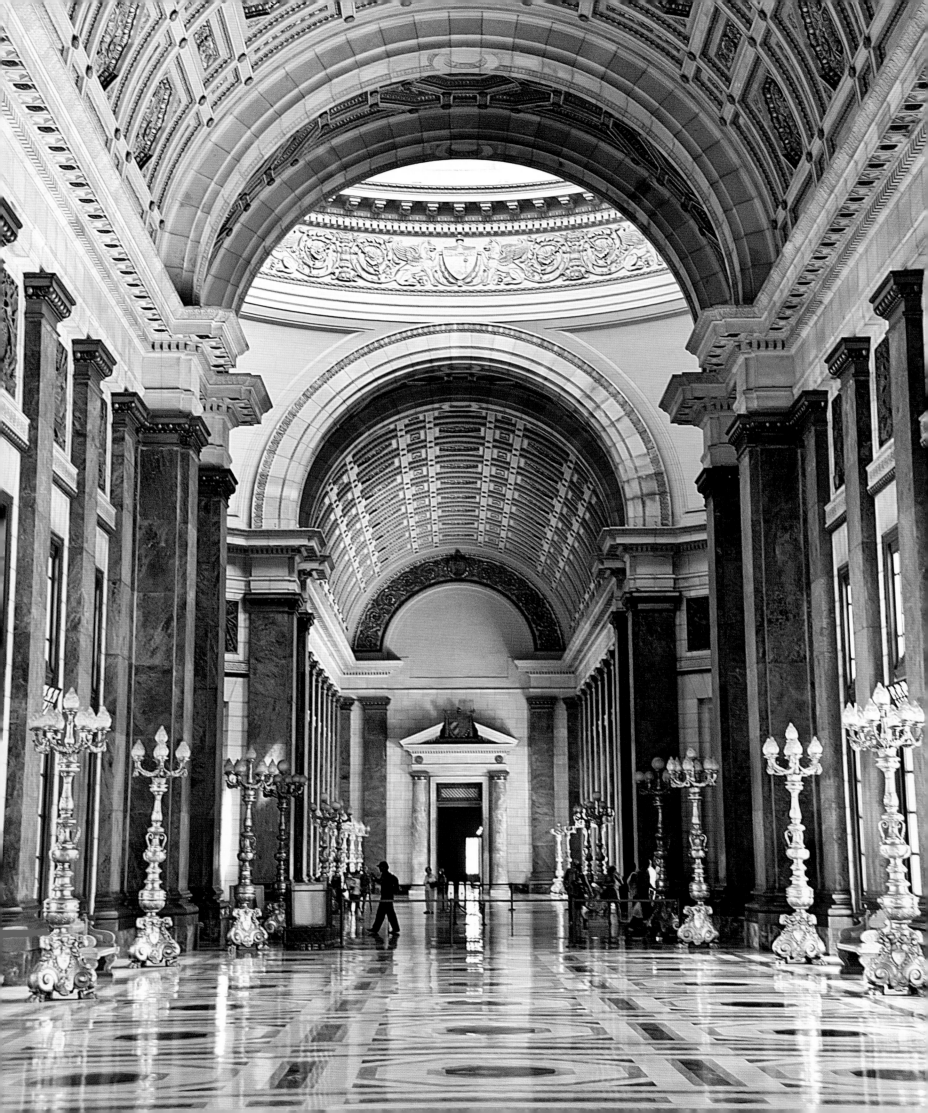

National Identity Through Public Works and Private Enterprise

Above: Auditorium of the Sociedad Pro-Arte Musical, known today as the Teatro Amadeo Roldán.

Opposite: The *Salon de los Pasos Perdidos* is one of a pair of ornately decorated, vaulted galleries in the National Capitol.

The year 1920 was one of extremes in Cuba: it brought the highest price ever paid for the island's sugar and a run on the banking system that resulted in a national financial crisis. The suicide—or murder—of "Pote," the unscrupulous vice president of the National Bank of Cuba, who thought himself ruined but left an estate of $14 million, confirms the highly charged atmosphere of the sugar boom. American banks took over a number of overextended sugar mills, and Cuba survived the financial crisis largely due to a $50 million loan from J. P. Morgan & Company. These "Yanqui" investments ensured a further consolidation of American control of Cuba's economy.

The unprecedented prosperity of the post–World War I period unleashed the building boom that produced the Vedado mansions and funded the construction of grand public structures. No other Latin American nation had the financial means to undertake the ambitious public works that were to be a source of great national pride and were seen as integral to Havana's standing as a world capital. During the 1920s, Havana acquired a new concert hall, a university acropolis, and both a National Capitol and a Presidential Palace.

Left: Stone benches with bronze lamps and other ornaments ground the canopy of trees in the raised pedestrian median at the center of Forestier's design for the Paseo del Prado.

Right: President and Mrs. Calvin Coolidge join the Cuban president and Mrs. Gerardo Machado in Havana for the 1928 Panamerican Conference.

Below: The National Capitol, based on the Washington prototype, was the culmination of Forestier's urban landscape designs.

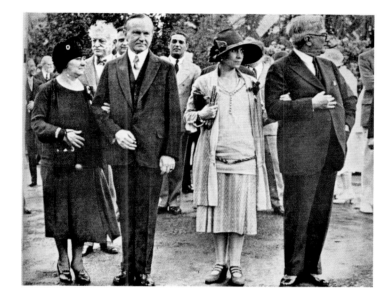

Gerardo Machado's presidency (1925–33) was marked by repressive measures as well as a national public works program. Secretary of Public Works Carlos Miguel de Cespedes would be known as the "tropical Haussmann" for bringing to Havana the French landscape designer Jean-Claude Nicolas Forestier to complete a network of *paseos*, parks, and urban spaces that reinforced the monumental image of a capital the world could admire. His designs linked together monuments and major public buildings, creating an appropriate context for them that responded to Havana's topography. Forestier celebrated the city's oceanfront location, emphasizing the importance of the port as the arrival point for visitors.

President Machado showed off his international capital in 1928, when Havana hosted the VI Panamerican Conference welcoming President Calvin Coolidge and a group of Latin American heads of state. Although Machado had just been reelected in defiance of the constitution's term limits, the city made such a good impression that J. P. Morgan & Company loaned the nation an additional $9 million. A year later, Chase National Bank donated $50 million toward the further implementation of Forestier's urban beautification plan for the city.

The domed National Capitol building and the Presidential Palace occupied principal roles in Forestier's vision. El Capitolio was brazenly modeled on the United States Capitol Building. It is a beautiful example of Beaux-Arts architecture and quickly became a symbol of the city. Now the Museum of the Revolution, the Presidential Palace has a distinctive dome and vast

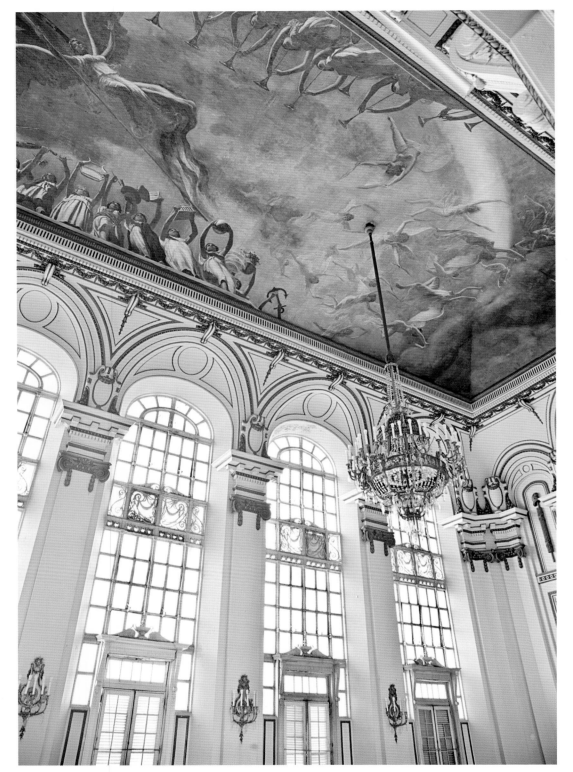

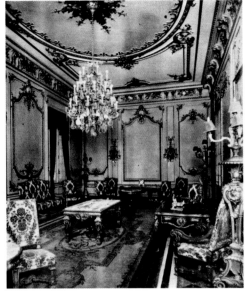

Left: The ceiling of the Hall of Mirrors at the Presidential Palace was decorated with allegorical murals by Cuban painter Armando Menocal in 1920.

Above: The Senate president's office was one of a series of richly furnished rooms in the National Capitol decorated in European historical styles.

Opposite: The dramatic marble staircase at the core of the Presidential Palace is a monumental interpretation of a colonial patio.

walls of glass, which illuminate the grand public spaces decorated by Tiffany Studios. Allegorical murals by Cuba's best painters celebrate the island's status and identity. A monumental staircase led to the vast Ambassador's Hall; state dinners took place in a beautifully paneled French neoclassical–style dining room; the President's Office featured Empire-style mahogany furniture. A balcony accommodated public appearances and overlooked another of Forestier's parks, which led to the oceanfront Malecón.

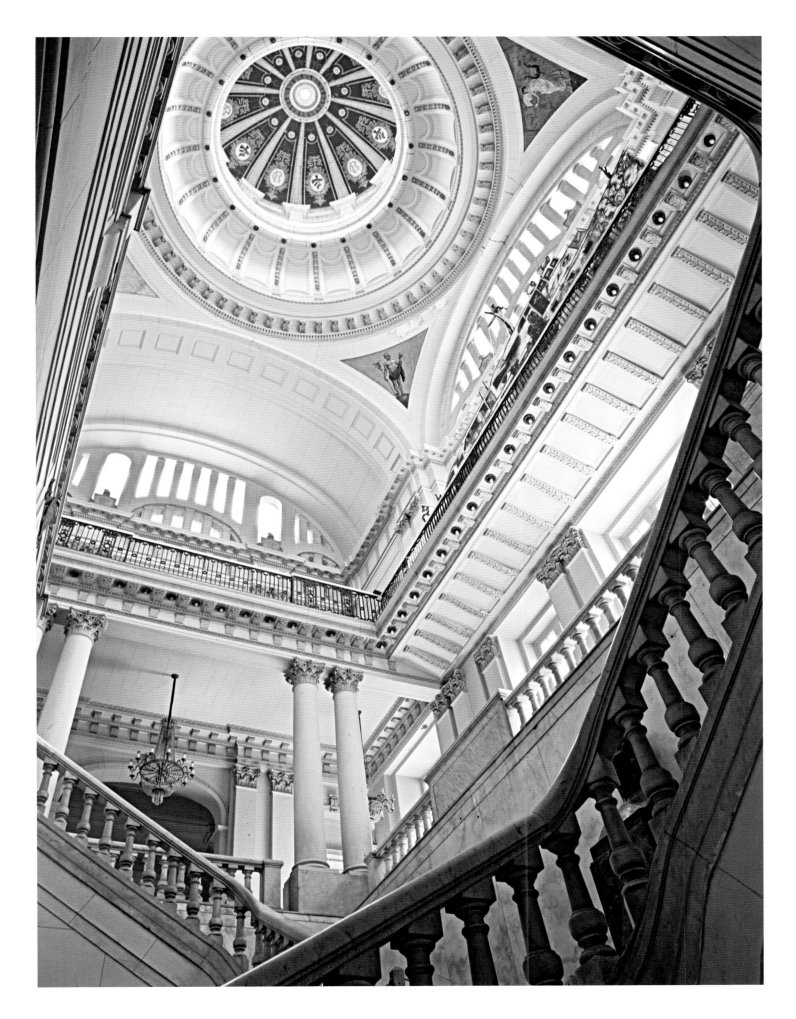

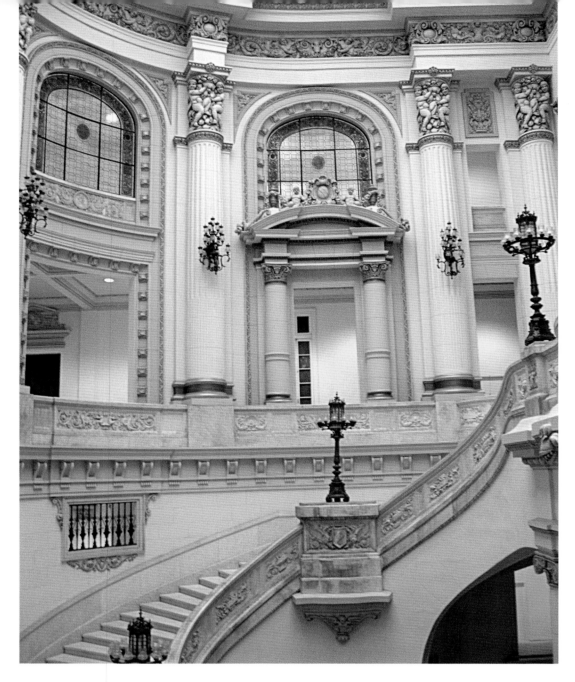

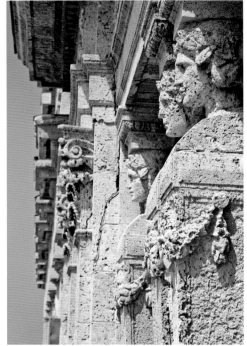

Left: The theatrical sweep and florid detailing of the staircase of Centro Asturiano clubhouse, built for Spanish immigrants, contrast with the restrained classicism of the Union Club interiors, intended to convey the prestige of the patrician membership.

Above: The Jaimanitas stone caryatids supporting the loggia of the Union Club are a symbol of the oceanfront Malecón.

The original building of the prestigious Vedado Tennis Club was renovated during the sugar boom to convey grandeur and prosperity.

Havana's social clubs built grand new clubhouses during the boom times. The aristocratic Vedado Tennis Club was given a makeover that included new ceremonial stairs, grand banquet spaces, and a glamorous décor to better express the membership's lineage and prosperity. The high standards of this renovation became a checklist of amenities for other club facilities. On the oceanfront Malecón, the Union Club built new facilities. While most of the city's clubs were organized around a sporting activity or a Spanish regional affiliation, the Union Club was an exclusive all-male society on the English model. Architect Evelio Govantes won the design competition—one of many held during the boom—and created a structure whose caryatid-supported loggia overlooking the ocean has become a Havana landmark. In 1927 the Centro Asturiano, a regional Spanish beneficence society, built a luxurious clubhouse on the Prado, asserting a connection to the mother country by their choice of architectural style. The massive, marble-clad, Spanish baroque and Plateresque-style building overlooks the Parque Central and sits across the Prado from the rival Centro Gallego.

The Miami tourism and building boom of the 1920s came abruptly to a stop with the destruction caused by the 1926 hurricane. The storm bypassed Cuba, and American tourists headed to Havana, enjoying the modern hotels, casinos, racetracks, and bathing establishments that were built to receive them. Many of these facilities went up along the Marianao coastline, located between the western suburbs of Miramar and the Country Club Estates. The new facilities were often designed in a playful, sometimes ersatz, Spanish colonial and Mediterranean

style that had worked so well in Florida and California to convey an exoticism that was part of the allure of a holiday. In Cuba, the exotic was a reality for the visitor. Dressing the tourist experience up in an elaborate architectural style only made the sense of escape of a Cuban vacation even stronger. However, in Cuba the style had a deeper significance, as it represented the historic architecture of the island's colonial past. Explorations of this architectural style were integral to the Cuban design community's constant search for a national design identity. Thus the motifs were not used exclusively to entice foreign guests; they were also celebrated as part of the Cuban heritage.

Moenck y Quintana's Havana Biltmore Yacht and Country Club (1927) dressed an American-style beach club up in colonial revival architecture. The front facade welcomes visitors with a play of shaded arcades against stucco walls, sloping clay tile roofs, and scrolling Spanish Renaissance decorations. Stone colonnades charmingly frame the view to the palm trees, white sand, and blue water. The Biltmore was the newest of Havana's exclusive membership clubs, known as the Big Five, which included the Vedado Tennis Club (El Tennis), the Havana Yacht Club (El Yacht), the Miramar Yacht Club, and the Casino Espanol.

La Concha Bathhouse was one of several bathing establishments open to the paying public near the amusement parks, dance halls, and restaurants of Marianao Beach. John Bowman, a larger-than-life American entrepreneur, hired New York hotel architects Schultze & Weaver and Cuban designer Francisco Centurion to lay out the facilities around courtyards connected by shady arcades. Period photographs show La Concha with its neighbors, the classically updated grande dame of El Yacht and the art deco–style Casino Espanol—three architectural styles along a short stretch of Havana beachfront.

Top left: A tea dance on the ocean-front terrace of the exclusive Havana Yacht Club.

Top right: Hollywood celebrated Cuban romance and exoticism in *Week-end in Havana*, incongruously starring Brazilian singer Carmen Miranda.

Above: *Social's* editor and celebrated caricaturist Conrado W. Massaguer created this iconic image encouraging North American tourists to enjoy the island's pleasures.

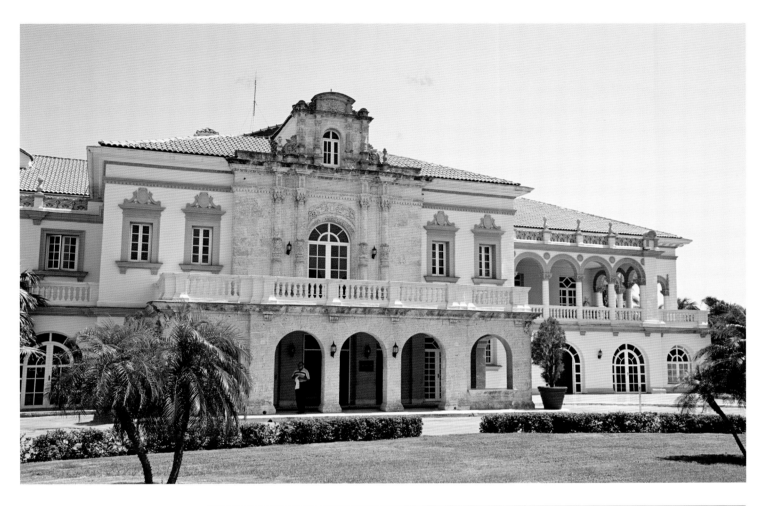

Above: The garden front of the Spanish-style Havana Biltmore Yacht and Country Club combines areas of carved Jaimanitas stone played against stucco walls, painted decorations, and sloping clay tile roofs.

Left: Italian Renaissance–style towers anchor the entrance facade of the La Concha Bathhouse, one of the many amusements developed for tourists along the Marianao oceanfront.

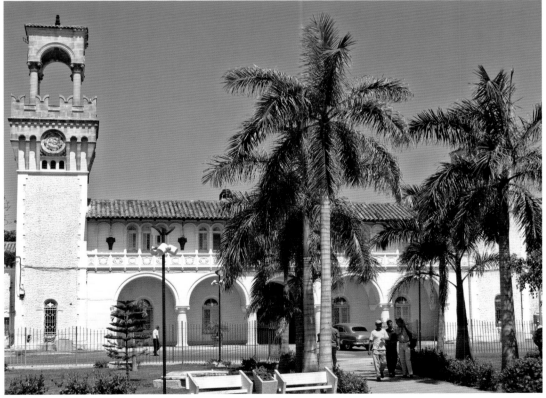

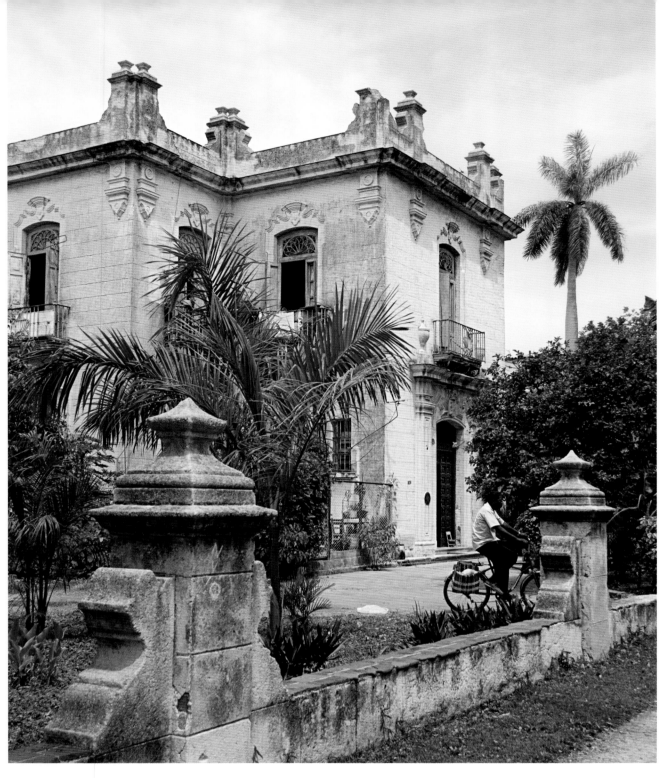

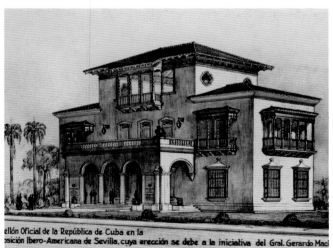

ellón Oficial de la República de Cuba en la
osición Ibero-Americana de Sevilla, cuya erección se debe a la iniciativa del Gral. Gerardo Mac...

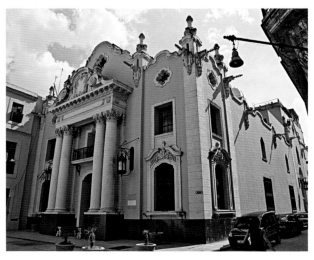

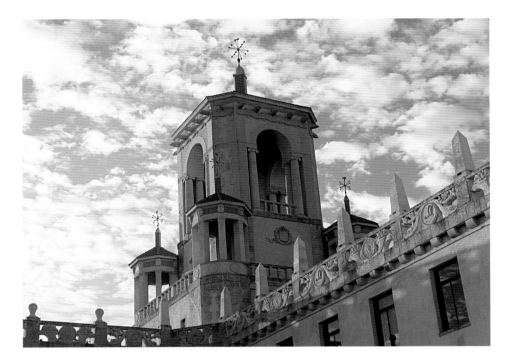

THE NATIONAL HOTEL
OF CUBA, HAVANA

Above: Art deco inflections are visible in the rooftop of the Hotel Nacional de Cuba.

Opposite top: The house of the Countess of Buenavista overlooking Miramar's Fifth Avenue references Havana's historic buildings in an early revival of Spanish colonial architecture.

Opposite below left: Cuba Pavilion at the Ibero-American Exposition in Seville, designed by Govantes y Cabarrocas, was seen as a modern interpretation of the Cuban colonial style.

Opposite below right: The Banco de Comercio in Old Havana is an imaginative remodeling of an eighteenth-century church as a bank building in a Mexican baroque vocabulary.

Starting in the late 1920s the Spanish colonial style became popular for residential construction just as it had in the southern and western United States. One of the earliest examples was Xanadu, the beachfront pleasure palace designed in 1927 by Govantes y Cabarrocas for American millionaire Irenée du Pont. The mansion dominated a rocky promontory overlooking miles of white sand beaches in the as-yet-undeveloped resort of Varadero.

In suburban Miramar, the 1928 house of the Countess of Buenavista is another early residential example of the neocolonial style. Architect Leonard Morales centered the family's coat of arms over a generous porch overlooking Fifth Avenue. Architectural "quotations" from specific colonial palaces— Palacio del Segundo Cabo and the Capitanes Generales—proclaim the builder's aristocratic lineage. Here is architecture as an exploration of personal and national identity— in a way that the use of American-style Beaux-Arts classicism was not. Enough time seems to have elapsed since the fierce fight for freedom from Spain to allow the embrace of the mother country's artistic heritage.

The Spanish colonial style worked equally well in commercial buildings downtown. Mexican architect Rafael Goyeneche renovated an eighteenth-century colonial church as the Banco de Comercio, drawing on the baroque style of Mexican churches. Scrolling parapets resemble waves at the skyline and are interrupted by the vertical thrust of pilasters capped in ornately decorated urns. The entrance is marked by huge pairs of columns supporting the most baroque of swans-neck pediments. The bank's interior layout retained the central nave and two side aisles, ironically culminating in a walk-in safe where the altar would have been.

The Spanish colonial style was appropriately used for the Hotel Nacional de Cuba, the nation's premier tourist facility, which opened on New Year's Day 1930 on a spectacular Vedado site overlooking the ocean. New York architect Lawrence Grant White of the famous firm McKim, Mead & White used a Spanish style to celebrate Cuba's past and to express the nation's identity. However, the style is given a slight art deco inflection as the building looks to the future, introducing a style that would be popular in the coming years.

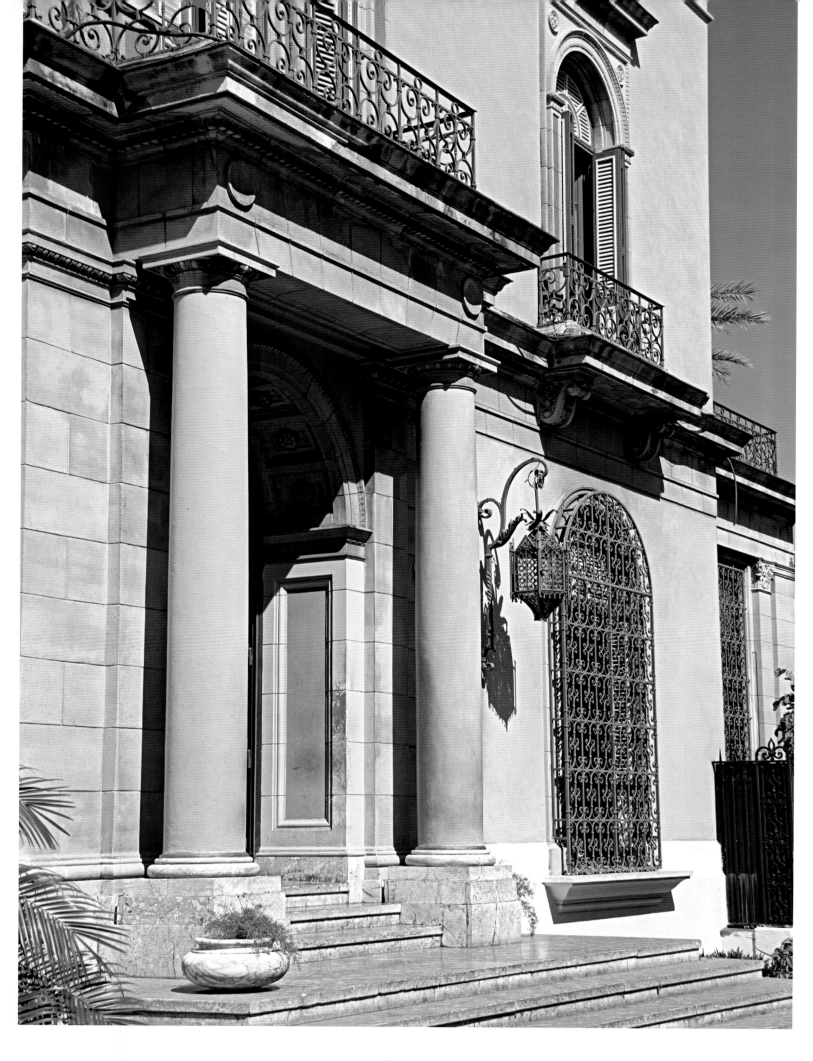

Casa de Catalina Lasa y Juan de Pedro Baró

Above: The alabaster bowl and gilt-bronze floral motifs of this sconce play off the rose-colored stucco walls of Catalina Lasa's bedroom.

Opposite: Polished marble detailing and lacy iron lanterns, window grilles, and balcony railings enliven the sobriety of the Renaissance exterior.

Catalina Lasa y del Rio was acclaimed as the most beautiful woman of her generation in Havana. She came from the right background and in 1898 married Pedro Estévez Abreu, son of millionaire philanthropist Marta Abreu, beloved for bankrolling the fight for Cuban independence. In 1906 Catalina and her husband built a beautiful house on the fashionable Paseo del Prado, designed in the Beaux-Arts style by New York City architect Charles B. Brun. Then everything came apart—or began happening—when Catalina met wealthy sugar planter Juan de Pedro Baró. The affair they initiated became a Havana legend, giving rise to tales of the couple being hounded by detectives at their Hotel Inglaterra love nest or finding themselves alone in a Havana theater after the disapproving audience left the house one by one.

Catalina's husband, whose father had just served as Cuba's first vice president, could not bear the insult to his honor. He forced her to leave their townhouse, forbidding her access to their three children. Catalina fled to Paris and into Juan de Pedro's arms. They lived together while they awaited a papal annulment of their marriages, which they received in 1917, and they were married in Venice. In their enormous Paris apartment, they entertained the crème of European society, often serving "exotic" Cuban dishes. They made their lives in that city for years, yet Havana still beckoned. The city that had treated them so shabbily exerted the same pull it has had over generations of exiles.

After taking short trips to Havana sometime in the early 1920s to test the waters, the couple commissioned a house from society architects Evelio Govantes and Félix Cabarrocas, with the owner's identity to remain a secret. The beautifully detailed, Florentine Renaissance style of their Vedado house is representative of the eclectic good taste of the upper class of the 1920s. The exterior, so consistent in its design elements, suggests conformity to the conservative life the couple had been forced to lead in Havana in the past. One might say that it was inside that their true natures and their legendary passion were reflected. The highly personalized, art deco interiors reflected the Parisian sophistication of their current lives and would be the setting for their triumphant return to their clans. The magazine *Social* called the house "the palace of an enchanted princess, or of an enchanting princess, who is Catalina."

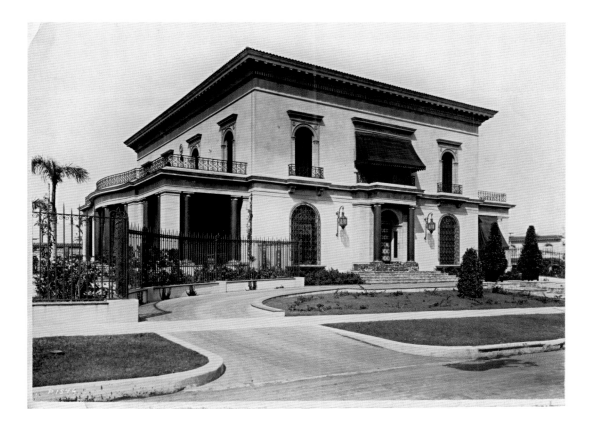

To decorate the house, Catalina and Juan employed Parisian designers who had enjoyed great success at the 1925 Exposition Internationale des Arts Décoratifs et Industriels Modernes— René Lalique, the design duo Dominique (Andre Domin and Marcel Genevriere), and Baguès—thus transporting to Havana the top practitioners of the latest international design trend. Their 1926 housewarming was controversial, but invitations were vied for—the opportunity to see the storied couple in their "modern" house.

Surprisingly for a house that is traditional on the outside and modern inside, the interior design relies for its impact on the use of a limited set of building materials. Moments of concentrated intricacy are played against expanses of simplicity. Although the original furniture is gone, the interior architecture has survived unchanged, revealing the coherence the designers achieved throughout the house. The extravagant base of richly veined red Languedoc marble on which the house appears to rest furthers that coherence, unifying the interior and exterior as it extends outdoors to form the porch paving, steps, and column bases.

Once inside a small vestibule introduces some of the design themes of the interior decoration, including marble floors in boldly contrasting colors and buff stucco walls decorated to imitate blocks of stone. Dominique was said to have brought sand from the Nile River to create the stucco walls and the hall's vaguely Egyptian columns. Arched openings leading to the library, the salon, and the dining room are fitted with decorative iron transoms by Parisian master metalworker Baguès, above polished Cuban mahogany doors. Throughout the house, the overdoors are decorated with geometric designs that often center on the couple's intertwined initials. French art deco lighting fixtures, like the bronze sconces in the halls, provided another opportunity to ornament otherwise simple spaces.

Far left: In the dining room, a French hammered-iron light fixture features one of several rose motifs associated with Catalina that are found throughout the house.

Left: Etched glass transoms in a geometric art deco pattern above decorative iron grilles create a transition between the dining room and the gardens outside.

Opposite: Mirrored niches above the dining room consoles displayed Catalina's collection of delicate glass flowers from the House of Chanel; a mirrored plateau set into the marble dining table highlighted the floral centerpieces.

The dining room is so skillfully designed that, no matter how inappropriate the current furniture, visitors are awestruck. Light pours in and is reflected by the room's materials. The split-level space begins with the formal dining area, a huge marble table anchoring the gold and cream marble and stucco space. Built-in marble consoles sit beneath corner niches, above which are backlit glass transoms with art deco floral motifs. These transoms are also found at the heads of windows. The original dining chairs—designed by Catalina's son Luis Estévez Lasa in an Empire style—remain, giving a sense of the original decoration. Marble steps lead up to a conservatory space, where the walls are sheathed in sheets of pale green glass and a fountain sits in the center of the shimmering silver and turquoise mosaic floor. The geometric glass faux-skylight ceiling was originally backlit, which furthered the impression of being outside. This early use of built-in lighting allowed the interiors to retain their simple, clean lines.

The outdoor spaces of the house were as carefully thought out as the interiors. The sun porch is an intimately scaled, domed space decorated with geometric lattice on the walls and ceiling. Vintage photographs show plants and flowers brimming from planters, trailing vines, and the exotic birdcages Catalina is said to have brought back from China. The splashing fountain at the center makes this one of Havana's most evocative spaces. The swelling colonnade of the large side porch is shaded today by canvas awnings, as it was originally. Period photographs show a circle of Cuban wicker rocking chairs arranged for family visits among the potted palms, iron grilles, and art deco pendant lights. The gardens were based on a concept by Jean-Claude Nicolas Forestier, the landscape designer whose designs for parks and avenues did so much to beautify Havana. On the other side, stairs and terraces

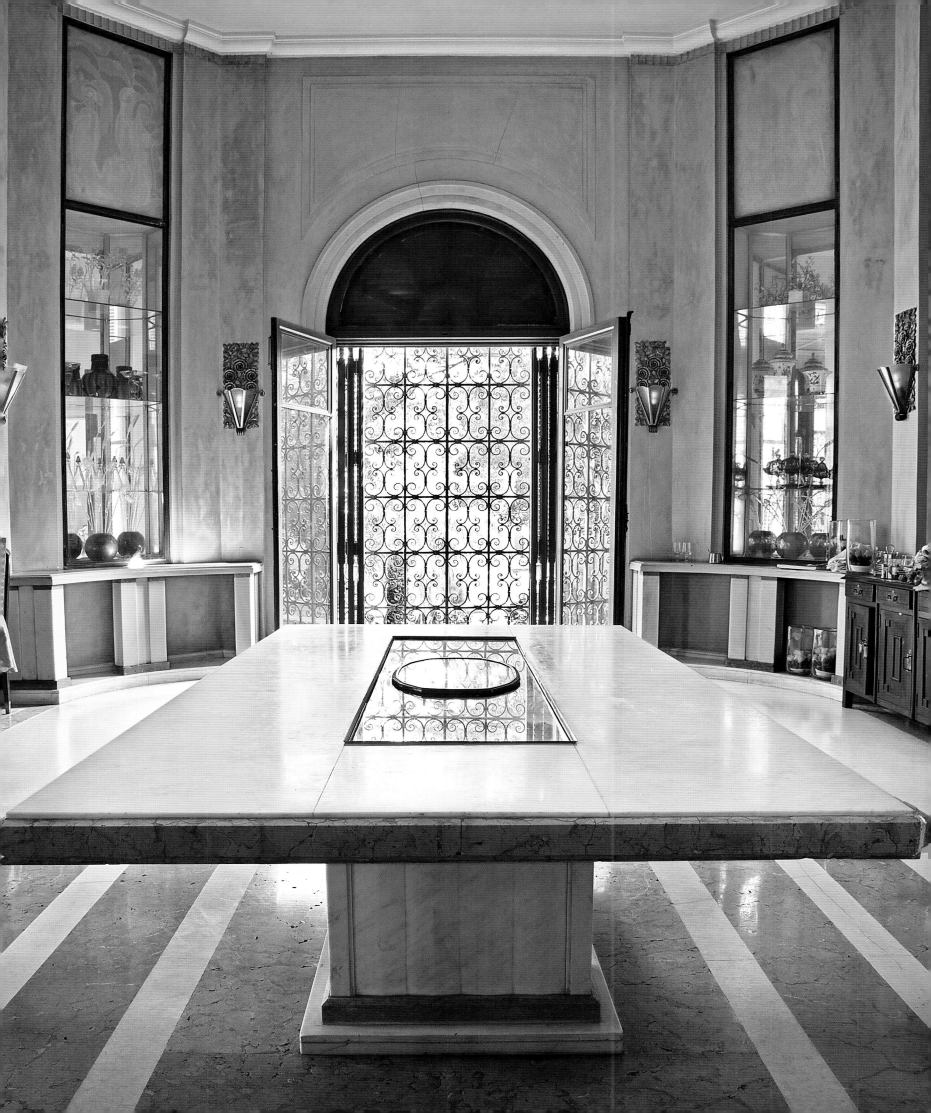

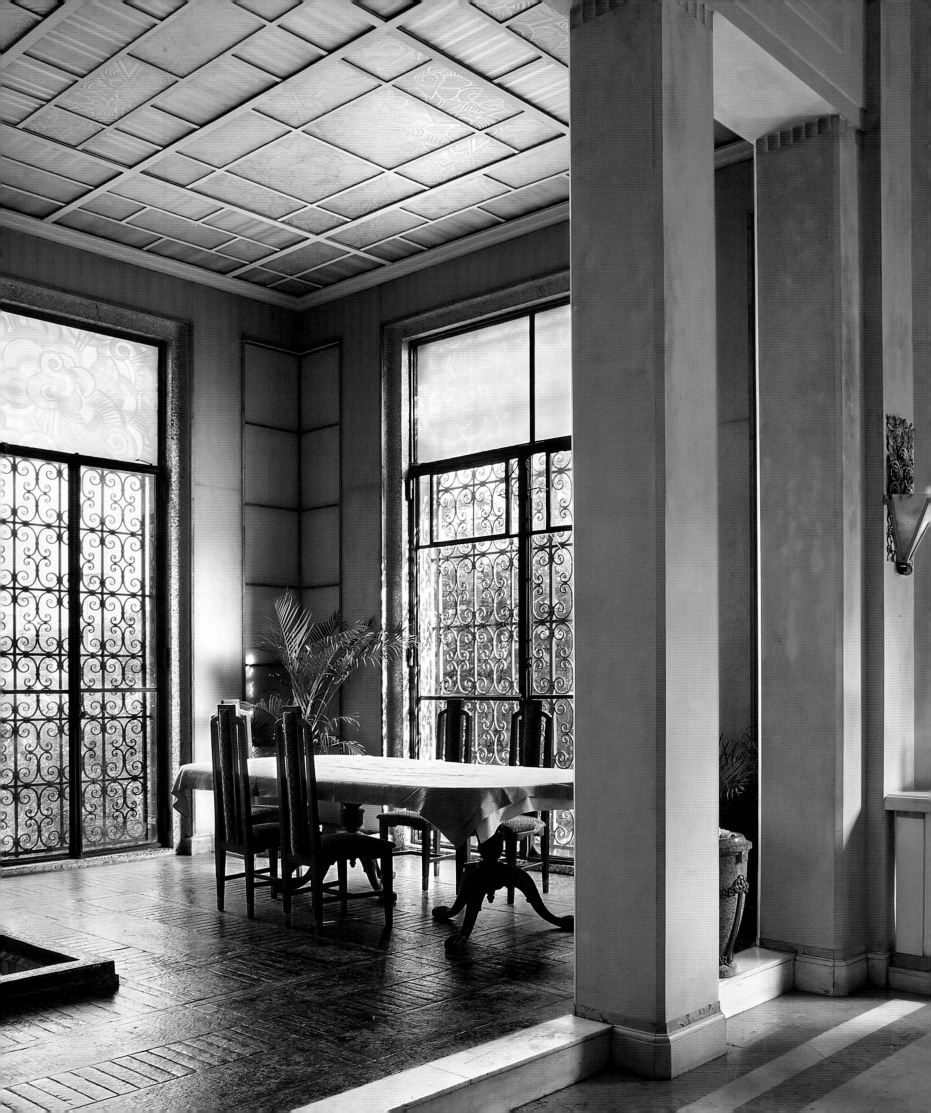

Opposite: A shift from warm tones to cool distinguishes the dining room from the adjacent garden room, with the golden marble floors giving way to delicate mosaics in turquoise, green, and silver.

Right: A decorative wood lattice covers the walls and domed ceiling of the sun porch where a hanging iron light fixture once held cascading tropical plants.

133

descend from the dining room's glass house down to what in Catalina's day were geometric flower beds. Legend says the gardens featured the famous yellow rose named Catalina that Juan de Pedro had specially bred in her honor.

It seems appropriate that some of the most interesting rooms of the house should be those designed for Catalina's personal use: her bedroom, bathroom, and sitting room. The bold arches throughout her suite mirror those on the exterior facades. In Catalina's pink marble bath, the tub is set in an arched recess made of frosted glass panels decorated in a marine motif. These were backlit—another early use of built-in lighting. An oversize arch supported by fluted stone pilasters creates a niche for the bed in a typically French manner. *Social* admired the sycamore bedroom furniture, which was luxuriously accented with areas of galuchat, or sharkskin, the blue fabrics of the bed and curtains contrasting with the ivory stucco walls. Floral-motif sconces and a blue Murano glass chandelier provided the lighting. In Catalina's boudoir, pink stucco walls—a color described as "ashes of rose"—feature an abstracted neoclassical decoration, while the petals of a floral chandelier by Armand Albert Rateau are said to open and close at the flick of a switch.

A loggia along the front facade connects Catalina's and Juan's bedrooms, and it is the only room where the Italian Renaissance style of the exterior has been allowed to enter the house. The space gives an idea of just how different the house might have been had it been decorated as a typical, eclectic Havana mansion of the late 1920s.

The ground-floor salon is a triumph with its restrained use of stucco, marble, decorative iron, and wood, as well as its mirrored doors and bands of carved Lalique glass that provide indirect lighting. The geometric design of the cream, gray, and pink marble floor is echoed in the geometry of the white plaster ceilings. In vintage photographs, ebonized art deco armchairs are in complete accord with the sophisticated setting. The design of these chairs and certain other furniture in the house has been attributed to Luis Estèvez Lasa, a designer and filmmaker,

Left: In the front hall, the grainy texture of the stucco walls and columns contrasts with the glistening surfaces of the polished marble floors, wood doors, and mirrored overdoors.

Right: Catalina's bedroom furniture was clearly in the spirit of the latest Parisian trends.

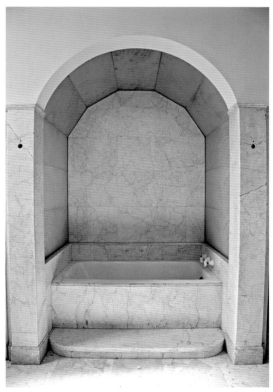

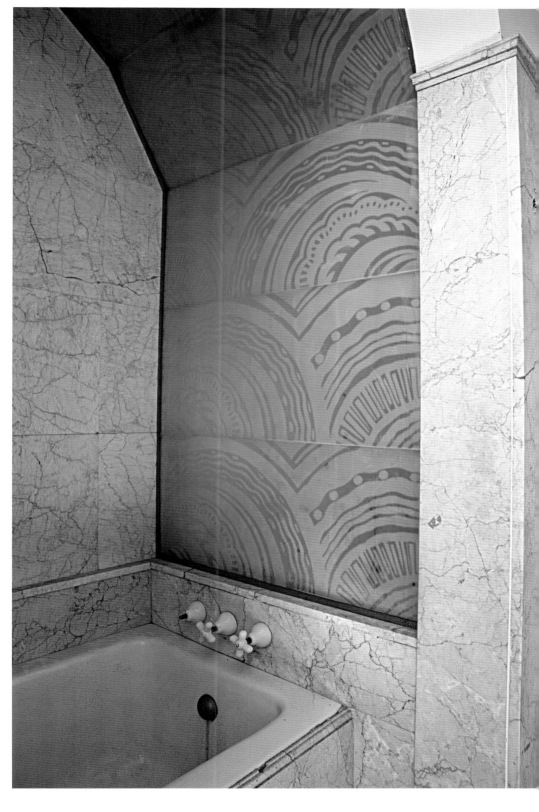

Top: The carved glass rods and gilded metal of the chandelier—in lieu of dangling crystals—in the stairwell are art deco interpretations of traditional forms.

Above and right: Catalina's bathtub was set in an arched niche lined with backlit panels and framed by sober marble pilasters that continue the architectural motifs of her bedroom.

Above: The entry to the salon from the front hall was personalized by ironwork interlacing the initials of Catalina Lasa and Juan de Pedro Baro in an unbroken design.

Overdoors throughout the house are filled with ironwork in handsome curvilinear designs.

Opposite: The gentle curve of the portico projects the shaded porch into the side garden landscape and supports a broad terrace accessible from the bedrooms above.

who may have also coordinated the individual contributions of the French and Cuban design teams. Pale wood rocking chairs scattered throughout the salon are unexpected—a meeting of Havana tradition and comfort with Parisian high style. This dual identity was possibly felt by other expatriates and travelers who formed part of Catalina and Juan's Cuban circle in Paris. The couple's enjoyment of the house was short-lived, as Catalina died in 1930. Juan had René Lalique design an art deco–style tomb for her, which the grief-stricken husband visited daily. When he died, the lore states, he was buried standing at her feet.

The house is now known as La Casa de la Amistad con los Pueblos, a place where visitors of all nationalities are received.

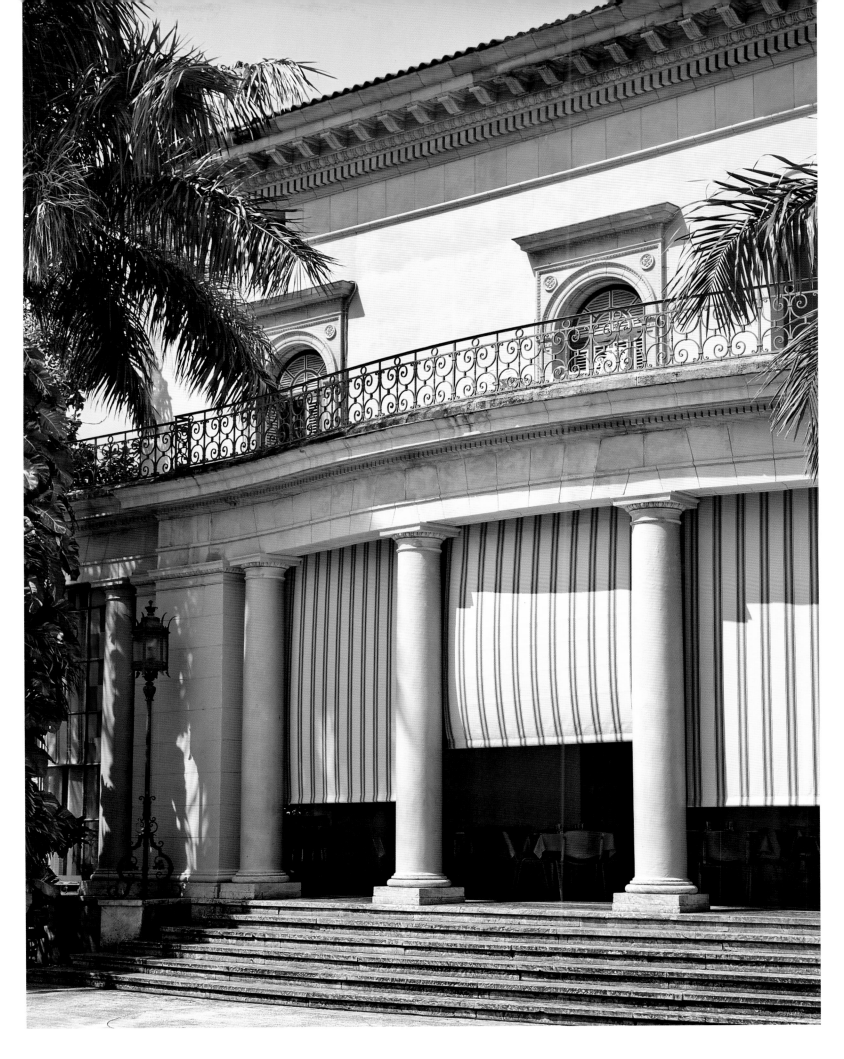

Casa de Mark A. Pollack y Carmen Casuso

It may seem surprising that the son of a Jewish haberdasher from Omaha, Nebraska, was the builder of one of the most spectacular twentieth-century houses in Havana—especially one so grounded in Cuban tradition, including that of having generations of an extended family living under one roof. Family lore says that Mark Pollack fell in love with Cuba during a fishing trip. In 1903 he married Carmen Casuso, whose father was described by a Chicago newspaper as "one of the most distinguished physicians in Havana and [. . .] wealthy." By then Pollack had resided in Havana for three years, having been one of the dynamic young Americans who moved to Cuba during the U.S. occupation to try their luck in this new frontier. Success came quickly: a 1911 photograph shows Carmen and their three children in their substantial Vedado home. Family photographs were often annotated in English for Pollack's relatives, with whom he maintained close contact, even though by then locals considered him thoroughly *aplata-nado*, meaning "Cubanized" (literally, "bananaized").

Pollack made his fortune in the tobacco warehouse business, storing the bundles of leaf tobacco used to fabricate cigars and cigarettes in U.S. and European factories. Pollack's warehouse was an eighteenth-century Old Havana mansion with a traditional arcaded patio at the center. Ever since Columbus was introduced to tobacco on the island, Cuba had exported the crop to Europe. Tobacco, like so many of Cuba's industries, had benefited from a huge investment of American capital after Cuba's independence from Spain. Foreign control of the industry meant that the two major players, the American Tobacco Company and the Imperial Tobacco Company (of Great Britain), all but had a monopoly. Mark Pollack was among the handful of successful warehousers/exporters who managed to stay independent.

Pollack's success led to his commissioning one of Havana's most beautiful houses from the Cuban classicist architect Leonardo Morales. Morales had been designing Havana's most important homes since the midteens. His talent, his degree from Columbia University, and his connections to the oldest Cuban families made him the most sought-after designer of his generation. If his friendship with Pollack seems surprising in Havana's highly stratified social world, one should remember Pollack was an amateur painter and a man of great sensitivity. Around 1927 Pollack suggested that he and Morales take a trip through Europe seeking inspiration for their Cuban masterwork, and the result was a house that can be understood as Pollack's self-portrait. In addition to finding inspiration for the Florentine Renaissance–style house, the pair returned from Europe with decorative architectural elements, such as the twisting, micromosaic column that serves as the newel post for the grand marble stair.

Above: Mark Pollack in the Venice studio of painter Carlo Cherubini, 1926.

Opposite: Recalling a monastic cloister, multicolored marble columns support stone arches and Catalan tile vaults surrounding the courtyard.

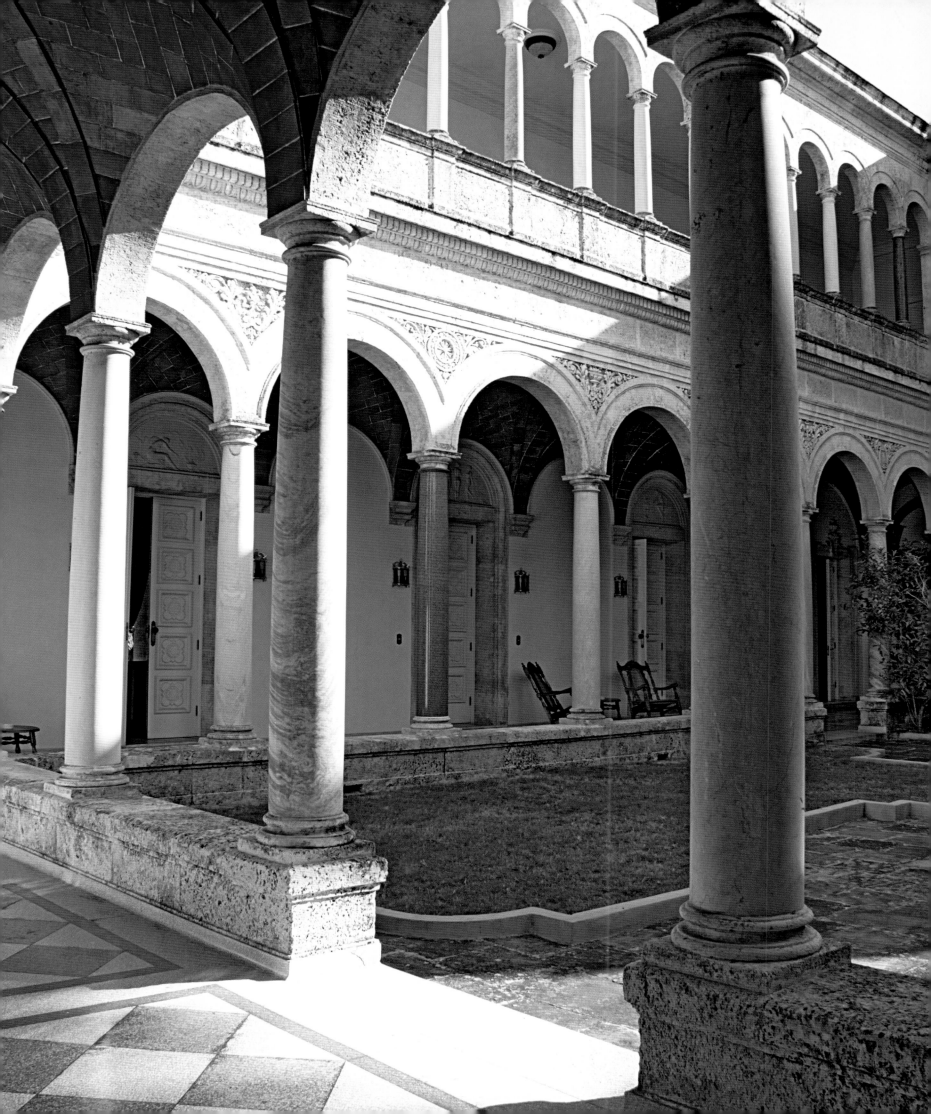

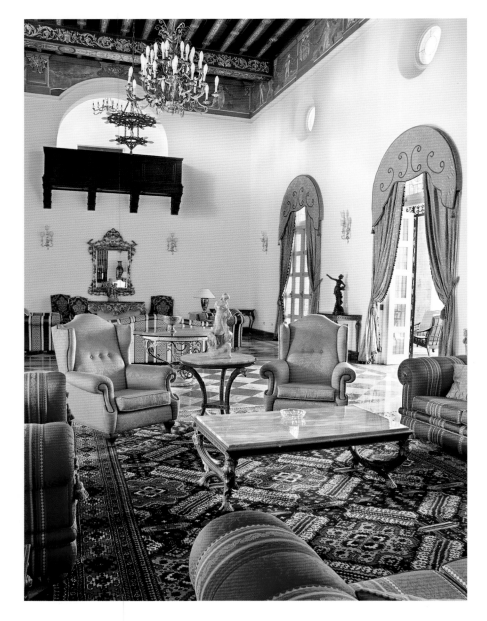

Above right: This glittering mosaic of aquatic life decorates a framed niche in the courtyard gallery.

Construction was completed in 1929 in time for the Pollacks' daughter Elena's marriage to Guillermo Aguilera, the son of an important rice-growing family. Although the house was representative of the architectural eclecticism of the late 1920s and 1930s, it also drew from Cuban traditions, in the spirit of the Spanish colonial revival style popular at the time. The courtyard is both the heart and the signature of the Pollack house. Its shaded arcade—portions of which are a single story, others two stories—defines corridors that access the public rooms and encourage ventilation, just as in the traditional Cuban colonial house. The patio columns, made from various marbles from around the world, constitute a collection of stone specimens. Their polished shafts contrast with the rough Jaimanitas stone of the facade, bringing subtle interest to the architecture. The courtyard was originally lushly landscaped and decorated with pieces of antique sculpture, including a well and fountain, which remain. The surrounding galleries were furnished with comfortable wicker chairs and the rocking chairs ubiquitous in the Cuban tradition. There are interesting details throughout: clay tile barrel vaults that continue the arcade into the corridor, multicolor floors, decorative iron grilles, and sculptural reliefs decorating the walls. An exquisite mosaic panel of a man-of-war floating in ocean waters is said to have been designed by Morales.

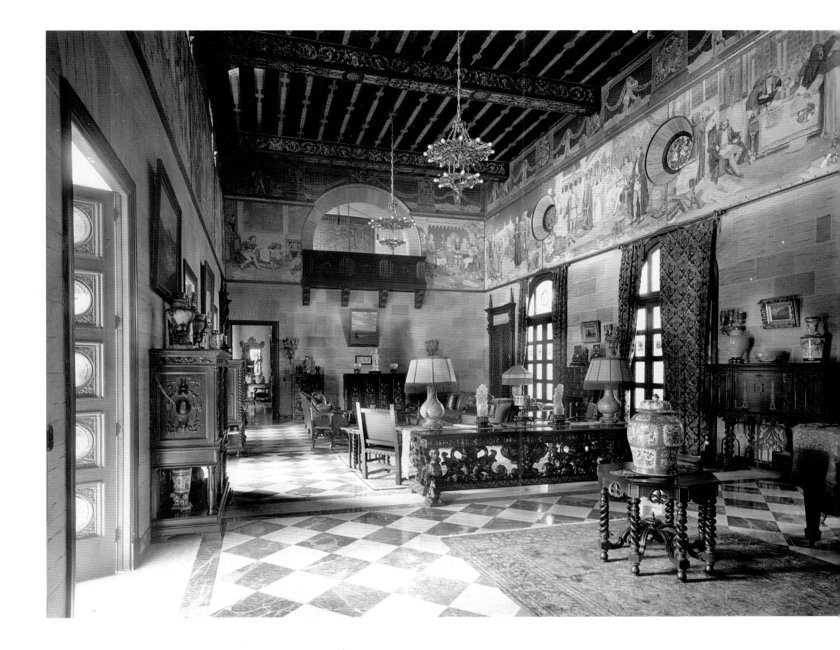

Above and opposite left: The eclectic decoration of the double-height living room included a historical mural on the upper walls, a polychrome beamed ceiling, multicolor stone floors, Renaissance-style bronze chandeliers, and carved wood furniture in a variety of European historical styles.

To fully appreciate the double-height living room, it is useful to study photographs of the interior taken shortly after the house's completion. The walls originally resembled blocks of stone with paintings of historical scenes—said to represent the discovery of America—forming a frieze at the top. This, in turn, supported a painted border of playful putti and young satyrs holding garlands and supporting the polychrome beams that give scale to the ceiling. Checkered marble floors were covered in oriental carpets, defining seating areas in the vast space. The eclectic decoration was completed by damask curtains and carved wood European Renaissance and baroque furniture alternating with comfortable upholstered pieces. At one end of the room is a musician's balcony; at the other, a bronze grille is all that remains of the original pipe organ. It has been suggested that Pollack himself painted the allegorical murals because likenesses of family members were included in the historical scenes. The family, however, denies his involvement, referring to a photograph taken in the Venice studio of artist Carlo Cherubini in which Pollack is standing among several similarly painted panels.

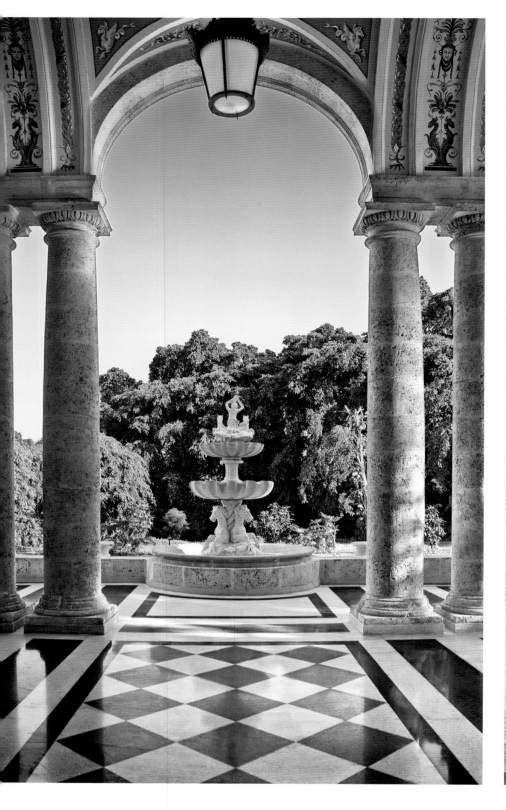

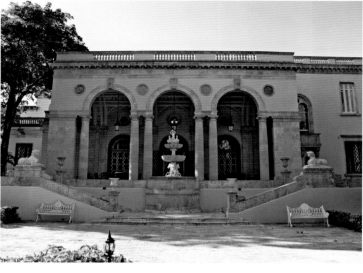

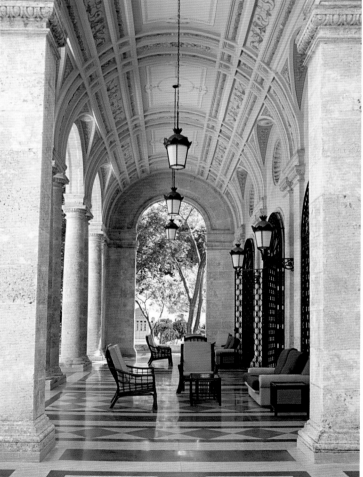

Just outside the living room is the spectacular loggia, considered one of Havana's most beautiful outdoor spaces—an Italian Renaissance version of a traditional Cuban family porch. Monumental pairs of rough stone columns support intricate beams that enliven the barrel-vaulted ceiling. Iron grilles, polished marble floors, and painted ceiling décor frame views in every direction. The theatrical design of this space includes an elaborate fountain on axis with the central arcade as well as a dramatic pair of outdoor staircases—a sequencing of elements in the Beaux-Arts tradition.

Mark Pollack's personal retreat was a double-height stone room on the second floor. It is unclear whether this room and the second-floor gallery were added by Pollack after the completion of the house. The studio is topped by an interpretation of the traditional Cuban colonial wood ceiling construction known as *tirantes y alfarjes*. Horizontal beams tie the opposite walls together while above them the coffers of the sloped ceiling have been decorated with carved flowers, polychromed to contrast with the stained woodwork. The space is lit by a large stained-glass window, another traditional element but updated by the use of simple solid colors. This is where Pollack, according to granddaughter Elena Aguilera, painted the landscapes he so enjoyed.

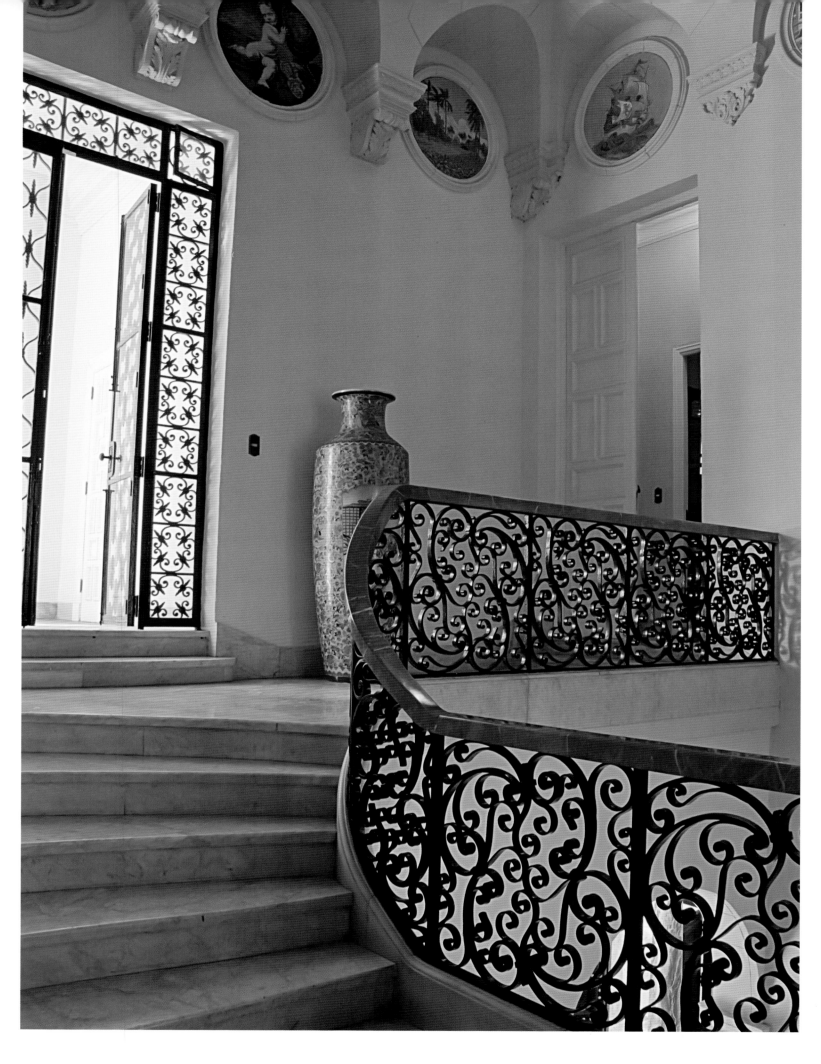

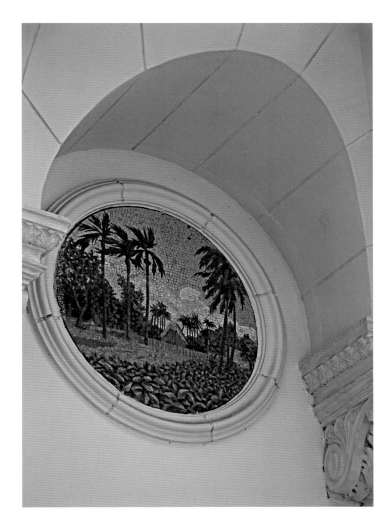

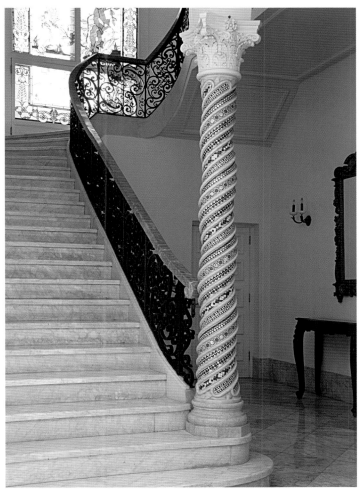

Opposite: Lacy iron railings in a foliate motif define the stairwell at the second-floor landing, which is decorated with a series of micro-mosaic rondels.

Top left: The mosaic panel depicting the thatch-roofed tobacco curing houses of Pinar del Río province.

Top right: A twisted marble column decorated with mosaic inlays is a surprising newel post for the stair.

An intriguing landscape is found at the top of the nearby stairwell, which was decorated with mosaic panels depicting, variously, a cherub holding flowers, an ancient Roman triumphal arch, a Spanish galleon, and in one panel, an iconic Cuban scene of tobacco fields and the tradi-tional thatch-roofed curing houses of Pinar del Río province—an obvious allusion to the source of Pollack's fortune.

Pollack and his wife lived in the house until their deaths in 1946. Their daughter, Elena Pollack, and her husband, Guillermo Aguilera, had moved into the family home after their marriage and here brought up their three children: Elena, Alina, and Guillermo. Pollack's granddaughter Elena Aguilera and her husband, Pedro Pablo Echarte, moved into the house when they were married and brought up their own three children in it. Family life, according to Elena, often revolved around the informal sitting room at the center of the bedroom wing. A beautiful neoclassical vestibule, all domes and niches executed in rough Jaimanitas stone, provides a transition between the public zone of the courtyard and the family's intimate wing.

The elegant neoclassical porte cochère, with its fluted Doric columns, provides a welcoming entrance to the house. Rough Jaimanitas stone was used for the columns, the door and window surrounds, and the roof balustrades, and this material plays against the smoother stucco of the unadorned walls. The openness of the porte cochère contrasts with the solidity of the exterior of the house, whose severity was perhaps designed to protect the intimacy of the family life that went on inside.

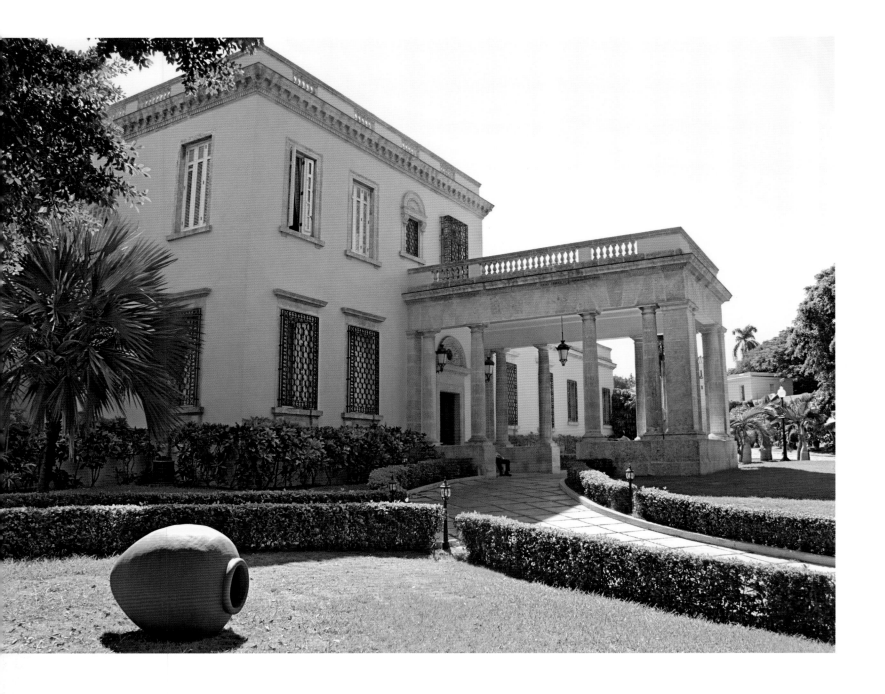

The last generation of the family to live in the house left their mark in the 1950s construction of a playhouse built for Elena Echarte by her doting grandfather. It was a copy in miniature of the midcentury houses going up all over the island, with a clay tile roof, stone veneer walls, window shutters, and porches. The interior included a fake fireplace, a bath, and a working kitchen with miniature appliances custom-made in Europe. In one family photo a magician keeps the crowd of children and their uniformed nannies enthralled at one of little Elena Echarte's birthday parties. In the background is the landscape surrounding the property, protecting this world of style and privilege from the outside.

The story of the house includes a recent rescue following decades of neglect: after the revolution, it was occupied by the Brazilian ambassador and then, inexplicably, was abandoned. The careful restoration has produced one of Havana's most beautiful *casas de protocolo*, where some of the most important diplomatic visitors are housed.

Above: The colonnaded porte cochère provides a note of airy welcome against the sober solidity of the stone and iron-work of the house.

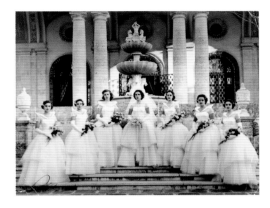

Top: A bride and her maids gather on the terrace steps outside the loggia.

Above: A magician performs in the garden during a birthday party for Pollack's great-granddaughter.

Right: The pool house is a later addition, but its scale and design relate well to the main house.

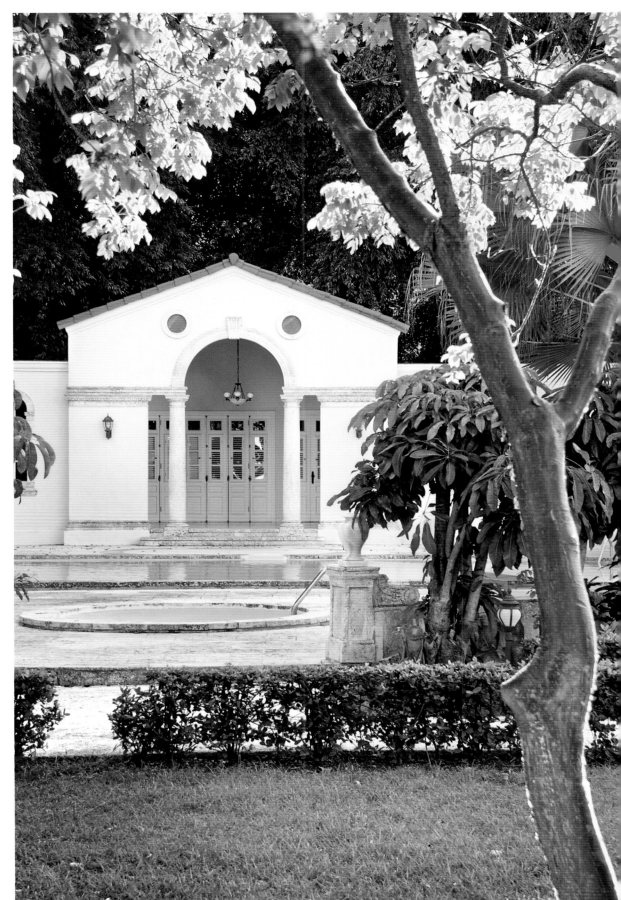

Jaimanitas, House of
Jane and Grant Mason

The glamorous, complex, and self-confident Jane Mason lived in Havana for only a decade, yet during that time she seems to have taken the city by storm. Her handsome husband, George Grant Mason, headed Pan American Airways in Havana—a strategic position in the 1930s as the world was gearing up for war. The couple built a stylish house designed by Rafael de Cárdenas, a Cuban society architect, and decorated by Jane herself in a combination of patrician comfort and bohemian chic—she had, after all, studied art in Paris. Elegant Cubans loved her naturalness, her gaiety, her casual style of entertaining in which she brought together younger Cubans, visiting European aristocrats, and the most successful members of the American colony. At a time when society women did not work—especially not in Havana—Jane started the successful Juanita souvenir shops, creating the "Made in Cuba" brand. She took promising local artists under her wing. She also had a much-publicized affair with that other star of Havana's American set, Ernest Hemingway, whom she met in 1931 aboard the *Ile de France*. The affair appears to have lasted through 1935, by which time the Masons' unhappy marriage had served as literary inspiration for the novelist.

Jane Kendall grew up in Tuxedo Park, New York, and married the wealthy, socially connected Grant Mason in 1927. First Lady Grace Coolidge famously described young Jane as the most beautiful girl to visit the White House—one of many anecdotes that would be repeated by the American and Cuban press. The Masons moved to Havana not long after Pan Am established regular mail service between the city and Key West. Around 1929, the year of the stock market crash, they purchased property in the elite Country Club Estates, which American and British investors had developed around a golf course and clubhouse a decade before.

Havana's magazines and newspapers were full of admiration for the handsome couple. *Social* referred to Jane as the leader of whatever society she frequented. That same magazine published Conrado Massaguer's caricature of her, in which she was described as an "incomparable hostess" whose house was a gathering place not only for a select group of high-society Cubans and foreigners but for "all intellectuals who pass through the island."

To see Jane Mason striking a sophisticated pose for the magazine *Social* in the front hall of Jaimanitas, accompanied by her reclining Dalmatian, is to understand how glamorous she must have appeared to Havana society. Her house was clearly the embodiment of her personal style.

The Masons left the house in 1938, but today much of the interior remains as Jane designed it. The house was purchased from them fully furnished in 1949 for use as the Canadian Ambassador's Residence. Unlike most Country Club properties, the front garden is not

Above: Accompanied by her Dalmatian, Jane Mason leans against a wall of her front hall in a portrait by Cuban society photographer Rembrandt.

Opposite: Bold arcades define one wall of the distinctively tiled corridor that links the front hall with the public rooms at the rear of the house.

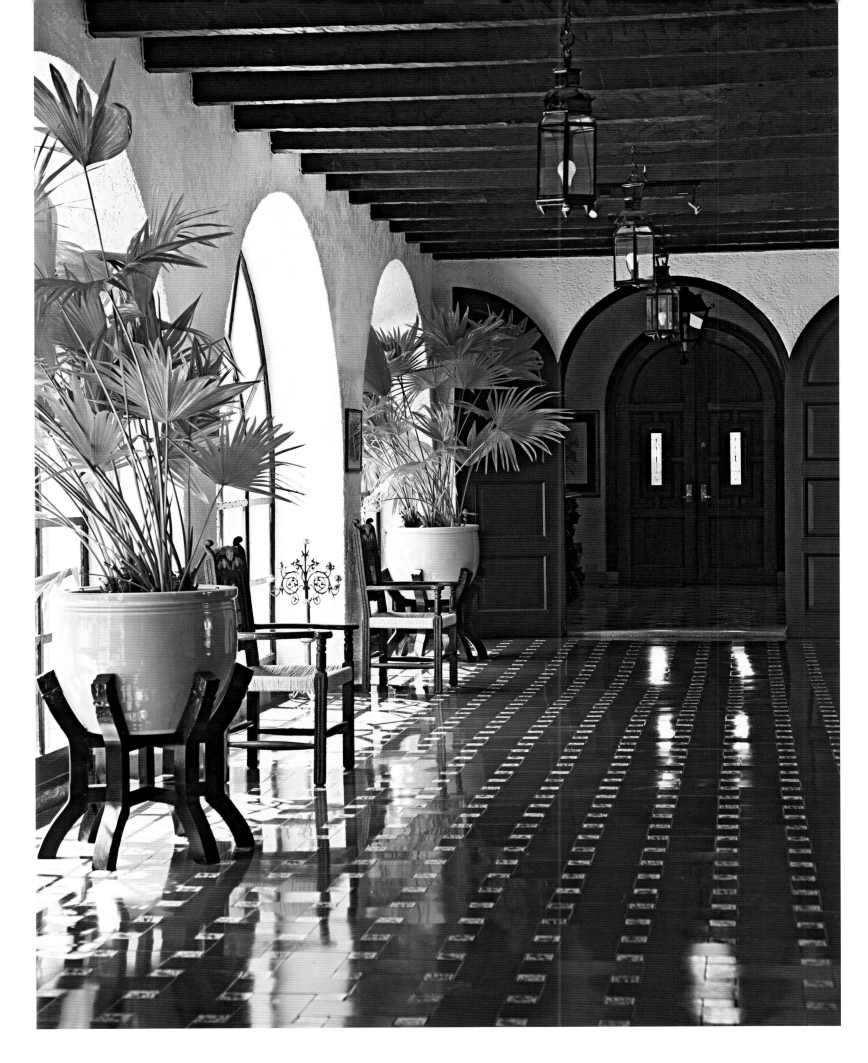

Above: The brick smokestack of an abandoned sugar mill attests to the days when even the suburbs of Havana were producing and processing that crop.

Right: The solidity of the street elevation is enlivened by a playful front door surround, with the variety of clay tile roofs containing interior volumes defining outdoor spaces.

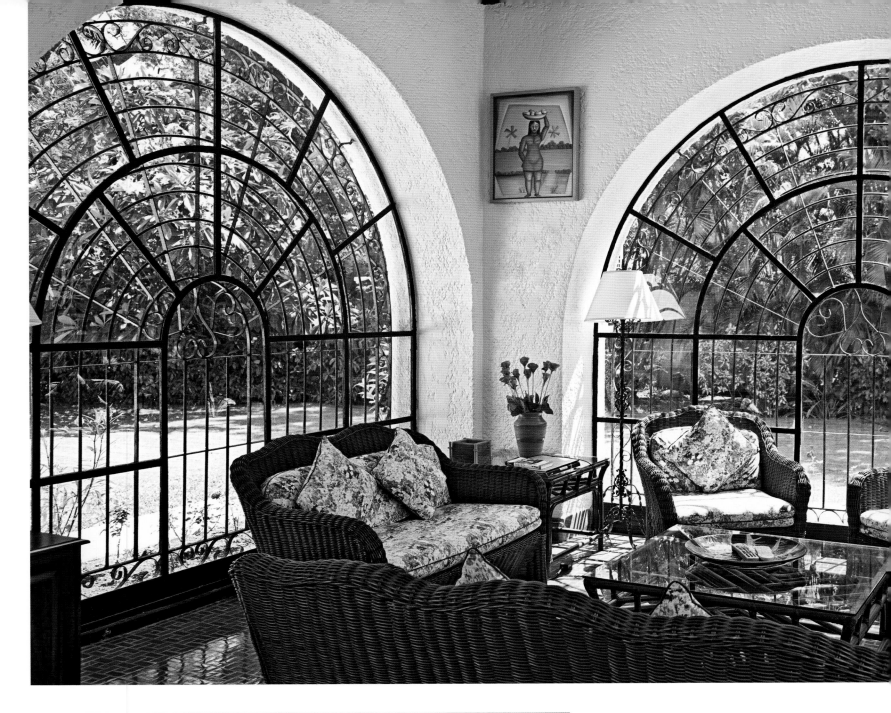

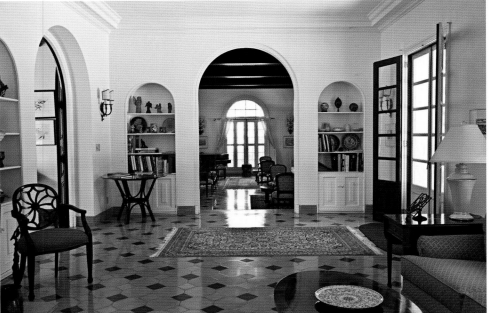

Above: The bold iron frames of the arched windows in the sun room are a striking original detail.

Left and opposite: An informal sitting room connects the corridor and the sun room. Shelves built into the arched wall niches display books and personal mementos, as they did in Jane Mason's day.

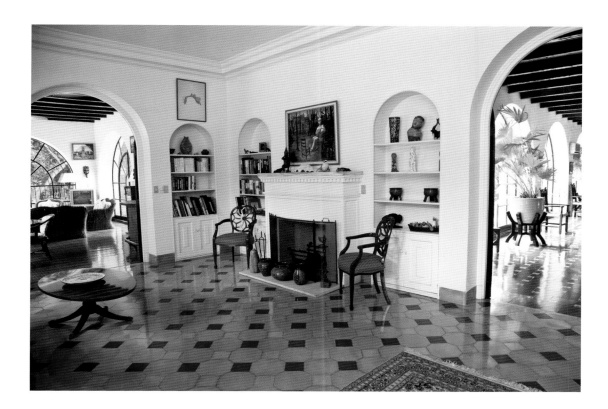

enclosed by a fence and instead meets the front lawn just steps from the sidewalk. The site backs up to the old golf course and its decorative lake, El Laguito. Across the street is the brick smokestack of a sugar mill long since demolished—a dramatic reminder of the days when even suburban Havana was involved in producing sugar.

The architecture of the Mason house seems much more sophisticated than most other Mediterranean-style houses found in Miramar and El Country. The sprawling H-shaped plan creates two interior courtyards that become the focus of different areas of the house. A long corridor forms the spine leading from the front hall all the way to the rear of the house, where three rooms—a casual glassed-in sun porch, an intimate sitting room, and the formal living room—overlook the rear garden. En route to these rooms and just off the corridor is the large dining room, which faces an intimate court anchored by the picturesque tower of a dovecote. An exterior stair is a theatrical element in the composition of another garden.

Period photographs confirm how much the spirit of the house has remained intact. One photograph of the small sitting room shows a three-panel screen decorated by Jane that remains in the house today. The mix of furniture there includes French Louis XV seating, a Spanish table, rustic chairs, an oriental carpet, and an eighteenth-century European painting. The built-in bookcases are unusual in Havana, as is the fireplace. In Jane's day they signaled a cozy, American-style informality—a quality also appreciated in *Social*'s description of the Masons' entertaining:

> Of course there are many parties in Havana with the grand manner of yore, but frankly they are such frightful yawns to write about or read of that we will confine our "Vanities" [column] this month to those bright groups whose informal activities are themselves

153

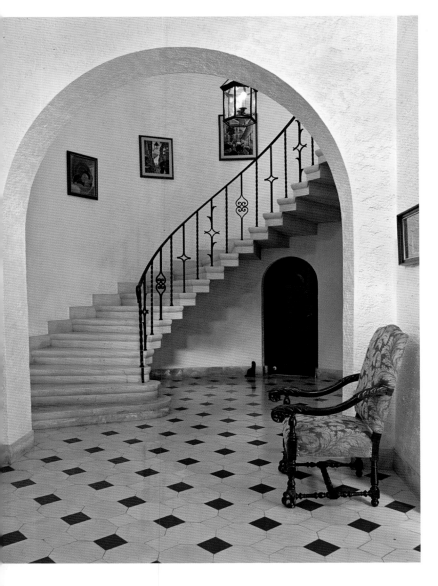

Left and above: Paintings by Jane Mason's protégé Gabriel Castaño line the curved stairwell.

Right: The living room today maintains the spirit of the original decoration, with furniture in several European styles arranged into groups for conversation.

marked with a red brush of radicalism . . . Take the buffet dance given by the George Grant Masons in honor of their houseguests Lord and Lady Sackville West of London.

Guest rooms were important in a house that every winter season drew guests from abroad to enjoy boating, tennis, riding, golf, and parties. This is the type of entertaining associated with English country houses, and Jane had spent time at her mother's, where the Prince of Wales and his brother had been guests. Period photographs of Jaimanitas show guest bedrooms fitted with twin beds whose headboards were decorated—probably by Jane—with floral or heraldic motifs. In one bedroom the chest of drawers and the curtain valance have also been hand painted to match the headboard.

Vintage images of the formal living room show similarities to today's décor: curtains at arched windows, a piano in the corner, comfortable sofas mixed with both French- and English-style chairs, oriental carpets anchoring seating groups on the cool Cuban tile floor. A 1928 article mentions Jane making her own curtains and painting most of the furniture in her earlier Cuban home, though Havana's ladies would have viewed this as madness, not charming eccentricity.

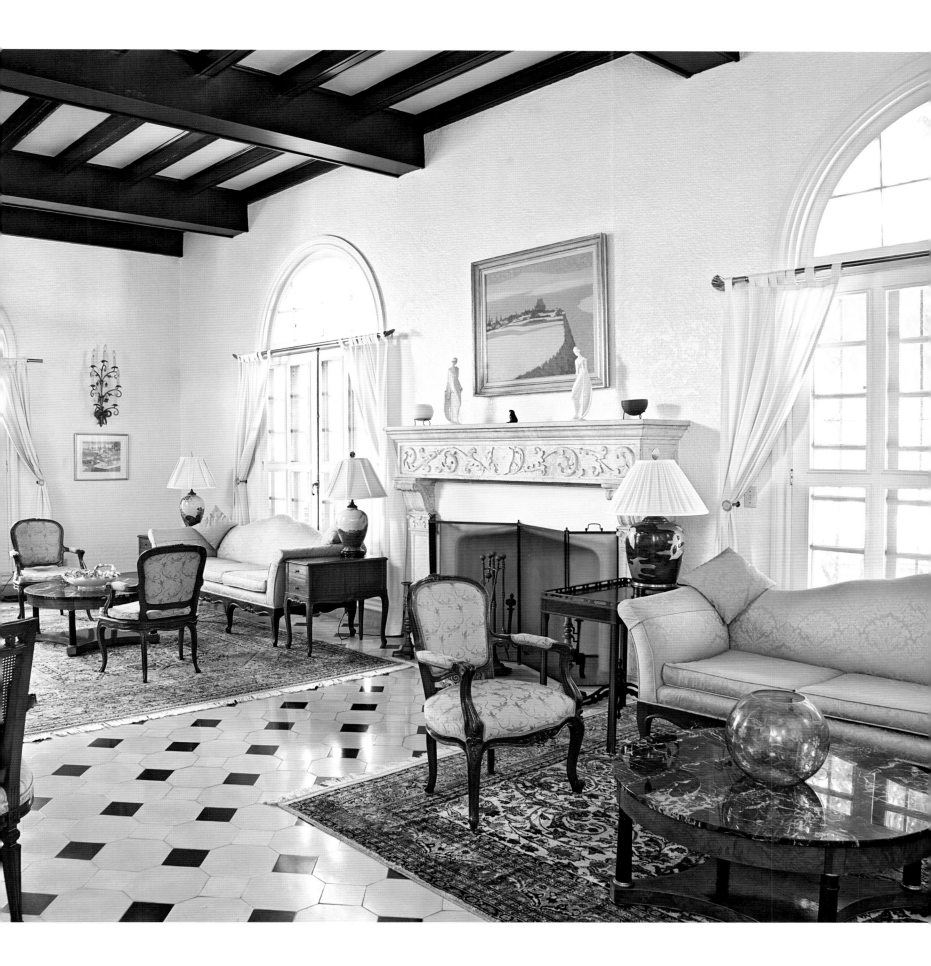

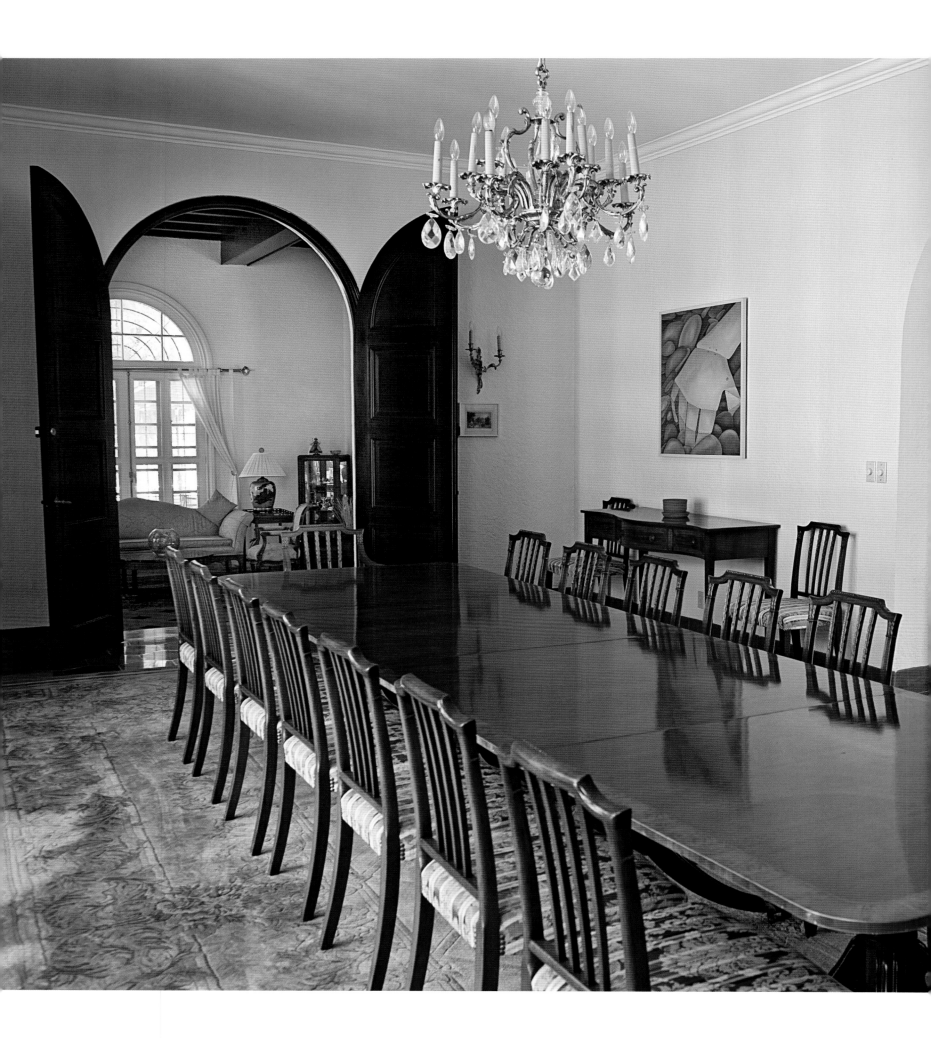

Above: Vintage views of the living room and a guest bedroom show the attention paid to comfort and detail while using a stylish mix of antiques.

Left: Daylight enters the dining room through doors opening onto an intimate courtyard.

Right: A picturesque outdoor stair leads to Jane Mason's studio above the master bedroom.

Left: The octagonal dovecote enlivens the walled courtyard outside the dining room and adds a theatrical element to the rear gardens.

Jane's original decoration for the front hall—tapestries, baroque candlesticks, carvings, and elaborate chairs with leather seats—took its cue from the antique Mediterranean style of the house. Hanging on the walls of the curved stair hall are several of the paintings of colonial Trinidad created by Jane's protégé, Gabriel Castaño. She presented these paintings at a 1933 show of his work in the Arden Gallery in New York.

Jane's support of the arts in Cuba found a remarkable outlet in the handicrafts shop she opened on the Paseo del Prado. Jane envisioned the Juanita Shop as a mecca for tourists— a place where they would be offered the best Cuban handicrafts selected by Jane or executed to her designs. Her outsider perspective allowed her to identify the most interesting Cuban crafts, and she energized local production of weavings, paintings, pottery, and sculpture. Unlike in Latin America, where a strong indigenous population had been producing handicrafts for centuries, Cuba had very little such tradition. Newspaper reports indicate that Jane went on to organize crafts classes for Cuban children. One Havana article mentions Jane opening a "cute doll and perfume shop . . . wisely following the sign of the times." An American article describing the latest high-society fads commented, "Mrs. George Grant Mason of Tuxedo Park has turned shop keeper in Havana and not through necessity."

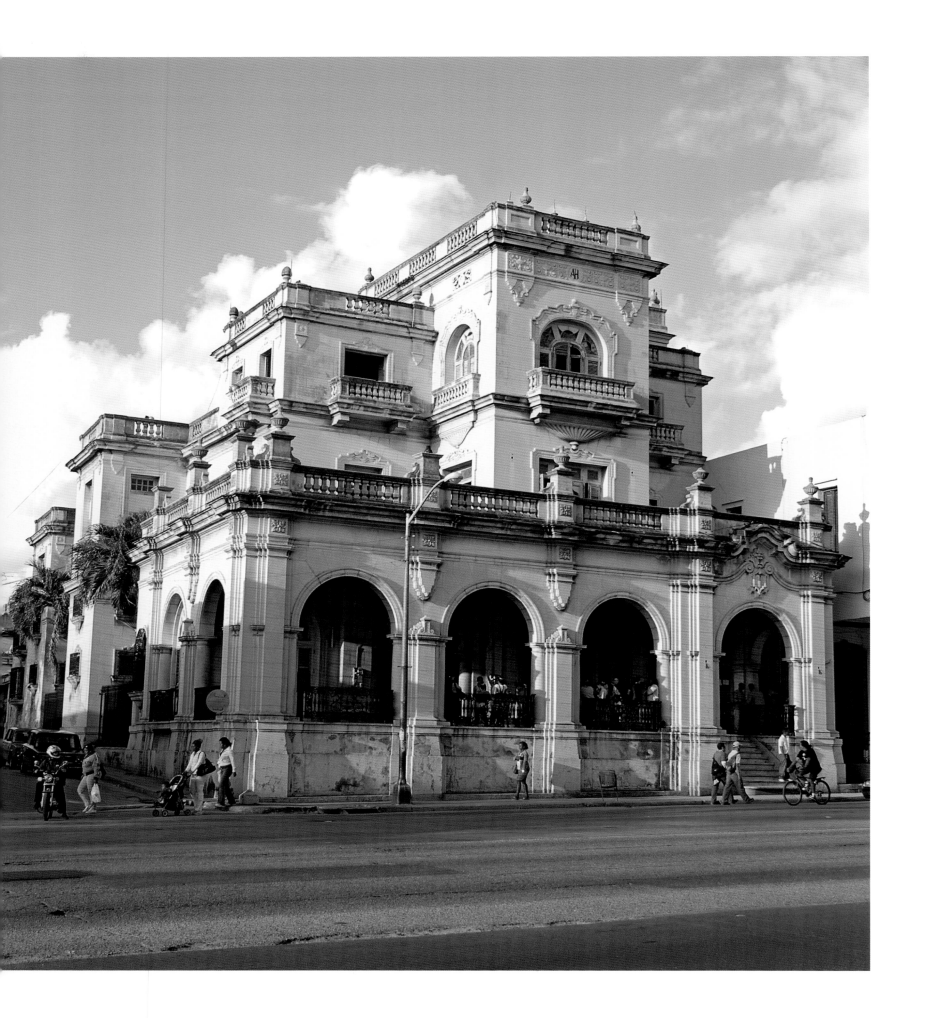

Casa de Alfredo Hornedo

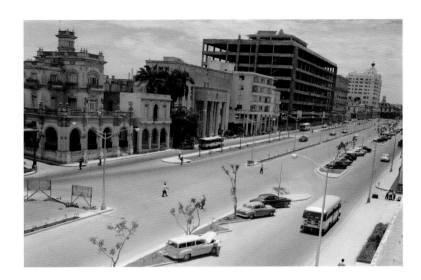

The Hornedo house is character-
ized by complex massing and
setbacks that create a variety of
balconies, roof terraces, and
window exposures. The Spanish
colonial–style arcaded porch is
raised above the street activities
on Paseo Carlos III.

Alfredo Hornedo's is another of Havana's rags-to-riches stories, but this time the protagonist
is a local boy, not an American or European immigrant. Hornedo was born in Havana in 1882,
and it is said that he grew up in poverty in the city's slums. He was an ambitious young man,
and his first business venture was an early version of a rental-car company. In 1904 or 1905
Hornedo married Blanca Maruri, the daughter of a wealthy family—the rumors were that he
entered the Maruri home through the service door as a chauffeur. With her money and family
connections behind him, he then launched his political career.

Hornedo joined the Liberal Party, where he was protected by President José Miguel Gómez,
one of the politicians who had their start in Cuba's war of independence. From the midteens
on he was active in politics as a member of a group that controlled the Havana mayor's office.
Hornedo was elected city councilman in 1914, then council president in 1916, and from 1918 on
he served several terms in Cuba's House of Representatives. Cuba's historically corrupt political
scene meant that Hornedo, fairly or not, was accused of taking kickbacks. Finding he was being
criticized in the press, he began buying and starting his own newspapers. His three periodicals
ostensibly represented different editorial views, but all bore final allegiance to the owner and
his career. El Pais (1921), El Excelsior (1928) and El Sol (1928) had tens of thousands of subscribers,
with an Associated Press wire service and foreign correspondents based in New York.

In the late 1920s Hornedo demolished his wife's family house on Paseo Carlos III, now Avenida
Salvador Allende, and commissioned architect Enrique Gil, a founder of Havana's school of architec-
ture, to design a mansion. Hornedo was a personality who inspired endless outlandish rumors,
and stories abound regarding the design of his Spanish colonial–style house. For instance, it is
said that Hornedo had to be talked out of paving the floor of the salon in gold coins.

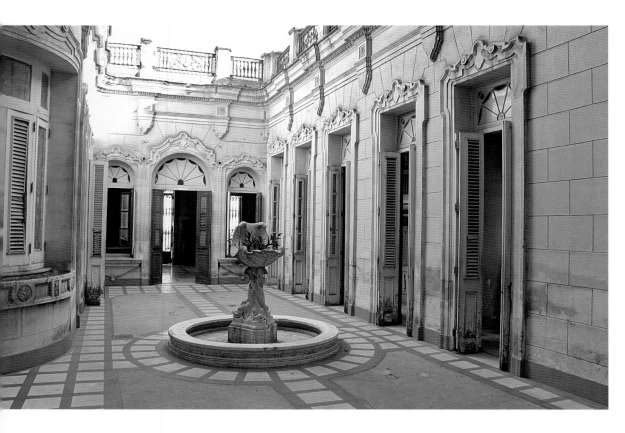

Above: The courtyard at the center of the house was unusual for the period—a return to colonial house traditions—as were the intricate Spanish baroque–style elements decorating the doors.

Right: The compound curves of stonework, iron railings, and stained glass windows come together in an especially flamboyant corner of the balcony.

Since the 1840s, Paseo Carlos III had been an elegant, sculpture-lined avenue where citizens came to enjoy evening carriage rides outside the city walls. Just off the street is the charming summer villa of the captains general, La Quinta de los Molinos, and its extensive gardens. In the late 1920s Jean-Claude Nicolas Forestier reconfigured the street as part of his master plan for beautifying the capital. Even though the rich of the 1920s were building homes in El Vedado or the more distant Miramar, Hornedo's corner site was still seen as a desirable address.

The house is vast and presents two distinct appearances. At the rear a huge garden, now paved, was surrounded by an elaborately decorated wall that gave the house privacy in the spirit of El Vedado. At the front, Hornedo's house is resolutely urban, with a street-facade porch built up to the lot line in the tradition of Old and central Havana. The generous front porch is raised off the sidewalk to provide privacy. Floor by floor, the house steps back in an effort to appear less massive and to offer at each level the amenity of a balustraded terrace. The central courtyard, a continuation of centuries of Cuban residential traditions, is an unusual feature in a house of this period, having disappeared decades earlier in Vedado houses. The dynamic curves of the courtyard balcony relate to the ornate Spanish baroque–style geometries that decorate the windows and doors. Curves, columns, ornate ironwork, wood louvers, stained-glass transoms and sidelights, mosaic panels, and geometric tile floors are the house's decorative motifs. The smorgasbord quality of the interior, the layer upon layer of decoration, is similar to that found in the 1922 house of Bernardo Solis, which Gil designed in partnership with Facundo Guanche.

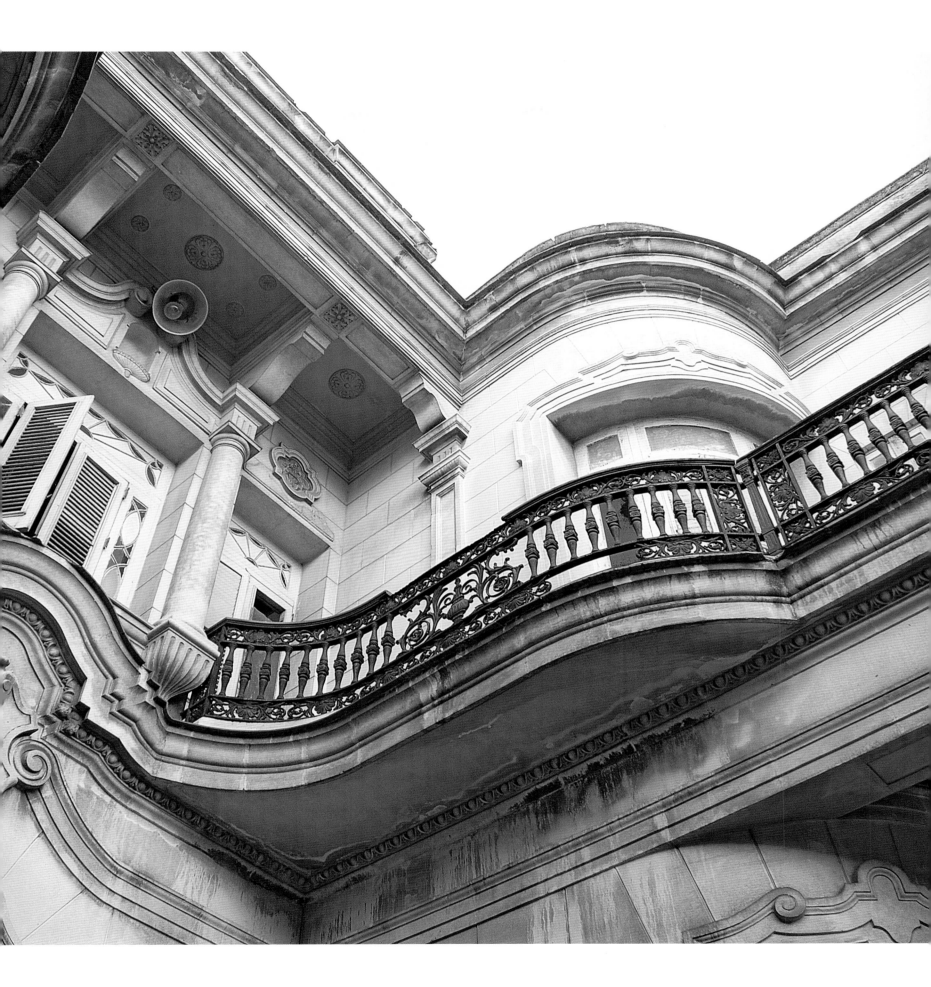

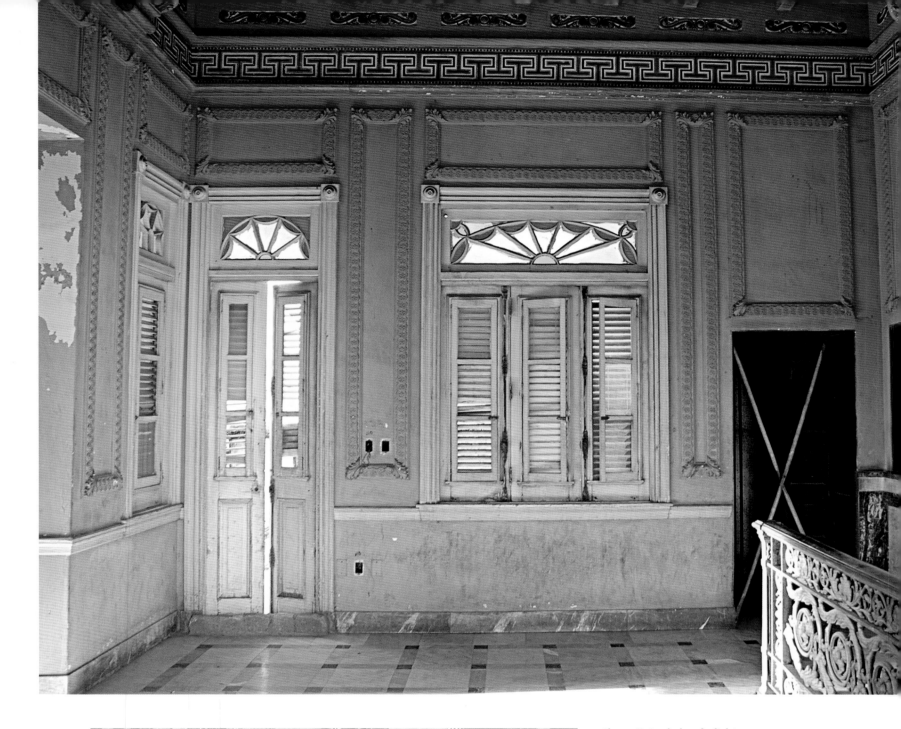

Above: Stained-glass fanlights above panels of operable wood louvers impart a distinctively Cuban flavor to this stair landing.

Left: On this upper-floor ceiling, beams define coffers that are painted to suggest intricately inlaid woods.

Right: A cornice displays an entire classical repertoire—egg-and-dart moldings, dentils, and acanthus leaves—executed in cast plaster and surrounded by painted decoration.

Below: Ornate ironwork is a signature of the house—here bold classical motifs form the stair railing.

The neglected condition of the house today—it currently serves as a community center, the Casa de la Cultura de Centro Habana—as well as the complex three-story design contribute to a feeling of disorientation. There are so many spaces, and it is often difficult to determine the original use of the rooms. Several retain their architectural decorations, including a variety of beamed and coffered ceilings, applied moldings creating bold wall panels, stained-wood wainscots, and colored-glass panels. Ornate plaster moldings are enlivened with stenciled designs, floral garlands, and gilding. One room in particular retains its elaborate painted décor, with ceilings painted to resemble coffers of intricately inlaid wood. The dilapidated rooms are, however, charming in their naive mixtures of styles and details.

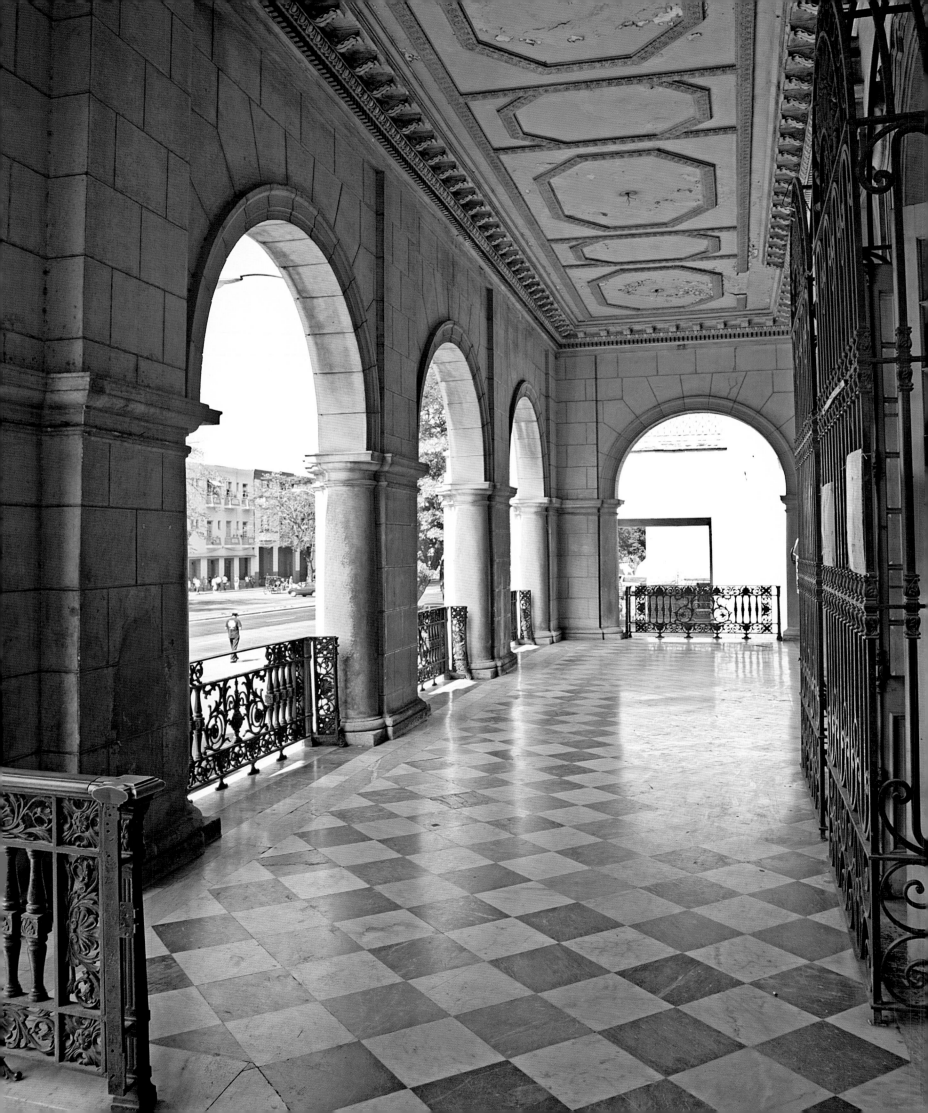

Opposite: Massive stone arcades, a paneled plaster ceiling, marble floors, and iron railings define the generous front porch as an extension of the interior.

Above: Hornedo's interlocked initials appear throughout, from the cartouche above the main entry to the hinges of the shutters.

A tour of the house is not unlike a treasure hunt in that much is there to be discovered: disparate details, odd juxtapositions of scales, and Hornedo's initials in unusual places, such as the cornice of a third-floor tower at the very center of the facade and even on shutter and window hinges. Hornedo appears to have enjoyed personalizing his buildings—throughout the next decades his major constructions would be given family names.

Hornedo's political career advanced through the 1930s and 1940s. He served as president of the Liberal Party from 1939 to 1947 and was elected senator in 1936, 1944, and 1948. Hornedo seems to have adapted to the vagaries of the island's political climate, supporting whoever was the current president or strongman. Nonetheless, in 1935 Hornedo was rejected for membership at both the Havana Yacht Club and Havana Biltmore Yacht and Country Club, due to his mixed-race origins. The club memberships had ostensibly been pursued in order to find a place for the sea baths that his wife's doctor had prescribed for her poor health. Hornedo's initial reaction to the snub was to chastise these important social institutions in his newspapers, but he was counseled by his top social reporter, Pablo Álvarez de Cañas, to create a social club of his own. Thus, Hornedo launched El Casino Deportivo, designed by Enrique Gil on a stretch of the Miramar oceanfront. This was not an exclusive club and required no large initial fee, but ironically, Hornedo denied membership to mix-raced users. He did, however, admit members from Havana's Jewish community, allowing them to bring their own kosher food and in this way to participate in the club life that was essential to the Havana social scene.

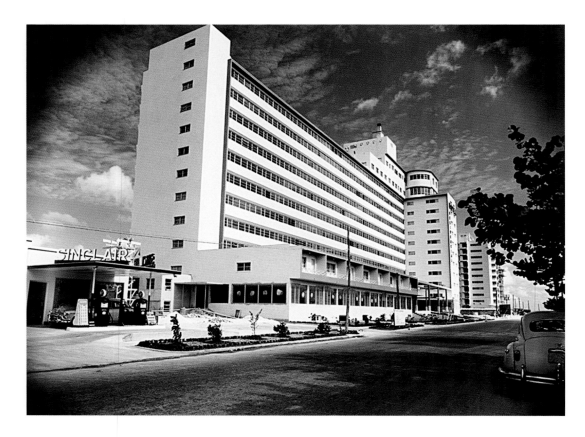

In 1941 Hornedo hired architects Rafael de Cárdenas and Cristobal Díaz to build new headquarters for *El Pais* in the central Havana business district. They designed a modern building with expanses of glass and the vertical thrust of chrome window frames and sleek granite columns. Art deco–style friezes by Spanish sculptor Candido Álvarez Moreno, depicting the news industry, brought the excitement and modernity of New York City publishing to the island. Interior views in contemporary publications show boldly patterned floors and the streamlined curves of counters, ceilings, soffits, and friezes reinforcing the art deco spirit.

Hornedo pursued other architectural ventures as well. Gil, a theater specialist, designed Teatro Blanquita, which is next door to El Casino Deportivo. The Streamlined Moderne–style building, which also included a skating rink, was inaugurated in 1949 and named for his deceased first wife, although by then Hornedo had wed his mistress, Rosita Almanza. In the late 1950s the theater was remodeled, and after the revolution it was renamed the Karl Marx Theater. Hornedo then built an eleven-story residential hotel overlooking the ocean in the La Puntilla area of Miramar, not far from the Blanquita Theater and the Casino Deportivo. Designed in 1956 by Cristóbal Martínez Márquez, the Rosita de Hornedo's striking T-shape layout created views for the residents of its 172 apartments. It offered the latest amenities. American gangster Meyer Lansky is said to have lived there when in Havana, but the most famous resident was Hornedo himself, who occupied the spectacular three-story penthouse. Then, soon after completing the Rosita, Hornedo partnered with his nephew Alfredo Izaguirre Hornedo to build the Riomar apartment building, another high-end tower next door but on an even better site—the point of Miramar where the Almendares River meets the sea. To this day the building boasts uninterrupted views of the Malecón sweeping its way back to Old Havana. While this area of Miramar now feels quiet, the theater, the beach club, and the series of apartment buildings once made this among the liveliest stretches of the Miramar coast in the days before the revolution.

Influences of the 1930s: Art Deco Style, African Art, Cuban Heritage

The art deco style embodied the dynamism of airplanes and transatlantic ships, the sophistication of Paris where it originated at the 1925 Exposition, and the modernity of New York skyscrapers—all in contrast to the classicism that preceded it. While the pure art deco interiors of the Baro-Lasa house were unmatched in Havana, a variety of art deco–style buildings helped make the transition from 1920s eclecticism to the rational modernism of the late 1940s and 1950s. Art deco worked well for a wide range of building types—private houses, movie theaters, corporate headquarters, churches, bathing clubs, and the national casino—connecting the city to what felt modern in the rest of the world.

Art deco–style apartment buildings sprang up in Havana beginning in 1932 with the Lopez Serrano tower. Although wealthy Cubans had traditionally shied away from multifamily dwellings, a series of apartment hotels were built in Vedado and Centro Habana. Initially catering to international businessmen, their on-site services included dry cleaning, grocery deliveries, restaurants, barbershops, and movie theaters. These buildings provided urban pieds-à-terre for the younger generation of the bourgeoisie with their proximity to the nightlife and business in the city center. The Vedado streets would soon be lined with three- and four-story, deco-detailed apartment buildings, each housing half a dozen families.

In 1931 *Social* magazine published an early example of the art deco style in Cuba: a house designed by Ernesto Batista with sophisticated interiors by designer/journalist Clara Porset. Highlights included black lacquer screens with bronze decorations, a dramatic beige and black-marble staircase, silver-papered walls, bronze baseboards, and two paintings by Gauguin, which provided a jolt of color. As always, Cuban and foreign magazines provided the island's designers with inspiration and connection to international trends. Throughout the early 1930s, Porset reported in *Social* on the design trends she observed in Paris and at international expositions. She embraced all that she regarded as good design: the abstract rationalism of a house by Le Corbusier ("a house according to the new formula"), how stylish Parisians combined their eighteenth-century furniture with strikingly contemporary paintings, or how Jean Dunand was reviving the ancient art of lacquer and making it modern.

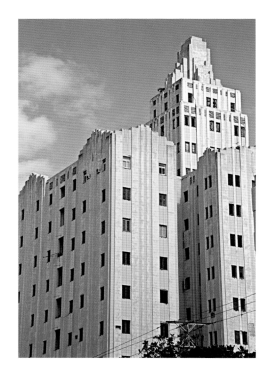

The stepped massing and the vertical thrust of the molded bands animating the facades of the Lopez Serrano building transport a piece of the Manhattan skyline to El Vedado. Movement and modernity are the theme of the nickel and enamel panel by Enrique Garcia Cabrera that is the centerpiece of the lobby.

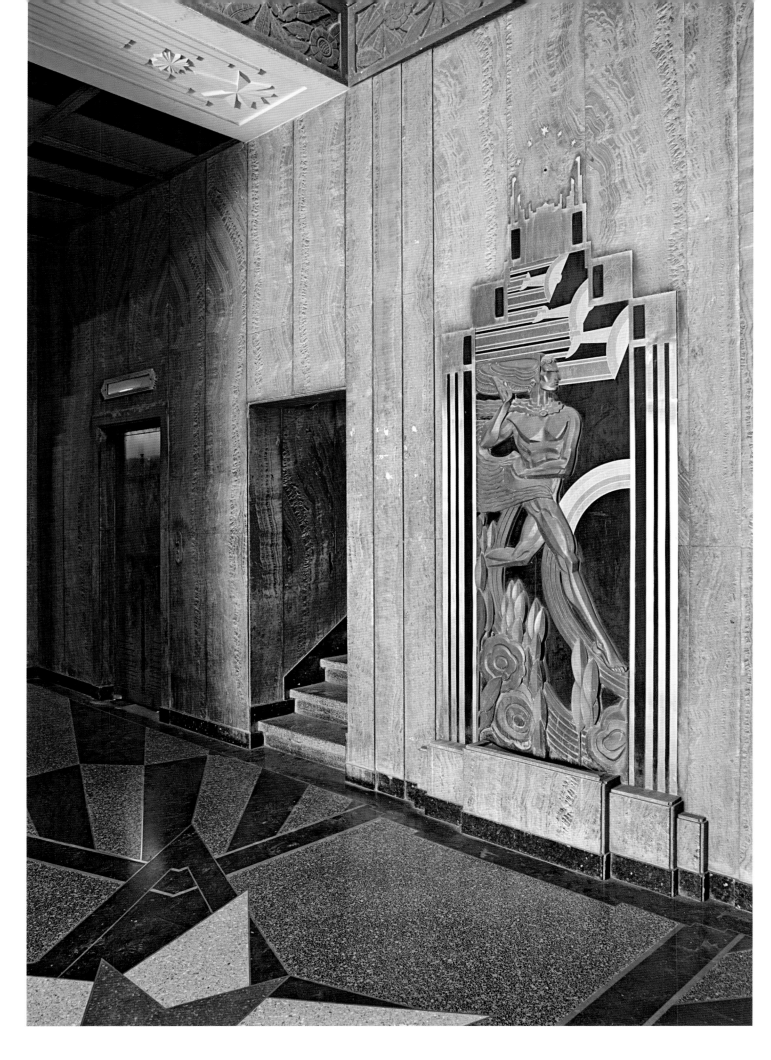

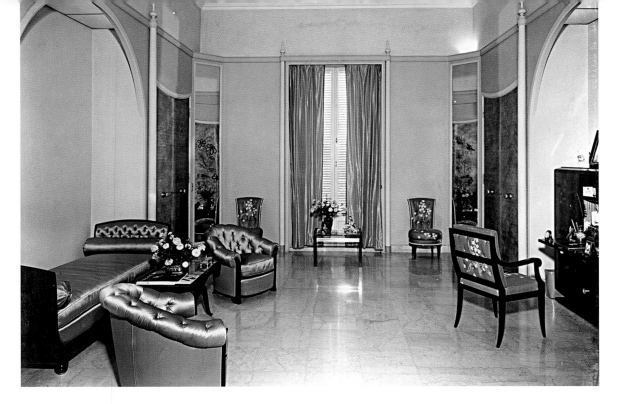

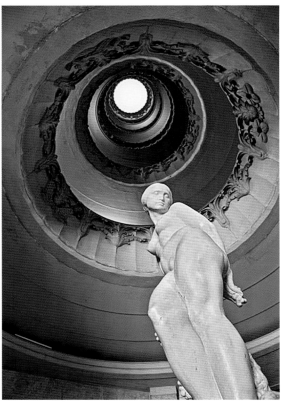

Left: The boudoir in the Gomez Waddington house, probably designed by Jansen, is an abstracted neoclassical setting with glamorous French furniture upholstered in embroidered satin.

Below left: Sober art deco details and dynamic massing are combined in the compact front hall of the Francisco Arguelles house in Miramar.

Below right: The stair of this late Vedado apartment building frames a central skylight.

Opposite: The sinuous spiral of the handrail plays against the bold geometry of the tiled floor in the rationalist/art deco–style house designed for Hilda Sarra by Rafael de Cárdenas.

The Francisco Arguelles house in Miramar was a completely deco creation that featured an entry overdoor panel by sculptor Juan José Sicre, unusual geometric moldings, and a dramatic entry hall with a small-scale Busby Berkeley staircase. Injections of art deco were found in the interiors of the Gomez Waddington villa, where deco pieces like a Jean Charles Moreux cocktail table were juxtaposed with traditional French furniture. In the 1931 Crusellas house, an art deco dining room was installed in an otherwise Spanish Renaissance–style mansion, showing how the international style could be appropriated. The Vedado house of Hilda Sarra features an art deco–style stair within a rationalist design inspired by Le Corbusier. It was never unusual for a single Havana building to include a variety of design expressions.

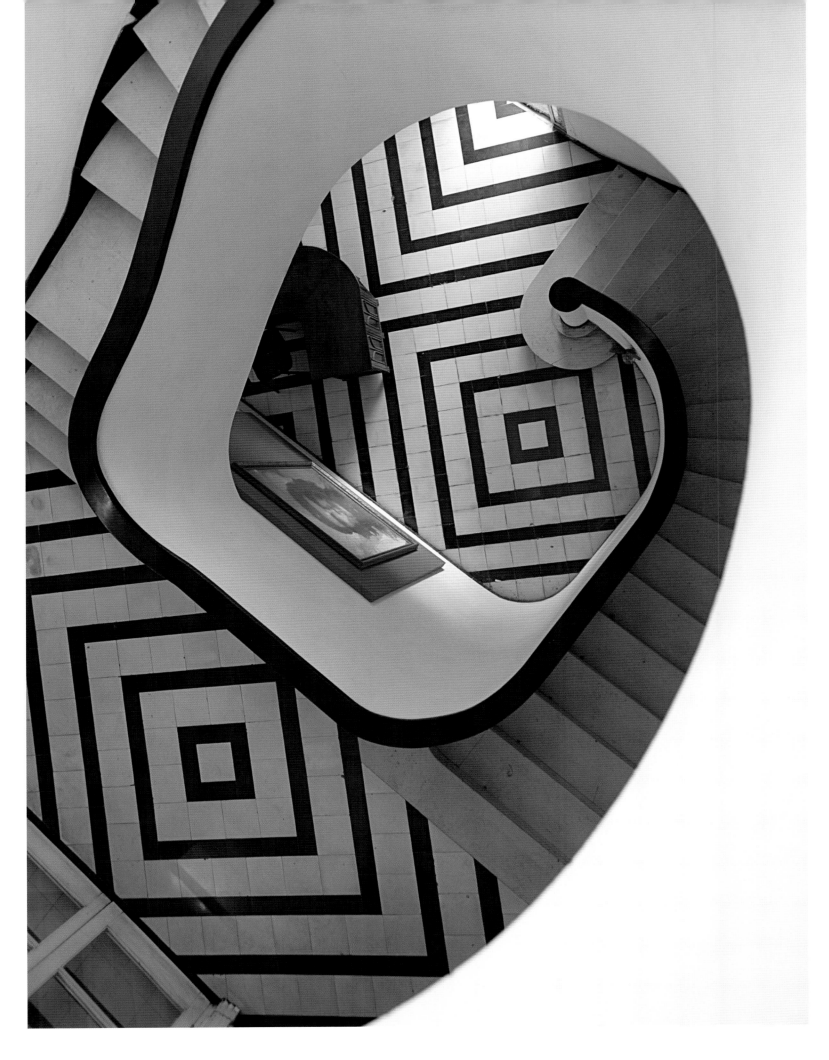

Opposite: The Bacardi Building lobby combines stepped, geometric forms with exuberant floral capitals on fluted pilasters; bronze lanterns emphasize the art deco style.

Above left: The exterior of the Bacardi Building is decorated with enameled terra-cotta geometric moldings and sculptural panels in boldly contrasting colors.

Above right: The parabolic arch framing the entry to the Church of San Agustin imparts a bold, geometric monumentality and references the reinforced-concrete structural system.

The new library at Havana University demonstrates how the art deco style could be used to update a classical building type and integrate well with the Beaux-Arts buildings of the campus. Similarly the Church of San Agustin is a successful essay in the deco idiom by premier classicists Morales y Cia. Parabolic arches give the interior a modern dynamism that is matched outside by an imaginative facade composition. The Teatro America movie theater was inspired by New York venues like Radio City Music Hall, with curving stairs alluding to the glamour of the films themselves. The iconic Bacardi Building of 1930 features exotic allusions—references to Babylonian ziggurats and their monumental gateways— that were sometimes incorporated in art deco designs. Ceramic panels by Maxfield Parrish decorate the exterior, while the interiors are characterized by a highly contrasting color palette, elaborate moldings and light fixtures, and patterned terrazzo floors.

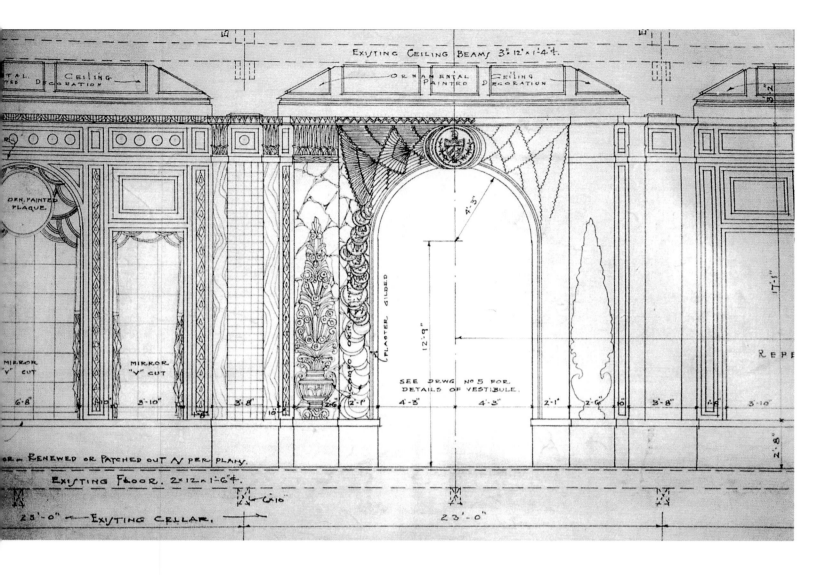

Schultze & Weaver refurbished the Casino Nacional in a deco style that appropriately alluded to Havana's tropical setting. Although the rooms have disappeared, the architect's drawings and period descriptions allow us to envision the glamorous effect of the polished metal finishes and moldings representing palm trees and tropical vegetation.

During the 1930s, Cuban intellectual and artistic life experienced a surge of interest in the past, including the traditions of the African population. This interest again followed a European precedent, manifested in the incorporation of images of African sculpture in works of art and in a new enthusiasm for collecting the pieces themselves. Perhaps the most famous example was Pablo Picasso's *Demoiselles d'Avignon*, painted in 1907. Among the Parisian collectors of tribal pieces was the fashion designer Jacques Doucet, who, in 1923, commissioned radical furniture from Pierre Legrain that combined African elements with the art deco aesthetic. Two years later, Josephine Baker's Revue Negre launched a fascination with things African—and Cuban chanteuse Rita Montaner was one of the headline performers.

One of the earliest Cuban works to explore the heritage of the island's enslaved Africans was anthropologist Lydia Cabrera's book of stories, *Contes Negres*, published in 1936, while she was a student at Ecole du Louvre in Paris. The same year, the Society for Afro-Cuban Studies was founded in Havana by her mentor and uncle, Fernando Ortiz, a collector of the musical

Right: The cockfight, a Cuban tradition, is depicted in a mural above the bar in the house of Eutimio Falla Bonet.

Far right: Lydia Cabrera conducting her fieldwork.

Below: Wifredo Lam's wife, Helena Holzer, surrounded by his paintings and collection of African art, 1947.

Opposite above: A drawing for renovation of the Casino Nacional by Schultze & Weaver suggests glamour with a classical framework of ceiling coffers, wall panels, and moldings executed in rich materials with art deco details.

Opposite below: A cover for *Carteles* magazine, designed by Andres Garcia Benitez in 1933, presents Afro-Cuban folklore in a language of art deco geometry.

instruments used in Afro-Cuban religious rites. As early as 1906, Ortiz began to publish his research on aspects of slave folklore, eventually launching the magazine *Archivos de Folklore*. These intellectuals felt the Afro-Cuban tradition, particularly in music and dance, was a part of the nation's popular culture that was worthy of serious study and celebration.

At the beginning of World War II, Lydia Cabrera returned to Havana, where she became the center of an artistic and intellectual circle that included other recent arrivals from Europe: painter Wifredo Lam, writer Alejo Carpentier, and art dealer Pierre Loeb. Soon, Cabrera began exploring Cuba's African traditions in a systematic way, traveling throughout the island, conducting interviews with survivors and descendants of the African slave past. Around 1938, Cabrera and her life partner, Maria Teresa (Titina) de Rojas, began restoring the latter's colonial era villa, La Quinta San Jose, in suburban Marianao. The interiors are enhanced by the historic elements the couple salvaged from demolished colonial buildings: paneled doors, stained glass, carved wood columns, and Spanish tiles.

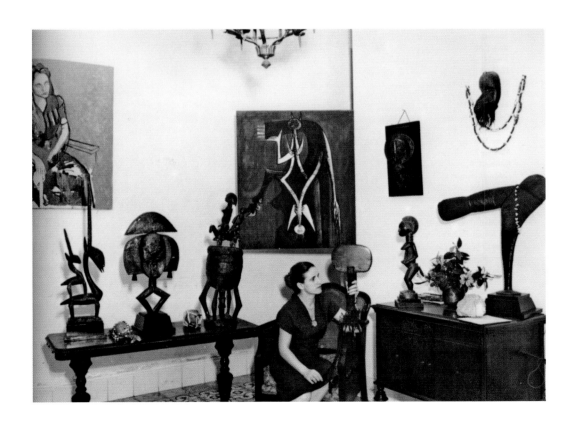

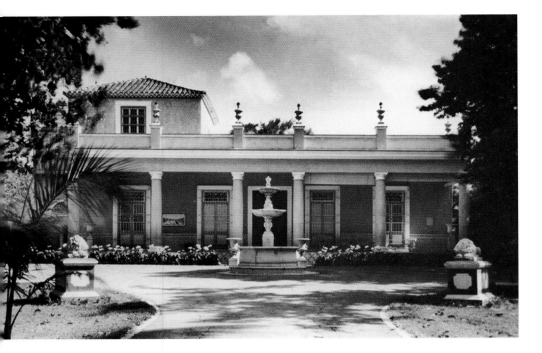

In 1931, *Social* sponsored a photography competition to document the island's historic architecture. Cabrera's own snapshots meticulously documented the most varied details of the island's disappearing colonial architecture. In 1938, the eighteenth-century baroque palace of Mateo Pedroso, which Titina had inherited, was restored by Joaquin Weiss, an early example of historic preservation on the island. Other important restorations of the time include the Palace of the Captains General, the cathedral portico, and the eighteenth-century mansions on the cathedral square. Also dating from this period are the creation of the National Archaeological Commission and of the Office of the Historian of the City of Havana, the entity that oversees the important preservation work in the city today.

Interest in the preservation of the island's Spanish colonial heritage found a champion in philanthropist Eutimio Falla Bonet, whose oceanfront Miramar home was the antithesis of a showy millionaire's mansion. The 1938 house tries to impress no one. It is an abstraction of the Spanish colonial house by a designer who thoroughly understood the essence of colonial buildings and used that knowledge to inspire the creation of a completely contemporary house. Architect Eugenio Batista organized the house around a series of courtyards, overlooking a dramatic swimming pool and the ocean beyond. Porches open to sea breezes served as the main social spaces of the modestly scaled house of one of Havana's wealthiest young men. Falla Bonet's legacy included the restoration of two eighteenth-century churches considered monuments of Cuban baroque architecture, using the Havana ateliers of Parisian decorators Jansen for the work. Coincidentally, one of those churches, Santa Maria del Rosario in suburban Havana, featured an early depiction of "representatives of all social classes and sexes"—including an African slave.

Above left: La Quinta San José, Lydia Cabrera's colonial summer villa in Marianao, was an early restoration project.

Above right and opposite: Santa Maria del Rosario, in suburban Bejucal, is one of two baroque churches restored through the generosity of Eutimio Falla Bonet.

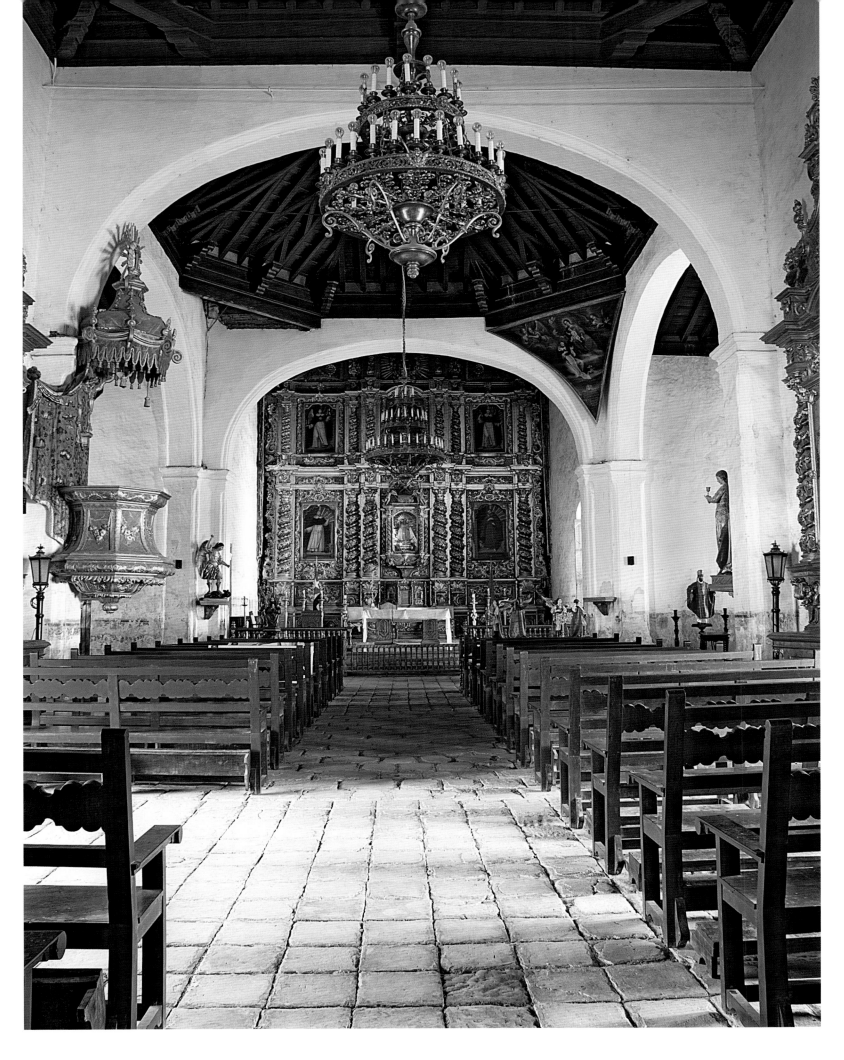

Country Club Mansions

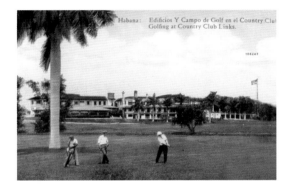

Above: An early view of the golf course and the original clubhouse buildings that formed the core of the Country Club development.

Opposite: The principal avenues of the Country Club Estates are notable for their winding layout, lush landscaping, and eclectic mansions set back on large, gated properties.

Havana's most exclusive residential neighborhood, the Country Club Park and Lake ("El Country"), was created by a group of American and British investors who in 1911 decided to build a golf course in the city's western suburbs. The Country Club Realty Company soon began accepting local investors, and in 1914 hired the Boston landscape architect Sheffield A. Arnold to design a subdivision in the spirit of the garden city concepts then fashionable in Great Britain and the United States. El Country featured winding, tree-lined avenues in the picturesque style of Frederick Law Olmsted, breaking with the grid layout that characterized Vedado and Miramar.

The development featured a golf course dotted by majestic royal palms and a sprawling clubhouse for the Havana Country Club where members could clinch their business deals in the American style at the 19th hole. The corporation offered over five hundred generous building lots laid out by the landscape designers to take advantage of the rolling topography and the lush landscape, which was animated by a beautiful lake in the shape of the island of Cuba and several small rivers. The neighborhood was contemporary with the development of Beverly Hills, its closest American counterpart.

Advertisements for El Country claimed that this neighborhood would be the Tuxedo Park of Havana. A 1918 advertisement in *Social* brags that the first offering of building sites had sold out to the island's leading families including Lobo, Herrera, Suero, Crusellas, Galban, and González de Mendoza: "Anyone can say I live in Vedado, but not everyone can say I live in Country Club Park."

This exclusivity was balanced by the promise of modernity. Another *Social* ad proclaims that it is old-fashioned to live in the city—a jab at the leafy streets of Vedado, whose mix of social classes and building types was now judged objectionable. While a new bridge across the Almendares River and use of automobiles allowed easy access from Vedado, the physical distance from the city center reinforced the desired sense of exclusivity and country living at El Country.

Clubs were a lynchpin of the westward expansion of Havana's new neighborhoods; developers would piggyback promotion of their new neighborhood onto the popularity of the clubs that already existed nearby.

Havana's club life dated to the 1880s when the Vedado Tennis Club was established for aristocratic aficionados of that sport. Over the next decades club facilities were built all the way

west along the Marianao oceanfront: the Miramar Yacht Club, the Havana Yacht Club, the Biltmore Yacht Club. Club life became integral to Havana's elite: children congregated there after school and competed in athletics, the family spent a Saturday together at the beach facilities, and young couples met and courted at clubs. New "American style" social events became popular after Independence—baby showers and bridge clubs—along with Cuban debuts, quinces, and weddings. Each club was known for a signature social event—New Year's Eve at El Tennis, the Christmas Day Tea Party and the *Baile Rojo* at El Country.

Luxurious homes and estates displaying the myriad architectural styles that were fashionable from the 1920s through the 1950s were constructed in El Country and the nearby Biltmore up until the revolution in 1959. These were the residences of members of the American expatriate community, European immigrants who had made fortunes in Cuba, and the children of the most successful characters from the early Cuban republic, heirs to fortunes in tobacco, sugar, and other commerce.

Today the neighborhood is officially known as Cubanacan, and the winding tree-lined streets and boulevards are home to many foreign ambassadorial residences, including the American Residence, which take advantage of the privacy and security offered by the generous properties. A number of Country Club houses have been converted into Casas de Protocolo or government-operated, diplomatic guesthouses.

After 1961 the verdant site of the Havana Country Club became the campus of the Instituto Superior de Arte. Designed by three young "revolutionary" architects, Italians Roberto Gottardi and Vittorio Garatti, and Cuban Ricardo Porro. The domed brick buildings housing dance, fine art, and music schools immediately became symbols of the new Cuba. The project stopped due to lack of funds, and the campus fell into disrepair until 2001, when the government approached the original architects to restore the buildings. Today, the campus is a thriving arts center and university, and the buildings are considered important achievements.

Humara y Maderne

Set behind thick hedges and secured by iron gates, the mansion of the Humara y Maderne family is set high on a hill overlooking the curves of Avenida 146. This house illustrates the

Above: The most socially significant beach clubs of the Marianao coastline—the Biltmore, the Havana Yacht Club, and the Miramar Yacht Club—were easily accessible to the residents of El Country.

Opposite: The Beaux-Arts classicism of the Humara house conveys an aloof dignity detached from the tropical setting. Tall hedges with ornate iron gates protect the privacy of the family. On the interior the double-height stairwell is surrounded by a classical arcade, an allusion to a Cuban colonial courtyard, while iron railings and geometric marble floors add an eighteenth-century French flavor.

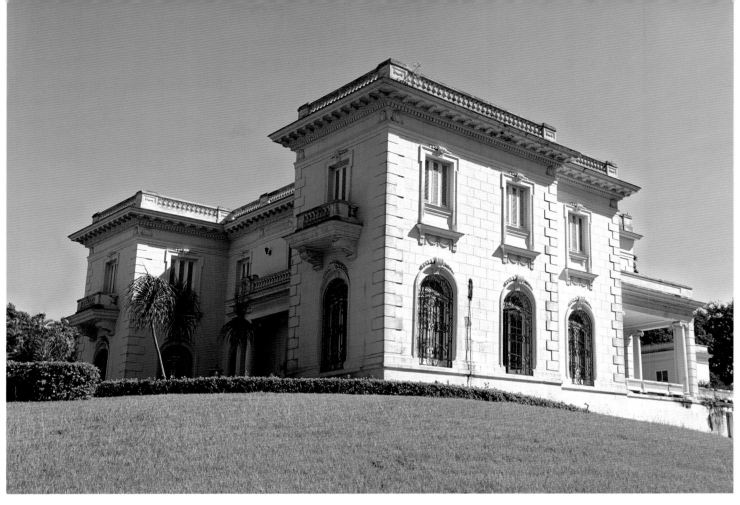

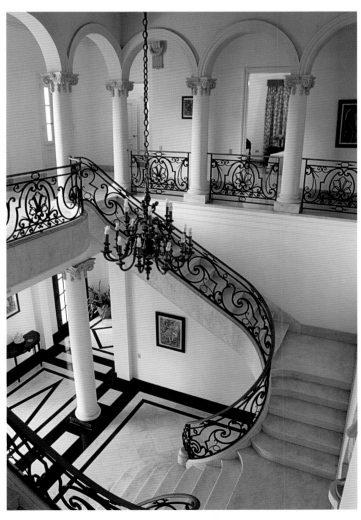

sense of remove that the developers of El Country used to promote the neighborhood. The exterior recalls the classical "boxes" of sugar boom Vedado, executed here at a larger scale— a society grande dame conveying formality. The facades display decorative Beaux-Arts details, which catch the bright Caribbean sun and create visual interest. Rusticated blocks accent the corners; a detailed cornice caps the house and supports a rooftop railing of turned balusters. Projecting balconies bring relief, and arched openings and window frames are enriched with classical garlands. Above the door, centered in the scrolling ironwork is the initial "H." The builder, businessman Miguel Humara y Maderne, was the son of Spanish immigrants. He owned a television station and represented RCA on the island, importing appliances, projection equipment, generators, and radio equipment.

The two-story stair hall is a dramatic space, recalling the central patio of a colonial house surrounded by classical columns supporting arches on the second floor. White marble floors with bold black designs convey a sense of coolness, reflecting the light and relating to the simple arched frames around doors. The bedrooms, ranged around the open stairwell, are pleasantly isolated from each other, and the marble baths represent the height of Roaring Twenties luxury.

Antonio Tarafa

One intersection of Avenida 146 seems to have belonged to the Tarafas, with three members of this influential family choosing to build houses there. Antonio Tarafa and his sister Laura lived on one side of the landscaped avenue, and Laura's daughter, "Chinie" Gomez Tarafa, built her house across the way. The patriarch, Colonel Jose Miguel Tarafa de Armas, was the most successful of the officers of the War of Independence in turning a military career into a lucrative business career. His American education made him the perfect business associate for the United States investors. The colonel built railroads throughout the island and constructed the port of Puerto Tarafa on the northeast coast. He convinced the Cuban Congress to designate his port the sole point of export for all the sugar mills in that important stretch of the island. Tarafa was one of only a few Cuban founding members of the Board of the Country Club. His son Antonio served as president of the family's sugar concerns and was an early promoter of air travel, acting as president and chief stockholder of Compania Cubana de Aviacion, the national airline.

Antonio Tarafa's house, designed by Govantes y Cabarrocas, is clearly visible behind a distinctive wall of rough stone that separates the property from the rare pedestrian. This connection of public and private zones is unusual for a neighborhood where most houses are concealed behind dense hedges and iron fences. A corner tower anchors the exterior, suggesting solidity and privacy. Scrolling brackets support sloping tile roofs, areas of the facade project to become pilasters, arched openings are framed by contrasting keystones. The style is Cuban eclectic—somewhere between Beaux-Arts classical and the Spanish colonial revival.

An unusual porte cochère projects off the side elevation to protect arriving visitors from the island's torrential rains. The importance of this entry, compared with the almost modest tile canopy over the front door, confirms the reliance on the automobile that was crucial to the neighborhood's development.

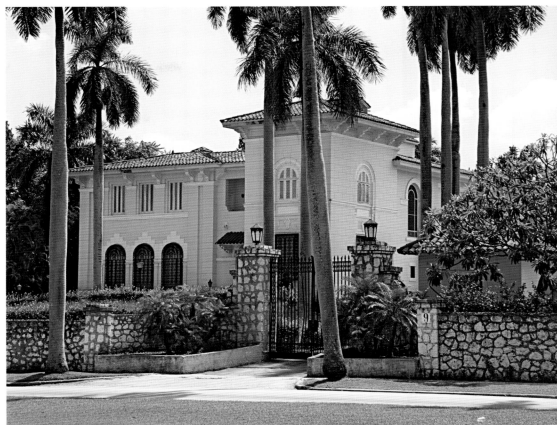

Govantes y Cabarrocas designed Antonio Tarafa's house in a signature style that combined classicism with more eclectic references. Iron gates, in a 1940s-style geometry, are an unusual element used between the public rooms and the front hall.

The ground-floor spaces are simple. Unadorned plaster arcades define a generous hall and support a simple wood beamed ceiling. The arched openings connecting to the living and dining rooms are fitted with beautiful pairs of partial-height iron gates, heirs to the colonial *mamparas*. The stair is lit by the traditional *vitral*, a tall arched window, decorated by an elaborate iron grille rather than the typical stained glass.

Laura Tarafa

Across the street from Antonio Tarafa's tower house is the chic Mediterranean-style home built by his sister Laura. The restrained Mediterranean details are a clue to the personality of the owner who spent most of the year in Rome. A very Cuban touch, however, is provided by the pair of enormous clay water pots or *tinajones* originally from the Tarafa sugar mill in Matanzas.

Laura Tarafa entrusted the interiors of her house to the most famous and glamorous decorating firm in the world, Maison Jansen of Paris. Jansen had set up offices in Havana to cater to this affluent clientele and their workshops were staffed with the most talented craftsmen, carvers, and upholsterers both in Cuba and in Europe. The focal point of the celestial blue entry hall is a unique carved-glass window lighting the sweeping marble staircase. The scene of a maiden playing the harp surrounded by forest creatures is the work of A. Labouret of Paris, and it is rendered in the unusual *dalle de verre* technique.

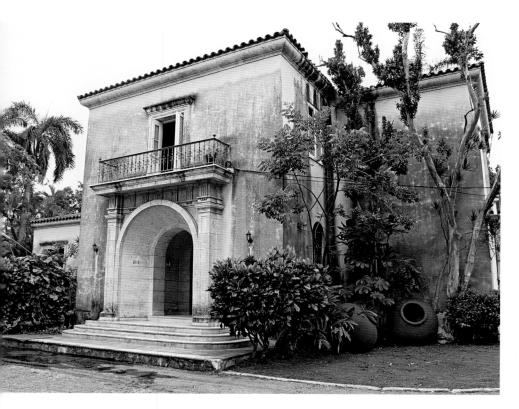

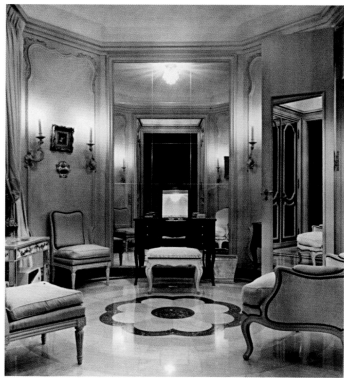

In the aftermath of the revolution, the house became a workshop for artistic ceramics and is currently a center for distribution of textiles. Despite many changes, much of the architecture of the master suite remains as Laura left it. The exquisite Louis XV tables and Jansen side chairs have not survived, but the marble floor and rococo-style paneling that define this perfect space endure. The master bath beyond is covered in slabs of boldly figured brown and gray marble. The master bedroom illustrates the transition from the glamorous past to the more mundane present—here the airy carving of the paneled walls contrasts with the textile-processing equipment.

Laura Tarafa and her two sisters were heirs to the family interests as well as major stockholders in the Trust Company of Cuba. The women were important patrons of Havana's cultural life supporting music, historic preservation, and even the anthropological research of Lydia Cabrera. Laura, especially, was known for her international circle of society friends; guests at the house included the Bulgaris and Christian Dior. While Laura moved to Italy soon after the revolution, her daughter Chinie remained in her own house across the street, splitting her time between Havana and Rome and finally bringing her mother's ashes back for burial in Havana.

Albert and Sylvia Kaffenburg

Rafael de Cardenas's prize-winning house for Americans Albert and Sylvia Kaffenburg is especially successful in connecting the house interior to the exterior. Its compact floor plan is defined by galleries and outdoor rooms surrounding a landscaped courtyard, creating a variety of pleasant spaces. A swimming pool and pool house set in the extensive grounds must make this one of the most pleasant Casas de Protocolo for foreign guests to visit. The siting of the house close to the street makes the privacy of the garden possible.

Sober classical details mark the front door of Laura Tarafa's Mediterranean-style house. The octagonal dressing room combined painted wall paneling with mirrored closet doors, an inlaid marble floor, and French furniture in the Louis XV and XVI styles.

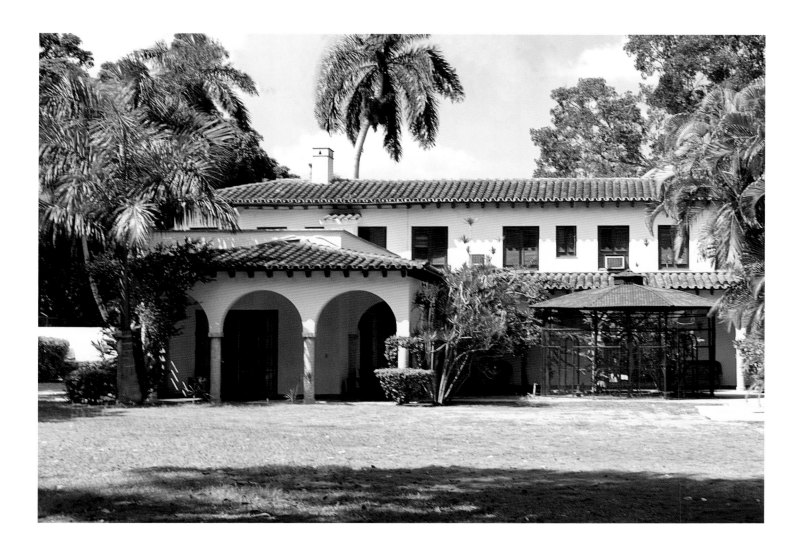

The arcades and courtyard overlooking the garden of the Kaffenburg house give an idea of the integration of architecture and landscape achieved by the American designer Milton Link.

The front facade is almost unwelcoming: its flat, two-story plane is animated by only a few picturesque elements judiciously arranged on the facade. The entry is marked by baroque pilasters framing an arch executed in rough Jaimanitas stone; the tall leaded glass window of the stairwell is unmistakable.

At the time of this design, de Cardenas had returned to Havana from Los Angeles, where he earned a postgraduate degree while working with decorator Paul Frankl and architect Richard Neutra. The Kaffenburg house would fit in perfectly in Beverly Hills. In awarding the 1940 gold medal, the jurors at the National College of Architects must have appreciated the way the design sits somewhere between contemporary and historical.

Archival photographs show a variety of seating areas for lounging or enjoying a game of bridge in the shaded galleries, the courtyard, or the poolside terrace. Today, a massive iron aviary occupies the center of the courtyard. Crucial to the achievement of this indoor/outdoor lifestyle was the work of American landscape architect Milton Link, whom Sylvia Kaffenburg had brought to the project from Florida. The pool house is probably a later addition using the materials and scale of the house to extend the built environment into the mature tropical landscape, punctuated by old royal palms. The details of Link's landscape have not survived, but the idea of outdoor living he and de Cardenas envisioned remains clearly evident.

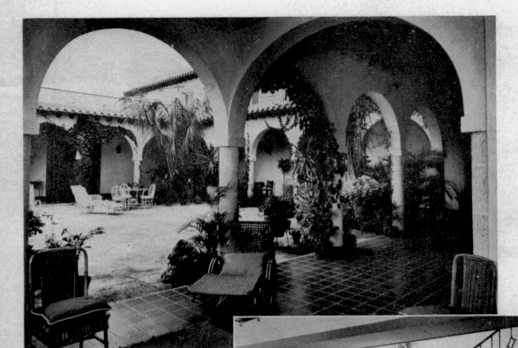

Detalles del patio y galerías de la residencia del señor Kaffenburg.

RAFAEL DE CARDENAS

ARQUITECTO

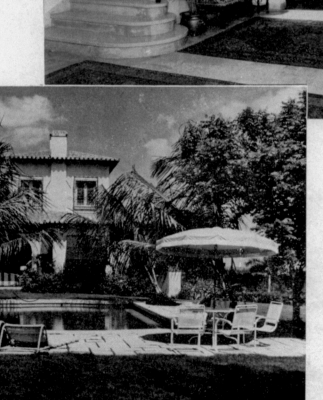

Detalle del foyer y escalera.

Piscina enclavada en uno de los jardines.

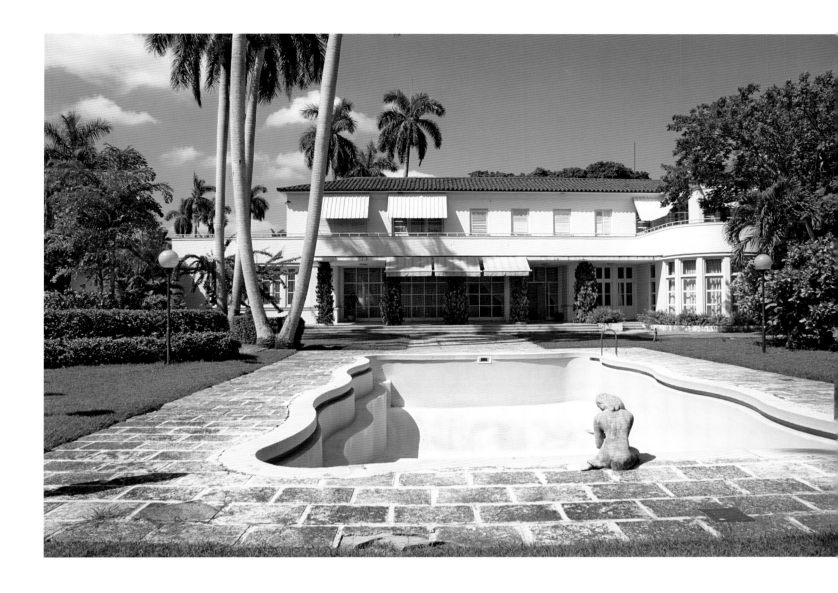

Pepe Gómez Mena

Above: On the rear of the Gómez
Mena house is a semicircular
dining room and a deep porch
overlooking the sinuous pool. The
sculpture is by Rita Longa.

Opposite: Architect's advertise-
ment illustrating the Kaffenburg
house, which won the 1940 gold
medal of the National Architectural
Association.

In the 1920s, sugar baron José (Pepe) Gómez Mena built one of Vedado's most luxurious mansions—a perfect pavilion created by the Parisian architects in charge of restoration at Versailles. It appears that a divorce from his first wife precipitated a move from his palace, now the Museum of Decorative Arts. For his new trophy wife, Elizarda, one of the glamorous quartet of Sampedro sisters, Pepe built a rather inconspicuous Streamlined Moderne house in the Country Club district. The spacious home suited both the casual get-togethers and the gala nights that the couple enjoyed hosting. Elizarda's sister, Edelmira, Countess of Covadonga, was part of their ménage, living in an upstairs guest room after her divorce from Crown Prince Alfonso de Borbon, heir to the Spanish throne.

Those who knew the house in its heyday were unimpressed by architect Adrian Macia's design: the nautical allusions of pipe railings and a bowing wing, curving slab canopies, and the horizontal and vertical masses of windows. Family members say Jansen was set to install their decoration of the house when the revolution occurred. The living room featured Pepe's collection of paintings by Joaquin Sorolla and the upstairs hall was lined with Elizarda's collection of palettes of famous artists. Simplicity might have been the point for Pepe. Having created the finest French house in town, it must have been refreshing to live

189

in these bright, cool spaces where interior opened seamlessly to exterior. Today, a series of leafy "tree-columns" create a beautiful transition between the shaded porch and the pool terrace and landscape beyond.

Perhaps the house was an intentionally blank canvas. It was transformed again and again by party decorator Mario Arellano, who ringed the pool with banquet tables for Gomez Mena's 1947 dinner in honor of King Leopold III of Belgium, his consort, and his young heir. Arellano was also responsible for "theming" the annual Christmas party—one year a Christmas tree floated above the waters of the pool. Today the house is known simply as "Casa 5," and in spite of its simplicity, it functions as one of the capital's premier protocol houses.

The Swedish Ambassador's Residence

The current Swedish ambassador to Cuba is a stylish diplomat who has achieved the almost impossible: making an official residence feel like a family home. While most official houses lack personality, the Swedish residence conveys a strong identity, both as a home and as a showcase for Swedish design. Located on a prime lot on the former Grand Boulevard, the house is less formal than its neighbors. A single-story entry wing with rustic stone walls and tile roof overlays the two-story mass of the house—a comfortable midcentury house found in America's affluent suburbs. The compact interior planning, with a strong connection to the outdoors, and the use of vaguely traditional details made sense for the era's conservative clientele. The builders were Dr. Manuel Vergara Yanes and his wife, Rosa Blanco Ramos, the daughter of sugar baron Francisco Blanco Calas, whose own, more traditional, house is next door.

The interior is cool and clean—and Swedish. A split-level front hall leads to a sweeping stair or down toward the sunken living room and dining room. Panel moldings and simple cove cornices create an elegant background in these rooms, probably the work of interior decorators Mario Arellano or Carlos Mendoza. The generous rear porch is the true heart of the house, anchored by rough stone walls behind a curving wood bar. The deep roof overhang keeps the space shaded and allows the garden to come inside; the cool terrazzo floors of the interior extend outdoors.

Today, the house features signature Swedish furniture and fabrics from the 1940s and 1950s, which feel surprisingly at home in Havana. The living room side chairs by Josef Frank are midcentury updates of the Louis XV style, and they complement the original wall paneling. A Frank cabinet-on-stand displays eighteenth-century Swedish porcelain. The colorful Frank fabric of birds and trees could easily represent Cuban nature. The dining table and chairs are midcentury Swedish and also play at updating the abstracted eighteenth-century style of the wall panels. A charming lead fountain of a beaming child displaying a seashell brings the garden inside the room. A spectacular Swedish midcentury chandelier suggests tradition. Throughout the house are framed engravings of plants inspired by the works of early-twentieth-century Swedish botanist Erik Leonard Ekman who spent time studying in Cuba.

Festivities at the Gómez Mena house: dinner in honor of King Leopold III of Belgium, his consort, and son and the annual Christmas party.

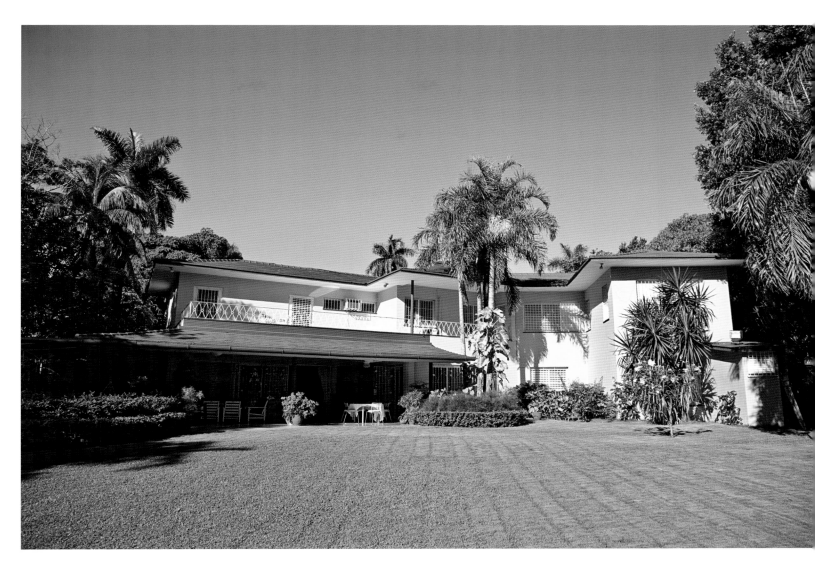

Above: Social life in the residence of Cuba's Swedish ambassador centers around the deeply shaded back porch, which accommodates informal seating, al fresco dining, and a period cocktail bar.

Right: Midcentury Swedish furniture and fabrics suit the period and lifestyle of the living room.

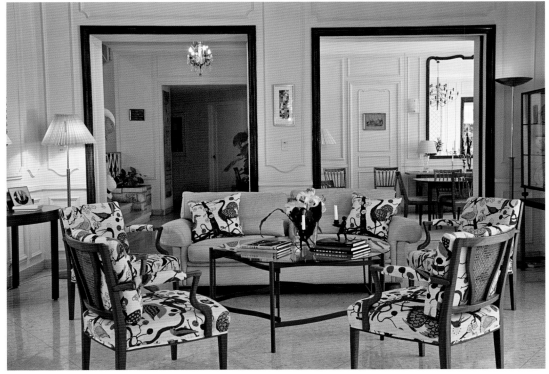

The United States Ambassador's Residence

The mandate to the team building the United States Ambassador's Residence in 1940 was to create the most impressive diplomatic residence in the western hemisphere to represent and reinforce the strong business and political ties uniting Cuba and the United States. The house would also reflect the stature of the post. As former ambassador Earl E. T. Smith testified to the U.S. Senate: "The United States, until the advent of Castro, was so overwhelmingly influential in Cuba that the American Ambassador was the second most important man in Cuba, sometimes even more important than the [Cuban] president."

The architectural publication *Cuba 1941* published the rendering *Residencia del Embajador de los Estados Unidos en Cuba*. Construction began in May 1940, during Franklin Delano Roosevelt's third term, and the cornerstone was laid in 1941. The resulting house is one of the most striking U.S. diplomatic residences in the world, a symbol of American power at the end of the Great Depression as World War II engulfed Europe and Asia. The design and construction coincided with the American defense of the Atlantic and Caribbean waters against Axis submarines and U-boats and with a major effort by the U.S. military to build up the Guantánamo Bay naval base, which was created in 1903 on the eastern tip of the island. The ambassador moved into the residence in 1942 as originally planned, the construction having proceeded despite the chaos, rationing, and shortages brought on by the war, which the United States had officially entered a year earlier. By the end of World War II, American dominance was affirmed, and the residence was ready for its role in U.S. involvement in postwar Cuban prosperity.

The design process for this type of building differs from that of a typical family home. Decisions are made by a formal committee directed by architects working for the U.S. State Department's Office of Foreign Building Operations. The team in this case included two U.S. ambassadors to Cuba, George Messersmith and J. Butler Wright. Messersmith had been in charge of the Office of Foreign Building Operations so he was especially suited to the task.

Above: Bronze eagle from the monument to the victims of the sinking of the *USS Maine* in 1898.

Opposite: The curved colonnade of the porte cochère projects to receive guests. The rendering conveys the complexity of the program requirements and the monumentality of the design.

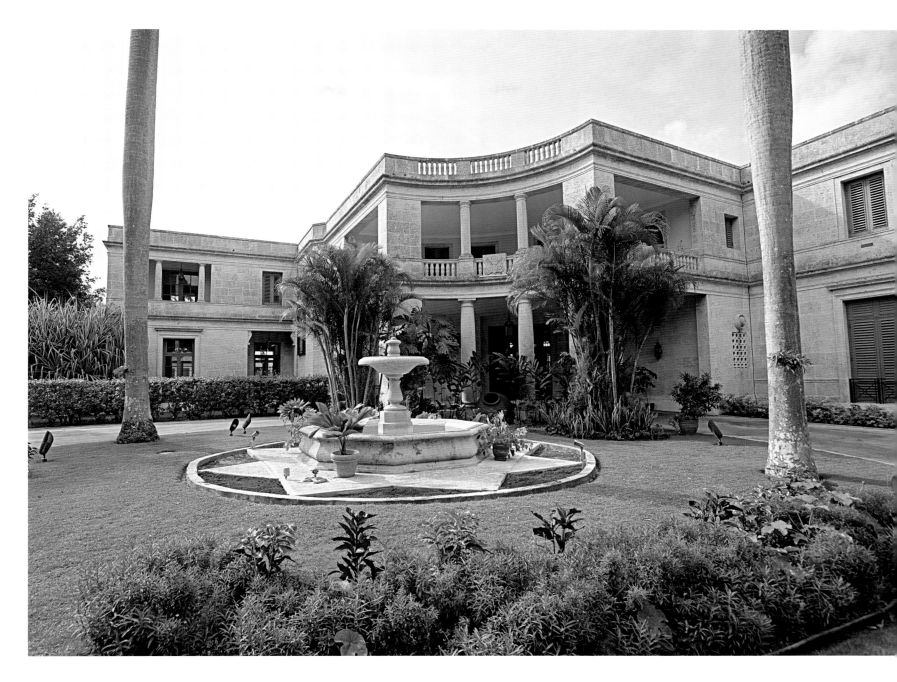

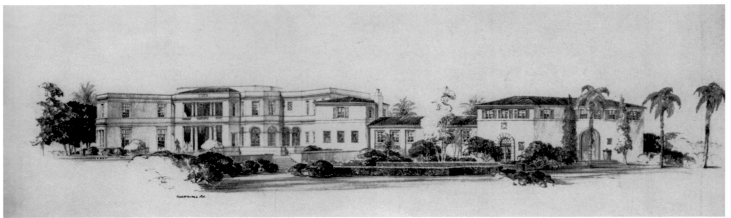

Ambassador Wright oversaw the purchase of eight building lots—on high ground, where the breezes are best—in the prestigious Country Club development. Three architects—Paul Franz Jaquet, Leland W. King Jr., and Frederick Larkin—were involved. Jaquet had previously collaborated with King on the U.S. ambassadorial residences in Lima, Peru, and Asunción, Paraguay. Larkin was responsible for design details related to services and landscaping. The Cuban architecture and engineering firm Mira and Rosich was awarded the construction contract.

The austere two-story mansion is in a neoclassical style, and its exterior of local Jaimanitas stone, now beautifully weathered, conveys a fortresslike feeling that cannot be accidental. The roof balustrade is a solid parapet instead of the more usual turned balusters. The residence's many requirements—to act as a symbol; to accommodate a family, endless guests, and a large staff; and to serve as an entertainment venue—resulted in a sixty-five-room building of more than thirty thousand square feet. The presence of an elevator in the building, unusual for Havana, seems to have been the basis for the rumor that the palatial residence was originally intended to be a winter retreat for Roosevelt, a place for him to relax and plan World War II strategy.

The challenge in designing such a huge structure is to humanize the scale. This was done partially by the push and pull of projecting wings that define outdoor spaces between them. The layout has been called butterfly shaped, with four wings emerging from the central core of the large formal hall.

A panel carved with an eagle is the focal point of the two-story entry colonnade. Within the State Department design vocabulary, the architects conveyed American grandeur. They responded to the Havana climate with a series of pleasant indoor-outdoor spaces—private porches for the family or their houseguests, grand covered terraces to be used in entertaining on an expansive scale. Throughout the house, the use of wood louvered shutters on all the windows and doors feels appropriately Cuban. Yet these shutters seem to protect against more than the sun, limiting the connection from the exterior to the interior life of the house, an impression conveyed in vintage photographs as well.

Following the Beaux-Arts tradition, the designers considered the sequence of spaces, beginning with the shelter of the curving porte cochère. The entry is through an iron grille, which might be considered an allusion to traditional Cuban materials. A semicircular vestibule, framed by columns, connects to a vast receiving hall at the heart of the building. The bold graphic effect of cream marble with contrasting black accents is introduced in floors and baseboards and continued on the stairs, where black risers and treads are carried by the curving cream stringer. Painted plaster panels, in an abstracted neoclassical style, frame the doors. In a 1957 photograph taken in this hall, Florence Smith, the glamorous wife of Ambassador Smith, stands next to a marble table arranging flowers. The same table, with its fluted classical column base, can be seen in a photograph of the hall taken during Vice President Richard M. Nixon's visit two years earlier.

The paneled dining room is a vast space designed for state dinners, now furnished with chinoiserie-decorated Queen Anne–style chairs surrounding the mahogany pedestal table. The room culminates in a floor-to-ceiling wall of glass that brings the tropical garden and light inside during the day. During Arthur Gardner's tenure as ambassador, the dining room glittered with an arrangement of cut-glass candelabras and serving pieces on the table, crystal sconces and chandeliers, and silvered tea paper on the ceiling. A freestanding screen concealed the pantry and kitchen.

The other important public space is the living room, a long, paneled room entered from the opposite end of the front hall. A plaster cornice decorated with medallions and leaves continues the neoclassical design, as does the simple fireplace mantel that is the focus of one wall. The luxurious fitted cream carpet installed in this room by Mrs. Gardner gave it a softness and warmth reinforced by the intimate seating groups she arranged. Chandeliers now hang from the two ceiling medallions, but the silk-shaded Chinese porcelain table lamps and standing lamps that Mrs. Gardner selected would have cast a softer light. She, like ambassadors' wives before and after her, sought to create a family home and imprint her own personal style on the house while respecting the symbolism of the official residence. The Gardners brought most of the furniture and artwork in the Ambassador's Residence—and, as important, the English butler and other staff—from their home in Palm Beach. Their daughter Suzanne vivdly recalls the profusion of flowers sent by guests in anticipation of a ball given by her parents to introduce her to Havana society. The 1955 society charity cookbook *Gusta Usted?* raved about "the refined grandeur that befits the most powerful people of our time."

Left: A glamorous diplomatic couple in front of the elegant curving stair. The wrought-iron railing and tall window recall the design of other Country Club houses.

Right: Designed to impress, the state dining room seats thirty-four in Queen Anne–style chairs arranged around a pedestal table. A wall of windows brings the tropical landscape inside.

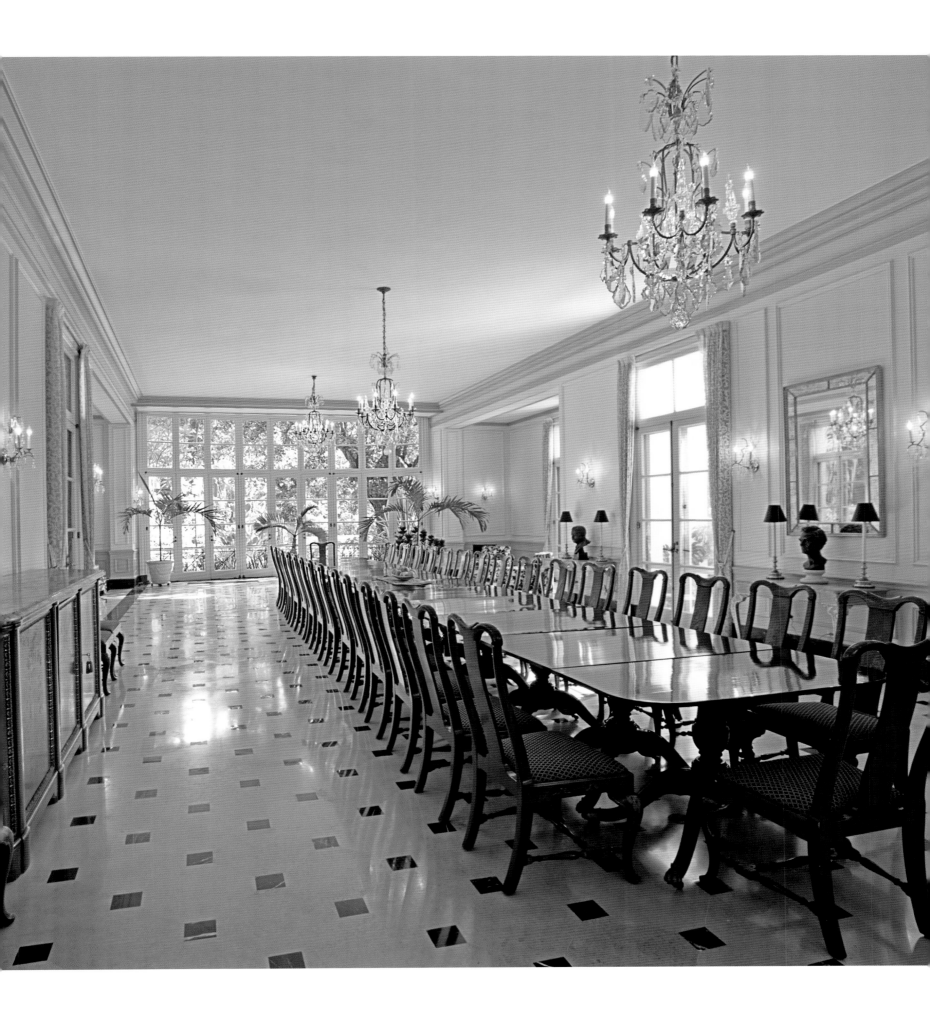

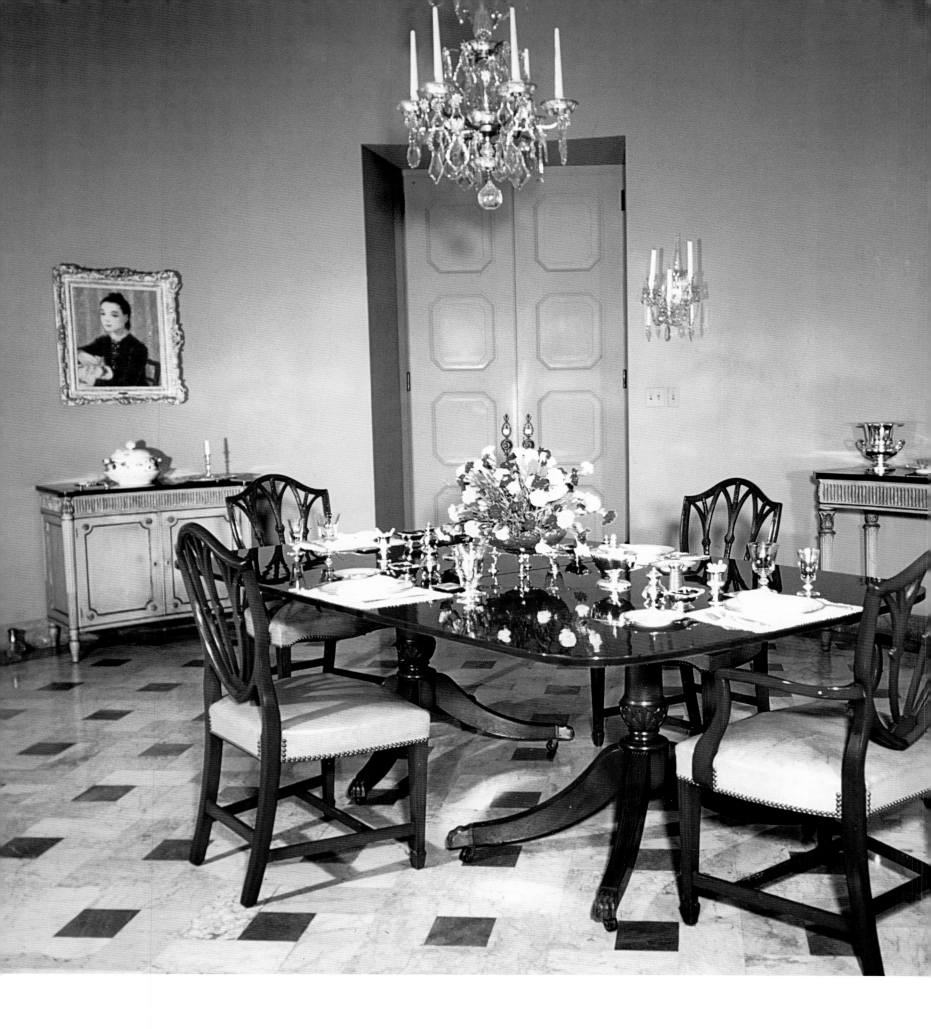

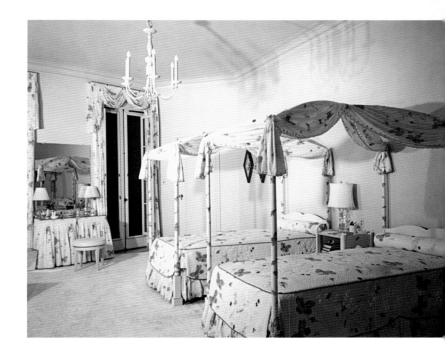

Ambassador and Mrs. Arthur Gardner brought family pieces to the residence during their tenure. The family dining room combined a mahogany table and Hepplewhite-style chairs and painted neoclassical-style pieces, as well as a painting by Dietz Edzard. A guest bedroom featured a charming floral fabric for the airy canopied beds, dressing table skirt, and curtains, while multiple seating areas and the soft light of shaded table lamps created intimacy in the formal living room.

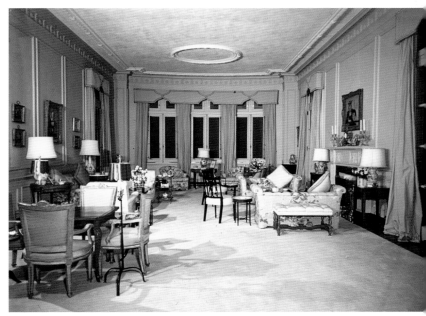

In contrast to these public spaces is the intimate oval-shaped family dining room, its arched openings—topped by fanlights—providing access to a shaded dining porch and the rear garden terrace beyond. A beautiful marble floor combines three subtle shades. Mrs. Gardner surrounded a small pedestal table with mahogany Hepplewhite chairs matching those in the dining room. Above a neoclassical painted console and commode hung a Dietz Edzard painting. This room in particular still evokes the family life that has always occurred in this home.

The second floor of the residence, designed to accommodate guests as well as the ambassador's family, includes seven bedrooms with baths, three sitting rooms, two dressing rooms, and a small kitchen. Each bedroom has its own loggia or balcony for enjoying the views, and a large porch overlooking the main terrace is an outdoor living room with views of the garden and, surprisingly, of the neighboring Casas de Protocolo.

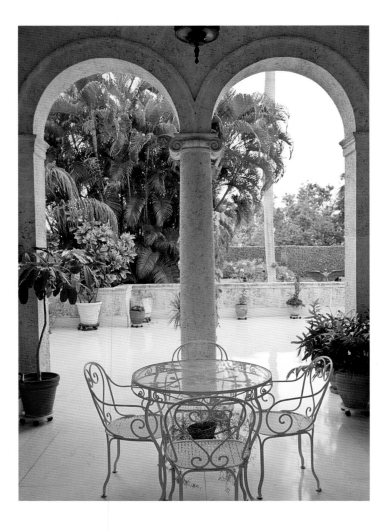

Left: An intimately scaled porch outside the family dining room provides a private spot for informal outdoor meals.

Right: The large porch off the formal reception hall connects the interior of the house to the terraces and vast gardens beyond.

A house with so many functions requires a variety of outdoor areas. A colonnaded porch, the outdoor equivalent of the formal hall, leads to a wide marble terrace. Beyond are the formal gardens. In 1954 an imperious bronze eagle was installed in the garden. It originally topped the battleship *Maine* memorial on the Malecón, but was toppled by a hurricane in 1926, not resurfacing for decades. A tennis court, large pool, and pool house are concealed in the landscape.

Americans began returning to Havana after the war, and the 1950s construction boom had much to do with accommodating their needs. The city's grandes dames once again planned lavish entertainments for diplomats and European royalty. When Winston Churchill visited Cuba, he dined at the U.S. Ambassador's Residence as the guest of Ambassador R. Henry Norweb. Bess Truman, Cardinal Spellman, Richard M. Nixon, and Senator John F. Kennedy were among the subsequent visitors.

The last U.S. ambassador to Cuba, Philip W. Bonsal, served from February 1959 through 1960. In 1961 the United States broke off diplomatic relations with Cuba, and the house became the residence of the Swiss ambassador. In 1977 it became the home of the Chief of the Mission of the U.S. Interests Section in Havana. One innovation of the current occupant has been the planting of a large kitchen and cutting garden of flowers, fruits, vegetables, and herbs for use in the house. The building remains a symbol and, as one of the most protected properties in the most secure neighborhood in Havana, there is a mystique about the house and its extensive grounds.

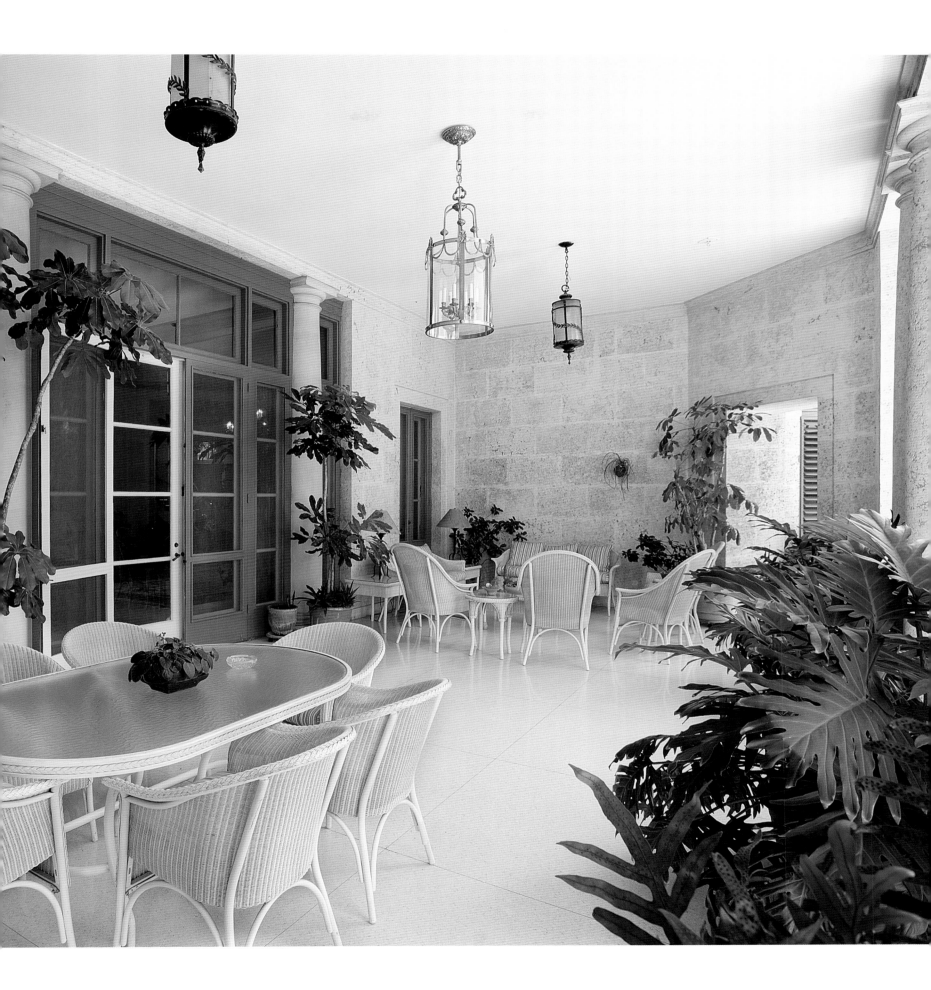

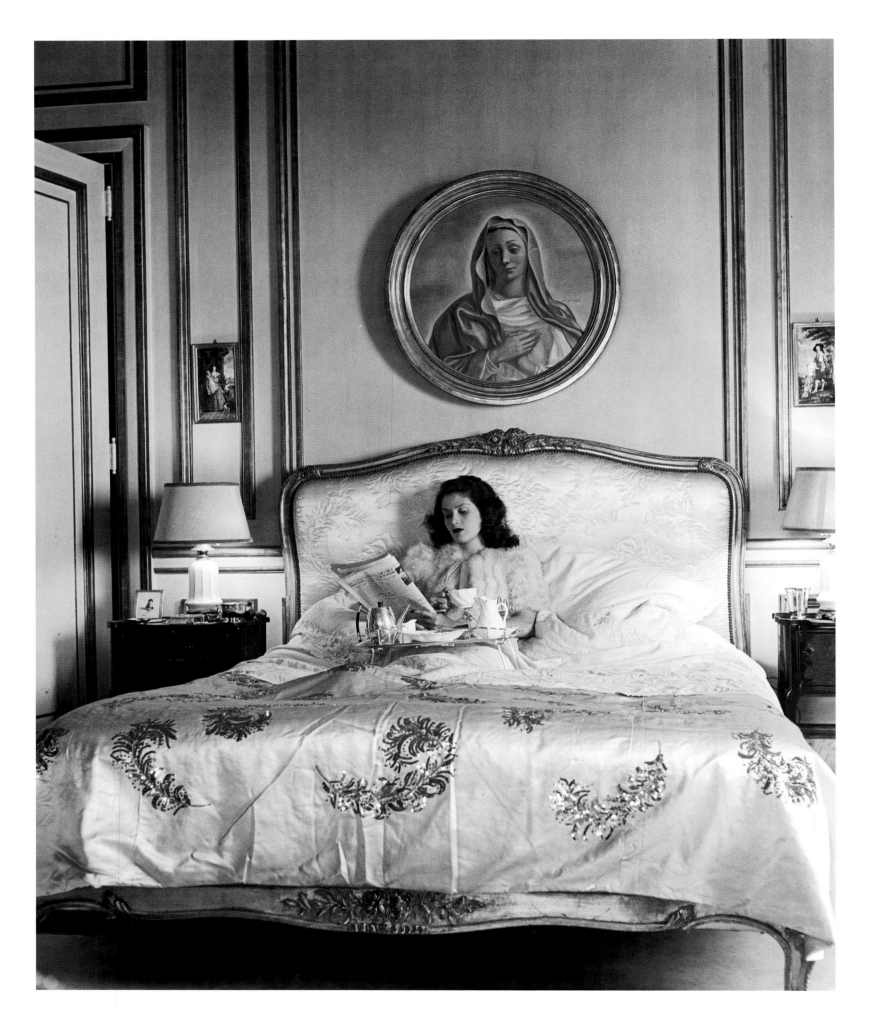

The Havana Tourists Never Saw

 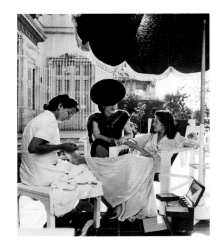

Above and opposite: Photographs for a *Life* magazine article featuring a day in the life of Alina Johnson Aguilera.

The February 1950 issue of *Life* magazine attempted to give readers a glimpse into the elegant life of Cuba's wealthiest families in the article "Cuba that American rum-and-rumba tourists never saw." The story included a picture of Pepe Gómez Mena's annual Christmas party with the much-anticipated décor by Mario Arellano. A dozen Havana beauties were featured wearing the latest couture purchased in Paris or during one of Christian Dior's sales trips to the island. A second *Life* article captured the postwar spirit of Havana in photographs from a day in the life of "Havana Glamour Girl" Alina Johnson Aguilera—breakfast in bed, a manicure in the garden, giving instructions to a staff of nine, all in her father's Jansen-designed mansion. In just a few pages, these articles conveyed the vast amounts of money this sophisticated class spent on clothes, schools, and parties. Cubans appear eccentric or exotic, but also well-versed in American culture—the result of fifty years of direct American influence.

Rum-and-rumba tourists were the most visible of the onslaught of visitors to the island at the end of World War II. Travel to Cuba was easy: airlines, ferries, and steamships connected Havana daily with the United States. All classes of tourists came to the island, but those on cheap package tours were the ones *Life* had in mind when referring to the average, unsophisticated snow-bird. Celebrities began returning to the island: socialite CZ Guest eloped to Havana and was married at Ernest Hemingway's Finca Vigia; Winston Churchill spent a relaxing week in the city smoking cigars and painting landscapes. Society hostesses vied to entertain a slew of visiting royalty, while *ancien régime* ladies considered it bad form to be fawning over these foreigners. Havana's hosts could offer their sophisticated guests a formal dinner dance at the Country Club followed by the casual style of their weekend getaways or their Varadero beach houses. Although hotels were being built at this resort, clubs like the Nautico and Kawama guaranteed the Cuban elite and their special guests never overlapped with the majority of tourists.

 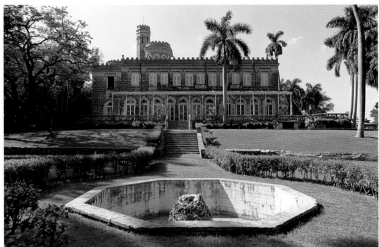

The vast resources of the elite were also directed toward the arts. Cultural milestones in the city's life included the 1955 opening of a new building for the Museo de Bellas Artes, which now featured ethnographic galleries dedicated to Afro-Cuban and Spanish colonial artifacts as well as European old masters. In 1956, the Count of Lagunillas donated his important collection of Greek, Roman, and Egyptian antiquities to the museum so the entire nation could enjoy his scholarly connoisseurship. About this time, bibliophile art collector Oscar Cintas offered his extraordinary collection of old master paintings and European decorative arts to the nation, but President Batista declined the offer because of the many conditions attached. Sugar king Julio Lobo assembled the largest collection of Napoleona outside of France, including a library dedicated to the subject, with librarians and their own cataloging system. These and other collectors like the Marquesa de Pinar del Rio made significant donations to the national museum.

A typical season at Havana's Pro-Arte Musical Auditorium might include performances by Victoria de los Angeles, Rudolf Serkin, Isaac Stern, and Arthur Rubinstein, in addition to concerts, ballets, and operas. Alicia Alonso, the Cuban prima ballerina who had captivated audiences in New York and London, might grace her hometown boards with one of her signature ballets. Among the important cultural institutions was the Lyceum Lawn Tennis Association, a ladies club known for lectures and thought-provoking exhibitions, as well as flower-arranging classes conducted by international masters.

The Augustinian friars of Pennsylvania opened the Catholic University of Villanova in the mid-1950s, conveniently located between Miramar and the Biltmore suburbs, reinforcing the detached lifestyle that characterized Havana's haute bourgeoisie. Classes here were not interrupted by the politically motivated strikes and closures that plagued those being educated at the University of Havana. Suburban sons attended high school at La Salle and Belen; daughters went to the Convent of the Sacred Heart; the coeducational Ruston Academy was another option. Other families preferred American boarding schools including Foxcroft and Choate, whose representatives periodically visited the island to recruit among their alumni.

It was during the 1950s that President Batista's membership application to the prestigious Havana Yacht Club was rejected, due, not so secretly, to his mixed-race ancestry. Batista did succeed in joining The Biltmore, one of the Big Five clubs at the top of the social hierarchy.

Left: Cuban-born ballerina Alicia Alonso captivated audiences from New York to London, dancing the classic repertoire and premiering contemporary pieces by George Balanchine and Agnes de Mille.

Right: Surrounded by terraced gardens, the castellated Quinta Palatino was built by an eccentric grande dame and was home to a Paris-based Cuban clan who returned to the island at the start of World War II.

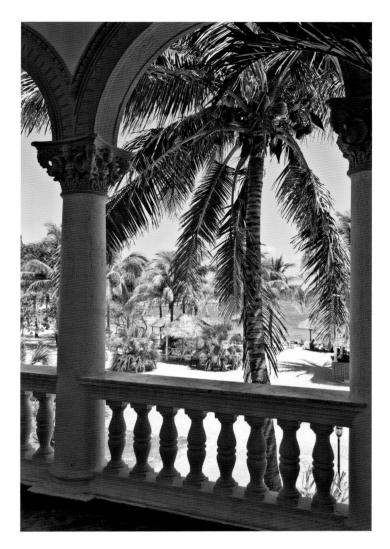

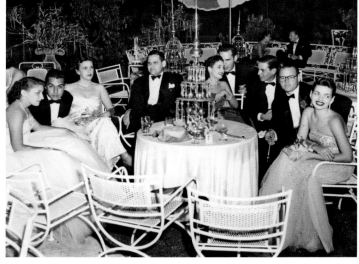

Left: The Spanish colonial–style arcades of the Biltmore Yacht and Country Club's second-floor galleries frame vistas of the beach.

Right top: Members of the younger set attending Pepe Gómez Mena's parties were often educated in American boarding schools in order to maintain ties to both countries.

Right below: Mario Arellano used French antiques to create an intimate atmosphere in Vedado's Cabaret Monseigneur, a supper club popular with the Cuban haute bourgeoisie.

Havana took its club life seriously, with many of the elite belonging to several. Children went swimming at the club after finishing their homework, mothers played a round of golf in the morning, fathers met associates for drinks after work. Members looked forward to annual events including the New Year's dance at El Country and their annual amateur musical revues. Batista might have been rejected by El Yacht, but his children attended school with the children of Havana's elite and his sons dated the daughters of Havana's old families so there were areas of social flexibility.

There were no membership requirements, however, for the enjoyment of Havana's famed nightlife—the casinos and horse races, the internationally famous Tropicana floorshows featuring headliners like Nat King Cole, Eartha Kitt, and Liberace in a modernist outdoor setting, the dives on the Marianao beachfront that were out of a film noir. Here the tourists and the local swells would indeed overlap, although affluent Cubans favored the Napoleonic dcécor of Cabaret Monseigneur, where Bola de Nieve played the piano for a mostly local audience. Cubans couldn't help but love the stylish supper clubs located in the brand-new American-style hotels in Vedado.

Finca Vigía,
House of Ernest Hemingway

From the comfort of his suburban Havana home, Finca Vigía, Ernest Hemingway was able to carry out his daily writing routine and indulge one of the passions that fed his spirit: adventures battling game fish in the waters of the Cuban Gulf Stream. Throughout the house were souvenirs of other, equally central loves: bullfighting, hunting game on African safaris, and dodging bullets as a war correspondent—activities that inspired his best work. Although this colonial country house is architecturally undistinguished, the personal mementos filling the spacious, simple rooms provide a wealth of personal details about its occupants.

It was here that Hemingway wrote two of his best-known works: *For Whom the Bell Tolls* and his Pulitzer Prize–winning novel, *The Old Man and the Sea,* inspired by his Cuban marlin-fishing experiences. In 1954 Hemingway was awarded the Nobel Prize and subsequently presented the medal to Cuba's patron saint, la Virgen de la Caridad del Cobre, at her shrine outside Santiago. Hemingway was already a significant figure in Cuba, a symbol of the mutual respect that could characterize relations with the United States, and this gesture further endeared him to the islanders. Finca Vigía is one of the most visited museums in Havana, since it so successfully brings alive facets of Hemingway's decades in the city, including the presence of the women in his life at the time. Even his beloved boat, the *Pilar,* has found its way to the property, recalling for visitors his struggle with a five-hundred-pound fish and the many hours he spent with his captain, Gregorio Fuentes, the inspiration for his old man of the sea.

Hemingway was first drawn to Cuba by the marlin fishing and possibly by young Jane Mason, an acquaintance of his wife Pauline's whom he had met in 1931. In 1932, while Hemingway was living in sleepy, counterculture Key West, he sailed down to Havana to sample the legendary fishing. The experience vastly exceeded his expectations and launched a series of annual visits that lasted longer and longer. During those visits he often booked a room at the Hotel Ambos Mundos—it was more comfortable than sleeping on board—and today this room is kept as a shrine to the writer. The hotel was the setting for one of the more storied anecdotes regarding his relationship with Jane, who was then completing her house in El Country. Jane was a headstrong, daring woman who is said to have let herself into Hemingway's fifth-floor room by walking out on the building's ledge and climbing in a window. When Jane hired away his captain to run her own boat, Hemingway employed Gregorio Fuentes to guide the *Pilar* from the Cojimar docks—thus laying the groundwork for literary history. By 1936 the affair with Jane was over, and the author used her as inspiration for several unsympathetic characters.

Above: The Swedish representative delivers the 1954 Nobel Prize in literature to Hemingway in the library of Finca Vigía.

Opposite: Like much of the house, the dining room feels connected to the surrounding tropical landscape. The space is decorated with simple Spanish-style furniture and the author's hunting trophies.

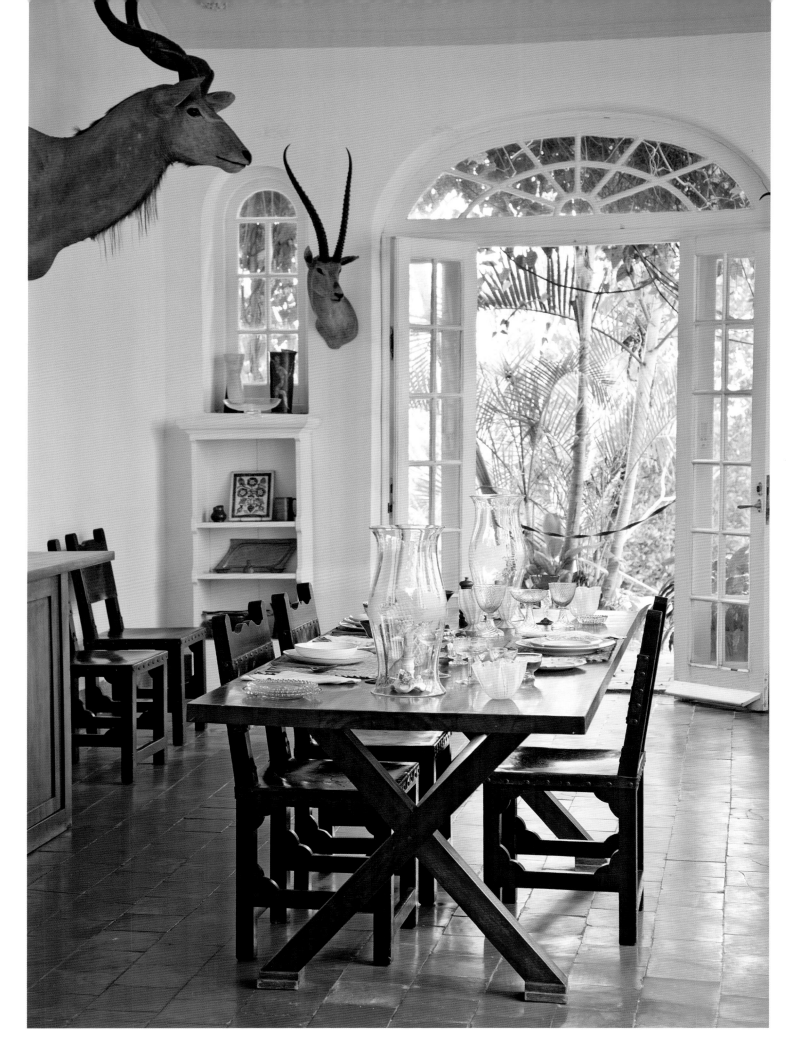

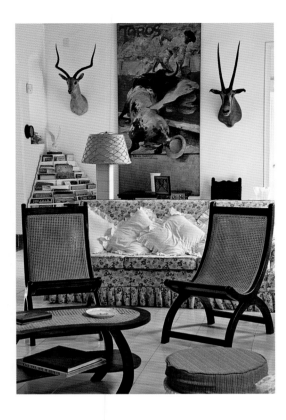

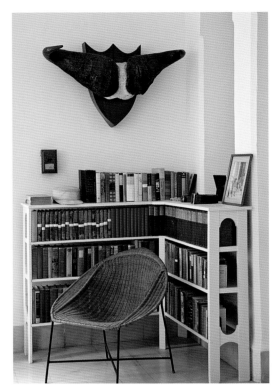

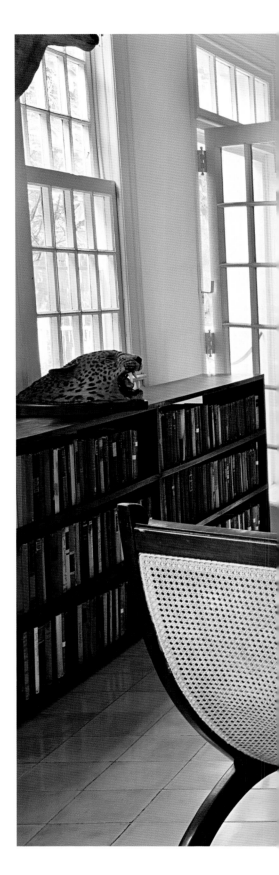

Hemingway then took up with writer Martha Gellhorn, whom he married in 1939, having obtained a divorce from Pauline. While in residence at the Hotel Ambos Mundos, Martha instigated the rental and renovation of Finca Vigía, a charming but decrepit suburban home. Eventually, using royalties from *For Whom the Bell Tolls*, Hemingway bought the vaguely classical, late-nineteenth-century country villa, particularly appealing because of its elevated site. The property was called La Vigía, "the watch tower," which had been its role during Spanish colonial days. Here the couple lived connected to the landscape, shaded by the leafy canopy of an ancient ceiba, with palms and flowering vines growing against the house. In this secluded spot Hemingway fashioned his routine of uninterrupted writing in the mornings, followed by visits to Old Havana haunts like El Floridita or La Bodeguita del Medio to knock back dozens of daiquiris.

Inside the house museum today, Hemingway is obviously present in the hunting trophies, as well as in the bullfighting posters and paintings that are reminders of his love of Spain. The living room's inviting, slipcovered sofa and chairs speak of American-style comfort, as does the nearby drinks table set with the bottles Hemingway left there. The space is cool and cozy at the same time, and also bright, thanks to the uncurtained windows, white painted walls, cream tile floors, and faded chintz. The American touch is appreciable in the simple built-ins designed by Hemingway's fourth wife, Mary: a shelf unit for his record player and collection of LPs, an inventive corner shelf displaying magazines, and low bookcases lining the room. Much of the furniture was commissioned from local woodworkers, including the simple wood trestle tables, tile-covered table lamp, and kidney-shaped coffee table. The stained wood *butacas* with their caned seats—quintessentially Cuban chairs—are another local touch.

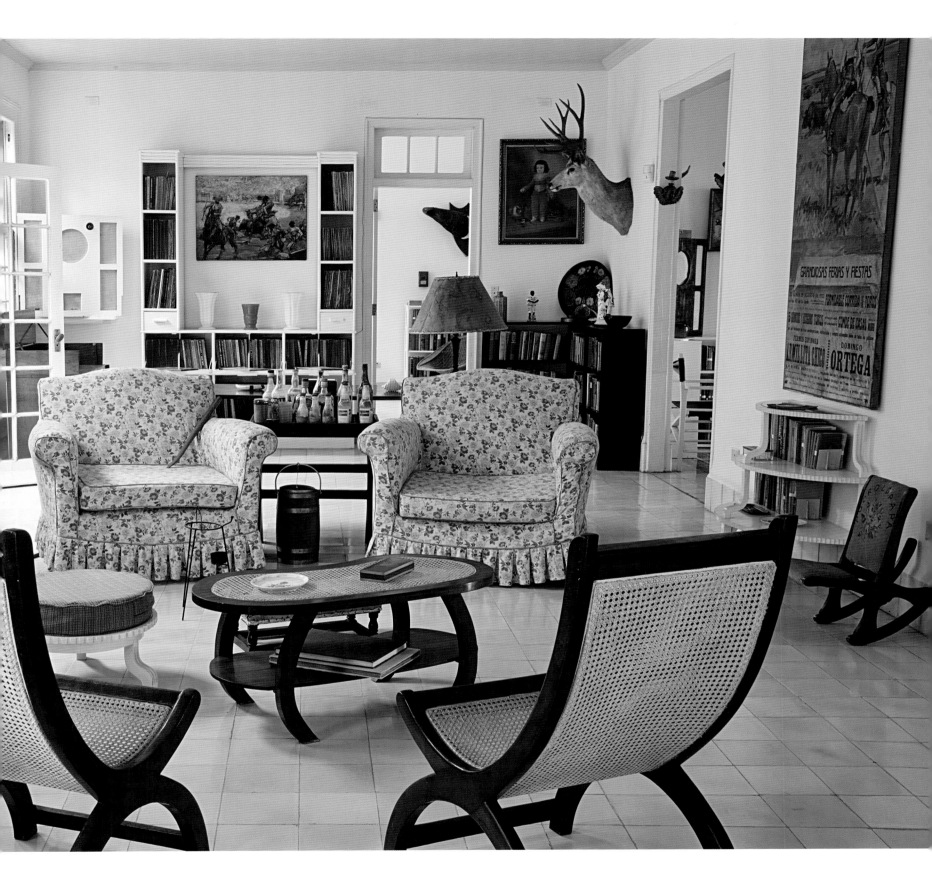

Above: French doors in the living room open onto a terrace.

Opposite left: A pair of caned low chairs, or *butacas*, frame the view of the comfortable slip-covered sofa and a bullfight poster beyond.

Opposite right: A simple corner bookcase in the author's bedroom with a 1950s wicker chair and a souvenir from the author's African safaris.

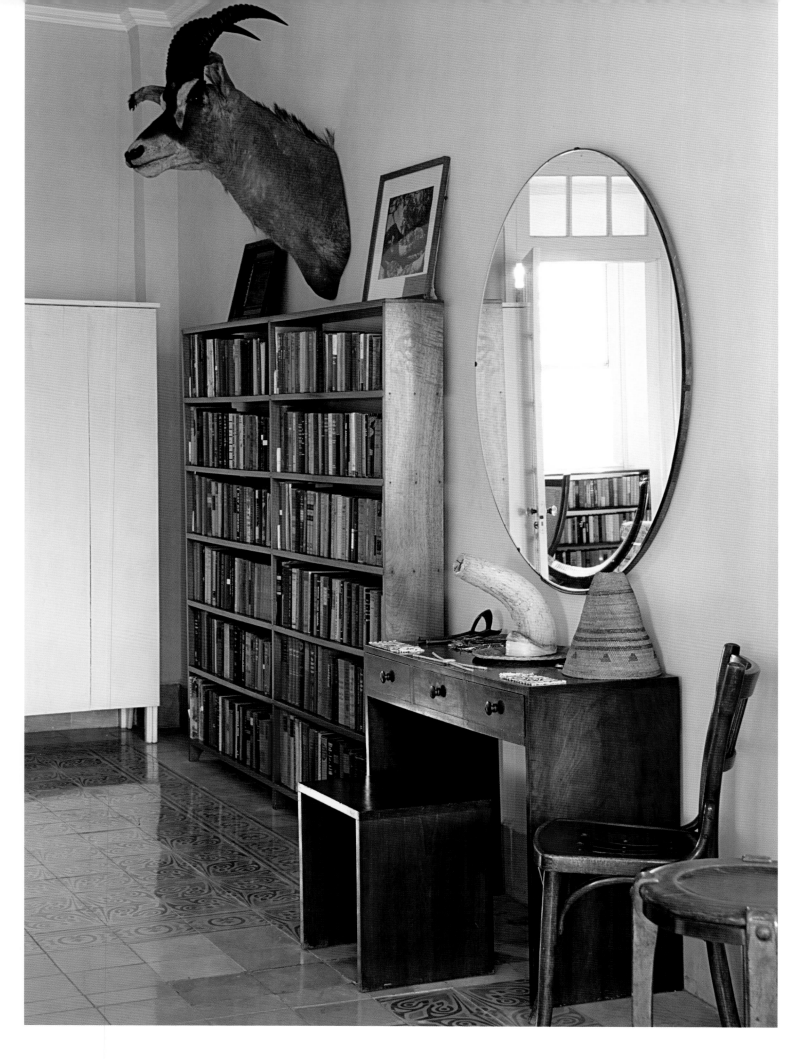

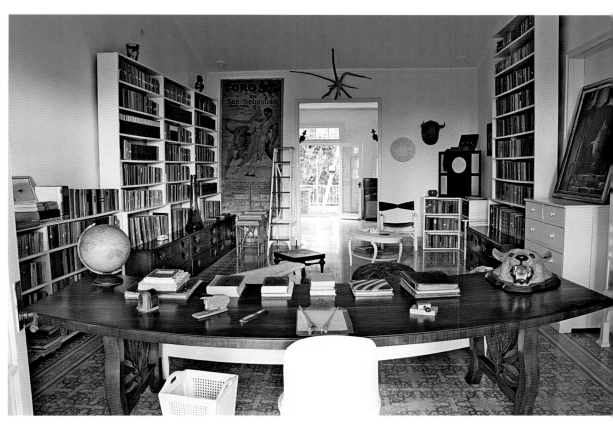

The dining room feels especially connected to the landscape: a thicket of palms brushes the glass doors and makes the tile floor's jolt of color even more striking. The walls are adorned with hunting trophies and with a copy of one of Joan Miró's early works, *The Farm*, which Hemingway had once owned. Hemingway's whimsical fish-patterned china is laid on the sideboard, and the simple trestle table is surrounded by Spanish-style leather chairs.

Hemingway loved company, and celebrity visitors to Finca Vigía included Hollywood producer Howard Hawks, Ava Gardner, Jean-Paul Sartre, Errol Flynn, and polo player Winston Guest. During the summer school vacations, his three sons came for extended visits, and Hemingway made every effort to make this a family home for them, even organizing baseball games with local boys. In 1942 one eclectic group of Hemingway's friends got up to some unusual activity, patrolling Cuban waters aboard the *Pilar*, in search of Nazi submarines. U-boats and submarines had become a real threat to local shipping, so Hemingway gathered Winston Guest, a Basque jai alai player, a Spanish priest, and captain Gregorio Fuentes to see what they would find. Going out under the nickname the Crook Factory, they used radio equipment supplied by the U.S. embassy.

In 1944 Hemingway returned to Europe to report on hostilities, and it was there that he met Mary Welsh, a writer for *Time* magazine whom he married in Havana in 1946. Mary was responsible for Finca Vigía's library, with its high sloping ceiling, Cuban tile floor, and built-in bookcases accessed by a library ladder. Thousands of Hemingway's books are preserved in the museum's collections—many annotated by the writer with his thoughts on the text or just random ideas. Above the door, the tortuous root of a mangrove tree protects the room from evil spirits. It was placed here by Hemingway himself, who seems to have dabbled in the syncretic beliefs of Afro-Cuban Santeria.

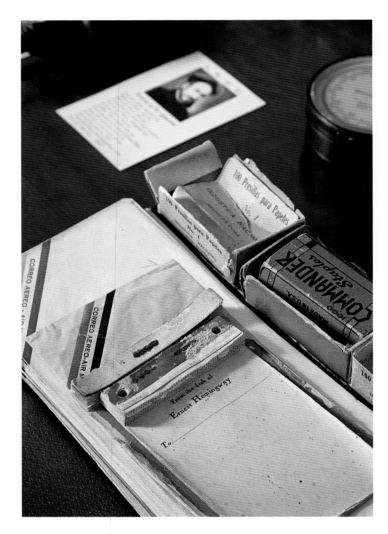

For the author's fans, his bedroom and adjacent workroom are Finca Vigía's most revered spaces. White-painted bookcases are everywhere, the titles on them ranging from Mark Twain to Jack Kerouac, from novels to histories to the letters of literary figures, from cat stories to travel books. On a low bookcase is Hemingway's Royal Arrow typewriter, where he wrote standing up because of back trouble. In one corner is a modernist wicker chair, possibly Cuban made. Period details include the 1950s air-conditioning unit. A director's chair is pulled up to a simple desk laden with curiosities: a notepad titled "From the desk of Ernest Hemingway," photos slipped under the glass top, his reading glasses, a pocketknife, shell casings, and a prayer to Saint Ignatius of Loyola. Mary's presence is strong in her expansive, robin's-egg-blue bedroom. A charming headboard of bookcases rests on tiered bedside tables—perfect for the reader working on several books at once. The eclectic spirit is maintained by the serviceable chest of drawers, baroque mirror frame, small campeche chair for her manicurist, portrait of a woman, and antelope head. To one side is a banquette used as a massage table; on a nearby wall hangs a ceramic disc warning, "Papa has it so in his back."

In 1950 Mary had a four-story tower built for Hemingway to house the dozens of cats he kept. His top-floor writing room—blue-green tile floors, painted bookcases, rattan lounge chair, a telescope, and a simple desk—overlooks the lush landscape.

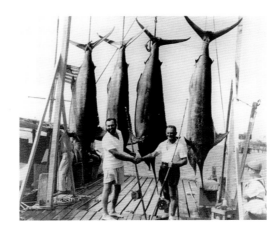

Above: Hemingway and Mike Lerner pose proudly with their day's catch of marlin during the author's visit to Bimini.

Right: A group of painted-iron garden chairs are gathered under the trees in one of Finca Vigía's many outdoor spaces.

Left: The green walls and floor tiles of the tower studio give the room the appearance of floating over the surrounding tropical landscape.

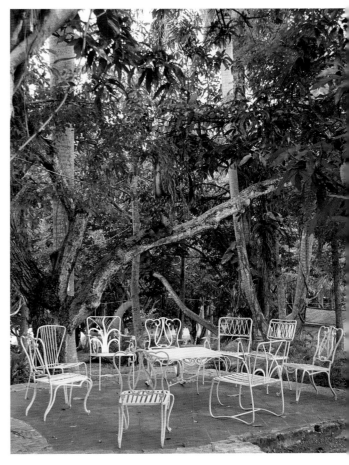

One of the principal charms of Finca Vigía is the hilly site covered with old fruit trees and its meandering paths leading to the swimming pool and tennis court. There is a surprise in the garden: rows of tiny tombstones identifying the burial places of Hemingway's beloved dogs. The scores of cats, however, were buried in unmarked places, since local superstition required no one know where your cat was buried, lest they gain power over you. The *Pilar* is currently exhibited under a protective roof sitting on the tennis court. It was installed here after the revolution, when Mary gave the house to the people of Cuba. The Hemingway Museum has guaranteed the preservation of this literary and cultural monument since 1964.

Hemingway's last visit to the house was in 1960, when he awarded to Fidel Castro the trophy of the big-game fishing tournament the author had established in 1950. The following year, suffering from depression, Hemingway took his own life in Idaho.

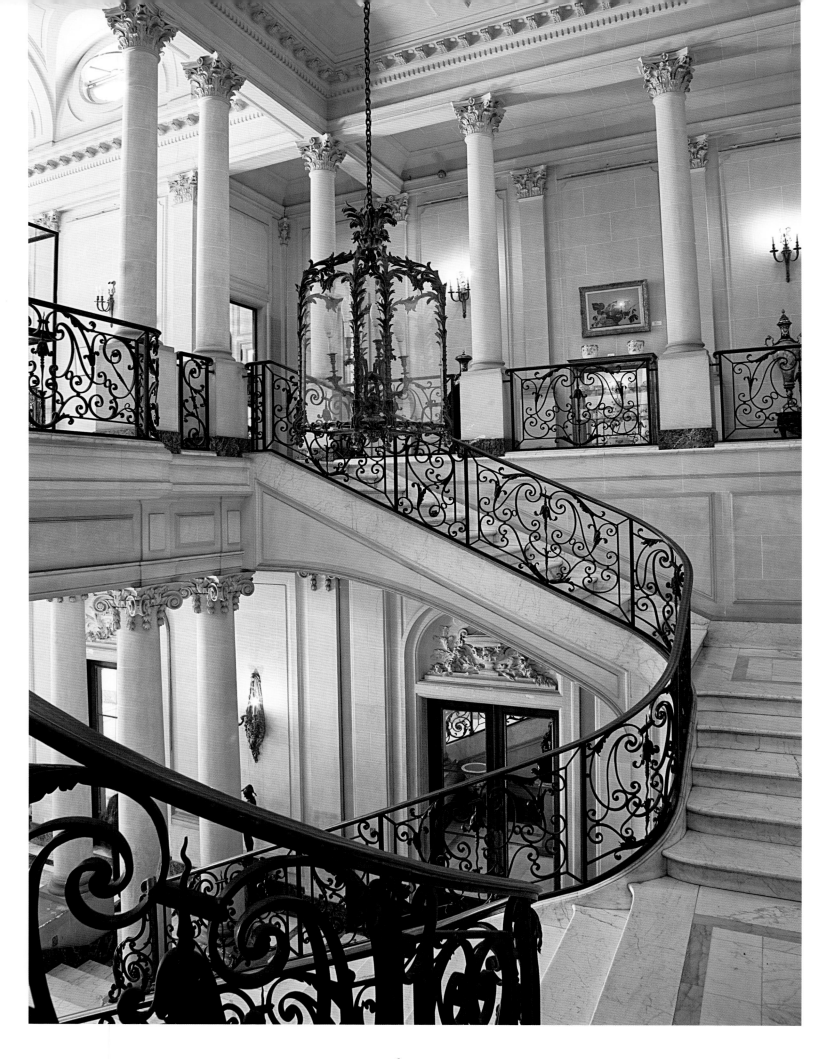

Palacio de la Condesa de Revilla de Camargo

At first glance the Countess of Revilla de Camargo seems an unlikely interpreter of Cuban culture for the stream of international visitors returning to the island at the end of World War II. Yet her entertaining of the early "jet set" featured rumba bands and rum cocktails in equal measure with French haute cuisine. After all, the Duke of Windsor, the Count of Barcelona, and the King of Belgium were in Havana to enjoy *el folklore*—just like the other tourists. The countess's French-style palace, now Havana's Museum of Decorative Arts, may appear the antithesis of all things Cuban, a monument to a Parisian lifestyle that has since disappeared, hermetically sealed from anything that might spoil the illusion. Yet in the museum's collection of photographs from the countess's many soirées, one sees her serving up Cuban local color for her jaded international guests. And they appear to be having a marvelous time.

Maison Jansen created the countess's perfectly believable French *hôtel particulier* in the Vedado. The imposing dining room and the jewel-like salon were designed for the formality of liveried footmen, but period photographs of the more casual loggias and the spectacular gardens demonstrate that the house provided an appropriate background for every kind of activity.

The house was built in the mid-1920s by sugar baron José (Pepe) Gómez Mena and his first wife, Olga Seiglie. In the 1930s the couple divorced, and Pepe built a streamlined house in El Country for his glamorous new wife. Pepe gave the Vedado house to his daughter Lilian in the mid-1930s, and she passed it on to her father's sister, Maria Luisa Gómez Mena, the Countess of Revilla de Camargo. There seems to be uncertainty regarding how much of the Vedado interiors Pepe commissioned, but friends and family assert that it was the countess who had Jansen devise the stunning décor one admires today.

Pepe Gómez Mena's French architects, P. Viard and M. Destuges, created a discreetly palatial limestone house protected by an imposing iron fence. The mansion was designed around a dramatic two-story entrance hall that is one of the most spectacular residential spaces in Havana. Stone columns and pilasters support a second-story gallery, and skylights and dormer windows light the soaring space. Period photographs show that the furniture and artwork set the tone and standard for the house: above formal damask sofas were two landscapes by eighteenth-century French master Hubert Robert, with a pair of exquisite satyr candelabras by Clodion nearby.

Above: Groups of putti above the entrance recall the sculpture of French master Augustin Pajou.

Opposite: The marble and wrought-iron staircase floats in the light-filled, double-height hall of the French-style palace.

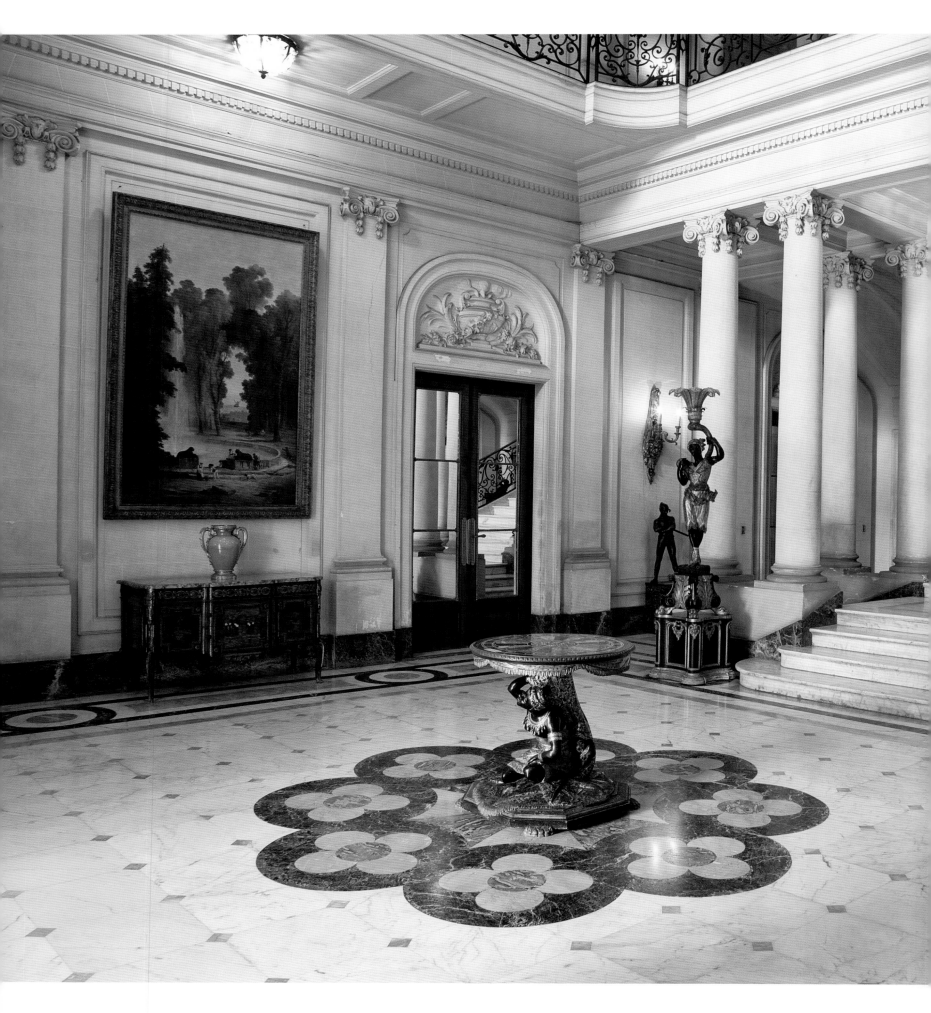

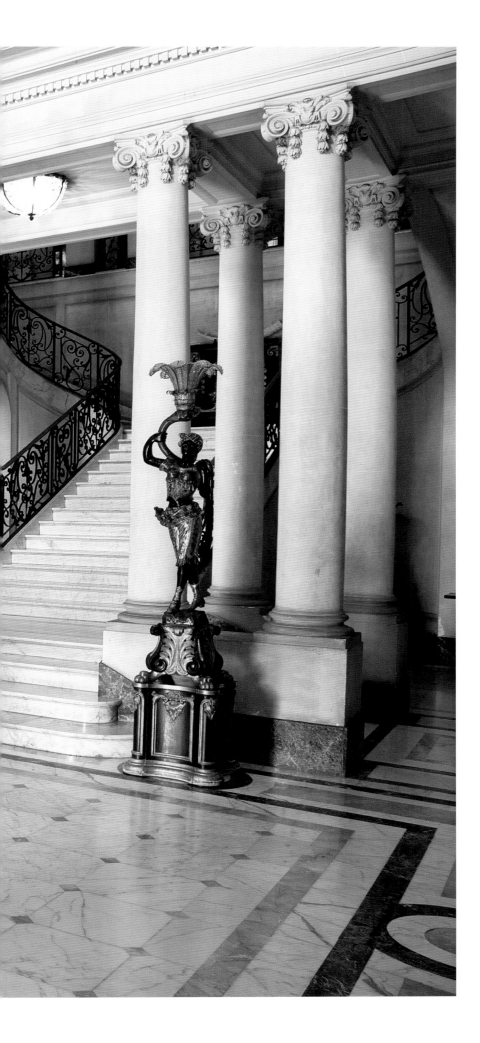

Left: An eighteenth-century landscape by Hubert Robert hangs over a Louis XV commode in the front hall, where clusters of Ionic columns frame the base of the monumental stair.

Above: A series of bull's-eye windows in the vaulted ceiling of the front hall are a classical yet practical detail encouraging ventilation.

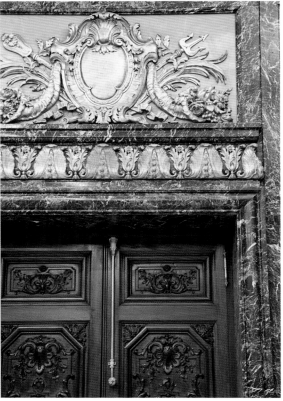

Left: The Countess posed for *Life* magazine in her dining room, which was set for a formal dinner using a single banquet table, one of several ways she arranged the room.

Right top: The dining room decoration brings together multicolored marble walls with gilt-bronze decorations and carved Cuban mahogany doors that give the room its opulence.

Right above: The Countess's niece Lilian Gómez Mena dances with the Duke of Windsor, while the Duchess is seen at the extreme right.

In the dining room, green and yellow marble walls are animated by gilt-bronze decorations, framing Aubusson tapestries and mirror panels. In 1950 *Life* magazine pictured the countess standing by her banquet table, which was set with the pair of solid gold candlesticks— weighing one hundred pounds each—she had recently used for a dinner in honor of King Leopold III of Belgium. For intimate dinners, draped tables for eight were spread around the room, decorated with fanciful crystal centerpieces. In one vintage photograph, the Duke of Windsor and Lilian Gómez Mena are among the couples dancing to an orchestra in a cleared area between these smaller tables.

Opposite: Jansen based the dining room architecture on the design of the salon of the Queen's Guard at Versailles.

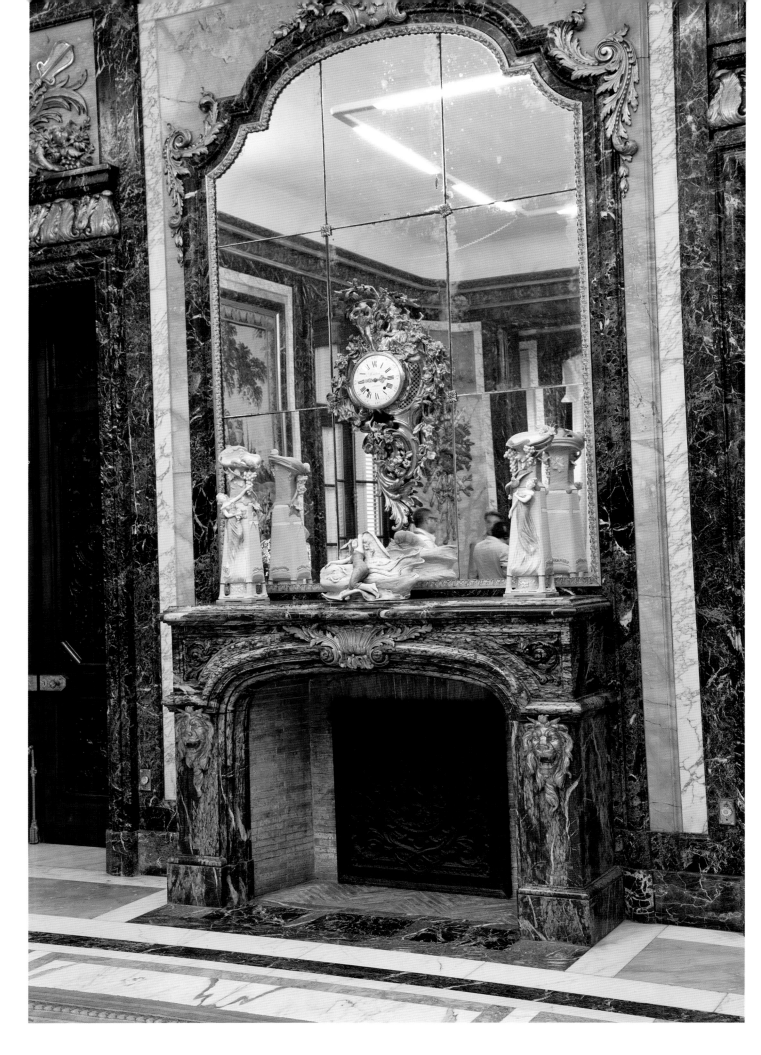

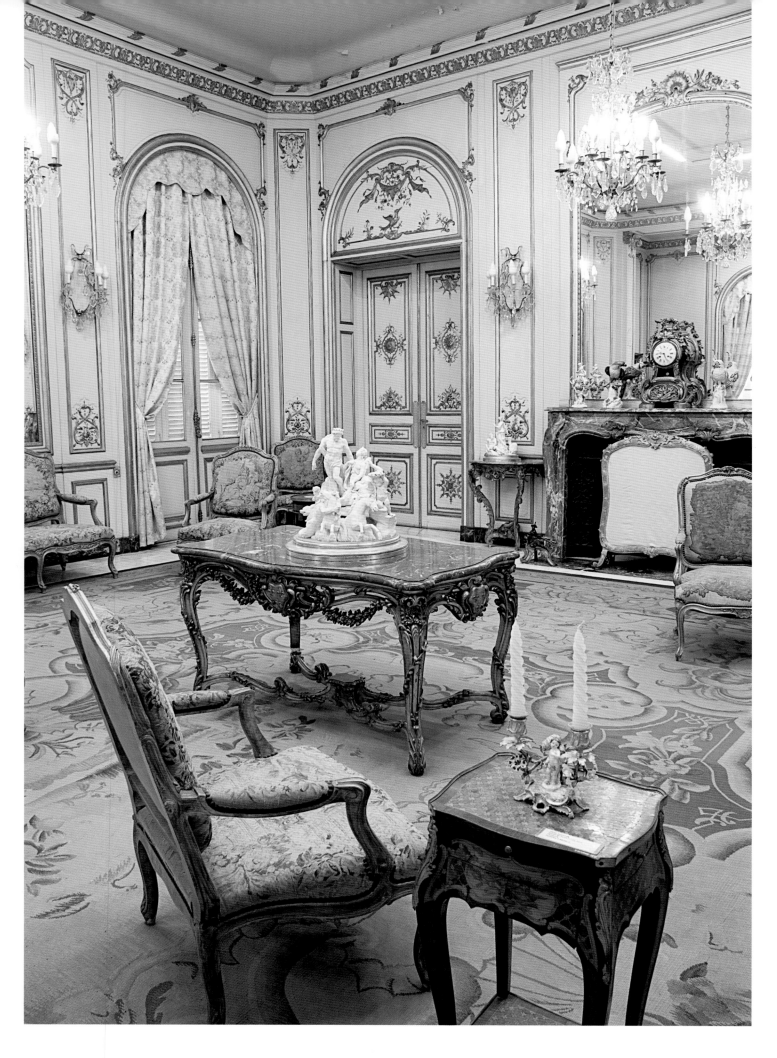

Above: A detail of the Chinese lacquer panels incorporated into the wall decorations of the bedroom used by the countess's favorite nephew, "Panchete" Vives.

Right: A pair of Venetian Blackamoor light fixtures are reflected in the mirrored doors of front hall.

Opposite: The painted and gilded paneling of the salon creates an airy background for an impressive collection of eighteenth-century French furniture and decorative arts.

The four crystal chandeliers around the perimeter of the formal salon are unexpected, their placement in front of mirror panels creating reflections while tying into similar wall sconces and candelabras on wood on stands. The rococo curves of the gold and cream painted paneling complement the room's eighteenth-century doors. Few decorators could have designed and assembled such a authentic setting. The nineteenth-century Savonnerie carpet seems brighter in period photographs but continues to anchor an impressive collection of eighteenth-century French furniture and portraits—although the countess's own portrait no longer dominates the room.

The glassed-in galleries facing side gardens were furnished more casually, with comfortable sofas and chairs. The white upholstered seating was flanked by red lacquer tables holding green lamps, and these furnishings were arranged on a white, red, and green floral carpet. Between classical pilasters are niches in the stone wall that have been decorated with a flock of eighteenth-century porcelain birds on a wood trellis background. Colorful tropical plants abound, connecting the space to the Four Seasons garden beyond, named for marble statues that came from the countess's earlier Vedado house.

The trellis decoration continues on the inventive garden wall/fountain that served as a theatrical backdrop for the countess's outdoor dinner dances. Vintage photographs record the decoration for one such event: iron garden chairs surrounding a mirror-topped banquet table set with multitiered glass candelabras and a multitude of flower arrangements and crystal. Oversize crystal candelabras lit the way down a second gallery's steps, which led to another garden where lead sculptures of fish shot jets of water at the corners of an outdoor dance floor, itself surrounded by water.

The countess's bedroom is a beautifully paneled neoclassical room, and among its Louis XVI period furniture is a secretary made by Jean-Henri Reisener for Marie Antoinette's use at Versailles. The countess's art deco–inspired bath features a gray, white, and pink marble floor with an arched bathtub niche at its center. Also en suite is a small boudoir in shades of turquoise and pale green, its papier-mâché furniture, crystal chandelier, and wall sconces suggesting the French Second Empire. The museum's research library is located in another of the original guest bedrooms, and among the library's treasure trove of information are files of correspondence and design drawings relating to the countess's legendary jewelry collection. Especially interesting are Cartier's drawing of an art deco–style diamond necklace with fifteen square-cut, graduated emeralds and Harry Winston's design photograph of another diamond necklace. The *Life* magazine piece mentioned the necklace of diamonds and twenty-four square-cut emeralds that the countess wore for the photo shoot.

Left: One of two glazed galleries overlooking the side gardens.

Right: A lattice-covered folly, decorated with plants and sculpture, served as background for outdoor dinners and dancing.

Below: Cartier's sketch of a diamond necklace incorporating the famous Revilla de Camargo emeralds.

Opposite: The countess's bathroom is modern in its Empire and art deco style as well as the use of indirect lighting.

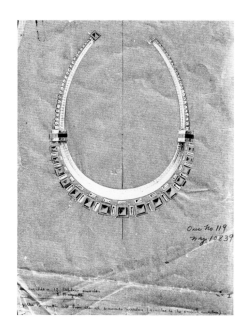

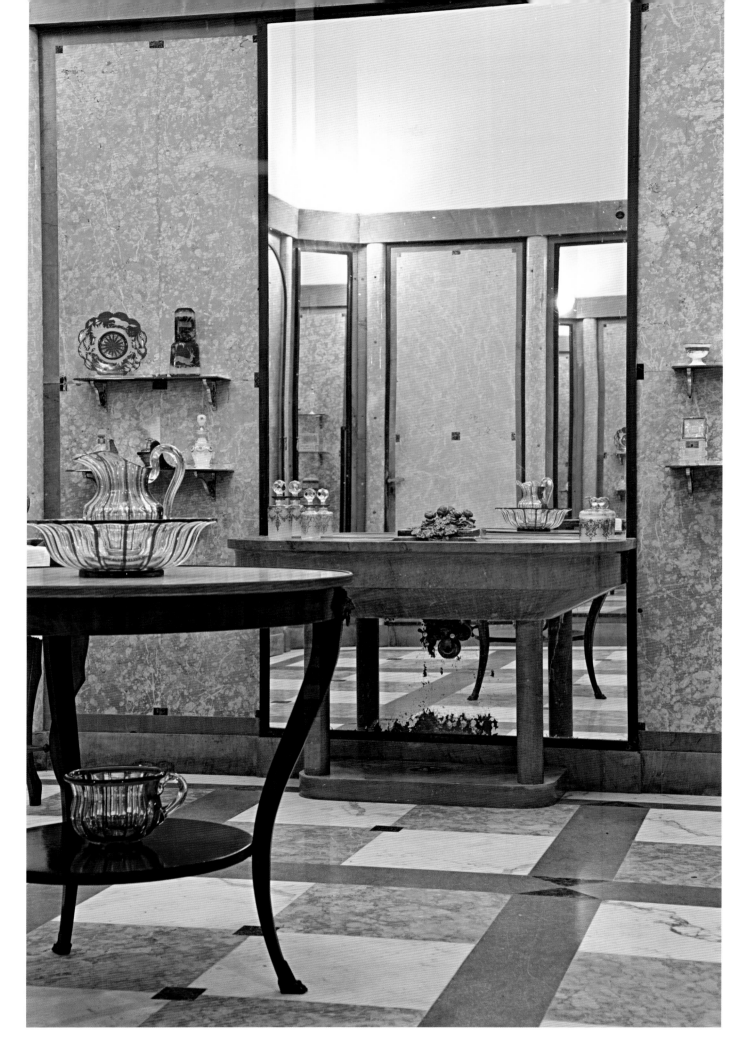

Among the countess's international guests were Alfred Barr and Edgar Kaufman Jr., who visited Cuba on behalf of the Museum of Modern Art in 1942. The countess's niece, Maria Luísa Gómez Mena Vivanco, organized for them an unusual mix—by Havana standards—of society guests and members of the artistic avant-garde. Thanks to this visit, MoMA's groundbreaking show of Cuban art took place in 1944. The niece, doted on by the countess since she was a little girl, was another outsize personality—a woman ahead of her time and therefore misunderstood by conventional Havana society. She met Picasso in Paris, after befriending Dora Maar. This led to her meeting Picasso's friend Cuban painter Wifredo Lam. Her Havana art gallery, Galeria del Prado, became a landmark of the avant-garde.

After World War II ended, exhausted European royals turned their eyes to Havana. Fashion designer Luis Estevez remembers the countess hosting Havana's first big postwar ball in 1948—wearing Dior couture. The party was probably for the Duke and Duchess of Windsor, who arrived aboard Marjorie Merriweather Post's *Sea Cloud*. Photographs of the evening show the duchess (in a Schiaparelli monkey dress) being serenaded by musicians in the Mural Room. The duke is holding court there with a trio of Havana ladies, a scene of shepherds in classical landscapes visible behind him. This and four other eighteenth-century French paintings made the news in 2003, when restorers discovered them concealed behind the discolored velvet wall covering they were trying to replace.

On February 19, 1948, the Count and Countess of Barcelona, heirs to the deposed Spanish royal family, arrived in Cuba for a two-week visit, staying with the countess after a visit to Varadero. Entertainments included a dinner at the home of Pepe Gómez Mena, whose sister-in-law had been married to the count's brother. Coincidentally, King Leopold III of Belgium arrived in Havana on February 16, 1948, accompanied by his chic wife, the Princess de Réthy, and his son and heir, Prince Baudouin. The trio were guests at the countess's Varadero beach house.

The beach house, with its striking circular courtyard, was next door to Pepe's, on the resort's Kawama peninsula, ideally sited between the ocean and the lagoon. It was a more intimate and contemporary place where the countess and those in her social circle could relax. Photographs of the interior show streamlined furniture in wicker and rattan, comfortable modern upholstery, built-in lighting, and an intriguing pair of murals, possibly by Mario Carreño. Photographs of her guests helping themselves to drinks from the bar cart reinforce the image of escape from the responsibility and formality of city life. Varadero was still unspoiled, and in this refined indoor-outdoor setting the countess was able to offer another vision of Cuba to her international guests.

In his novel *La Consagración de la Primavera* Alejo Carpentier evokes the over-the-top quality of the Revilla de Camargo parties, describing a gala with a Paris 1900 theme at the home of a fictional countess. The landmarks of belle époque Paris have been re-created throughout the garden, and American technicians have succeeded in freezing the swimming pool—alas, only temporarily—for a skating performance by pseudo Rockettes. The fictional countess describes her style of entertaining: "I'm not one of those who gets their friends together to applaud the antics of a children's party conjurer. When I was in Buenos Aires last year, Dorita de Alvear had the entire corps de ballet of the Teatro Colón dancing in her garden, backed by the complete symphony orchestra for just thirty guests. One either is or one isn't."

In 1961 the Countess of Revilla de Camargo left Havana after hiding silver and valuable paintings in a room she then had walled up, though the cache was soon discovered using a metal detector. The countess had insured her Havana mansion with Lloyds of London for one million dollars in the event of a political revolution, so she went into exile a very rich woman. She died in 1963, and one year later the Museum of Decorative Arts opened with the Countess of Revilla de Camargo's collection of eighteenth-century French furniture and painting as its centerpiece. Over time, pieces from other important Cuban collectors have been added.

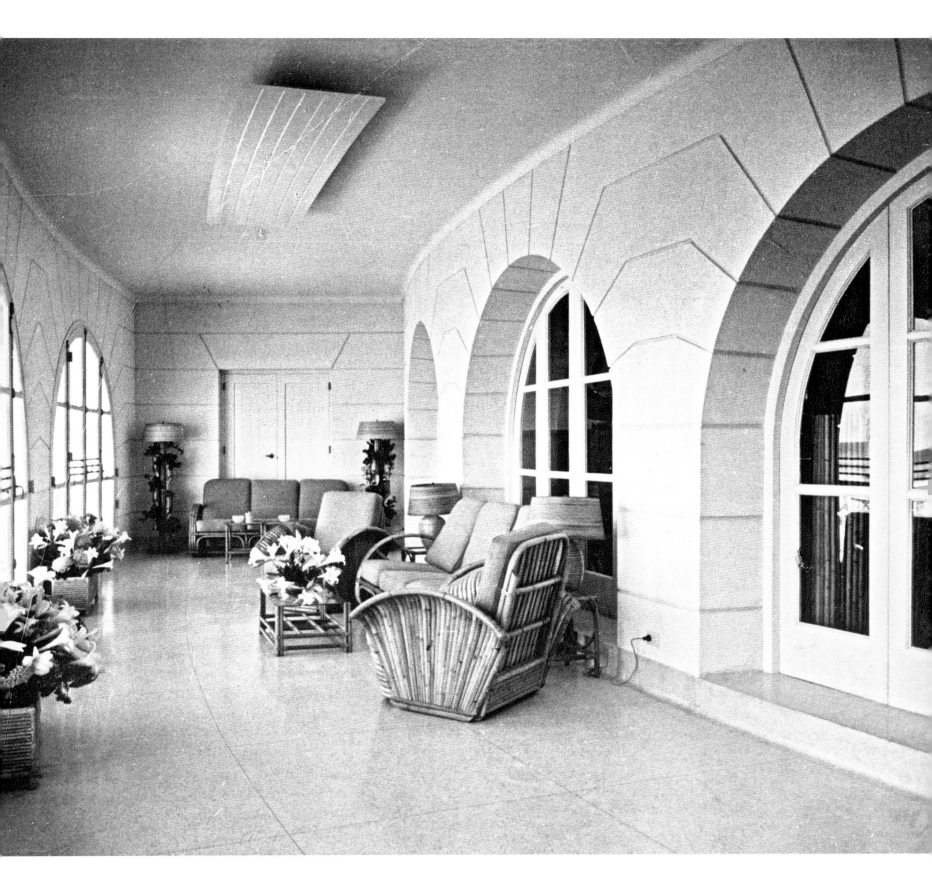

Above: A sitting area at one end of the curved corridor is furnished with rattan pieces, hothouse flowers, and tropical plants.

Opposite left: The countess's Varadero beach house was designed around an unusual circular courtyard. The bar cart suggests the more casual resort lifestyle offered there.

Opposite right: The Varadero dining room features bold, streamlined furniture.

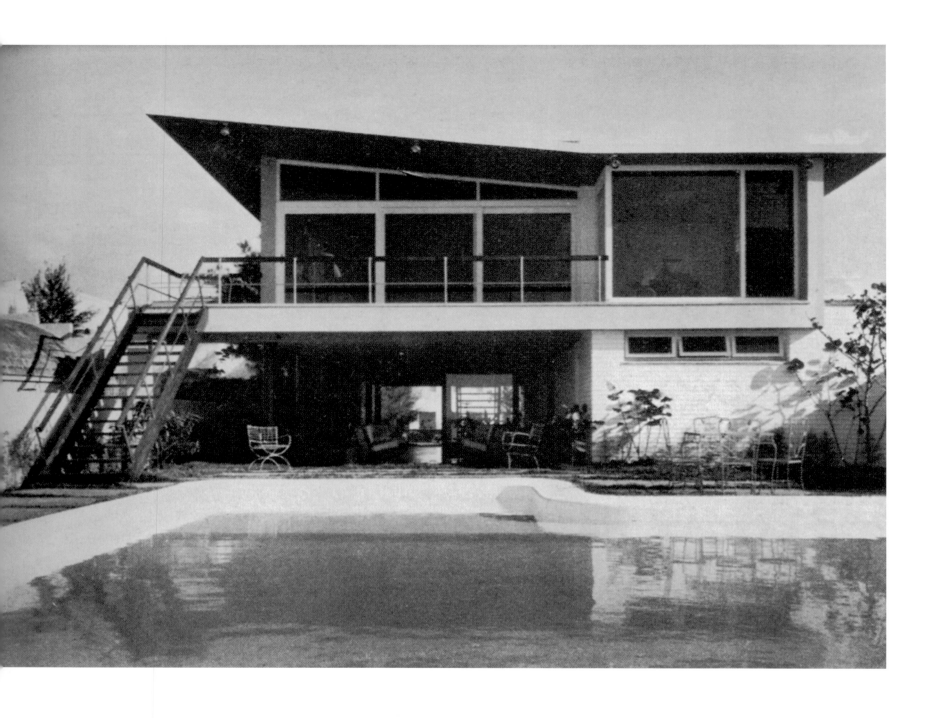

Cuban Modernism

Above: Havana's most important exhibition spaces for contemporary art were the Galeria del Prado and the Lyceum Lawn Tennis Club.

Opposite: Architect Miguel Gaston's Miramar home displays signatures of Cuban modernism: the butterfly roof, outdoor stairs, strip windows, and the indoor-outdoor sitting area created below the suspended second floor.

The tenets of international modernism were evident in Cuban art about a decade before its influence was felt in architecture. Cuban painting and sculpture made great strides in the 1940s with artists embarking on a fruitful search for a Cuban national identity. Havana's buildings, however, would not feel truly modern or original until the 1950s when a parallel search for Cuban identity in architecture emerged.

The evolution of Havana's residential architecture can be seen by comparing the Kaffenburg house, winner of the 1940 Gold Medal of the National Association of Architects, to the Cueto Noval house, the 1949 recipient of the same award. Kaffenburg's is a Spanish colonial house of a type built throughout the 1930s, whose virtue is its compact simplicity and connection to the landscape. In contrast the Cueto Noval house feels modern even today, representing international avant-garde trends elegantly adapted to Cuba's climate and culture. Today the house is considered a milestone in the development of tropical modernism, architecture distilled from a thorough understanding of the international trends and the regional traditions appropriate for the Cuban climate and culture.

The Cuban presence at the 1939 World's Fair in New York represents the dual strands of avant-garde and traditional aesthetics that characterized the arts throughout the 1940s and 1950s. Cuban works featured in the Riverside Museum's exhibition of contemporary Latin American art were acclaimed by reviewers, most notably the sculpture of Rita Longa. Many of the artists represented had rejected the academic teachings of Havana's Academia de Bellas Artes de San Alejandro. The traditional view was represented by two Rembrandts lent by famed collector Oscar Cintas to the "Masterpieces of Art" exhibition. Although the island was beginning to produce internationally recognized artists, the wealthiest Cubans still attached more status to the works of the European old masters or Spanish luminist painters such as Joaquin Sorolla.

Avant-garde artists and Havana's old guard were linked symbolically in the person of cultural patroness Maria Luisa Gómez Mena, daughter of wealthy Alfonso Gómez Mena and confidante of his sister, the Countess of Revilla de Camargo. Maria Luisa's Galeria del Prado exhibited the era's most important painters, attempting to entice the haute bourgeoisie to invest in the art of the future. It seems as though every Cuban artist of note, including her husband Mario Carreno, painted a portrait of Maria Luisa, an eccentric who helped make the 1944 exhibition "Modern Cuban Painters" at the Museum of Modern Art a reality. According to the catalog, "The modern movement in painting [was still] young [in Cuba], [with all] the virtues of youth, courage, freshness, vitality and a healthy disregard for its elders in a country which is very old in tradition and very new independence." This international recognition of Cuban artistic expression gave confidence to both artists and collectors.

Havana's cultural scene of the 1940s was energized by the return of Cuban socialites, artists, and intellectuals who had been living in Europe and sought to escape the armed conflict. Amelia Pelaez was among the Cuban painters who returned after studying first in New York at the School of Visual Arts and later in Paris at the Ecole du Louvre. Back in her Havana child-hood home, Pelaez embarked on visual investigations of what it meant to be Cuban. Her bold, geometric paintings synthesized the iron grilles, glass fanlights, mosaic floors, sinuous colonial furniture, and lush tropical foliage of her surroundings to create highly personal interpreta-tions of the island's architectural tradition through the lens of the Cubism she studied in Paris. Many see her art as a response to the ever-increasing Americanization of Cuban life; to this day she is one of the island's most beloved artists.

During the 1940s some architects began to follow where the fine arts led, first with a series of Streamlined Moderne style buildings that continued the transition to international modern-ism that art deco had initiated. The nautical allusions in Rafael de Cardenas's Arostegui house might be considered late art deco and seem especially appropriate to the steeply sloping site overlooking the Almenadres River. De Cardenas had built Spanish colonial and Venetian Gothic mansions as well as a series of abstracted Varadero beach houses. In a similar spirit were the curving balconies of the Solimar apartment building in central Havana, a masterwork of this transitional style. Santa Rita church in Miramar presents a vaguely colonial revival exterior and a contemporary interior defined by the boldness of concrete parabolic arches holding up the roof. This late work by Leonardo Morales, the city's foremost classicist, underscores the ability of Havana's designers to adapt to the latest trends while setting the stage for a new generation.

Design versatility was the hallmark of the work of Theodore Bailey, an American decorator. A mid-1940s advertisement displays the conservative good taste of a Louis XV commode in the corner of a paneled room with a Régence mirror above, in sharp contrast to the subsequent contemporary style of a dining room in a Vedado apartment—up-to-date and in the spirit of New York's Paul Frankl—featured in a later advertisement. Another dramatic illustration of the changing tastes is seen in the 1941 advertisement for Max Borges's architecture practice where a striking streamlined house is shown next to others in the ever-popular Spanish colonial style.

Left: Amelia Pelaez's 1943 painting of a platter of fish is set within the context of the traditional Cuban family home that she explored in her artwork.

Right: A c. 1945 Wifredo Lam painting was used by New York's Pierre Matisse gallery as the cover of an exhibition catalog.

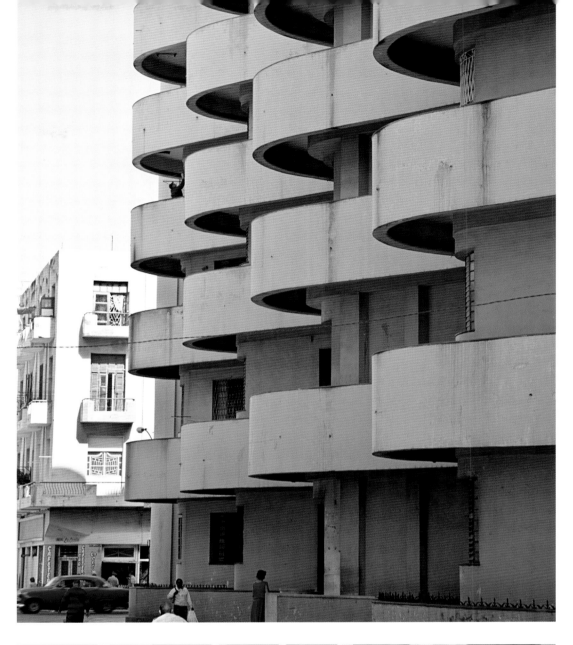

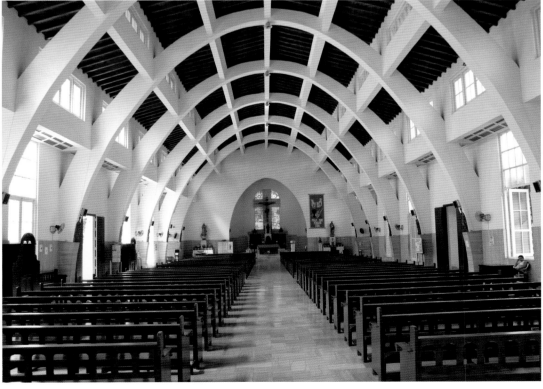

Above: The wavelike rhythm of the Solimar apartment building balconies refers to the nearby ocean. The layout encourages ventilation in the tight Centro Havana site.

Right: In suburban Miramar, the dynamic structure expressed in the interior of Santa Rita de Cassia contrasts with a traditional exterior.

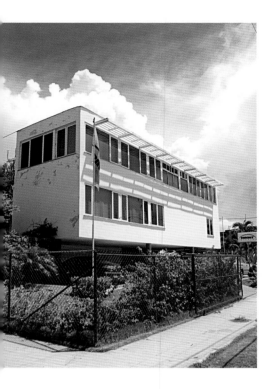

His son's Miramar house of 1948–50 is an early example of a rational villa floating over the landscape on Le Corbusier-style *pilotis*. Just as the artists had rejected the Academy, architecture students affirmed their commitment to the international modernism of Le Corbusier, Richard Neutra, and Mies van der Rohe by burning their "Vignolas," treatises on Renaissance architecture that were the foundation of classical design.

American postwar prosperity was immediately felt in Havana. The optimism about the future was given expression in the new buildings of the Radiocentro complex at the top of the steep slope of La Rampa in Vedado. These clean, modern volumes, housing a movie theater, television studios, shops, and offices lay the groundwork for the modern hotels, shops, and towers—many designed by prominent American architecture firms—that would turn this part of Vedado into the new core of modern Havana of the mid-1950s.

The Havana Hilton, the Hotel Riviera, and the Hotel Capri embodied the latest trends in American hospitality design, based on the flamboyant hotels in Miami Beach. Murals, sculpture, and decorations by the most important contemporary Cuban artists helped ground these International Style works in an unmistakably Cuban identity. The Hilton tower floats over a "podium" sheathed in a floral mosaic by Amelia Pelaez. The tower of the oceanfront Riviera Hotel is anchored by the monumental figures of a mermaid and sea horse by Cuban sculptor Florencio Gelabert. Changes in zoning allowed construction of these taller buildings near the Hotel Nacional, creating an area of Vedado that was synonymous with the excitement of Havana in the 1950s. The shops, offices, car showrooms, airline offices, and movie theaters along the brand-new La Rampa energized a part of Havana that the elite had left behind decades earlier. In the same area was the Embassy of the United States, an elegant rationalist block by New York architects Harrison Abramowitz. Its reinforced concrete structure expresses solidity while overlooking a prime spot on the oceanfront drive of the Malecón. Another notable building was the FOCSA luxury apartment tower, its boomerang shape resting on an entire city block of amenities.

Left: The pure white volume of the Miramar home of Max Borges Jr. floats above the surrounding landscape.

Right: Architect's drawing of the Radiocentro buildings, which incorporated a movie theater and the CMQ television station.

Opposite from top left: The Hilton, with a bold mosaic mural by Amelia Pelaez; Hotel Riviera with a fountain representing a Cuban mermaid; American Embassy, Harrison & Abramowitz, and Olan Tower, Antonio Santana.

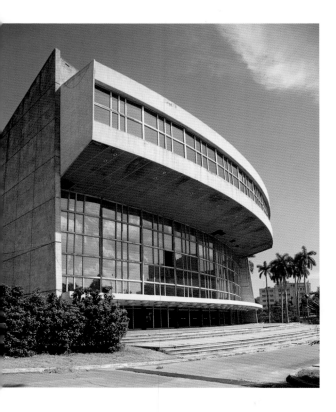

On an urban scale, the City Planning Office was engaged in creating a new, more centralized Plaza Civica to be organized around a monument pairing a large statue of Jose Marti with a star-shaped obelisk. An array of modern buildings went up around the monument, including the National Library, City Hall, and a variety of government ministries. The best buildings are elegant modern compositions incorporating murals or sculpture by Cuban artists like Amelia Pelaez or Rita Longa. Other structures, such as the Palace of Justice and the National Library, express an almost classical monumentality that evokes an earlier era. The National Theater is dynamic building expressing its interior functions in the sloping roof of the concert hall and the cantilever of the upper-floor lounge.

The influence of European masters was strongly felt in Havana. The construction of Neutra's house for the von Schulthess family was watched closely by the local design community, and the completed building was heaped with accolades. Havana hosted the 1950 Congreso Panamericano de Arquitectos, which focused on urbanism, adapting the Athens Charter for use in Latin America and expressing concern over demolitions in the city's historic core and awareness of the natural environment. The interest in developing a coherent plan for Havana was expressed in a misguided design by Jose Luis Sert, envisioning a city of super-blocks in the manner of Le Corbusier, achieved at the expense of scores of historic buildings that had to be demolished.

By the 1950s, the residents of Miramar and El Country rarely felt the need to cross the Almendares River back into older Havana. The architectural taste of Havana's elite remained fairly conservative, bolstered by the comfortable isolation of the western enclaves. Their life-style reflected the American influence at every step: consumer goods, education, aspirations, travel destinations, and so on, and their houses would not appear out of place in Miami Beach—ostensibly modern, spacious, with a few abstracted details.

Left: Arroyo y Menendez's National Theater, one of a series of public buildings designed around the vast new Plaza Civica.

Right: Nicolas Quintana's Cabañas del Sol at the Varadero Yacht Club represent the culmination of a simple regional modernism, deftly adapted to the island's climate and lifestyle.

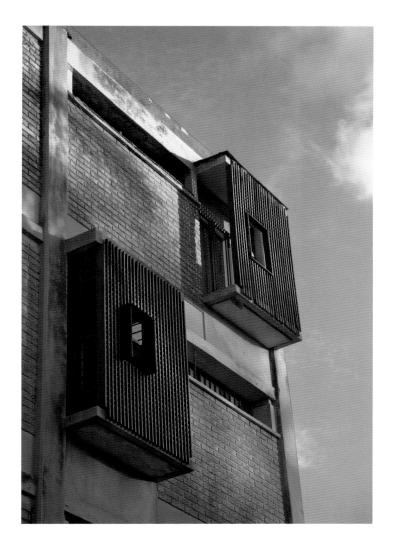

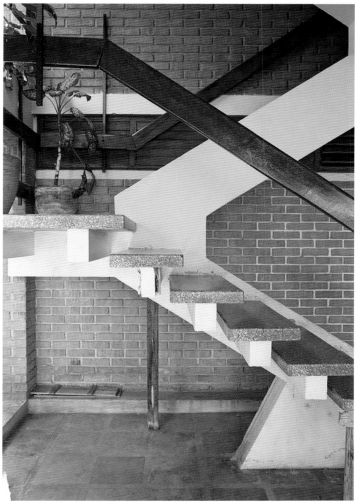

Left: Recalling Cuban colonial precedents, wood screens form bay windows projecting from the brick and concrete facade of Mario Romanach's Miramar apartment building for Evangelina Aristigueta de Vidana.

Right: Terrazzo stair treads rest on a concrete structural stringer in front of brick walls with wood louver strip window, at the ground floor of Romanach's apartment building for Josefina Odoardo.

Interesting works include the butterfly roof of architect Miguel Gaston's Miramar house, floating over its swimming pool and overlooking the ocean beyond. Similar concrete butterfly roofs are found at the exquisite cabins of the Varadero Yacht Club. The undulating concrete shells of Max Borges's Club Nautico are suspended above that beach club's open-air interior. Areas of glazing set between these waves let in light and recall the Tropicana's legendary open-air nightclub, also by Borges.

In new subdivisions like Nuevo Vedado or Alturas de Miramar architectural experimentation seems to have been encouraged by the dramatic topography. In Miramar, inventive two- and three-story apartment buildings offered spacious modern living to the middle class as well.

The most memorable residential works were the idiosyncratic interpretations of international modernism that were inspired by the essence of Cuban colonial home-building, with emphasis on materials, ventilation, and indoor-outdoor flow. Among the best of these tropical modernist works were the homes and apartment buildings of Mario Romanach, with their expressive forms, beautiful materials, celebration of staircases and courtyards, and emphasis on natural ventilation. In some of his apartment buildings, louvered walls line the public stairwells, providing airflow between the apartments and the circulation core. The terraces in others are enclosed by screen walls and positioned away from the street to create a new kind of outdoor privacy.

The furniture designs of Clara Porset, who had been reporting on design for *Social* since the 1920s, won several awards at MoMA in the 1940s, and she produced some furniture designs for Knoll International. Photographs of her interiors for Frank Martinez's Lezama Lima house have become icons of Cuban modernism in the same way the Julius Schulman pictures of Palm Springs represented an era. There isn't much to them—the latest Scandinavian pieces interact with traditional Cuban mahogany rockers with caned seats and the even more traditional *butacas*-type armchairs. Woven straw rugs cover geometric floors that recall the traditional Cuban floor tiles. Plants and louvered wood doors are everywhere, blurring the boundaries between interior and exterior—the most logical way to live in the island's tropical climate.

Architect Emilio del Junco's own contemporary house went a step further by incorporating elements salvaged from colonial Cuban houses, commissioned pieces by Cuban avant-garde artists, and the latest Scandinavian modern furnishings.

And the church at suburban Guatao speaks of the interesting possibilities that might have been, had Cuba's residential architecture remained on this quest to reconcile modernity and national identity. An angular skeleton of reinforced-concrete beams and columns hovers over the church, whose walls of wood louvers and stained glass reconcile these quintessentially Cuban materials with the structural modernity. The church seems to embody that happy meeting of the past and present that Eugenio Batista advocated in a 1960 article in *Artes Plasticas* that advocated a study of Cuba's architectural legacy in order to create houses that were essentially Cuban while part of the modern world.

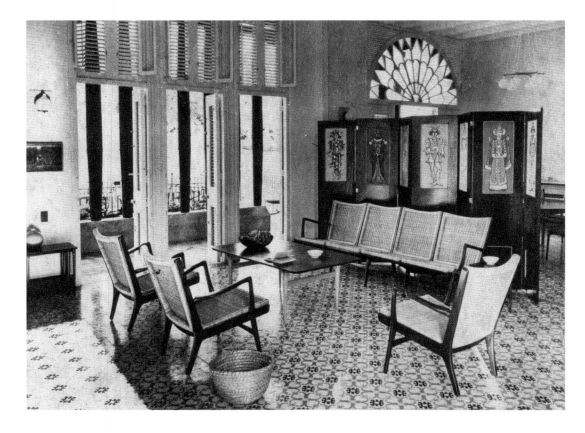

Left: Architect Emilio del Junco's own house at suburban La Lisa combined salvaged colonial stained glass, traditional cement tile floors, adjustable wood louvers, exposed concrete ceiling vaults, Scandinavian furniture, and paintings commissioned from Cuba's most significant contemporary artists.

Opposite: A Cuban mahogany spiral stair leads to the choir loft of the Guatao church, lit by modern interpretations of the stained-glass fanlights that traditionally dappled the harshness of the tropical sun.

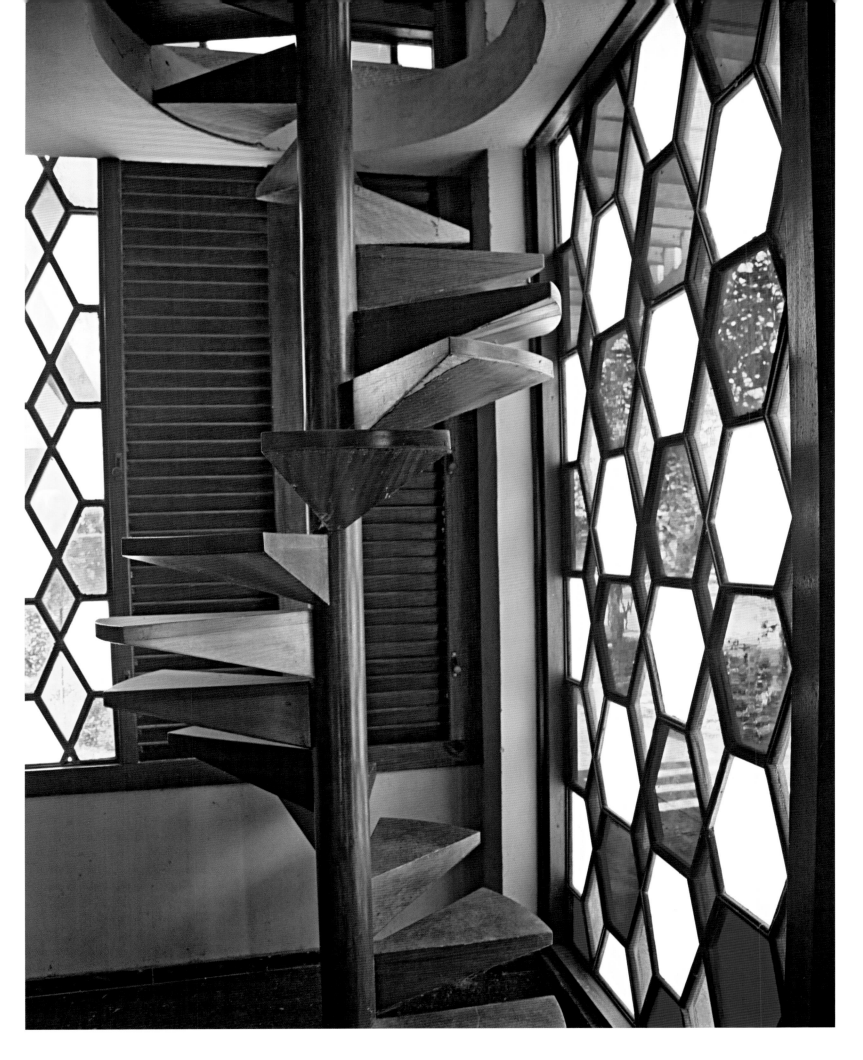

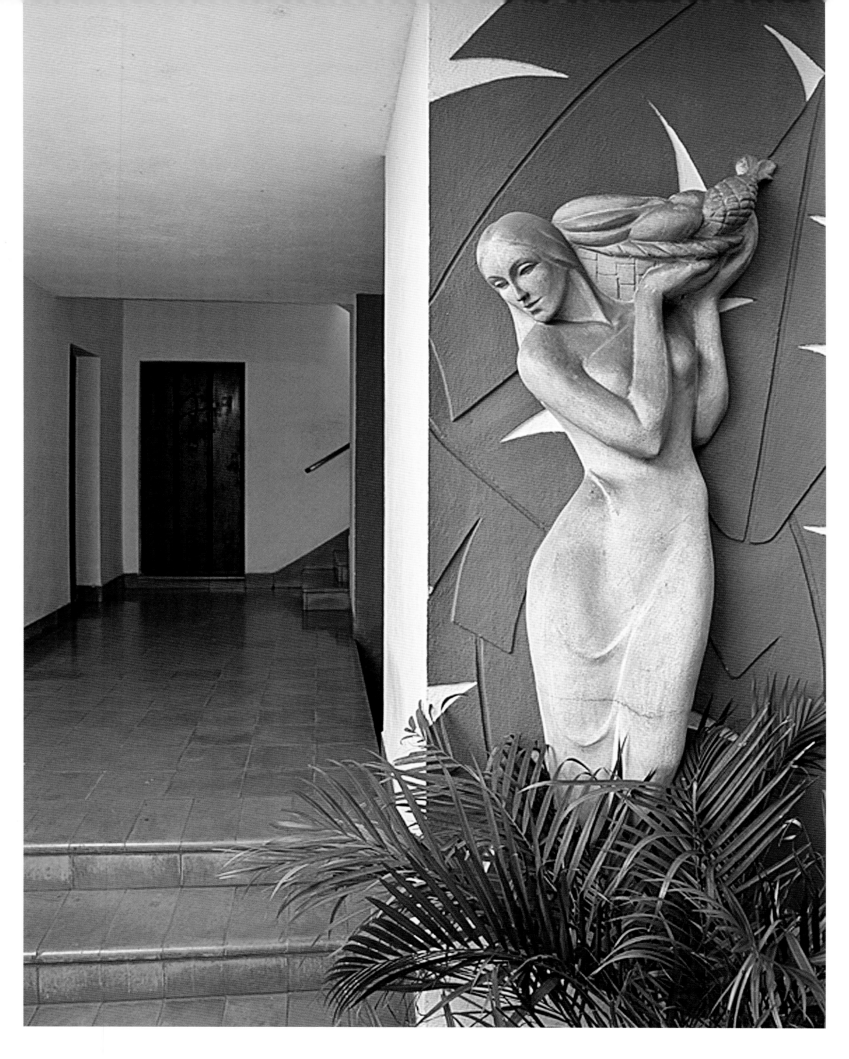

Casa de Rita Longa

Above: Rita Longa with her marble torso at the 1939 exhibition of Latin American artists at the Riverside Museum.

Opposite: A relief representing a woman bearing a basket of tropical fruit at the entrance to the house.

Havana connected emotionally to the work of sculptor Rita Longa. Her work was admired and sought after, but it did sometimes generate controversy, as in the case of Santa Rita de Casia. Longa's work included the sacred and the profane, and at times she combined the two in ways that unsettled Havana's conservative bourgeoisie.

Longa had the good fortune to collaborate with architects throughout her career, creating free-standing sculptures and incorporating her work into buildings as light fixtures, balcony railings, fountains, and columns. This level of collaboration illustrates a moment when the island's best architects commissioned Cuba's artistic vanguard to create murals and sculpture that took the architecture one step further. Longa's frequent collaborator was her cousin Eugenio Batista, one of the most talented architects of his generation and, like her, a member of the González de Mendoza clan. Batista's projects gave Longa opportunities to explore forms beyond traditional sculpture. Her balcony railings for a modernist Vedado apartment building captured the movement of the ocean, transforming Batista's simple building and giving it an identity.

In 1941 Longa, her mother, and her two aunts built a pair of two-story houses—a version of the extended-family living captured in the portrait of Antonio González de Mendoza and his descendants. Longa's aunt, Nena Arostegui, and her sister Carmen—Longa's mother—asked Batista to design houses for an unusual fan-shaped lot. In her book of memories, Arostegui described the construction of these houses in Miramar, which was then a *finca* being developed by her uncle Ramon Mendoza and his partners. In her lifetime, Arostegui experienced the westward moves to successive Havana neighborhoods that characterized the life of the city's bourgeoisie. She recalled that this part of Miramar was "a desert" at the time, as yet undeveloped for blocks on end. When the houses were completed, Arostegui would live in the house on the right half of the property with her husband and sons. Longa and her family would live in the second house, which was set farther back in the property, with Carmen and her sister Aurelia sharing an apartment above. Batista created simple yet very efficient houses that gave every resident the appropriate amount of privacy.

Longa shared the ground-floor apartment with her husband, diplomat Fernando Alvarez Tabío, Cuba's representative to the United Nations in the 1960s, and their two sons. The apartment included a small studio space in the entry area where she began creating the sculpture commissioned by Havana's leading families for their homes. The studio is a treasure trove of maquettes and installation photos that show the decades of commissions for garden sculptures and fountains, including a sculpture for the pool of Pepe Gómez Mena's Country Club house, where Longa installed the seated figure of an Indian woman whose basket spills water into the pool.

Longa captured the movement of the ocean in the railings she designed for an apartment building by architect Eugenio Batista. For the Teatro Payret, another collaboration with Batista, she created a graceful Muse.

The 1940s were a particularly fertile period for Longa—launched by her success during the 1939–40 New York World's Fair at an exhibition of contemporary Latin American art at the Riverside Museum. *Time* magazine's art critic admired the Cuban work and singled out "the most effective sculpture, a torque figure, by handsome 27-year-old Rita Longa, who is chief of the section of Teaching and Art Appreciation in the Department of Culture under Cuban Ministry of Education."

Longa's highly personal, artistic house, which her granddaughters preserved after her death in 2000, departed from the prevailing ideas of good taste of the day in its unusual simplicity and in the confidence of its design. Longa's appreciation of the importance of scale is especially evident in these small spaces, which she shapes via a series of pieces of built-in furniture and wall decorations that define functional areas within the open plan. The first such installation is the arresting female figure holding a basket of tropical fruit that Longa applied to one of the structural columns in the carport/entry area. Stylized banana leaves create a background for the figure and connect her to the surrounding landscape. The relief performs a functional purpose—her basket conceals a light—and it also clearly proclaims the house as Longa's.

Longa's interior design statements were, like her sculpture, simple and very effective. A low, L-shaped limed wood bookcase defines a vestibule. To the right, floor-to-ceiling shelves conceal the banquette of the seating area. A mural of oversize tropical leaves springs from the entry bookcase and turns the corner to tie the interior to the garden beyond. The mural is given architectural context by the overlaid wood grid. Longa's interpretation of nature is designed to complement the adjacent garden and integrate it into the room. The L-shaped banquette is anchored at right and left by the simplest of zoomorphic side tables. Floating

opposite is an undulating stone base that supports a curving glass top to create a cocktail table. Longa designed all the pieces, including the built-ins.

The shelves throughout the house hold books, family photographs, and maquettes for Longa's pieces or small sculptures by friends. Arranged on the entry bookcase are a wedding picture of a glamorous Rita in late art deco mode, a small-scale model of the Tropicana dancer, and a beautiful marble torso carved by Rita in the mid-1950s. On the walls hang paintings by her contemporaries, including a landscape and a Gitana head by Victor Manuel. The dining room table is a white-painted modernist piece surrounded today by four iron chairs brought in from the garden when the caned seats of the original wood chairs wore out. They seem to float on the simple cream tile floor.

Throughout the limited space Longa's aesthetic catches the visitor's eye and moves it around the house. The bedroom hall, for example, is painted a deep terra-cotta to offset the white of the ivory elephant tusks hung there. Three French doors with traditional Cuban wood louvers flood the space with light and create a connection to the small garden, which Batista's design keeps private from the neighboring house.

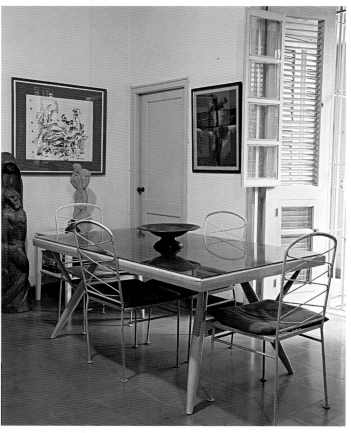

Top: Low bookcases define the spaces in the house; a portrait of Longa hangs in the background.

Above left: Today simple painted iron chairs brought from the garden surround the original 1940s dining table.

Above right: Longa's small studio remains as she left it, with small-scale models of her larger pieces as well as photographs of her sculptures installed in their complex landscapes.

Opposite: The corner banquette of the sitting area is anchored by Longa's mural of tropical foliage.

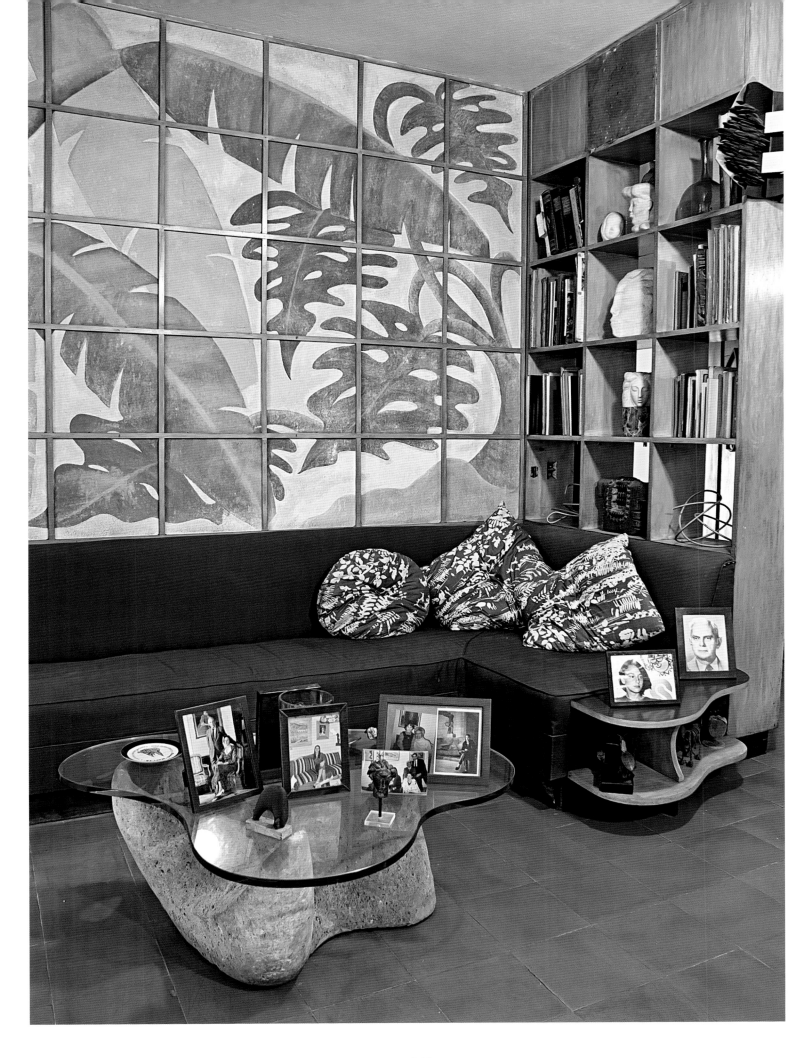

Among Longa's collaborations with Eugenio Batista was the Teatro Payret in downtown Havana, a 1940s renovation of a late-nineteenth-century theater. The sober classical exterior yields to the surprise of crisp modern geometry in the lobby: zigzagging ceilings, sloping curves, structural beams, level changes, and cutouts. Longa's bronze sculpture of a classical muse with flowing hair and swirling veils is the focal point of an opening between floors.

For Batista's abstracted classical temple at the intersection of several important suburban roads, Longa sculpted the Virgin and Child, to represent protectors for travelers, at the center of the colonnade. Sixty years after its installation, offerings of flowers and money are still left at this sculpture, *La Virgen del Camino*, which is venerated by Havana residents. So popular was the statue from the moment it was installed that a bank account was created in the Virgin Mary's name to handle the contributions, earning Longa's sculpture a place in *Ripley's Believe It or Not*. For another, very different Havana audience, Longa created *Form, Space, and Light*, which was placed outside the Museo Nacional de Bellas Artes and became an emblem of that institution.

Longa's most controversial work was the 1943 statue *Santa Rita de Casia*, commissioned by the dynamic Father Lorenzo Spirali for the main altar of a new church of that name on Fifth Avenue in Miramar. The priest was a key figure in postwar Catholicism, involved in the creation of Villanova University and a persuasive fundraiser. The wealthy parishioners—the noon Mass was an opportunity to show off the latest fashions—found Longa's Santa Rita too shapely, too sensuous and suggestive to grace the altar of the church. A painted plaster maquette was relegated to a niche at the back of the church. Father Spirali, however, felt compelled to have Longa officially exonerated by church authorities for the provocative work. The sculpture and the surrounding controversy illustrate the last decades of insular, upper-middle-class suburban life—a world of family, church, school, and club—before the revolution.

At Colón Cemetery, Longa's *Pietá*, a white marble sculpture on a black background created for Senator Guillermo Aguilera's dramatic memorial, poignantly captures the essence of grief and mourning. Longa also engaged the imagination of generations of Havana children with her

Left: Offerings of fresh flowers surround Longa's sculpture *La Virgen del Camino*, a patron saint of travelers.

Right: Longa's sculpture *Form, Space, and Light* was carved on site outside the National Art Museum.

Right: Longa's pure white *Pietá* is installed on the polished black granite wall of the Aguilera family tomb in Colón Cemetery.

Below left: Longa's controversial depiction of Santa Rita de Casia.

Below right: The family of bronze deer on a rocky landscape at the entrance to Havana's zoo.

sculpture of a family of deer installed at the entry of the National Zoo of Cuba. Her abstracted profile of Cuba's native warrior chief Hatuey became the logo of Hatuey Beer, and the image was engraved onto a commemorative tray that rests on her vestibule bookcase.

Longa studied sculpture with Juan José Sicre at Havana's art school, the Academia de Bellas Artes de San Alejandro. Sicre did not disdain decorative sculpture, and his reliefs and friezes were among the first sculptures to be incorporated into the architecture of Havana's early art deco buildings. Perhaps it was his influence that helped shape Longa's understanding of sculpture's collaborative role in works of architecture and landscape.

House of Harriet and Alfred von Schulthess

Connoisseurs of twentieth-century architecture are often surprised to learn that the Swiss Ambassador's Residence in Havana is a rare Caribbean work by Richard Neutra, set within an imaginative garden by Roberto Burle Marx, the Brazilian landscape architect. The house has recently been restored, allowing visitors to appreciate how Neutra—who defined midcentury modernism in California—subtly adapted his signature International Style to tropical Cuba. The house was commissioned by a Swiss banker and his wife, who shared a great love for Cuba and, during their nearly ten years on the island, immersed themselves in the culture.

Alfred von Schulthess was a money manager who invested foreign capital in Cuba as a partner in Havana's Banco Garrigo. His wife, Harriet Bodmer, was the daughter of the Swiss industrialist, philanthropist, and bibliophile Martin Bodmer. In 1954 following their move to Havana from New York, the couple decided to build a house in El Country, and Neutra was recommended by a mutual friend. Neutra had been practicing in Los Angeles since the early 1920s.

According to architectural historian Eduardo Luis Rodríguez's description of the design and construction process, Neutra listened to his clients' wishes, unlike other celebrity architects of the period. Often he would have clients fill out questionnaires in order to flesh out their design needs, and he would keep a photo of his client nearby while designing. However, he also made clear that a Neutra house would be done Neutra's way. As often occurred in projects by an out-of-town designer, a local Havana architect was brought on to translate Neutra's vision to Cuba's conditions and building methods, obtain building permits, and deal with local inspections. Neutra hired young Raúl Alvarez, and by all accounts Alvarez became an important member of the team, helping to make the house Cuban by advising on the climate, local materials, and special conditions like hurricanes, humidity, and termites. Daughter Sandra von Schulthess remembers visiting the construction site often as a little girl and how exciting the house felt because of all the glass. Members of Havana's architectural community also monitored the progress on the house, since it was the work of a respected European master. During this period, many architects made it their mission to explore what it meant to be modern while remaining Cuban, to create works that were true to both traditions.

The house was sited on a corner of the lot, a spot selected because its higher topography would provide better air circulation. Neutra positioned the building so that the solid walls of an end facade faced the street—thereby giving very little away to the visitor entering the driveway gates. His approach was the opposite of the Beaux-Arts tradition, which would have revealed everything for the visitor to admire at once. Instead Neutra's subtle design requires that the viewer travel through the entire site in order to fully understand the house. Visitors

Above: Stained-wood stair treads cantilever off the concrete wall while stainless-steel rods serve as railings.

Opposite: In the rear garden, a flamboyant tree in bloom frames a view of the bedroom balcony, which is supported by a series of projecting concrete beams.

Overleaf: Wood-paneled walls, concealing sliding pocket doors, define two seating areas and the dining room within the open plan of the public zone.

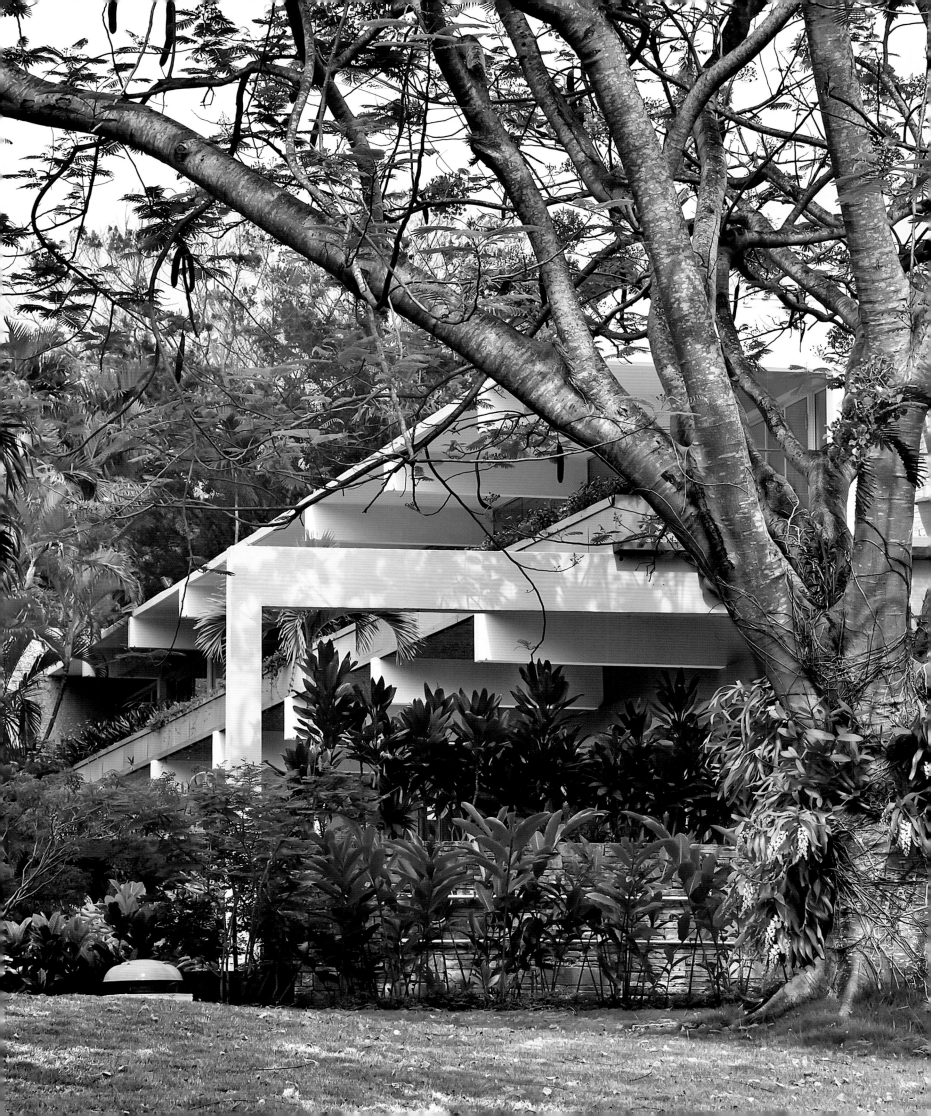

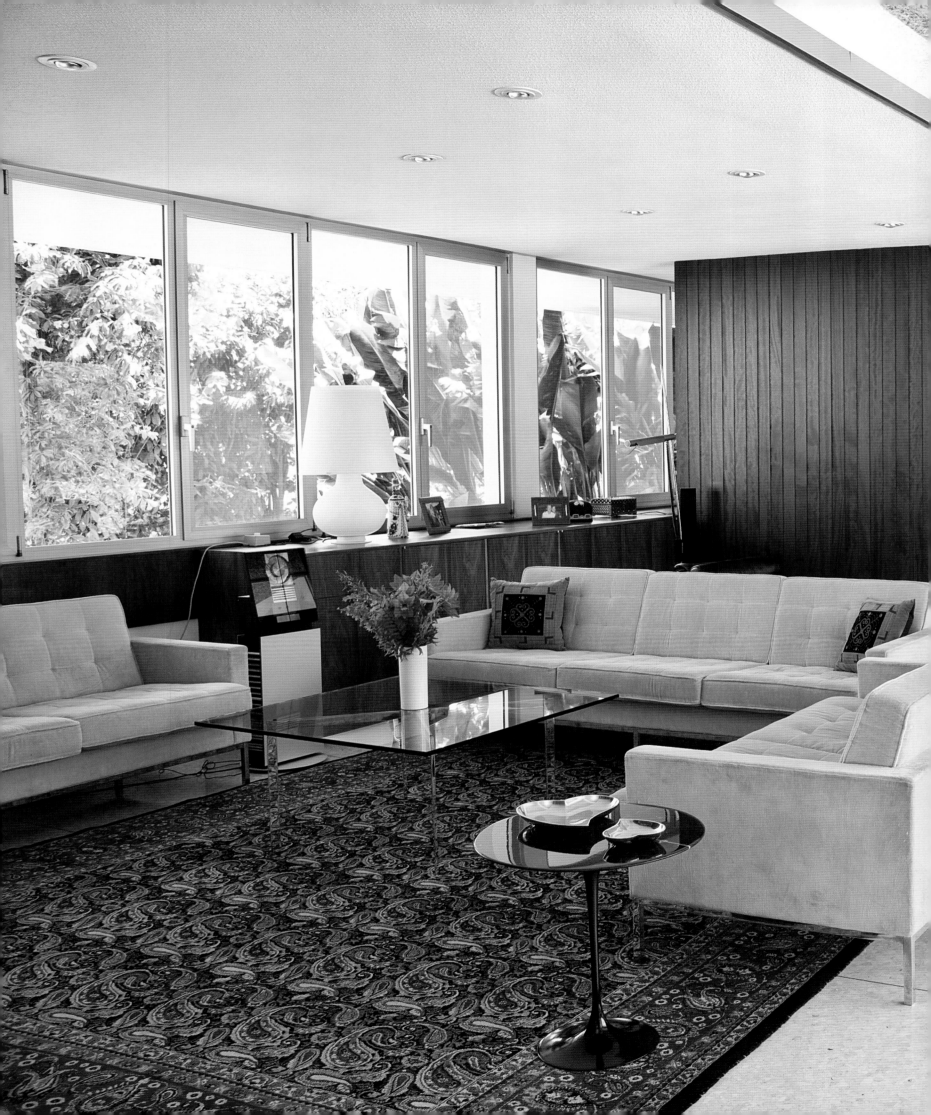

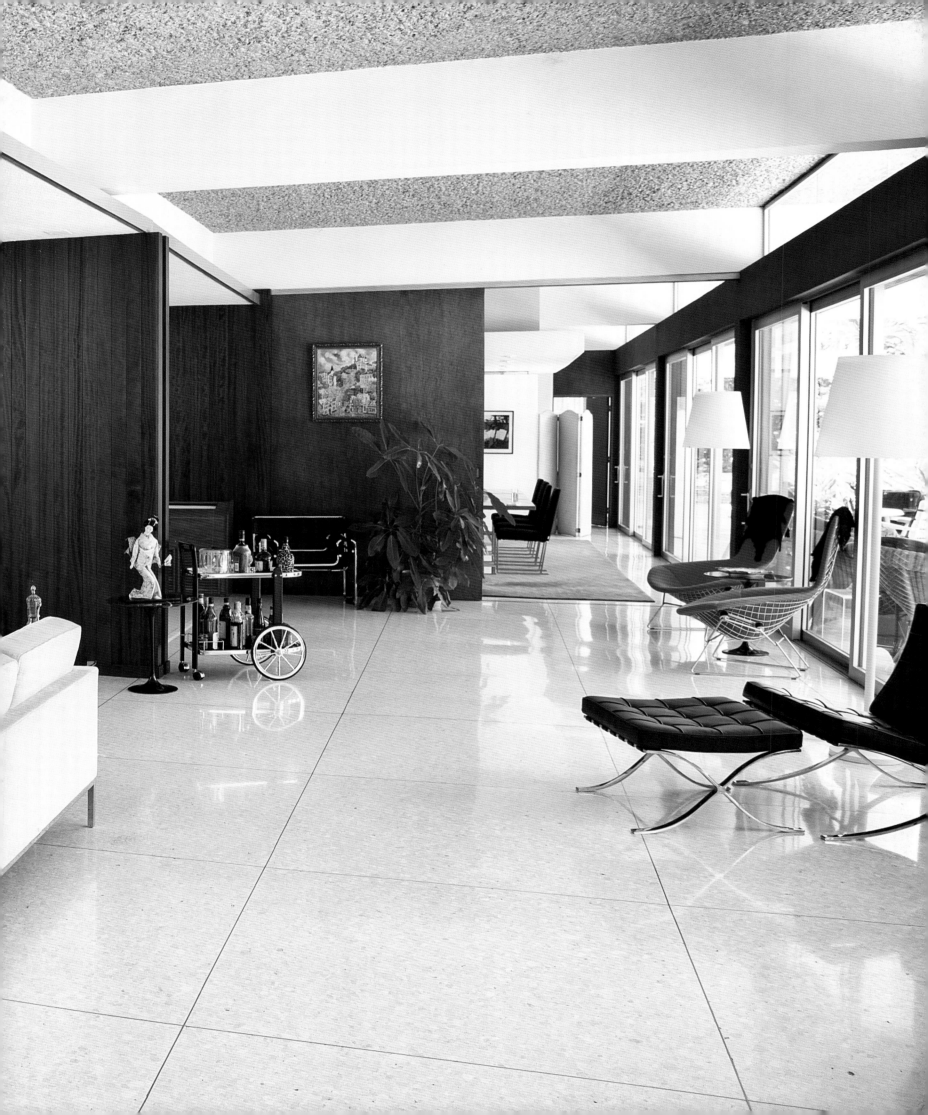

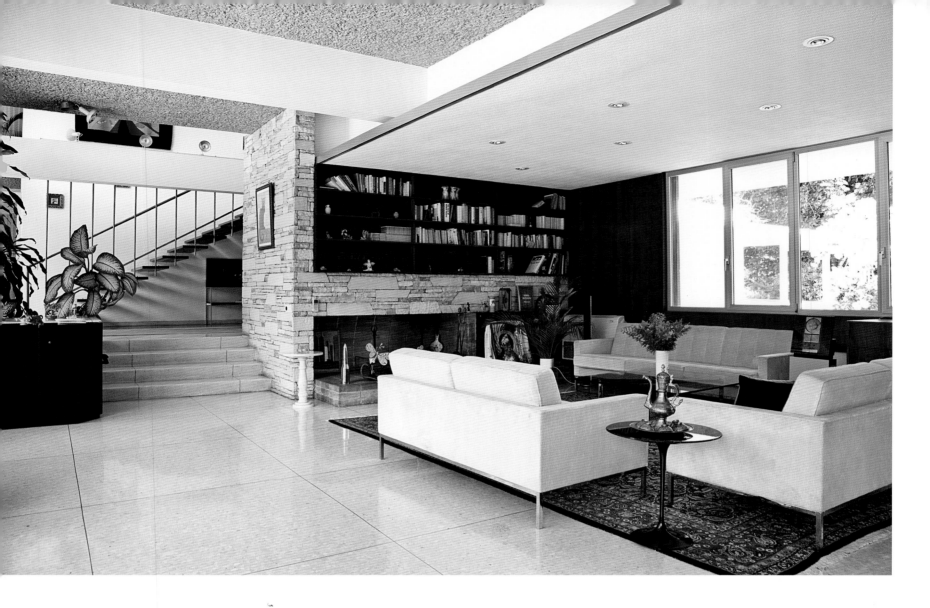

are first received in a U-shaped space defined by a long entry canopy, the body of the two-story house, and the single-story service wing—perhaps a reference to the colonial courtyard.

The layout von Schulthess requested was simple and straightforward. A living room, dining room, and playroom had been envisioned as a large open space that could be subdivided by folding walls. As the design process evolved, the clients requested the possibility of more solid divisions between spaces, so wood walls were added to conceal sliding doors. Yet, even with these changes, the visitor who steps down from the front hall is greeted with a view of the interior from one end of the house to the other. At opposite ends of the ground floor were the parents' studies; Mr. von Schulthess's office was just off the front hall, with a guest suite nearby.

Neutra was interested in making connections between the inside and outside in a way that went beyond making the interior open to garden views. He continued exterior building materials inside the house to make the link. The stone used in the wall of the guest-suite garden is also found in the living room fireplace. A low stone planter framing the living room entry appears to shoot through the glass wall of the garden facade, anchoring a pair of slab shelves laden with potted plants indoors and out. Within the open-plan design vocabulary, Neutra creates drama through small changes in floor level, ceilings that rise and fall, and beams that extend from inside to outside.

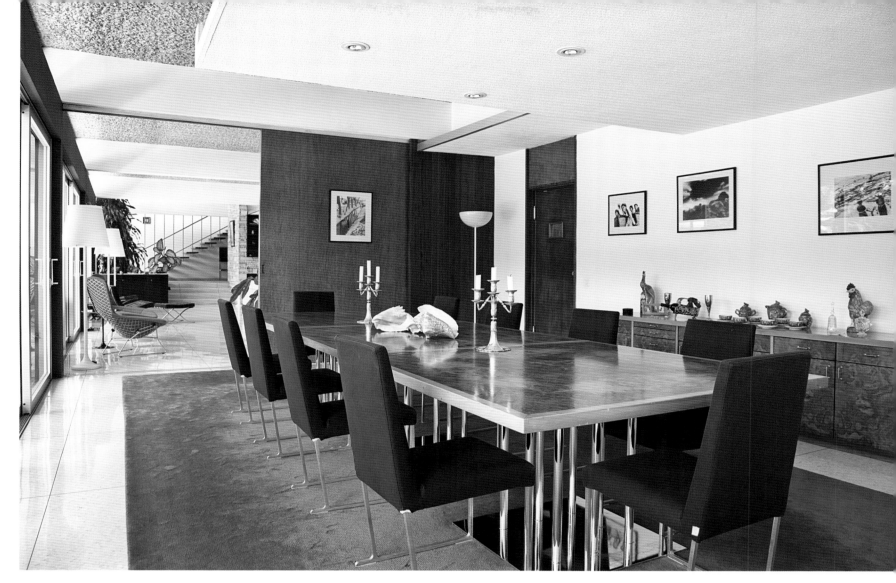

Opposite above: The fireplace wall was built of the same stone used in portions of the exterior, creating an indoor-outdoor connection.

Opposite below: A concrete slab canopy provides shelter from the driveway to the front door, allowing the house to sit in the landscape away from the vehicles.

Above: In the dining room, the sliding door is partially open to provide additional separation, while creating an extra wall for the display of artwork.

Right: The view from the front door through the stair to the landscape beyond.

The subtlety of Neutra's design is revealed in the juxtaposition of rough materials—the bush-hammered concrete ceilings, the stone walls, the interior and exterior wood siding—against the smooth painted beams and ceilings, terrazzo floors, and walls of glass. As Neutra wrote to a mutual friend, in a simple building like the von Schulthess house it was crucial to achieve and maintain a balance between the landscape, the furniture, and the interior and exterior.

Sandra von Schulthess remembers the three very similar second-floor bedrooms the girls were allowed to select. A simple stair rose from the playroom area to their rooms and that of their governess. The generous master bedroom area was found at the opposite end of the house, directly off the spectacular steel and wood stair, giving the parents privacy. A continuous balcony was accessed by individual bedroom doors. It created a deep overhang that protected the glass walls of the living area below from the sun. A cascade of green from planters built into the balcony wall connected the house to the pool garden beyond. The ground-floor terrace ran the length of the house, extending the public rooms out into the tropical landscape. Sandra remembers this expanse, with its gentle ramp at one end, as the perfect place to rollerskate. She and her sisters enjoyed a typical life in Havana's most exclusive suburb, riding their bikes down the hill to the Ruston Academy. Like other Havana kids, their leisure time was spent with friends at the beach club where they competed in swimming meets and in sporting events.

Landscape architect Roberto Burle Marx was admired in Cuba for his role in the Brazilian avant-garde that included architects Oscar Niemeyer and Lucio Costa. His design for the von Schulthess garden remains one of the most important landscapes on the island. The house was inventively integrated with the garden via a series of linear elements that extended the geometry of the building outward, including a continuous planter anchoring the terrace and the house and a series of pools, paved terraces, and ornamental plant beds. Beyond this recti-linear part of the garden, large areas of rolling lawns were accented periodically by flowering trees. A path curved sinuously along the property's edges, which were planted densely for interest and privacy from the neighbors. Under the shaded canopy of palms and ficus trees, one finds crotons, colorful bromeliads, lush ferns, and a water garden—the exotic plant mate-rial associated with Burle Marx work. Although changes to the design have been made since the garden was first installed, one can still appreciate much of it. Sandra von Schulthess recalls how much of the large reflecting pool was eventually covered up—it became overrun with frogs and algae—but she remembers the magical effect of the house mirrored in this body of water, another instance of connecting inside with outside.

One of the design signatures of the house is the spiral stair that rises sculpturally from the garden off the ground-floor guest bedroom, giving access to the roof terrace. Originally, rail-ings and planters defined an area from which the ocean could be viewed.

Visitors often wonder how the house, with its walls of sliding glass doors, responded to Cuba's climate. In addition to the shade provided by the balcony and Neutra's having sited the house to take advantage of breezes, there is good cross ventilation—the house is essen-tially one room wide and has windows on both sides. It appears that from the project's inception, however, the clients requested individual air-conditioning units for the bedrooms

Above: A pair of stone plant shelves projects from the body of the house, separating the private area of the terrace from the public zone related to the living and dining rooms.

Opposite: Roberto Burle Marx's landscape connected the house with the swimming pool, the geometric planting beds, and the reflecting pool; the broad lawns are bordered by curving paths planted with shrubs and flowering trees. The area of lawn seen today between the swimming pool and the fountain was once part of a larger reflecting pool.

Left: Bedroom spaces are defined within the repeating bays between the concrete beams that support the roof slab and the second-floor balcony.

Right: A spiral stair leads from the ground-floor guest-suite garden to the rooftop terrace.

and the studies. Sandra notes that the family never spent the summer months in Havana, preferring to visit an uncle in California or see family in Switzerland.

Knoll International is credited with furnishing the interior. Hans Knoll had recently opened a store on the Paseo del Prado and was visiting the island on business when the von Schulthess house was being built. In 1956 the family moved into the house, although some details were still being finalized.

The von Schultess social circle in Havana seems to have been international—European ambassadors, the American colony, and wealthy Cubans. The couple loved Cuba and built their house intending to spend the rest of their lives there. But in 1961, after the Cuban revolution nationalized the Banco Garrigo, the family left the island.

258

Casa de Isabel y Olga Pérez Farfante

Above: Wood louvers can be adjusted to maximize breezes and views of the landscape.

Opposite: At the entry to the second-floor apartment are a pair of Hans Wegner Sawbuck armchairs and a Scandinavian table and dining chairs.

Raúl Pérez remembers the utilitarian industrial-style black rubber treads that architect Frank Martínez originally installed on the wood steps of Isabel and Olga Pérez Farfante's house. Pérez, an architect by training and nephew of the two sisters who built the family home, finds it amusing that, at a time when the Cuban bourgeoisie typically aspired to the solidity of marble or terrazzo, the sisters were thrilled with the sculptural staircase of lightweight iron tubing and basic wood treads.

Although the Pérez Farfante house appears to give everything away from the street, it reveals itself only as one moves around and through it. Nothing prepares the visitor for the dramatic views framed by the architecture, the interior focal points that keep the eye moving, or the sense of delight when a wall slides away to turn an interior room into an open-air space.

In this house the Cuban custom of extended family living took the form of a duplex, which allowed community as well as privacy. Martínez drew on traditional Cuban construction in his use of adjustable wood louvers that fill floor-to-ceiling openings, balconies that act as front porches overlooking the street, and a shaded recess at the heart of the house that references the colonial courtyard and separates the public and private wings.

The house was built in Nuevo Vedado, a neighborhood developed in the 1950s that took advantage of the often dramatic topography and encouraged architects and middle-class homeowners to experiment. Today the winding streets of simple yet interesting midcentury houses has a special charm. One can picture the mid-1950s optimism and the prosperity of the lawyers, bankers, and doctors building homes here, as well as the family life of homemakers with servants and neighborhood children attending private schools.

Olga and Isabel Pérez Farfante were women who balanced academic careers with family lives—something still unusual in the 1950s. Although there is a sense that patrons of avant-garde contemporary architecture must be very wealthy, the Perez Farfante sisters were not. They were the daughters of a Spanish grocer from a local small town and his schoolteacher wife. The parents impressed upon the girls and their two brothers the importance of education, sending them to Europe and the United States to complete their studies. Olga balanced a dentistry practice with her job as a teacher at a prestigious high school. Isabel studied biology at the University of Madrid and graduated summa cum laude from Harvard. She was a professor at Havana University and an expert in crustaceans and the Cuban fishing industry. After the revolution, she continued this important work at the Smithsonian Institution. Isabel was the firstborn and seems to have been the strongest personality in the family. According to Raúl Pérez, Isabel and her economist husband were part of a golden generation at Havana University, where the brightest from a variety of fields interacted. This was probably where Isabel met Frank Martínez.

Pérez recounts being told of the push and pull that occurred during the design process but quotes his uncle to illustrate their trust in the architect: "The only thing we asked of Frank Martínez was that he respect the philosophy of the building site." Theirs was not a typically

The house is raised above the ground-floor landscape, with a shaded vertical recess separating the public and private zones of both floors.

Above left: The concrete roof and floor slabs define a framework into which are inserted the stair-well's sheet of glass, the louvered walls of the public areas, and the strip windows of the bedrooms and baths.

Above right: Wood treads are supported by the exposed iron structure of the stair; the glass wall provides a sense of merging the exterior with the interior.

desirable site but rather a pair of lots parallel to the street, the second of which dropped steeply down to an old rock quarry. Isabel, her husband, and their two sons moved into the downstairs floor in 1955; two years later Olga and her family came from the pueblo.

Although the house is unmistakably modern—and the exterior appearance is marred today by the inevitable Havana chain-link fence at the street level—the front has the elegance of a classical temple. Columns support the roof, and at the roofline, a projecting thin concrete slab protects the house from sun and rain. Asymmetries of massing, windows, and corner treatments dispel the idea that its design is traditional, however. Concrete floor slabs are expressed as continuous horizontal planes on the facades. The walls are infilled from slab to slab with concrete block, fixed glass, or wood louvers, allowing the function of an interior space to be read on the exterior. The rear facade, too, reflects the interior: strip windows at the bathrooms, sheets of glass at the stair, sliding louver doors at the public core, and perforations in the block wall ventilating the service area. Conversely, construction materials used on the exterior are carried indoors: the weathered concrete-block walls that meet the white concrete floor slabs, the glass and wood louvers, the concrete columns that rise four stories. This continuity of materials blurs the distinction between interior and exterior—an achievement of the best of Havana's modernist houses.

Left: In the second-floor living room, a wicker butterfly chair sits in front of the wood louvered wall, which permits breezes to flow through the public areas.

Right: In the third-floor master bedroom, a Harry Bertoia chair contrasts with the cement-block walls, cast-concrete column, wood louvers, and terrazzo floor.

The effective layout is identical on both floors. Public rooms and bedrooms are placed in separate wings at opposite ends of the house, connected by a linear entry space. When the louver doors at the adjacent front balcony are slid open, this pre-living-room entry space is doubled in width. Sliding open the corresponding louvered doors at the rear facade brings views of Havana's woods and the horizon into the center of the house.

The tubular steel and wood staircase, continually changing in the light, is visible from the front door of each apartment. Set toward the center of the rear facade, the stair acts as a vertical accent rising in its glass box—or, as seen from the ground floor, floating down as it emerges from the solidity of the house. Thanks to the dramatic site and the lightweight design of the stairs, the user has a sense of drifting high above the landscape. Like much in this house, the stairs are a simple yet complicated element.

Today the third-floor master bedroom displays an appealing monastic quality: a white plastered column floats in front of a cream block wall, a strip window sits above the built-in headboard, a white Harry Bertoia chair provides a slick contrast, and on a simple wood bookshelf gleam the gold bindings of a nineteenth-century German history of the world. A generous master dressing room is a surprise for the era and functions as a buffer separating the parents' room from the children's.

Above: Cuban-made midcentury
wicker chairs in the dressing
room that buffers the master
bedroom from the public areas.

Opposite: In the dining room, a
portion of the wood-paneled wall
drops down to create a kitchen
pass-through and counter where
the original barstools are still
pulled up.

The kitchen connects to the public area, in a nod to the modern American lifestyle that Cubans
were always emulating. But middle-class Cubans of the 1950s had cooks and housekeepers
long after the same income group in the United States had given up their servants, and the
kitchen forms part of a clever series of service spaces, including laundry and maid's bath. These
areas were provided with their own set of spiral stairs, allowing servants to move around the
compact house without going through the public rooms. Stained-wood siding used as a warm
accent on one of the living room walls flows into the dining room and wraps the box of the
kitchen, cleverly revealing a modern bar when the pass-through drops down.

The second-floor level is substantially cooler than the upper floor, since the thin concrete-slab
roof is not insulated and tends to heat up from the sun. The house was designed to maximize
cross ventilation, but the rear facade's exposure to the setting sun requires the use of light
cotton curtains to shade the glass.

The sisters shared a love for contemporary painting, examples of which are found throughout
the house: a Gitana head and landscape by Victor Manuel, two watercolors by Hipólito Hidalgo
de Caviedes, and a Mirta Serra. A portrait of Isabel Perez Farfante by Victor Manuel once hung
on the second floor. The original furniture, purchased with the advice of the architect, includes
Scandinavian classics by Hans Wegner as well as Cuban-made pieces that perfectly comple-
ment the 1950s architecture.

Left: A 1950s still life by the Cuban painter Angel Acosta Leon hangs over Danish teak pieces in the second-floor living room.

Right: Hipólito de Caviedes's angelic trio represents the melding in Cuba of the classical language of the arts with the island's Afro-Cuban traditions.

The open ground floor, which includes the service and parking areas, the entry stairs, and a garden, is a wonderful place to sit and enjoy the shade and the views. The wood slats used as formwork for the concrete-slab ceiling add texture in an unexpected place. The use of simple outdoor spaces like these—areas of the house that keep the interior cooler by promoting air circulation and allow an appreciation of the beautiful surroundings— were advocated by Cuba's most thoughtful midcentury architects. The concept of a house raised on slim concrete columns, or *pilotis*—detached from its surroundings—appealed to midcentury Cuban architects and their enlightened clients. This language of architecture descended from the rational, late-1920s villas of Le Corbusier. In its application here, it lightens the feel of the house.

Here and in the nearby Emma Justiniani house, Frank Martínez aimed for international modernism with a Cuban flavor, recognizing the value of time-tested elements such as wood louvers and the use of courtyards and their circulation galleries. These works illustrate how it was possible to be modern without rejecting everything that came before. In a 1960 treatise

The dining room cover is supported by a three-story, cast concrete column visible behind the upper floors' wood louvers.

Overleaf: An open-air seating area is created at the ground floor, where the mass of the house is suspended over the land, commanding views of New Vedado's lush vegetation.

for *Artes Plasticas*, architect Eugenio Batista juxtaposes images of nineteenth-century Cuban houses with another Nuevo Vedado house by Martínez, the 1959 house of Eloísa Lezama Lima. Batista urges architects to allow a study of Cuba's architectural past to guide them in selecting design elements that work well for the island's culture and climate.

In his analysis of the Lezama Lima house, Batista celebrates the same ambiguity that is encountered in the Pérez Farfante house and in colonial houses, asking where the boundary is between the interior and exterior, where the courtyard stops and the adjacent gallery begins. He notes that in Martínez's work, as in the past, the spaces are blurred: courtyards become living rooms and galleries are more than circulation space.

The Pérez Farfante house is a milestone, reconciling the Cuban search for national identity with the following of modernist trends that made Cuban designers and their clients feel connected to the modern world. In this house Martínez demonstrated it was possible to be of the world while remaining Cuban—a concern that has been central to the island nation since its inception.

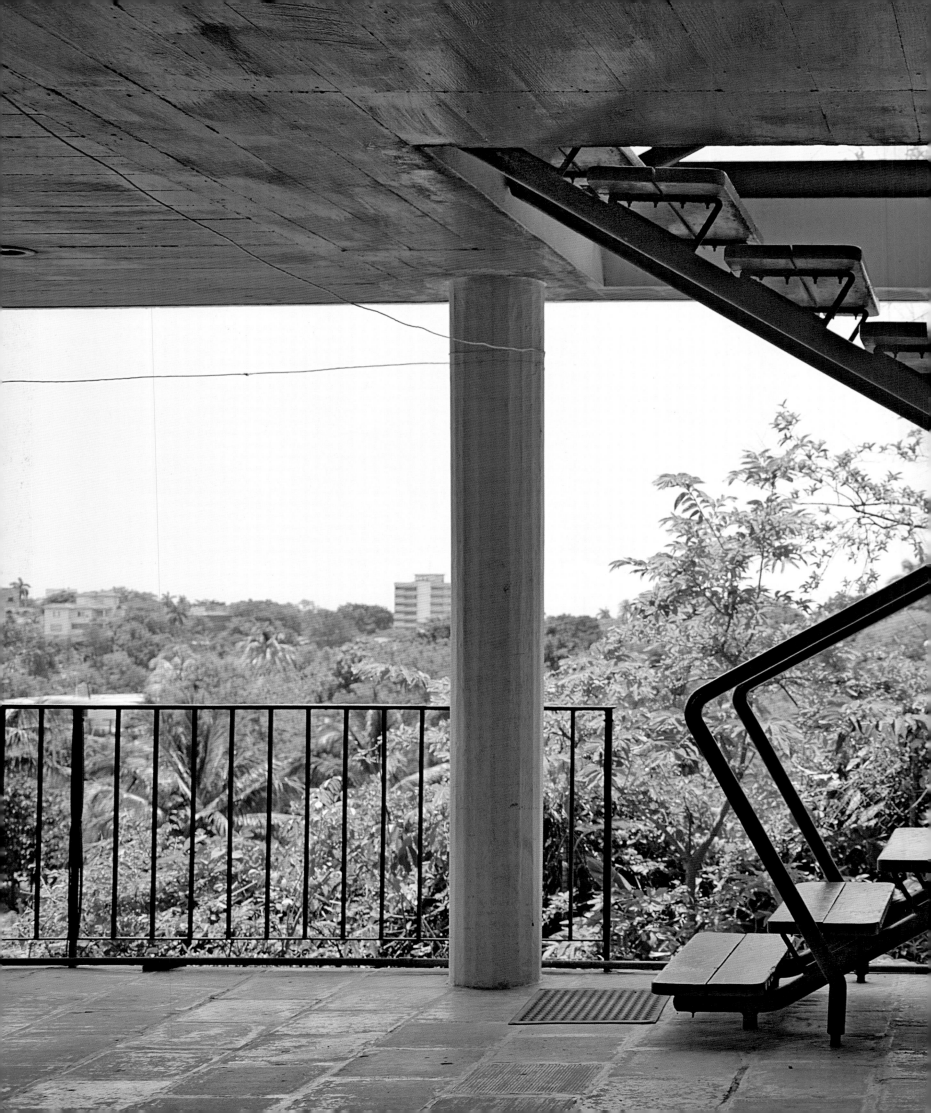

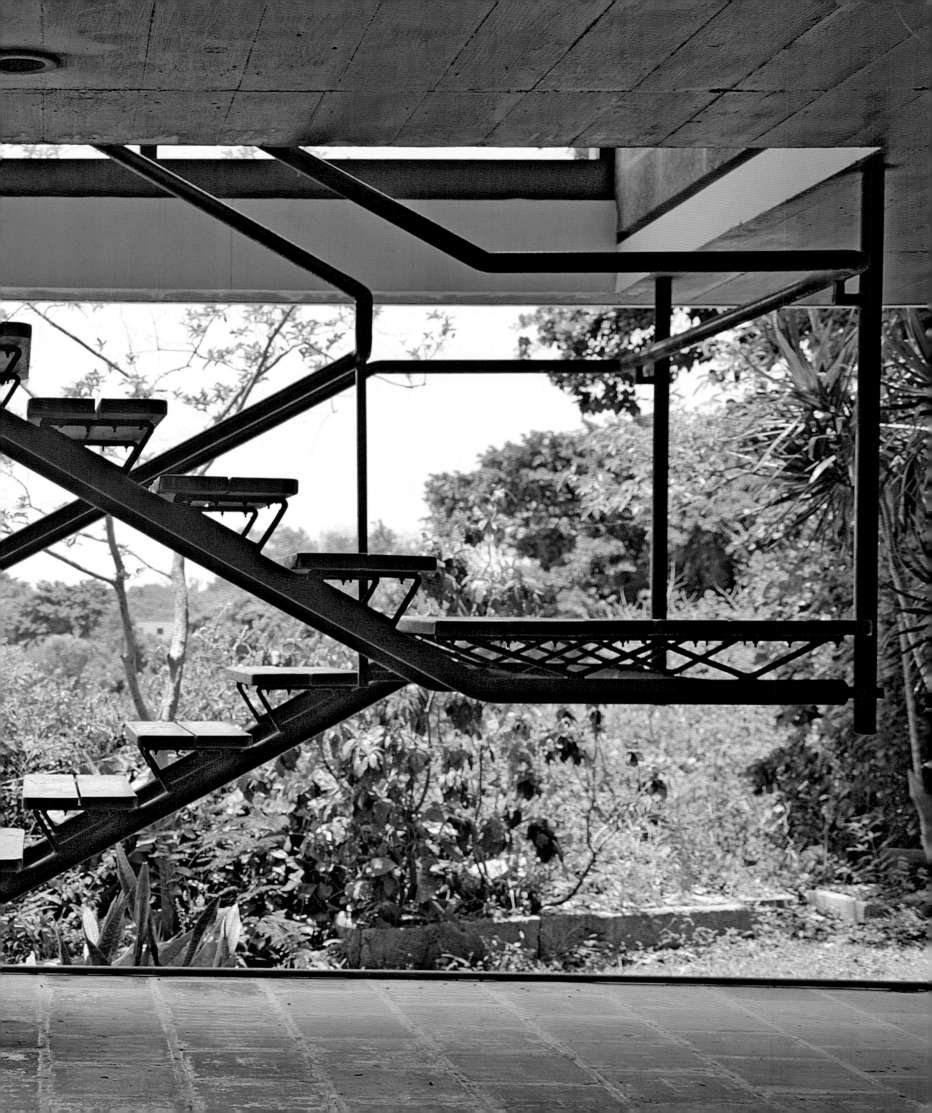

Bibliography

PRINCIPAL SOURCES

Cornide, Maria Teresa. *De la Habana: de siglos y de familias.* La Habana: Editorial de Ciencias Sociales, 2003.

De las Cuevas Toraya, Juan. *500 Anos de Construcciones en Cuba.* Madrid: D. V. Chavín Servicios Gráficos, 2001.

DAPA22, Cuba Theme Issue, *The Journal of Decorative and Propaganda Arts.* The Wolfson Foundation of Decorative and Propaganda Arts, Miami, 1996. Essays consulted:

> Menocal, Narciso G. "An Overriding Passion — the Quest for a National Identity in Painting."

> Venegas Fornias, Carlos. "Havana between Two Centuries."

> Gelabert-Navia, Jose A. "American Architects in Cuba, 1900–1930."

Jiménez Soler, Guillermo. *Los Propietarios de Cuba 1958.* La Habana: Editorial de Ciencias Sociales, 2006.

Jiménez Soler, Guillermo. *Las Empresas de Cuba 1958.* La Habana: Editorial de Ciencias Sociales, 2008.

Lobo Montalvo, Maria Luisa. *Havana: History and Architecture of a Romantic City.* New York: The Monacelli Press, 2000.

Perez Jr., Luis A. *On Becoming Cuban: Identity, Nationality and Culture,* Chapel Hill: The University of North Carolina Press, 1999.

Rodríguez, Eduardo Luis. *La Habana: Arquitectura del Siglo XX.* Barcelona: Blume, 1998.

Rodríguez, Eduardo Luis. *The Havana Guide: Modern Architecture 1925–1965.* New York: Princeton Architectural Press, 2000.

Rodríguez, Eduardo Luis, and Maria Elena Martin Zequeira. *La Habana: Guía de Arquitectura.* La Habana–Sevilla: Dirección Provincial de Planificación Física, 1998.

ADDITIONAL SOURCES

Abbott, James Archer. *Jansen.* New York: Acanthus Press, 2006.

Abbott, James Archer. *Jansen Furniture.* New York: Acanthus Press, 2007.

Alonso, Alejandro G. *Amelia Peláez.* La Habana: Ediciones Boloña, 2007.

Alonso, Alejandro G. *La Obra Escultórica de Rita Longa.* La Habana: Editorial Letras Cubanas, 1998.

Alonso, Alejandro G., and Pedro Contreras. *Havana Deco.* New York: W. W. Norton, 2007.

Álvarez-Tabío Albo, Emma. *Vida: Mansión y Muerta de la Burguesia Cubana.* La Habana: Letras Cubanas, 1989.

Archer-Straw, Petrine. *Negrophilia: Avant-garde Paris and Black Culture in the 1920's.* London: Thames & Hudson, 2000.

Arquitectura en La Habana: Primera Modernidad. Espana: Sociedad Editorial Electa, 2000.

Balderrama, Maria R., ed. *Wifredo Lam and His Contemporaries, 1938–1952.* New York: The Studio Museum in Harlem, Harry N. Abrams, 1992.

Barclay, Juliet. *Havana: Portrait of a City.* London: Cassell, 1993.

Battersby, Martin. *The Decorative Thirties.* New York: Whitney Library of Design, 1971.

Bermúdez, Jorge R. *Clara Porset: Diseño y Cultura.* La Habana: Editorial Letras Cubanas, 2005.

Boadi, Antonio, and Manuel Ecay. *Cuba Arquitectura y Artes Similares: Anuario de Arquitectura.* La Habana, 1941.

Cabrera, Raimundo. "Cuba y América Revista Ilustrada," *La Habana,* 11 diciembre 1904.

Carley, Rachel, and Andrea Brizzi. *Cuba: 400 Years of Architectural Heritage.* New York: Whitney Library of Design, 1997.

Carpentier, Alejo. *La Consagración de la Primavera.* La Habana: Editorial Letras Cubanas, 1987.

de Castro, Fernando. *In Memoriam, Rafael de Cárdenas.* La Habana: Arquitectura no. 285, April 1957.

Bianchi Ross, Ciro. *Asistiré.* La Habana: Juventud Rebelde Digital, September 26, 2004

Colecciones de Arte Universal: El Museo Nacional de Bellas Artes de Cuba. La Habana: Editorial Letras Cubanas, Caja Duero, 2001.

Cuba: Art and History from 1868 to Today. El Museo Nacional de Bellas Artes and Musée de Beaux Arts de Montreal. Montreal: Prestel Publishing, 2008.

Cuban Painting of Today. New York: Museum of Modern Art, May 1944.

Database of the Cuban Genealogy Club of Miami.

Dimock, Joseph J. *Impressions of Cuba in the Nineteenth Century: The Travel Diary of Joseph J Dimock.* Wilmington, Del: Scholarly Resources Inc., 1998.

El Encanto: *Guía Provincial de La Habana en el Municipio de La Habana.* La Habana: años 1950.

Essler, Fanny. *Cartas desde la Habana: Traducción de Francisco Rey Alfonso.* La Habana: Ediciones Boloña, 2005

Estrada, Alfredo José. *Havana: Autobiography of a City.* New York: Palgrave Macmillan, 2007.

Farinas Borrego, Maikel. *Sociabilidad y Cultura del Ocio: Las Elites Habaneras y Sus Clubes de Recreo (1902–1930).* La Habana: Fundación Fernando Ortiz, 2009.

Griffith, Cathryn. *Havana Revisited: An Architectural Heritage.* New York: W. W. Norton, 2010.

Havanity, April 20, 1941.

Hazard, Samuel. *Cuba with Pen Pencil.* London: Sampson, Low, Marston, Low & Searle, 1873.

Hemingway, Hilary, and Carlene Brennen. *Hemingway in Cuba.* New York: Rugged Land, LLC, 2005.

Hewitt, Mark Alan, et al. *Carrère & Hastings: Architects.* New York: Acanthus Press, 2006.

House & Home. "Caribbean Mansion," August 1952.

Jacques, Denise. *The Tiled Mansion.* Havana: Ponton Caribe. 2003.

Kellner, Douglas. *Earl Smith: Testimony 1960 to U.S. Senate.* Washington, D.C.: 1989.

Levine, Robert M. *Cuba in the 1850s: Through the Lens of Charles de Forest Fredricks.* Tampa: University of South Florida Press, 1990.

Loynaz, Dulce Maria. *Fe de Vida.* La Habana: Letras Cubanas Editorial, 1997.

Linares Ferrara, José. *Historia de un Proyecto: El Museo Nacional de Bellas Artes.* La Habana: Oficina de Publicaciones del Consejo de Estado, 2003.

Llanes, Lillian. *Havana Then and Now.* San Diego: Thunder Bay Press, Chrysallis Books Group, 2004.

Lydia Cabrera: An Intimate Portrait. New York: INTAR Latin American Gallery, 1984.

Las madrinas del Hospital Universitario Calixto Garcia. *Gusta Usted.* La Habana: primera edición, 1956. Miami: Ediciones Universal 1999.

Mascuñana, Joaquin. *Crónica de los festejos celebrados en honor de SSAARR con motivo de su permanencia en esta isla.* La Habana:

Thomas, Hugh. *Cuba or The Pursuit of Freedom.* London: Eyre & Spottiswoode Ltd, 1971.

Photography Credits

Imp. de El Eco de los Voluntarios y Bomberos, 1893.

Menendez, Madeline. *La Casa Habanera, Tipologia de la Arquitectura Domestica en el Centro Histórico*. La Habana: Ediciones Boloña, 2007.

Morales Menocal, Juan Luis. *Havana Districts of Light*. Paris: Telleri Vilo Publishing, 2001.

Moruzzi, Peter. *Havana Before Castro: When Cuba was a Tropical Playground*. Layton, Utah: Gibbs Smith, 2008.

Newcomb, Rexford. *Spanish Colonial Architecture in the United States*. New York: Dover Publications, 1990.

New York Herald Tribune, "American Aids Cuban Artist," January 17, 1933.

New York Times, "Alexis, The Grand Duke In Havana," March 11, 1872; "Alexis, The Grand Duke's Sojourn in Havana," March 15, 1872; "Cuba Preparing to do honor to Spanish Royalty," May 10, 1893; "Churchill meets the Pres of Cuba," February 2, 1946.

Oficina del Historiador de la Habana, Portal oficial.

Park, Rebecca. *Brief History of the U. S. Residence and Eagle*. Havana: June 2005.

Perez Jr., Luis A. *Cuba Between Reform and Revolution*. New York: Oxford University Press, 1998.

Préstamo Hernández, Felipe. *Cuba, Arquitectura y Urbanismo*. Miami: Ediciones Universal, 1995.

Reynolds, Doris. Naples, *The Moorings and the Cuban Connection*. Naples, Fl.: Coastal Elegance and Wealth, March–April 2007.

del Rio Bolivar, Natalia. *Vértigo del Tiempo memorias de Nena Arostegui*. La Habana: Ediciones Boloña, 2006.

Rodriguez, Eduardo Luis. *Modernidad Tropical, Nuetra, Burle Marx y Cuba: La Casa de Schulthess*. La Habana: Embajada de Suiza en Cuba, 2007.

Scarpacci, Joseph L., Roberto Segre, and Mario Coyula. *Havana: Two Faces of the Antillean Metropolis*. New York: John Wiley & Sons, Ltd., 1997.

Sanchez Robert, Siomara. La Habana: Puerto y Cuidad, *Historia y Leyenda*. La Habana: Publicación de la Oficina del Historiador de la Cuidad Ediciones Boloña. 2001.

Santa Cruz, Mercedes, Condesa de Merlin. *La Habana: Traducción de Amalia E. Bacardi*. Madrid: 1981.

Scully Jr., Vincent. *Modern Architecture: The Architecture of Democracy*. New York: George Braziller, 1961.

Social, La Habana, February 1916 (Mendoza); March 1918; May 1930 (Baró Lasa); June 1930 (Aviles and Baró Lasa); August 1930; January 1931; February 1931 (Solis); March 1931 (Mason); May 1931; July 1931; April 1936 (Mason).

Stout, Nancy, and Jorge Rigau. *Havana/La Habana*. Rizzoli International Publications, 1994.

Time, "Cuba: Snare Jubilee," February 17, 1936; "Art of the Americas," July 12, 1939.

del Toro, Carlos. *La Alta Burguesia Cubana: 1920–1958*. La Habana: Editorial de Ciencias Sociales, 2003.

Trollope, Anthony. *The West Indies and the Spanish Main*. New York: Carroll & Graff Publishers, Inc., 1999.

El Vedado: Regulaciones Urbanísticas. Dirección Provincial de Planificación Física. La Habana: Ediciones Boloña, 2007.

Washington Post, "Married in Havana," July 29, 1947.

James Archer Abbott, *Jansen Furniture* 186 right; Jansen 224 right

Biblioteca National de Cuba, José Marti 15 right, 129, 134, 172 top, 238

Bruce Buck 2, 52

Rafael Diaz Casas Collection 231

Cernuda Arte, 232 right

Corbis 64 bottom

Ana Maria Crossfield Collection 190, 205 top right

Cuba Arquitectura y artes similares 188, 193 bottom

Cuban Heritage Collection, University of Miami 10, 12, 15 left, 17 top, 24 top left and right, 44 left, 45, 53, 54, 57 bottom, 124 bottom left, 177 top right, 178 left

Emilio Cueto, *Mialhe's Colonial Cuba* 16

Ediciones Universal, *Cuba Arquitectura y Urbanismo* 18

Alfred Eisenstadt, Time & Life Pictures/ Getty Images 182 left

Eliot Elisofon, Time & Life Pictures/ Getty Images 196, 220

Adrian Fernandez 13 bottom left and right, 14 left, 26, 27, 28–29, 30, 31, 32, 33, 34–35, 36–37, 37, 38–39, 40, 41, 55, 56, 57 top, 59 top left and right, 59 bottom left, 60 bottom, 74, 75, 76, 77 bottom left and right, 78, 104, 105, 106, 107, 108, 109, 110, 111, 112–13, 113, 114, 115, 116–17, 118 left, 119, 120 top right & bottom 121, 123, 124 top and bottom right, 126, 127, 128, 130, 131, 132, 133, 135, 136, 137, 139, 140, 142, 143, 144, 145, 146, 147 right, p. 149, 150, 150–51, 152, 153, 154, 154–55, 156–57, 158–59, 160, 170, 171, 172 bottom left and right, 174, 175 left, 178 right, 179, 180, 183, 185, 186 left, 187, 189, 191, 195, 200, 205 left and bottom right, 207, 208, 209, 210, 211, 212, 213, 214, 215 right, 216, 217, 218–19, 219, 220 top right, 221, 222, 223, 225, 226, 233 top, 234 left, 236, 237, 239, 240, 242 bottom, 243, p. 244 top, p. 244 bottom left, 245, 246, 247 top and bottom right, 248, 249, 250–51, 252, 253, 254, 255 256, 257, 258, 259, 260, 261, 262–63, 264, 266, 267, 268–69

Ramiro Fernandez Collection 14 right, 17 bottom, 122 top left, 235 bottom

Fototeca del Museo de la Ciudad de la Habana 42

Suzanne Gardner Collection 198, 199

Ernest Hemingway Collection/John F. Kennedy Presidential Library and Museum 206, 215 left

Hotel Nacional de Cuba 125 right

Denise Jacques Collection 148, 157, 159

Robert W. Kelley, Time & Life Pictures/ Getty Images 182 right

Nina Leen, Time & Life Pictures/Getty Images 202, 203

Elena Lord Collection 138, 141, 147 left top and bottom

Dr. Roberto Machado Collection 168

Makario Collection 161

Hermes Mallea 11, 13 top left, 24 bottom, 25, 34, 44 right, 58 left, 63, 72 left, 84, 86–87, 90 top, 94, 117 bottom, 118 right, 120 top left, 122 bottom right, 125 left, 162, 165, 166, 167 right, 181, 235 top and right

Carey Maloney 244 bottom right

Nestor Marti 19, 21, 22–23, 43, 46, 47, 48–49, 49, 50–51, 59 bottom right, 61, 62, 64 65, 66, 67, 68, 68–69, 70, 70–71, 72 right, 77 top, 78-–79, 80–81, 81, 82, 83, 85, 88, 89, 90 bottom left and right, 91, 92, 92–93, 95, 96, 97, 98, 99, 100–1, 102, 103, 173, 192, 193 top, 197, 201, 204 right, 224 left, 233 bottom, 242 top, 247 bottom left, 262, 265

Gjon Mili, Time & Life Pictures/Getty Images 204 left

Peter Moruzzi, *Havana Before Castro* 230

Museo Nacional de Bellas Artes de la Habana, Montreal exhibition, "Cuba Art and History from 1868 to Today" 58 left, 73, 176 bottom, 232 right

Museo del Prado, Rosales 20

Museum of Decorative Arts Library, Havana 220 bottom right, 224 bottom, 227, 228, 229

Gordon Parks, Time & Life Pictures/ Getty Images 194

The Studio Museum in Harlem, "Wifredo Lam and his Contemporaries" 177

Hugh Thomas, *Cuba or the Pursuit of Freedom*, 117

Joaquin Weiss, *Arquitectura Contemporanea Cubana* 169, 175 right, 241, 234 right

Wildy 13 top right, p. 60 top, 163, 164, 167 left, 177 top left

The Wolfsonian-FIU, The Mitchell Wolfson Jr. Collection 176 top

Acknowledgments

I am grateful to my partner, Carey Maloney, for his enthusiastic support during every phase of the creation of this book, which would not have been possible without his support, sense of humor, energy, and unerring eye—as well as his eagerness to convey the glamour and historic significance of Havana's residential architecture.

Margarita Alarcón Perea was the godmother of this publication, sharing her time and bursts of inspiration as well as her passion for my theme. Much appreciation to friends in Havana who have been part of this process from the very beginning: Alejandro G. Alonso, Ernesto Cardet Villegas, Pedro Contreras, Reny Martínez, and Siomara Sánchez Robert. All are experts in the study of Cuban culture and decorative arts, and they generously shared their decades of connoisseurship with me.

My gratitude to the friends who ardently supported this project, sharing their personal Havana reminiscences as well as their photography collections, constantly helping me to expand my network of resources: Iliana Cepero, Rafael Díaz Casas, Ramiro Fernández, Jorge García Tudurí, Ignacio Martínez-Ybor, and the encyclopedic Juan Portela.

Throughout the development of this book, I was given a warm reception inside Havana's private homes, diplomatic residences, and cultural institutions, where knowledge and special insight were always contributed. I want to express my special thanks to the families of the homeowners who helped me to visualize life inside these great houses: Ana María Alvarez Tabío, Ana María Crossfield, Suzanne Gardner MacLear, Gloria Gómez Mena de Marina, Luis Estevez, Enrique Govantes Pemberton, Elena Lord and Elena Aguilera, Alane Mason and Tony Mason, Fichu Menocal and Virginia Morales Menocal, Nina Menocal, Karin Oldfeldt, Alina Pedroso, Carlos Pérez and Sandra von Schulthess.

Among the residents who welcomed me into their homes are Ambassador Peter Burkhard of Switzerland, Head of the U.S. Interests Section, Jonathan Farrar and Terry Farrar, Canadian Ambassador Michael Small and Denise Jacques, Canadian Ambassador Jean Pierre Juneau and Mme. Juneau, Ambassador Dianna Melrose of Great Britain and Ambassador Caroline Fleetwood of Sweden.

I am grateful to the directors of Havana's museums who shared my passionate belief that this was a story that needed to be told: Moraima Clavijo Colóm, director, Museo Nacional de Bellas Artes; Margarita Suarez García, director, Museum of Colonial Art; Maria Elena Roche López, director, La Casa del Vedado, Katia, Varela, director, Museum of Decorative Arts; Gloria Alvarez, director Fototeca of the Museum of the City of Havana; Margarita Ruiz Brandi, director of Patrimony, Ministry of Culture, Kenia Serrano Puig, director of the Cuban Institute for Friendship with the Peoples.

Esperanza Bravo de Varona and Maria Estorino graciously supported my research at the most important resource for Cuban studies outside the island: The University of Miami's Cuban Heritage Collection.

My gratitude to members of Havana's architecture and historic preservation community including Dr. Eusebio Leal Spengler, Historian of the City of Havana, Gonzalo de Cordoba, Jose Antonio Choy and Julia de Leon, Enrique de Jongh, Orlando Inclán, Victor Marín, Severino Rodríguez Valdes, and Daniel Taboada Espiniella.

Friends and colleagues who offered their expertise include James Archer Abbott, Natalia Bolivar, Matthew Carnicelli, Emilio Cueto, Gail Davidson (Cooper Hewitt Museum), Jasper Goldman, Gustavo Lopez (Museum of Decorative Arts), Max Lesnik, Vivien Lesnik Weisman, Narciso Menocal, William C. Nixon, Keiji Obata, Natalia Revuleta Clews, Marianne Thorsen, Mayda Tirado, Rufino del Valle, and Jack Weiner.

My appreciation to the creative team at the Monacelli Press, Elizabeth White, Stacee Lawrence, and Rebecca McNamara, and to Susan Evans of Design per Se. I am grateful to Paula Rice Jackson for introducing the project to Monacelli and to Gianfranco Monacelli for supporting it.

Finally, I respectfully acknowledge the creativity and talents of the architects and designers, builders, and craftsmen who built the Great Houses of Havana, which are a source of pride for Cubans everywhere.